Flat Broke with Children

Women in the Age of Welfare Reform

Sharon Hays

OXFORD
UNIVERSITY PRESS

OXFORD
UNIVERSITY PRESS

Oxford New York
Auckland Bangkok Buenos Aires Cape Town Chennai
Dar es Salaam Delhi Hong Kong Istanbul Karachi Kolkata
Kuala Lumpur Madrid Melbourne Mexico City Mumbai Nairobi
São Paulo Shanghai Taipei Tokyo Toronto

First published by Oxford University Press, Inc., 2003
198 Madison Avenue, New York, New York 10016

First issued as an Oxford University Press paperback, 2004
ISBN 0-19-517601-4 (pbk.)

www.oup.com

Oxford is a registered trademark of Oxford University Press

The Library of Congress has cataloged the hard cover edition as follows:
Hays, Sharon, 1956–
Flat broke with children : women in the age of welfare reform / Sharon Hays.
p. cm.
Includes bibliographical references and index.
ISBN 0-19-513288-2
1. Public welfare—United States.
2. Welfare recipients—United States.
3. Poor women—United States.
4. Mothers—United States.
5. Poor single mothers—United States.
6. United States. Personal Responsibility and Work Opportunity Reconciliation Act of 1996.
I. Title.
HV95 .H36 2003 362.83'92'0973—dc21 2002009841

9 8 7 6 5 4 3 2
Printed in the United States of America

To my husband, Thomas Ehlers,
and to the memory of his mother, Jessica Marks (1930–2000)

Contents

Acknowledgments

In pointing out how difficult it is to survive on a welfare check without the help of friends and family, one of the welfare mothers I met suggested that everyone, rich and poor alike, deserves to be in a "help situation." In writing this book, I was fortunate to have been embedded in a particularly abundant help situation.

If not for the generosity of the welfare mothers and welfare caseworkers who opened up their worlds to me and shared their time, their hopes, and their stories, this book, of course, could not have been written. For the welfare mothers who taught me so much, I can only hope that I did some justice to their explicit request that I should "let people know what's been going on here." And, as inadequate as it is, I offer my gratitude, respect, and admiration to the welfare caseworkers who were especially gracious with me, letting me pester them with questions and peep over their shoulders for more hours than I can count. Among them, special thanks are owed to the welfare supervisor who in this book I call Nancy (and who is a hero to me), and to two other welfare caseworkers who, with Nancy, read through early drafts to reassure me that the welfare offices I was describing resembled the ones they knew.

Bethany Bryson and Sarah Corse are the most wonderful colleagues a girl ever dreamed of, and they were right there with me through every stage in this process, reading drafts, propping me up, and talking it out. Also providing incredibly useful critical readings and much-needed emotional support were Laura J. Miller, Demie Kurz, Bess Rothenberg, and Rae Blumberg. Many others helped me to write this book by sharing their wisdom, their friendship, and good humor: Elizabeth Long, Ann Lane, Eileen Boris, Bella DePaulo, Karin Peterson, Gianfranco Poggi, Barbara Risman, Jeff Weintraub, Dick Madsen, and Bennett

Berger. All of these people have given me more than they know, and will forever be in my heart and my head.

My students, Anne Wallin, Karlin Luedtke, Patti Goerman, Jessie Gillium, Katie Klinger, and Charity Donnelly, helped me do all the (indescribably tedious and crucial) transcribing and reference tasks. Anne and Karlin also read drafts and offered friendships that I cherish. Two administrative staff members, Joan Snapp and Edith Conti, made my life easier in so many ways that it is hard to fully express my gratitude.

I have also been aided and inspired by people who dedicate themselves to making books happen. Gladys Topkis, one of the more brilliant and generous women on the planet, helped me to get this off the ground. Sydelle Kramer, with a strong and spirited character that I love, was way too patient with me, and backed me up every step of the way. Tim Bartlett, the toughest critic any writer ever wrestled with, taught me much, and my thanks are not nearly enough.

The University of Virginia Center for Children, Families, and the Law funded my research in Sunbelt City, and the University of Virginia Vice Provost for Research provided me with a summer research fellowship to write; I am very grateful to them both.

Much more than an acknowledgment is owed to my family. They gave me their strength when mine faltered, offered their love and support (no matter how cranky I became), and suffered through some of my most underdeveloped ideas and lousiest drafts. Mom, Dad, Connie—all my love and a million kisses. Finally, I dedicate this book to my husband and to the memory of his mother who, for some years in his youth, raised my Tom and his three sisters as a single mother on welfare. The man she brought up, the one I love, could not be greater testimony to her strength of character, and to her commitment to serving the larger good.

Flat Broke with Children

Chapter 1

Money and Morality

A NATION'S LAWS REFLECT A NATION'S VALUES. The 1996 federal law reforming welfare offered not just a statement of values to the thousands of local welfare offices across the nation, it also backed this up with something much more tangible. Welfare reform came with money. Lots of it. Every client and caseworker in the welfare office experienced this. New social workers and employment counselors were hired. New signs were posted. New workshops were set up. In Arbordale and Sunbelt City, the two welfare offices I studied to write this book, every caseworker found a new computer on her desk.* In small-town Arbordale, the whole office got a facelift: new carpets, new paint, a new conference room, new office chairs, and plush new office dividers. The reception area, completely remodeled with plants and posters and a children's play area, came to resemble the waiting room of an elite pediatrician's office more than the entrance to a state bureaucracy. Sunbelt City acquired new carpets, a new paint job, and new furniture as well. And all the public areas in that welfare office were newly decorated with images of nature's magnificence—glistening raindrops, majestic mountains, crashing waves, setting sun—captioned with inspirational phrases like "perseverance," "seizing opportunities," "determination," "success."

* Arbordale and Sunbelt City are pseudonyms for the two towns where I studied the effects of welfare reform. I gave them these ficticious names to protect all the clients and caseworkers who shared with me their experiences of reform.

As I walked the halls of the Sunbelt City welfare office back in 1998, situated in one of the poorest and most dangerous neighborhoods of a western boom town, those scenes of nature's magnificence struck me as clearly out of place. But the inspirational messages they carried nonetheless seemed an apt symbolic representation of the new legislative strategy to train poor families in "mainstream" American values. Welfare reform, Congress had decreed, would "end the dependence of needy parents on government benefits by promoting job preparation, work, and marriage."[1] Welfare mothers, those Sunbelt signs implied, simply needed a *push*—to get them out to work, to keep them from having children they couldn't afford to raise, to get them married and safely embedded in family life. Seizing opportunities.

States were awash in federal funds. And the economy was booming in those early years of reform. Everyone was feeling it. There was change in the air. A sense of possibilities—with just a tinge of foreboding.

The Personal Responsibility and Work Opportunity Reconciliation Act of 1996, the law that ended 61 years of poor families' entitlement to federal welfare benefits—the law that asserted and enforced a newly reformulated vision of the appropriate values of work and family life—provided all that additional funding as a way of demonstrating the depth of the nation's commitment to change in the welfare system. It provided state welfare programs with federal grants in amounts matching the peak years of national welfare caseloads (1992 to 1995)—even though those caseloads had everywhere since declined. This meant an average budget increase of 10 percent, before counting the tremendous amount of additional federal funding coming in for new childcare and welfare-to-work programs. Even though there was lots more money, most states did not pass it on to poor mothers in the form of larger welfare checks. In fact, only two states raised their benefit amounts, while two others lowered theirs at the inception of reform.[2]

Most of the welfare caseworkers I met were optimistic about the new law, at least in the first year of its enactment. "Welfare reform is the best thing that ever happened," was a phrase I heard frequently. A number of caseworkers, echoing popular sentiment, told me that "welfare had become a trap" and the clients had become "dependent." Some focused on the tax money that would be saved. Others pointed out that lots of caseworkers are mothers too, and economic necessity forces them to come to work every day and leave their children in day care, so it seemed only

fair that welfare mothers should be required to do the same. Still others emphasized that welfare reform provided caseworkers the opportunity to do what they were meant to do all along—it allowed them to "help people." Eligibility workers in particular, who had long had the job of simply processing applications and pushing papers, told me that they had grown tired of just "passing out the checks." Welfare reform, one such worker enthusiastically noted, offered the training and services necessary "to make our clients' lives better, to make them better mothers, to make them more productive." At the same time, some welfare workers, especially the social workers and employment counselors, worried about the long-term consequences of reform and wondered about how some of their clients would survive. But almost all caseworkers agreed that the old system was a problem and that the "self-sufficiency" and familial responsibility required by welfare reform were (at minimum) good ideas.

Welfare clients experienced the change from the moment they walked into the welfare office. It wasn't just the new waiting room and the freshly refurbished offices. Things were different. The eligibility workers were still there, asking the same demanding and intrusive questions: "Do you have a savings account? How many people live in your household? What is the social security number of your child's father?" But now there were also those newly hired or promoted social workers and employment mentors, referring clients to programs with new acronyms and talking in excited and upbeat tones about jobs and special services. They seemed helpful, solicitous. The word was out on the street and in the housing projects within a year after the law was passed—the welfare office was helping people with childcare, there were vouchers to buy gasoline for your car, they were paying for work uniforms and clothes for job interviews. Current and potential welfare recipients who were not well connected enough to hear the news on the street might see it on television—those stories of poor single mothers who had "made it" with the help of reform, pictured with their children or in their new workplaces, smiling, happy, redeemed.

But there were problems too. There was apprehension, anxiety, disgruntlement. At the federal level, some officials of the Clinton administration resigned their posts in protest of the passage of the Personal Responsibility Act, citing its punitive policies and inadequate supports. Liberal policy institutes expressed deep concern about the long-term

impact of denying a financial safety net to the poor. And children's advocates, feminists, and others pointed out that welfare reform specifically targeted women, children, and a disproportionate share of non-whites—thus adding to the hardship of those who already face widespread discrimination.[3]

For most welfare caseworkers and clients, I soon discovered, the problems and concerns they faced were much more immediate and seemed much more pressing. For caseworkers, the new law meant that there were lots of new rules to be learned. State procedural manuals, already incredibly unwieldy, were growing by leaps and bounds. The forms were multiplying apace. Job titles were created or changed, everyone had new duties, a vast amount of time was spent discussing the changes and how best to implement them. New computer systems weren't working properly. Caseworkers in Arbordale were being asked to input all information into two different programs in order to make certain that records were not lost. In Sunbelt City, the multimillion dollar computer system designed to accommodate the new rules and regulations of welfare reform was still not working two years after the reform was instituted. I heard jokes in the hallways that the time limits on welfare benefits would ultimately prove meaningless, since the computer systems would be unable to track recipients.

Caseworkers who had been in their jobs for over a decade were being told that they had to change their way of doing business. Previous welfare "reforms" they'd experienced seemed relatively minor compared to the massive shift brought on by the 1996 law. There were new quotas to meet, new protocols to follow. The pressure was on. Added to older concerns about "error rates," the mistakes in determining welfare eligibility and benefit amounts, were new concerns about "participation rates," welfare reform's requirement that ever-growing numbers of poor parents be placed in jobs or work-related activities. And there were those new, less flexible rules regarding the establishment of paternity, and the logistical nightmare of coordinating childcare placements. The Arbordale supervisor, Nancy, a 21-year veteran of the welfare system, worried about how her caseworkers would cope. She sent them all on a retreat that followed the logic of the "grieving process": believing that facing this kind of massive change was much like grieving for a lost loved one, the workshop illuminated the emotional process one can expect—anger, denial, bargaining, depression, and finally, acceptance. But the

changes just kept on coming. In Sunbelt City and Arbordale, there were major turnovers in welfare employees.

Welfare clients who had been in their "jobs" for years—many of them cycling back and forth between low-wage work and welfare-subsidized stay-at-home motherhood—were being told that they had to change *their* way of doing business.[4] This included women who had long understood welfare as a place to go when they lost their jobs, when they desperately needed medical insurance, when their depression overwhelmed them, or illness or physical disabilities (their own, or their children's) left them temporarily unable to work. It included mothers who found themselves on welfare when their boyfriend or husband became too abusive and just had to go, women who once made decent wages but were laid off their jobs and had run out of unemployment checks, and prostitutes who visited the welfare office when they were suffering from business woes. It also included poor, single mothers with young children and no marketable skills who had struggled for years to cobble together all available resources in order to make ends meet on their miserly welfare checks—$354 a month for a family of three in Arbordale; $348 for such a family in Sunbelt City.

At the inception of welfare reform, one in every eight children in the United States was supported by a welfare check.[5] One in eight. Like all those before them, those children lived in families that were *desperately* poor. In order to be eligible for welfare benefits, applicants must prove that their household income is less than one-half of the federal standard for poverty. In 2002, that meant a mother with two kids must show an income of less than $7,510 a year—but most prospective clients had much less than that.

All those mothers and their children faced a "new" welfare office. It was a welfare office that was much more demanding. It's more "hassles" than ever before, welfare clients told me. Jessie, with a 13-month-old infant and a three-year-old son, found herself overwhelmed by the pace: "They're always telling you to hurry up and go. 'Get that form! Go to this workshop! Go over there! Come back here!'" Carey, who'd just returned to welfare after successfully juggling work and single motherhood for six years, explained, "It used to be a whole lot more peaceful," but since reform the workers "are just too busy—there's too much going on." Some recipients emphasized the "huge number of ridiculous regulations" that made their lives miserable, a few even said that caseworkers

"don't really want to help you anymore." But most welfare mothers blamed "the system" for any problems they experienced and recognized that caseworkers were "just doing their jobs."

More than that, those kinds of complaints often came from the very same poor mothers who told me that, overall, welfare reform was a positive change. Like caseworkers, almost all welfare recipients noticed the public enthusiasm for reform signaled by all the new programs, the influx of federal dollars, and the surge of media coverage that occurred in the first years of implementation. They clearly understood the language of "personal responsibility." And many of them said that they thought it was about time that all those other welfare mothers they were hearing about, the ones who just "sit on their butts all day," were reminded of their responsibilities to their children and to hard-working, tax-paying Americans. When they found themselves subjected to this pressure directly, however, it often felt improperly targeted or unfairly administered.

By the time I was completing my research, the Personal Responsibility Act along with the strong economy of the previous decade had resulted in a dramatic decline in the welfare rolls—from 12.2 million recipients in 1996, to 5.3 million in 2001. The rolls had thus been cut by more than half; yet during that same period, the number of people living in dire poverty had declined by only 15 percent. Although nearly two-thirds of former welfare clients had found some kind of work, half of those were not making wages sufficient to raise them out of poverty. The fate of those who were without jobs or welfare—over one-third of former recipients—remained largely unknown.[6]

As the economy stalled in 2001, it was evident that welfare reform had impacted poor families' willingness to seek help as well as the government's willingness to provide it.[7] While 84 percent of desperately poor (welfare-eligible) families had received benefits prior to the passage of the Personal Responsibility Act, by 2001 less than half of them did. This meant that millions of parents and children in America were living on incomes lower than half the poverty level and not receiving the benefits for which they were technically eligible. No one was certain how all those families were surviving, but food banks, homeless shelters, and local charitable organizations were all reporting an increasing number of customers, and welfare offices were seeing some of the families who had left earlier, coming back again.[8]

What is welfare reform all about? Ask the caseworkers and clients who have faced it on a daily basis, and they'll say it's more rules, more hassles, more prying, a new maze of demands—fast paced, complex, confusing. Some will also say it's punitive, uncaring, or at least inadequate for the task at hand. Ask again. It's more services, more help, and has provided a much-needed change, I heard time and again, for all those welfare clients who had been dependent on the welfare system for far too long.

Is welfare reform a positive change? Though there have been signs of doubt and protest, overall, the resounding national reply has been yes. Despite the hassles, the inadequacies, the food lines, and the millions of women and children whose fate remains unknown, thus far the powerful symbolic message of welfare reform has triumphed.[9]

The Cultural Logic of Welfare Reform

A nation's laws reflect a nation's values.

Like all laws, the law reforming welfare operates as a mechanism of social control to deter would-be transgressors and to discipline those who are measured as deviant according to its standards. By punishing those who break a society's moral code and supporting those considered worthy, laws can also serve to strengthen and affirm the values prescribed.[10] This is no less true of the belief that people should stop at stoplights than it is of Americans' affirmation that older citizens deserve Social Security and our collective condemnation of murder as the highest crime. Thus, the Personal Responsibility Act is much more than a set of policies aimed at managing the poor, it also provides a reflected image of American culture and reinforces a system of beliefs about how *all* of us should behave.

Of course our laws are an imperfect reflection of our values. In the case of welfare reform, for instance, it is clearly important to consider the power and financial resources of the politicians primarily responsible for designing the law relative to those who are its central targets. The content and form of laws are also constrained and shaped by the organizational practices and procedures of political and social life—the partisan bickering, the vote mongering, the committee negotiations, the language and structure of the legal system, the existing mechanisms for implementation and enforcement. And it certainly cannot be assumed

that the values legislated are fully shared, let alone regularly practiced, by all members of the society. Still, in modern democracies where politicians are charged with representing the interests of their constituents, it can be said without much doubt that there is a strong relationship between the nation's laws and more widespread cultural norms, beliefs, and values.

The purpose of this book is to explore the cultural norms, beliefs, and values embedded in welfare reform. While millions of dollars have been spent to track the outcomes of this legislation, and while scholars, politicians, and pundits have fiercely debated the effects of every policy contained within it, I want to focus attention on the broad *cultural* significance of this reform effort. What does the Personal Responsibility Act tell us about the values of our society? How have its moral prescriptions been translated into concrete practices? What message does it send to the poor and to the nation? In particular, I was interested from the start in determining just what welfare reform is saying about work and family life in American society today.

The Personal Responsibility Act can ultimately be understood as a social experiment in legislating family values and the work ethic.[11] All the controversy, uncertainty, and enthusiasm that attended its enactment are testimony to its experimental nature. And even now, after years of policy analysis and political celebrations of this reform's "success," there are continuing disagreements about its long-term consequences, and different audiences have interpreted its import in different ways. Yet few doubt that there were problems in the old welfare system, and nearly everyone recognizes that the reform of welfare is connected to widespread social concerns regarding the proper values of work and family life. The pages of this book are meant to tease out both the worthy principles and more disturbing realities from which those concerns have emerged.

Scores of books have been written on welfare. Scholars have rendered the history of welfare programs, charted the increasing animosity toward the welfare system and welfare recipients, illuminated the hardship of the poor, analyzed the efficacy of welfare policies from every possible angle, studied the shape of economic hierarchies, and systematically examined the gender and race inequalities reflected in and impacted by welfare laws.[12] All of this work informs my own. The most

popular studies of welfare, however, have been those that criticize the values of welfare recipients and the values perpetrated by the old welfare system.

The depth of public concern with the morality of welfare recipients and the welfare system is reflected in national opinion polls. Although those polls consistently demonstrate that Americans are in favor of providing aid to the poor and vulnerable, they also show that most Americans have been profoundly dissatisfied with the values of the old system of welfare. Over 90 percent believed that the system needed overhaul; over 80 percent favored welfare reform. In all these polls, Americans forcefully indicate that they are less concerned about the costs of welfare than they are about its effects on the morality of the people being served. When criticizing the old system, only 14 percent named costs as the central issue; over half, on the other hand, said that the old system encouraged people to "adopt the wrong lifestyle" (65 percent), discouraged people from working (80 percent), encouraged women to have more children (57 percent), and operated to keep people poor (51 percent). And over 70 percent of Americans believed that welfare recipients were both abusing the system and had become overly dependent upon it.[13]

The welfare recipients whose morality has been under attack are not just desperately poor. The vast majority of adult welfare clients—over 90 percent—are *mothers*. Most of these women are raising their children alone: just 7 percent of welfare cases are two-parent households; an even smaller percentage are single-parent households headed by men. Black and Hispanic Americans are also overrepresented on the welfare rolls, largely because they are more likely than whites to be poor: 38 percent of welfare recipients are black, 24.5 percent Hispanics, and 30 percent white. But the real face of a welfare recipient is the face of a child—children outnumber adults on the rolls by a ratio of more than two to one.[14] As anyone who has ever spent time in a welfare office knows, it is a world of women, children, and diversity.

There is no question that the old system that served these poor families suffered from multiple problems. Its benefits were so dismally low that almost all recipients had to come up with additional sources of help just to cover the cost of their most basic needs. Its policies operated to make it all the more difficult to climb out of poverty, and its recipients were systematically stigmatized. Further, despite the crucial importance of paid work and family ties in American culture, the old welfare system

did very little to help recipients manage employment, to subsidize child-care, or to include poor fathers.

Conservative and liberal scholars have argued over whether money or morality was at the root of the problems involved. The conservative critics of welfare (including Charles Murray, George Gilder, and Lawrence Mead) offered the primary fuel for negative public sentiment. They accused welfare recipients of being lazy, promiscuous, and pathologically dependent, and they argued that the welfare system encouraged those bad values with overly generous benefits and "permissive" policies that provided incentives for family dysfunction and nonwork. According to these thinkers, the welfare system thereby not only perpetuated poverty but, by promoting laziness and single parenting, actually caused it to increase.

Liberal scholars (including Kathryn Edin and Laura Lein, William Julius Wilson, Sheldon Danziger, and Kathleen Mullan Harris) have agreed that there were problems in the old welfare system and among the poor. But they have consistently argued that any problems of morality that existed among poor families were primarily the result, rather than the cause, of economic hardship.[15] Hence, while conservatives claimed that the value-orientation of the welfare system and the welfare poor needed overhaul, liberals emphasized that welfare policy needed to focus on providing better economic supports for the poor. These are critical issues. Yet, whether the problems are framed as moral or economic, the solutions are always *both* moral and economic—they require decisions regarding the extent to which and the methods by which the nation will respond to its poorest citizens.

In this book, I join the conservative critics of welfare in focusing squarely on the question of values. In this case, however, I intend to not only scrutinize the allegedly "bad" values of the poor, but also to critically examine the allegedly "mainstream" values embedded in the newly reorganized welfare system. There are, in fact, fundamental tensions in the values set forth by the Personal Responsibility Act, and there is widespread disagreement regarding just what vision of the good society it should serve.

At the heart of welfare reform is a debate over whether individual self-sufficiency should be our nation's central goal or whether, for women at least, the maintenance of "traditional" family values should remain central. This controversy, in its broader and more subtle forms,

extends well beyond disagreements over welfare policy. It speaks to foundational American ideals of independence and commitment to others, and it underlines just how precarious those ideals have become in the age of fragile families, social mistrust, rising economic inequalities, and an unstable global marketplace. Those tensions also reflect more immediate practical and moral dilemmas faced by vast numbers of Americans today as they struggle to both support their families financially and to care for their children and one another.

Welfare reform is one response to those problems. Although it offers the symbolic appearance of a solution to serious social concerns, its exclusionary assumptions, its rigid regulations, and its narrowly drawn and opposing images of the proper approach to work and family life raise many questions regarding whether this law can truly resolve the problems of the poor families it targets, and whether it actually offers a positive and valuable response to the cultural disagreements and practical troubles of the nation. With these issues in mind, my aim is to document the Personal Responsibility Act as it is played out in the language of policy, the procedures of welfare offices, and the lives of the millions of mothers and children who receive welfare.

The story begins like this.

Work, the Family, and Welfare

Welfare policy in the United States has long been closely connected to the nation's cultural vision of the appropriate commitment to work. Nineteenth-century poor laws established the moral distinction between the "deserving" and "undeserving" poor—providing aid to those who were out of work through no fault of their own and punishing the "intemperate," "immoral," "idle" undeserving with placement in poorhouses, miserly aid, and forced work.[16] From the start there were concerns about the (innocent) children of the undeserving poor, and some provisions were established to place such children in good homes where they could be properly cared for and trained as workers. But these anxieties regarding children did not, at first, translate into concern for protecting mothers or for maintaining family cohesion.

What we have come to understand as "welfare" today, however, was firmly connected to our values regarding family life from its inception. Its roots are in early twentieth-century state laws providing Mother's

Pensions, specifically aimed at protecting widows so that they might care for their children at home.[17] These laws were expanded and made more inclusive when New Deal legislation instituted the program of Aid to Dependent Children in 1935.

The 1935 federal law establishing welfare followed directly from the American family ideal of a breadwinning husband and a domestic wife—if the husband was absent, the state would step in to take his place in the support of mother and children. The history of welfare makes it clear that, in practice, aid was denied to many women who were understood as not "virtuous" enough to be worthy of the family ideal.[18] Yet the cultural message clearly asserted that *good* women should stay at home with their children. And by the late 1960s, increasing numbers of poor single mothers were using welfare for precisely the purposes for which it was originally intended—they were staying at home to care for their young children, just as the ideal of appropriate family life prescribed.

The ensuing rise in the welfare rolls that began in the 1960s and continued into the 1990s was a major propellant for the Personal Responsibility Act, and was also directly connected to a broad range of changes in American society, including the feminization of poverty, the increase in single parenting, and the changing shape of the workforce and economy. The size of the welfare rolls was also impacted by the 1960s focus on aid to the poor. That decade was marked by the War on Poverty, the formation of the National Welfare Rights Organization, a series of court challenges and legislative changes that equalized the giving of aid, and the creation of the federal poverty programs of food stamps and Medicaid. But even at that moment in history, when the nation seemed collectively dedicated to providing support for the poor and vulnerable, there was fierce disagreement about the best approach. And the rise of the welfare rolls, alongside the continuing rise in single parenting, caused increasing concern among politicians and the public.[19]

Numerous successive welfare "reforms" were enacted in hopes of stemming the tide. State welfare programs began decreasing their benefit amounts to make welfare less attractive. New federal rules were enacted throughout the 1970s and 1980s. Welfare mothers were encouraged to get training and go to work, a limited number of two-parent families were allowed to receive welfare benefits under stringent criteria, and the system of child support enforcement was linked to welfare. Relative to the changes wrought by the Personal Responsibility Act, how-

ever, these reforms were mere tinkering, leaving lots of loopholes and exemptions. Less than 10 percent of welfare recipients actually participated in the work programs by the 1990s, very few two-parent families qualified for aid, and only a small proportion of welfare clients actually received any child support. And throughout all these changes, the national guarantee of a familial safety net remained solidly in place.[20]

Both the cultural logic and the practical reality of welfare changed dramatically with the passage of the 1996 legislation renaming welfare as Temporary Assistance to Needy Families (TANF). The Personal Responsibility Act firmly established the absolute demand that mothers participate in the paid labor force, offering no exceptions to the more "virtuous" or more vulnerable women among them. The only indication of concern for the fate of ("innocent") children within it was the provision of temporary subsidies for paid childcare. Most significantly, by ending the entitlement to welfare benefits, this law suggested that the nation no longer believed that women and children deserved any form of special protection.

From the moment I recognized this logic, it seemed to me a rather one-sided reflection of the nation's values. Many people, after all, still think that children, at least, deserve some form of protection. And welfare reform's demand that mothers take paying jobs occurs at a time when society as a whole is still expressing tremendous ambivalence regarding the labor force participation of mothers. Although 73 percent of mothers are now employed, and 59 percent of women with infants now work for pay, many Americans are still worried about the consequences of this change.[21] In fact, the very same politicians who signed the law reforming welfare have continued to busily espouse the "family values" that had previously relied on women staying at home to maintain the warm hearth, provide for the emotional sustenance of family members, and shore up family ties. Similarly, scholars of family life continue to debate the problems of paid child care, women's second shift, the time crunch at home, and the declining commitment to family and children said to be signaled by rising rates of divorce and single parenthood.[22] The tensions between the values of home and the values of paid work are apparent in these debates. But the most widely hailed message sent by welfare reform appears straightforward—all mothers must be prepared to leave the home to find paying jobs that will support themselves and their children.

From this perspective, welfare reform might be said to represent the triumph of classical liberal individualism. That is, women are no longer seen as the dependents of men, properly embedded in family life. Instead, women are treated as genderless individuals and, just like men, they are understood as competent, rational, independent beings who can be held responsible for their own lives and their own breadwinning. Similarly, welfare reform could be interpreted as representing the success of liberal feminist goals in constructing a new vision of family life. Earlier welfare policies followed the logic of difference feminism, assuming that mothers should stay at home and practice a distinctively female ethic of nurturing care. The work requirements of welfare reform, on the other hand, seem to signal the expectation that women can and should join men in the public sphere of paid work, operating according to an individualistic ethic of "personal responsibility."[23]

All welfare mothers are now required to work, including those with infants and toddlers.[24] From the moment they enter the welfare office, they must be looking for a job, training for a job, or in a job. If they can't find a paying job or suitable short-term training, they are assigned to work full-time for a state-appointed agency in return for their welfare checks. But the provision of welfare reform that gives work requirements real teeth, and the provision that is in some respects even more harsh than nineteenth-century policies, is the federal time limits on benefits. After five years, all welfare recipients are expected to be self sufficient—and no matter how destitute they might be, they will remain ineligible to receive welfare assistance for the rest of their lives.[25] Many states have chosen even shorter time limits, as is true of Arbordale and Sunbelt City. In both, after two years of aid, single mothers are barred from welfare receipt for two years; when that period is complete, they may return to the welfare office and repeat the cycle until their five-year limit is reached.

Given the power of the work requirements and the virtually airtight enforcement mechanism of time limits, should we understand the law as saying that male breadwinners are a thing of the past, and women should be seen as perfectly able to care for themselves and their children on their own? Has the cultural championing of individualism won out over the concern for children? Is the old family ideal dead?

As it turns out, the promotion of perfected individual self-reliance is not the only message sent by reform. Although the attention paid to

state efforts at placing welfare recipients in jobs has led many to believe that work requirements are the centerpiece of this legislation, a reading of the Personal Responsibility Act makes it appear that the intent of law-makers was to champion family values above all else. It begins, "*Marriage is the foundation of a successful society. Marriage is an essential institution of a successful society which promotes the interests of children. Promotion of responsible fatherhood and motherhood is integral to successful child rearing and the well-being of children.*"[26]

The law goes on to describe the problems of teenage pregnancy, out-of-wedlock births, children raised in single-parent homes, and fathers who fail to pay child support. Indeed, a reading of this statement of the law's intent would lead one to believe that the problem of poverty itself is the direct result of failures to live up to the family ideal. Congress emphasizes the close connection between the rising number of births to unmarried women and the growing number of people receiving welfare benefits. We are told that these single-parent homes not only create dependence on welfare, they also foster higher rates of violent crime and produce children with low cognitive skills, lower educational aspirations, and a greater likelihood of becoming teen parents—who will then produce children prone to repeat the cycle and foster ever-higher rates of crime, poor educational attainment, teen pregnancy, and welfare receipt.

These problems, Congress proclaims, are responsible for "a crisis in our Nation." To solve this crisis, the Act sets forth the following four goals:

1) provide assistance to needy families so that children may be cared for in their own homes or in the homes of relatives;

2) end the dependence of needy parents on government benefits by promoting job preparation, work, and marriage;

3) prevent and reduce the incidence of out-of-wedlock pregnancies and establish annual numerical goals for preventing and reducing the incidence of these pregnancies; and

4) encourage the formation and maintenance of two-parent families.[27]

It should be noted that only one of these goals is directed at paid work. And even in this case it is set alongside marriage as one of the two proper paths leading away from welfare.

Read in this way, work requirements can be understood as a method of enforcing family values through their deterrent effect—as measures meant to discourage women from choosing divorce or single parenthood.[28] Single mothers on welfare are effectively punished for having children out of wedlock or for getting divorced. The punishment they face is being forced to manage on their own with low-wage work. But in this argument, the punishment of current welfare mothers is less important than the training of other poor, working-class, and middle-class women who, when they contemplate divorce or out-of-wedlock childbearing, will learn to think twice before they decide to raise children without the help of men. Hence, removing the safety net and forcing welfare mothers to work is actually a way to reinforce all women's proper commitment to marriage and family.[29]

This, the "family values" version of welfare reform, is also the basis for a second set of edicts contained in the Personal Responsibility Act. Congress offers, for instance, financial incentives to states for the development and promotion of programs of sexual abstinence education. It calls on the nation to "aggressively" enforce statutory rape laws. Our lawmakers insist that teenage welfare mothers live in adult-supervised arrangements in order to receive benefits. And above all, this version of welfare reform absolutely requires that all welfare mothers establish the identity of their children's fathers and work with child-support enforcement officials in demanding that fathers provide financial support.[30] These edicts are designed not only to regulate the reproductive behavior of poor men and women but also to convince men everywhere that if they should consider divorce or unwed parenting, they will be held responsible for the financial support of their progeny—and should therefore reassess their behavior and their options.

How, then, are we to interpret the message of welfare reform? Are marriage and family commitment the central concern? Or is the importance of individual self-sufficiency so great that the care of children can take a back seat to mothers' paid work? Are we reasserting the portrait of a nurturing mom and a breadwinning husband, or are we pressing for a world full of breadwinners?

There are, in fact, two distinct (and contradictory) visions of work and family life embedded in this legislation. For shorthand purposes (and to emphasize the disjunction between them), I have come to call these two visions the Work Plan and the Family Plan. In the Work Plan,

work requirements are a way of *rehabilitating* mothers, transforming women who would otherwise "merely" stay at home and care for their children into women who are self-sufficient, independent, productive members of society. The Family Plan, on the other hand, uses work requirements as a way of *punishing* mothers for their failure to get married and stay married. In the Work Plan we offer women lots of temporary subsidies, for childcare, transportation, and training, to make it possible for them to climb a career ladder that will allow them to support themselves and, presumably, their children. No longer dependent on men or the state, these women will make their own choices about marriage and children. According to the Family Plan, work requirements will teach women a lesson; they'll come to know better than to get divorced or to have children out of wedlock. They will learn that their duty is to control their fertility, to get married, to stay married, and to dedicate themselves to the care of others.

If the Work Plan follows the logic of classical liberal individualism, imagining all women and men as equally competent individuals capable of competing in the market, achieving self-sufficiency, and utilizing market-based solutions to the problem of caring for children, then the Family Plan can be said to follow the logic of a certain form of classical conservatism. According to this model, systems of social connection, obligation, and commitment, epitomized by the operations of traditional family life, are essential to the maintenance of social order. Also crucial to social stability is the requirement that people conform to their proper roles within the social hierarchy.[31] Hence, the Family Plan can solve the "problem" of where children fit by relying on an image of family life where women are subservient nurturers and men are financially successful heads of households.

As you might have noticed, however, welfare reform represents something more than a simple disagreement between liberals and conservatives. Conservatives are certainly not the only ones who worry about the fate of children and community and familial ties, and liberals are not the only ones who think that people should be able to achieve self-sufficiency. The two competing visions embedded in welfare reform are directly connected to a much broader set of cultural dichotomies that haunt us all in our attempts to construct a shared vision of the good society—independence and dependence, paid work and caregiving, competitive self-interest and obligations to others, the value

of the work ethic and financial success versus the value of personal connection, familial bonding, and community ties. These cultural oppositions also inform debates between liberals and communitarians regarding the primacy of individual freedom versus the centrality of moral community, and arguments among feminists over whether to stress women's independence or valorize women's caregiving. These oppositions also mirror the uncertainties we find in public concern over women's labor force participation, the costs and quality of childcare, the time pressures faced by dual-earner couples, and the problems of divorce and single parenting. And the tensions in the Work and Family Plans are tightly connected to a whole series of issues often treated as the result of declining family and community values—including latchkey kids, unsupervised teens, deadbeat dads, abortion, gang violence, drug abuse, rising rates of crime, declining civic engagement, and ever-lower levels of social trust.[32]

As a reflection of our nation's values, welfare reform thus represents a powerful tug-of-war taking place in a society that is uncertain about the proper path. Rather than offering a single, coherent, and inclusive solution to problems of work and family life today, welfare reform offers us two narrow and opposing visions. It thereby simultaneously promises to solve all our problems, and promises to solve none of them.

Higher Values, Multiple Meanings, Cultural Distortions, and the Politics of Exclusion

Part of the reason that welfare reform has been so widely affirmed is surely because its two competing messages are able to satisfy two distinct constituencies. Depending upon one's angle of vision, welfare reform can be seen as a valorization of independence, self-sufficiency, and the work ethic, as well as the promotion of a certain form of gender equality. On the other hand, it can serve as a condemnation of single parenting, a codification of the appropriate preeminence of lasting family ties and the commitment to others, and a reaffirmation that women's place is in the home.

Further, it is certainly no accident that the primary guinea pigs in this national experiment in family values and the work ethic are a group of social subordinates—overwhelmingly women, disproportionately nonwhite, single parents, and of course, very poor. Politicians and welfare

critics have labeled them "wolves," "alligators," "reckless breeders," and "welfare queens."[33] They have become throwaway people. And those powerful stereotypes have made them readily identifiable symbols of societal failures in family and work life.

But there is more. The popularity of welfare reform has also followed from its ability to satisfy even more numerous constituencies, at the same time it arose from a much more widely shared set of higher moral ideals.

If you scrub off all the controversy and contradiction of welfare reform, at bottom you can find a set of honorable moral principles. The worthy ideals implicitly championed by this reform represent collective and long-standing commitments to the values of independence, productivity, conscientious citizenship, family togetherness, social connection, community, and the well-being of children.[34] There is nothing *inherently* contradictory in these principles. The reasons they emerge as contradictory and even punitive relative to welfare reform is that this legislation takes place in the context of massive changes in family and work life, deepening levels of social distrust, rising social inequalities, and an increasingly competitive and global capitalist marketplace. In a connected way, these higher principles were refashioned and debased through processes of cultural distortion and exclusion—processes that have translated social and moral complexity into simplified slogans and stereotypes that obscure the more difficult dilemmas and the more disturbing social inequities involved.[35]

By the time our nation's ideals were codified into the law reforming welfare, they had been passed through so many hands and been sifted through so many (often conflicting) interests, beliefs, and experiences that they were transformed almost beyond recognition. They had been tossed about by politicians seeking votes, policymakers hoping that their bright ideas would win out over others, states trying to trim their budgets, and scholars and pundits who sell books and make it big on the lecture circuit by providing simple, provocative, one-sided portraits of complex issues.

The values of independence, citizenship, connection, and community were similarly reinterpreted by a populace that includes members of the working and middle classes who have become increasingly worried about their chances of achieving or sustaining the American dream. Their concerns may differ depending on where they sit in the class hier-

archy, but Americans have good reason to be worried about global competition, trade wars, corporate downsizing, the technological revolution, declining real wages, rising home prices, the volatile stock market, the decline of trade unions, a precarious Social Security system, and the rising split between educated professionals and less-educated blue-collar and service workers, just to name a few.[36] When it comes to welfare reform, these worries get funneled into the condemnation of *those* people who are spending the nation's tax dollars while avoiding work and remaining apparently immune from all the economic woes faced by the rest of the country.

The principles of independence and commitment also took on different meanings for the growing numbers of working mothers who are struggling to juggle the demands of work and home. That welfare reform is a response to the widespread employment of mothers is a fact that is hard to miss. Working mothers today face not only glass ceilings, a sex-segregated labor force, and the "mommy track," they also face intense demands on their time and energy, especially with regard to child-rearing.[37] If mothers choose to stay at home to avoid such pressures, like welfare recipients, they are often devalued and dismissed and their work at home is treated as inconsequential. Nearly all women recognize this. And like some mothers who work in the welfare offices of Arbordale and Sunbelt City, many working mothers imagine that welfare recipients have been spared from the intense demands and difficult choices they face. To many women, this seems unfair.

Long-standing national values took on a distinct significance for the many employers who have had trouble finding and keeping workers for the lowest paid jobs. Such employers couldn't help noticing the benefits of welfare reform. Work requirements and time limits throw millions of desperate women into the labor market and put them in a position where they must accept low wages, the most menial work, the poorest hours, with no benefits, and little flexibility. Thus, low-wage employers gain not only the benefit of this large pool of "eager" new workers, they arguably also gain greater control over their existing workers—who must now fear that if they don't accept their current working conditions, they can be replaced by former welfare recipients.[38]

A further, and central, source of exclusionary images of welfare mothers is persistent racial tensions and continuing discrimination against nonwhite and immigrant groups. Race is so powerful in shaping

negative images of welfare recipients that when Charles Murray wrote his famous book attacking the welfare system, *Losing Ground*, he focused almost exclusively on blacks—ignoring the other two-thirds of welfare recipients. When Ronald Reagan immortalized the image of a Cadillac-driving "welfare queen," it was not by chance that the story of fraud he chose to (grossly) exaggerate was a story of a black woman. In *The Color of Welfare*, sociologist Jill Quadagno forcefully argues that a central reason that U.S. welfare policies have long been less generous and inclusive than those of other Western industrial nations is precisely because of this country's history of racism. And as Martin Gilens demonstrates in *Why Americans Hate Welfare*, the racial coding of welfare recipients shows up in opinion polls as a primary feature of Americans' disdain for the welfare system.[39] Most people recognize that welfare has come to be associated with blacks, even though they have never been a majority of welfare recipients. Laying all the problems associated with poverty at their doorstep allows many people to feel smugly superior, and it also helps to perpetuate the cultural and economic underpinnings of racial inequality.

Finally, the process of distortion continues as our higher moral principles are continually tattered and corrupted by all these groups—that is, all of us—through the propagation of stereotypes and mythologies and slogans that speak to our particular interests and concerns and offer neat and tidy responses to complicated social problems.

The Work and Family Plans of welfare reform are both examples of distortion and exclusion. In the Work Plan, values of independence and productivity, once grounded in ideals of democratic citizenship and notions of collective progress, are reduced to a vision of calculating, self-interested individuals competing in the "free" market. This image provides no answer to who will care for the children, and leaves us to wonder just how we will care for one another or how we might be convinced to work together to build a better society. It implicitly suggests that we conceptualize children as relatively meaningless appendages and view our fellow citizens as merely potential rivals in the quest for success. And it ultimately excludes from full social membership all those people who fail to achieve middle-class economic stability.

The Family Plan, on the other hand, implicitly transforms the values of community ties and commitment to others—values that have long served to temper the rampant self-interest described in the work

model—with an extremely narrow and rigid vision of the "traditional" family. It thus excludes all those people whose families diverge from the 1950s Leave-It-to-Beaver model. And it implies that we simply turn back the clock on women's movement into the paid labor force, failing to notice, apparently, that this movement is not only connected to the changing shape of the contemporary family but has also been crucial to women's greater independence and to their claim to productive social membership.

By the time our worthy moral principles have made it through state policymakers and local welfare offices into the lives of welfare clients, they have taken further twists and turns, as I will show. Enforced at the local level, our collective commitment to healthy family life can, for instance, have the effect of pressuring women to enter into or maintain relationships with physically abusive, drug-abusing, or law-breaking men. Independence, in this context, often looks like a job on the graveyard shift at Burger King or Dunkin' Donuts, a job that forces you to spend half your wages on substandard childcare and leaves you unable to buy winter coats for the kids.

A look at the process through which these more disturbing outcomes emerge and attention to the larger practical and cultural consequences that follow from them will, I hope, provide some basis for reconsidering the deeper meaning and importance of those original principles and for reevaluating the social changes and the political, economic, and cultural mechanisms that have distorted them.

Entering the World of Welfare

For three years, from December 1997 to January 2001, I visited welfare offices and the homes of welfare clients. Most of my time was spent in and around two welfare offices—one in a medium-size town in the Southeast I call Arbordale, another in a large metropolitan area in the West that I call Sunbelt City. I arrived in both these offices when caseworkers and clients were still busy acquainting themselves with the new rules and procedures for the reform of welfare: Arbordale's official start date for implementation was June of 1997; Sunbelt's was December of that year. Given that both states established a two-year time limit on the receipt of welfare benefits—allowing two years on, two years off, two years on, until recipients reached the federal five-year limit—I was able

to witness the first full cycle of reform, watching the first groups of welfare families experience reform and observing the first groups as they hit their time limits.

During my time in Sunbelt City and Arbordale, I interviewed welfare caseworkers at all levels, I went to staff meetings, and I watched caseworkers carry out the series of routine interactions with welfare clients that fill much of their days. I went to the workshops that clients are required to attend; I read through all the forms that they are required to fill out. I spent hours hanging out in waiting rooms and observing the goings-on. I visited the homes of welfare mothers and interviewed them there. And I spent a lot of time in housing projects. In the end, I accumulated hundreds of pages of field notes, mountains of welfare forms and welfare manuals, and more than a thousand pages of transcriptions from the nearly 90 interactions and interviews that I had tape-recorded. I logged in over 600 hours of fieldwork, and I spent time with over 50 caseworkers and about 130 welfare mothers.[40] Taken together, my interviews, ethnographic research, and analysis of welfare policy provide a portrait of welfare reform as it is played out at the local level.

The Arbordale welfare office is located on two upper floors of a government building in the downtown area of a quaint, historic city that retains the feel of a small-town community, even though its population of over 100,000 marks it as an average-size city. The waiting room, as I've suggested, is quite plush, and nearly half the caseworkers' offices have views of the city. Although situations arise in this office that prompt concern and harried activity, and although there is always enough work to keep the employees busy, overall, the Arbordale welfare office has a relaxed and comfortable air. The receptionist has been at her job for years and greets many welfare clients by name. The waiting room is rarely full, and when it is, one can overhear conversations between clients who know each other and witness reunions of old friends and extended family members.

The only indication that dangerous situations are a concern in the Arbordale welfare office is the guard who polices the downstairs entrance and the locked doors between the welfare waiting room and the workers' offices that must be opened using a keypad, the combination of which is known only by caseworkers. Of course there are other clues that this office serves the poor, including, as I'll explain, a number of

signs outlining the rules and regulations of welfare reform. Yet, in general, the Arbordale office mimics the style of the town in which it is located, offering the feel of community and of a place where people know and trust one another.

The Sunbelt City welfare office, on the other hand, sits in the middle of an urban strip mall, surrounded by parking lots, discount stores, a beauty parlor, and fast-food restaurants. It is adjacent to a vast and run-down housing project. The streets of that project are considered so dangerous that one welfare mother residing there told me "even the police are afraid to come here." The Sunbelt welfare office is fortified against the dangers of its neighborhood by barred windows, locking gates, and an armed guard who sits in the reception area underneath a large sign warning clients that knives and firearms are prohibited within the building.

Despite the office remodeling that came with welfare reform's influx of federal dollars, the Sunbelt City welfare office retains the feel of a cold and impersonal state bureaucracy that serves the disadvantaged. It's not just the gates, the guard, and the warning signs, or even the orange plastic waiting room chairs and the floors of dirty-gray institutional linoleum tile. It's also the overcrowded conditions, the signs commanding "Wait Here," "Take a Number for Service," and "Authorized Personnel Only," and the voices coming over the intercom announcing the number of the next customer to be served or calling on this or that caseworker. This office additionally has something of a prisonlike feel engendered by the seemingly endless rows of locking doors, each with its own number, leading into the tiny rooms where caseworkers conduct eligibility interviews with welfare clients. In all these ways—its impersonality, its overcrowding, its image of impending danger, and its treatment of people as mere "numbers"—the Sunbelt City welfare office seems to reflect the nameless, faceless, "suspect" status of the urban poor.

Overall, the welfare offices in Arbordale and Sunbelt City are both very peculiar and very average. That is, they simultaneously represent the diversity that one finds in welfare offices across the nation and, taken together, they provide something close to a vision of the "typical" operations of welfare offices under reform. I will tell you more about them as the story unfolds, but a few more introductory facts are in order.

The Personal Responsibility Act offered wide discretion to states in the enactment of welfare reform and in the use of welfare money. There are, therefore, notable differences in the policies of Arbordale and Sunbelt City. Arbordale's home state, for instance, has a "family cap" provision that disallows welfare benefits to children born when their mothers are already receiving aid; Sunbelt City's state does not. Sunbelt's state has a provision to identify (and potentially protect) welfare mothers who are the victims of domestic violence; Arbordale's state does not. Like most states, both of these permit mothers with infants to be temporarily exempt from the work requirements: Arbordale allows mothers to stay at home when their children are younger than 18 months old (a very generous provision relative to most states); Sunbelt City offers new mothers a lifetime maximum of 12 months of work exemption. Also mimicking wide variations among states, Arbordale and Sunbelt differ in the extent to which they are willing to use the federal "hardship exemption" that allows them to spare 20 percent of their cases from welfare time limits: Sunbelt City maximizes its use of these exemptions; Arbordale exempts almost no one.[41]

Both Arbordale's and Sunbelt's home states have, as noted, instituted two-year time limits on welfare, placing them among the 22 states that have similarly chosen shortened time limits.[42] Although some states are allowing welfare clients the federal maximum of one year of training toward work and some states are relatively flexible in the speed with which they require their clients to get jobs, both Arbordale and Sunbelt City have instituted "work first" policies that emphasize the expedient placement of recipients in whatever jobs are available.[43] Relative to other states in the nation, neither Arbordale nor Sunbelt is particularly generous or particularly miserly in its welfare benefit amounts or in the number of programs they have instituted to aid welfare families.

Both Arbordale and Sunbelt City are located in states with very low unemployment rates, and both have a relatively low cost of living. In 1999, Arbordale was profiled in a national newspaper article for its extraordinarily low unemployment rate, though the report went on to emphasize that most of the jobs available were in high-tech, professional-level fields (and it was thus very unlikely that they would be filled by former welfare recipients). Compared to many cities in the nation, Sunbelt City tends to have higher paying jobs in the unskilled service sector ($7 to $9 an hour), thanks to a booming tourist economy and a

good proportion of wealthy local residents. Sunbelt is also located in a state with a number of strong unions, while Arbordale sits in an anti-union, "right-to-work" state.

Overall, the low unemployment rates and cost of living in these states mean that welfare families in both Arbordale and Sunbelt City are much better off than those in New York City, Washington, D.C., Baltimore, St. Louis, and many of the major cities of the Northeast and poor rural areas of the South.[44] Neither state has made the national news for its welfare program; neither has been named as particularly unique, innovative, or successful (although Arbordale's state did receive one of many federal "high performance" bonuses for its work in getting people off the welfare rolls). These states are not especially noteworthy for their size or for great inequalities of wealth or skewed family values within them. Although all states' welfare programs are unique, Sunbelt City and Arbordale sit somewhere in the mid-range on most measures.

During my years of watching welfare reform unfold in these two locales, I imagined my work as akin to observing a morality play on family values and the work ethic. But this was no made-for-television movie nor *Survivor* nor *Real TV*. So I spent a lot of time worrying about the consequences of what I saw. I was sometimes hopeful, sometimes amused, sometimes elated, but more often angry, depressed, frustrated, or confused. Of course I will try to persuade you to think about these matters in the same way that I do, but I will also try my best to be fair, and honest, and thorough, and to provide you with enough information to make sense of all this in your own terms. Throughout, my emphasis will be on uncovering the implicit and explicit message of welfare reform regarding work and family, dependence and independence, and competitive individualism and commitment to others.

Documenting the Experiment

The chapters that follow offer a journey into the world of welfare. I begin by taking you inside the welfare office. Chapter 2 examines the enforcement of the work ethic in this context, Chapter 3 looks at how the Personal Responsibility Act has been used to promote the congressional image of proper family life, and Chapter 4 considers the emerging responses of clients and caseworkers to these massive changes in the welfare system.

At ground level, the edicts of the Personal Responsibility Act meet up with the organizational framework of the welfare office and are translated into a set of rigid rules and routine procedures. These rules and procedures are sifted, in turn, through the practical concerns and moral ideals of welfare caseworkers. This complex mix of rules, values, and concerns then confronts the complicated lives of poor mothers and their children. Taken together, these realities make the outcomes of reform far less straightforward than policymakers or statistical renderings might lead one to believe. At the same time, an analysis of this process provides a vivid portrait of the practical tensions and moral dilemmas produced by this reform effort. Although caseworkers and clients face these dilemmas in a setting that is far removed from the daily lives of most Americans, the problems they encounter are, as you will see, ultimately familiar not only to the poor but also, in one form or another, to the majority of people in American society today.

The multiple patterns in the lives of welfare clients are the focus of Chapters 5 through 7. Welfare mothers, as I've noted, have been demonized for their promiscuity, their immaturity, their dependence, and their manipulative behavior. By those who are more sympathetic, on the other hand, welfare mothers have been portrayed as noble heroes or innocent victims.[45] Both these portraits are, in some respects, incomplete and inaccurate. In these chapters I'll tell you about women who are noble, women who are manipulative or unethical, women whom my students would describe as "clueless," and women whose moral standards and practices make many of my co-workers, friends, and relations look relatively shallow, self-serving, and lazy.

Welfare mothers weren't flown in from Mars, and they did not emerge fully formed from their mothers' wombs. Their lives, like our lives, are shaped by their experiences and by the economic, cultural, and political structures of this society. Chapter 5 explores the social and historical context of their lives, the roots of the feminization of poverty, the rise of single parenthood, and the exclusionary stereotypes that have made these mothers the contemporary targets of mistrust and disdain. Chapter 6 provides portraits of the lives of welfare mothers—portraits that tell a story of widespread patterns in American life today and contain a vision of the often-torturous pathway to single mothering, the difficulties in male-female relations, the pressures of low-wage work, and the hardships involved in raising children alone. Chapter 7 contin-

ues this tale by focusing specifically on the question of whether there is such a thing as a "culture of poverty" and pondering whether some welfare mothers are stuck in it, and whether we could or should extract them from it.

The concluding chapter considers the "success" of this experiment in family values and the work ethic. I examine the decline of the welfare rolls in the late 1990s and explain what we have actually witnessed and why many observers have already been celebrating. Welfare reform has not been without victories. It has offered helpful practical support as well as genuine hope to a large number of welfare families. On balance, however, its successes have been outweighed by its defeats. And its moral and economic costs, in the long run, will be paid not just by the poor, but by all of us.

As a reflection of the nation's values, welfare reform ultimately operates to bury rather than solve the tensions involved in the creation of a balanced and egalitarian vision of the good society. The burying of these tensions is accomplished, in part, through the two central points on which policymakers implicitly agreed. First, ignored are the structured features of our economic, political, and cultural systems that are responsible for the large number of women and children living in poverty and the historically high levels of single parenting, divorce, and unwed childbearing. Instead, these phenomena are treated as if they are solely the result of personal choices and individual pathologies. Second, at the same time policymakers are actively engaged in legislating moral prescriptions for work and family life, they treat the work of raising children, the issues of wages and working conditions, and the problems of gender and race inequality as "private" concerns, appropriately negotiated by individuals in isolation. Our nation's leaders thus make use of multiple meanings of "private" in order to avoid the very public and collective necessity for grappling with the tensions in the ideals of egalitarian citizenship, independence, and commitment to others.[46]

The effect of this privatization and legislation is to deny social conflict, to implicitly hold individual women primarily responsible for the maintenance of family values, and to allow low-wage employers to treat people as if they were disposable commodities one might purchase at Wal-Mart. This cultural logic also allows politicians and others on both sides of the debate to simultaneously condemn the "dependence" of

poor woman and children on the state and celebrate their dependence on miserly employers or men.[47] All this is hidden in what appears at first to be the simple demand that welfare mothers be sent out to work.

The problems that welfare reform attempts to bury nonetheless reemerge, and take new forms, as states formulate policies to satisfy the federal requirements, as welfare offices attempt to carry out these provisions, and as clients and caseworkers attempt to make sense of the meaning of these edicts for how they should do their work and how they should live their lives. A closer look at this process can tell us much about the state of the nation, and about the practical and moral importance of creating a just and inclusive society that publicly recognizes our interdependence.

Agreement of Personal Responsibility

I understand that TANF [Temporary Assistance for Needy Families] is a temporary assistance program and that I am responsible for:

- *Working to support my family and to become self-sufficient;*
- *Looking for and accepting employment;*
- *Participating in assignments from my case manager;*
- *Notifying my case manager immediately of any changes in my circumstances;*
- *Keeping appointments with my case manager in a timely manner; and*
- *Arranging child day care and transportation that allows me to participate in the Employment Program.*

I understand that it is my responsibility to take advantage of the opportunities offered by the Program. By taking advantage of these opportunities, I will help my family in becoming self-sufficient.

If you choose not to sign this Agreement, your TANF benefits will end.

*Signature required of all welfare clients, Arbordale.**

Chapter 2

Enforcing the Work Ethic

THE FIRST THING YOU SEE ON ENTERING THE Arbordale welfare office is a large red banner, 12 feet long, 2 feet high, reading, "HOW MANY MONTHS DO YOU HAVE LEFT?" Underneath that banner is a listing of jobs available in the area—receptionist, night clerk, fast-food server, cashier, waitress, data entry personnel, beautician, forklift operator. In most cases, the hours, benefits, and pay rates are not listed. The message is unmistakable: you must find a job, find it soon (before your months run out), and accept whatever wages or hours you can get.

Contrary to the hopes of many politicians, the promotion of family values seemed less than a minor distraction when compared to the massive amount of time the welfare offices of Arbordale and Sunbelt City dedicated to the pursuit of welfare reform's work requirements. Among the piles of paper that clients received in their visits to those offices, I uncovered none that proclaimed, "Marriage is the foundation of a successful society." There were no dating services offered, no family planning programs touted. And there was nothing in the Agreement of Personal Responsibility each applicant was required to sign that implied that marriage was an alternative route to self-sufficiency.

* This particular statement is peculiar to Arbordale, though every state is required by federal law to have some version of an "Individual Responsibility Plan" signed by every adult welfare recipient (U.S. Department of Health and Human Services 1999B).

There were, however, materials stressing time limits, describing employers' expectations of employees, providing job search tips, leading clients to the job hot line for public employees, and informing clients where to acquire clothes for work, where to seek help in writing a resume, and how to decide on the proper childcare provider. One pamphlet, "Taking Charge of Your Future," was designed to teach welfare mothers how to behave at a job interview: "Shake hands firmly. Don't criticize a former employer. Use good eye contact. Smile. Show enthusiasm. Sell yourself." Another handout outlined the principle that "Work Is Better Than Welfare," reminding clients that they have a responsibility to work and offering platitudes that included "All jobs are good jobs," "As long as people are on welfare, they will be poor," and "Work is the first priority. Any earnings are good."

Welfare recipients, of course, are not merely being encouraged to work. In Arbordale and Sunbelt City, they were reminded repeatedly that work requirements are backed up by strictly enforced time limits—two years at the state level, five years overall—and they were continuously admonished to "save their months." Welfare caseworkers and supervisors, for their part, were painfully aware of the time limits, and they were also aware that the work requirements are enforced through federal "participation rates" requiring states to place increasing percentages of their welfare clientele in jobs. Should a state fail in this task, its federal financial allotment will be decreased.[1] If a caseworker failed in her piece of this task, she could lose her job. For welfare mothers, this translated into constant and intense pressure to find work. The symbolic device of the "ticking clock" measuring one's time on welfare was used incessantly by Arbordale and Sunbelt caseworkers and quickly found its way into the vocabulary of the welfare mothers I met.

Just as most of the public and the popular media have assumed all along, welfare reform's Work Plan thus takes center stage in the welfare office. According to the logic of this plan, if the welfare office can train mothers to value work and self-sufficiency, the need for welfare receipt will be eliminated, and former recipients will become respectable, "mainstream" American workers. In this model, the ideal of independence—long associated with values of citizenship, self-governance, and full social membership in Western culture—is thereby transformed into a simple demand for paid work.[2]

There are a number of problems with that logic, as this chapter will

demonstrate. A foundational problem is the false assumption that most welfare recipients were previously lacking the motivation to work. Another problem, apparent to anyone who has ever tried to survive on a minimum wage job, is that the low-wage work typically available to welfare recipients offers neither financial independence nor the independence associated with the higher ideals of American citizenship. These difficulties, I soon discovered, are made worse by the procedural enactment of reform. Immersed in a bureaucratic machine, the rigid rules and demanding regulations of reform not only diminish the dignity of the people being served, they also degrade the values that the Personal Responsibility Act purports to champion.

Added to all this is a final key failure of the Work Plan of welfare reform. This model seems to forget that the target group for welfare reform is *mothers with children*. In our culture, children are assumed to be "dependent" on their parents. To the extent that we expect welfare mothers to continue to care for their children, those mothers cannot be "independent" in an unfettered sense, and what the law is asking of them is far more than "self" sufficiency.

Nonetheless, as many scholars of American culture have pointed out, the work ethic is a central value in this society.[3] Although the care of one's children is certainly work and surely represents a contribution to the larger good, given that many mothers in American society today are called upon to juggle both paid employment and the care of their families, it is worth examining just what happens when the welfare system sets out to enforce its vision of independent, working motherhood.

Valuing Work

The work requirements of welfare reform are based on the argument that past welfare policy provided a financial incentive to eschew work and thus contributed to a steady decline in the work ethic among the poor.[4] The system of reform is therefore intended to instill the commitment to work that welfare recipients are presumed to lack. The trouble is, as I've noted, that the assumption underlying this logic is wrong.

The majority of welfare mothers already *have* a work ethic. There is a tremendous amount of research available to show that long before welfare reform, most welfare recipients wanted to work and most had worked, at least part of the time. Half of all mothers entering the welfare

office in the early 1990s came off the rolls in less than two years. At least one-third worked on or off the books while they were on welfare. Eighty-three percent had some work experience, 65 percent had been recently employed, and two-thirds would leave welfare with jobs. At one time or another, many did find themselves out of work, desperately poor, and back at the welfare office again—about 40 percent who left the rolls would later become repeat customers. But nearly all welfare recipients would ultimately spend three times as many of their adult years off the welfare rolls as on.[5]

In considering these facts, it is important to realize that most of the people who apply for benefits at the welfare office are, of course, a different portion of the population from your average yuppie, and the work opportunities available to them differ correspondingly. Nearly half are without high school diplomas (47 percent); just 19 percent have had some college. The work experience of many is in low-skilled, dead-end jobs. And the mainly single women who face the requirements of reform have, on average, two children to worry about when they consider the costs and benefits of the types of jobs that are open to them.[6]

The reasons that this group of Americans cycles between welfare and work, and the reasons that some have difficulty ever finding suitable jobs, are therefore multiple, though ultimately neither mysterious nor unfamiliar. Problems with childcare, problems with the physical or mental health of themselves or their children, obligations to extended family members, unexpected financial difficulties, low wages, overly demanding employers, job layoffs, changing work schedules, the indignities of bottom-end employment, and a commitment to properly responding to the needs of their children can all lead hard-working, "independent" women to seek out the help of the welfare office, as will become increasingly clear.

As a start, consider Carolyn. A once-married, black Sunbelt City welfare mother with a high school diploma, her story contained a number of the patterns I saw in the lives of welfare recipients. She had worked for most of her adult life, and she had also spent nearly all her life hovering somewhere close to the poverty line. She had been employed as a waitress, a clerk at the District Attorney's office, a telephone operator, a nurse's aide, a receptionist at the power company, a childcare worker, and a discount-store cashier. She initially went on welfare when she had her first and only child with a man she planned to marry. Carolyn cried

when she told me the story of how that man began to physically abuse her and ultimately raped her during her pregnancy: "When I first met him, he was a really good man," she said. "But then he started taking drugs. It was terrible. I was afraid all the time." Shortly after the rape, she escaped that situation and moved in with her sister, but lost her job. By the time she gave birth, she was suffering from a nervous breakdown. ("He had drove me insane: that's what they said, in the letter from the psychiatrist.") It was following her hospitalization for that breakdown, ten years before I met her, that she first went on welfare with her then two-month-old baby girl.

By the time her daughter was two years old, Carolyn went back to work. Three years after that she took on the full-time care of her three nieces (aged 3, 9, and 12) when their mother was imprisoned for selling drugs and Carolyn learned that those children were otherwise bound for the foster care system. At that point, she took a second job to care for those four kids, and tried hard to avoid returning to welfare. But after a few years her carefully organized (though always precarious and stressful) work/family balance was thrown into disarray. Her brother and sister-in-law who had been helping with childcare and transportation moved out of town. This left Carolyn trying to manage with the public bus system, paid caregivers, and after-school programs for her daily round of transportation to two jobs, the childcare provider, the older kids' schools, and back home again—along with all the added expenses that went with this new strategy.

Then came the final straw. Carolyn was laid off one of her jobs. By this time, she was deeply in debt and ill: the stress of her situation had contributed to serious heart problems, and her doctor was urging her to "take it easy." All these difficulties—transportation, relationships, low wages, precarious jobs, ill health, and the care of children—came together and landed her in the welfare office where I met her. It was clear to me that, at that point in her life, Carolyn was hoping for a little rest and recuperation. But the terms of the newly reformed welfare office, as you'll soon see, required just the opposite.

Although the poor mothers I met in Arbordale and Sunbelt City all came from different circumstances, many of them shared at least some of the troubles from which Carolyn had suffered. The primary point is that, in the vast majority of cases, when women end up on welfare it is not because they have lost (or never found) the work ethic. It is only

because a moral commitment to work is, by itself, not always sufficient for the practical achievement of financial and familial stability.

Constructing the Work Ethic

The model used to train low-income mothers like Carolyn in the work requirements of the Personal Responsibility Act is a model of behaviorism. This model—made famous by the training of Pavlov's dogs—posits that a system of rewards for proper behavior and punishments for improper behavior can teach people to behave in the desired way.[7] Under reform, the central punishments used to prod clients into the labor market are time limits, work "participation" rules, and the system of sanctions. The central rewards designed for that purpose are "supportive services" and "income disregards."

Welfare reform's system of supportive services allows caseworkers to subsidize the costs of childcare, provide bus token and gasoline vouchers, pay for clothing and supplies for work, and, under certain conditions, cover expenses like rent and utility payments. Arbordale and Sunbelt caseworkers could also use supportive services, in special cases, to help welfare mothers repair their cars, buy prescription eyeglasses, pay the deposit on a new apartment, or partially cover the costs of reconstructive dental surgery. In accordance with the rules of reform, all this support is time-limited and must be work-related. And with the exception of childcare subsidies, all this support is provided at the discretion of welfare caseworkers.[8]

In addition to these potentially quite helpful subsidies, paid work is made more attractive to welfare clients through the system of income disregards. Once a welfare mother gets a job, a portion of her wages will be "disregarded"—that is, she can continue to receive all or part of her welfare check along with her paycheck until her income reaches the poverty line (or until her time limit is reached). Given just how far below the poverty line many welfare mothers and their children have lived in the past, this is a big boost for a number of them, providing more income than they have ever experienced.

As helpful as these services are, they pale in comparison to the system of strictly enforced rules—all backed up by the threat of punishment. The first set of rules is the "work participation" requirements designed to keep welfare mothers busy pursuing employment from the moment

they set foot in the welfare office. The second set is the "reporting" rules, designed to assure that clients maintain contact with the welfare office at all times so that their work and their welfare eligibility can be constantly monitored. The precise sequencing and specifics of these requirements vary somewhat from state to state, but the system's outlines are established by the edicts of the Personal Responsibility Act.

The demanding and often humiliating characteristics of these rules are best understood through the eyes of the recipient. After you have been through your two-hour appointment to establish your eligibility for benefits, after you have signed your Agreement of Personal Responsibility and vowed to commit yourself to self-sufficiency, you are required to meet with an employment caseworker. You will then be given a literacy test, your work history will be documented, and your employment-related skills assessed.

Your initial participation requirement is to make 40 job contacts in 30 days. This is known as your "job search." There are workers at the welfare office that check on these job contacts, so you cannot simply go downtown and fill out an application at every establishment you pass. You are instructed to meet only with employers who actually have jobs. If it should be discovered that you were offered a job that you did not take, you will be punished (as I will explain in a moment).

During this time, you must also attend a series of "job readiness" or "life skills" classes. The courses I attended in Arbordale and Sunbelt City were three- to five-day workshops that included reiterations of the rules of welfare reform, motivational speeches on the sense of pride engendered by paid work, and therapeutic sessions on how to manage stress and how to determine whether your relationships with family and friends are furthering or thwarting the goal of self-sufficiency. These courses also included sessions on how to dress for an interview, defer to your employer, get along with your co-workers, manage childcare, budget your time, balance your checkbook, speak proper English rather than street slang, and, of course, discover the job or career that is right for you.

If you have not found a job at the end of your 30-day search, you must enter a training program that your caseworker chooses for you or with you. Both Arbordale and Sunbelt City, like many states, chose training programs in accordance with a "work first" policy emphasizing expedient entry into the labor market rather than long-term, career-oriented

training. Even though many of the caseworkers I met recognized that low-wage jobs were inadequate to cover the costs of raising children, state policymakers deemed the work first model the most realistic strategy given the time limits and federal work participation demands. Nearly all the training programs offered in Arbordale and Sunbelt City are therefore geared to low-wage service sector and clerical jobs (and nearly all are in fields traditionally defined as "women's work"). These include training sessions for office skills, nursing assistants, introductory computer use, food service employment, cook's helpers, certification for childcare work, and preparation for the high school equivalency exam. In Sunbelt City there is even a workshop for aspiring "guest room attendants"—otherwise known as hotel maids. Local employers (phone companies, factories, hotel chains, insurance companies) also sometimes offer workshops to train welfare recipients for positions that need to be filled; at the completion of training, employers pick the best trainees for paying jobs, leaving the rest to fend for themselves.

If you are not in training or a job within a specified period, or if you or your caseworker decide you are not yet ready for a paying job, you will be assigned a Community Work Experience (workfare) position. In this case you will be required to do unskilled work for a state, county, city, or other nonprofit agency—sweeping streets, answering phones, sorting papers, serving food at a school cafeteria, or working as a childcare provider, groundskeeper, bus driver, or custodian. All of these jobs are without pay, and all are pitched as work experience. In Arbordale and Sunbelt City, once you are signed up for a workfare placement, you must follow through for the contracted period (usually three to six months), even if you should be offered a paying job elsewhere.[9]

At the same time you are following these participation rules, you must also manage your reporting responsibilities. You must, for instance, meet with your welfare employment worker every 30 days to discuss your progress toward self-sufficiency. You must inform the caseworker immediately if you fail to attend a day or an hour of your training program or workfare placement. You must notify your caseworker immediately if you change your childcare provider, open a bank account, take out a life insurance policy, change your address, buy a used car, or let a friend stay in your home.

If you should get a job, you must, of course, quickly contact your welfare worker. At this point you have the option of closing your welfare

case or continuing to take advantage of the programs of supportive services and income disregards. If you choose the latter path, your clock will keep ticking and you will remain under the watchful eye of the welfare office and remain obligated to notify welfare caseworkers of any change in your circumstances. These reporting requirements will now also include, for instance, a ten-cent raise, a shifting work schedule, or a day you miss work to take your child to a doctor's appointment.

If you should quit your job, participation rules require you to prove "good cause." Not liking your work, having problems with childcare, experiencing other family problems, having a sick child, your own illness, arguments with supervisors, having your apartment building burn down—none of these counts as good cause. If you are fired from a job, you must prove that it occurred through no fault of your own. Otherwise, this is treated as equivalent to quitting a job without good cause.

If you should fail in any of these tasks, you will receive a "sanction."

The system of sanctions is key. Sanctions are the central form of punishing welfare mothers for their failure to comply with welfare rules—their failure, in other words, to behave appropriately.[10] To be sanctioned means that all or part of your welfare benefits are cut. In most states, sanctions operate on a graduated system, becoming increasingly punitive for repeated violations. In Arbordale, for instance, the first sanction costs you one month of welfare benefits, the second sanction means three months without welfare, the third lasts for six months. In Sunbelt City, you lose an increasing percentage of your welfare check for an ever-longer period of time, and with your third sanction you become *permanently* ineligible for welfare benefits. This system, I discovered, operates quite effectively to keep nearly all welfare recipients in line, since most of them learn to fear that they might be punished in this way.

Being sanctioned is the harshest status of all. You receive little or no welfare money, yet your "clock" is ticking and you are using up your lifetime allotment of welfare benefits. Nationwide, at any given time, it is estimated that about one-quarter of welfare clients are under sanction for their failure to comply with welfare regulations—more than double the number of recipients who suffered such punishment prior to welfare reform.[11] Failure to make job contacts, attend a scheduled meeting with a welfare caseworker, go to all your job readiness classes, arrive at your workfare placement on time, or cooperate with child support enforcement, or quitting a job without good cause or getting fired from a

job because of some mistake—all these are sanctionable offenses. Sanction rates were so high in Sunbelt that one caseworker worked full time on nothing but the sanctioned cases. In both offices, there were separate workshops just for sanctioned clients. I attended a number of these "sanction workshops," so I became quite familiar with the responses they elicited.

Most of the sanctioned welfare mothers I encountered were surprised and angered by being sanctioned. As many as half, I would estimate, didn't fully understand the reason for the sanction when it occurred. Even though these mothers received "official" notification of the requirements in advance and received written notice of the sanction when it occurred, the system of participation and reporting requirements they face is extraordinarily complex. Welfare caseworkers contend with these rules day in and day out, and most still have a hard time remembering them all. I was therefore not surprised that a good number of welfare clients were uncertain as to which rule they had broken.

Most clients, I learned, would just "sit out" their sanction, treating it as yet another welfare regulation with which they must comply. Some sanctioned welfare mothers simply drifted away and disappeared (given that they were receiving no support, they presumably left to seek out alternative sources of income elsewhere). A few thought they might "beat" the system by temporarily removing themselves from the welfare rolls. This last strategy was ineffectual however: their clocks kept ticking, they were ineligible to reapply until their sanctioned period was over, and if they did reapply, they would have to start over from the beginning—certification, the wait for the first check, then the job search, life skills classes, training, employment, or unpaid work-experience placement.

Overall, the rules designed to enforce work emerge as a relatively confusing mix of commands, backed up by some welcome gifts, and many, many, less welcome requirements. In pondering this system of rules, rewards, and punishments, the observer might consider to what extent it adds up to a model of the values of "mainstream" America.

The welfare clients I met heard two pieces of this message loud and clear: they knew they were expected to find jobs, and they knew they were expected to obey the rules. Many of them also heard, more faintly perhaps, the enthusiasm that was often conveyed by the caseworkers who enforced those rules, an enthusiasm for genuinely improving the

lives of welfare families. Yet, just as the behaviorist model of welfare mixes rewards with punishments, that enthusiasm was also mirrored by another implicit message, one that emerged from the constant pressure, echoed persistently in the background, and was assimilated by most of the welfare mothers I encountered: "You are not wanted here. Americans are tired of helping you out, and we will not let you rest, not even for an instant, until you find a way to get off welfare."

The message of the importance of paid work is a very powerful message indeed.

Bureaucracy and Autonomy: A Sidebar

Given the decline of the welfare rolls in the years following reform, it is clear that the work requirements and time limits and sanctions of the Personal Responsibility Act have played a role in convincing poor mothers to get off the welfare rolls, faster, than they did in the past. Also impacting this process is the organization of the welfare system that has structured the enforcement of those work requirements and time limits and sanctions.

The welfare office is, first and foremost, a bureaucracy. It is a world of rigid rules and formal procedures. It is a world where every new welfare client can be represented as a series of numbers: a case number, a number of children, a number of fathers of those children, a number of dollars in cash income, a number of months on welfare, a number of required forms, oaths, and verifications. It is also a world where every welfare client has come to symbolize a potential case of fraud and a potential "error" in the calculation of appropriate benefits.* It is no surprise, therefore, that the congressional Work Plan was simply translated into a complex system of bureaucratic rules and regulations. When this bureaucratic system is used to promote an ethic of independence, however, a number of contradictions emerge.

* Caseworkers, localities, and states are all judged for their "error" rates, the mistakes made in determining eligibility and benefit amounts. The federal government rewards states that have few errors and punishes those that have many. Prior to welfare reform, when "work participation" rates became a key method for judging effectiveness, error rates were central. They now sit alongside "participation" as one of the two things that everyone in the welfare office has to worry about.

Most Americans have some experience with rigid bureaucracies, if only the Department of Motor Vehicles, the Internal Revenue Service, a credit agency, or an insurance company. Such bureaucracies are efficient precisely because they are cold and impersonal. Operating like human assembly lines, they apply uniform rules, follow regularized procedures, and ignore the particular circumstances of each case as far as possible. Bureaucracies also serve as a powerful form of social control. Every rigid, unforgiving rule signals yet another demand with which the client must comply. The messiness of human existence is precluded, and no excuses are allowed.[12]

Welfare mothers thus learn the message of reform in a context that most people experience as dehumanizing and degrading. This arrangement also means that they first hear the messages of "personal responsibility" and "self-sufficiency" in a context where they are required to be deferential and compliant, obediently following the rules laid down by others. Of course, given the sheer number of welfare clients and welfare rules, the welfare bureaucracy could be construed as a necessary evil. But it seems to me that if human dignity is an issue, one can ask the question of whether all the rules of welfare are absolutely essential. And if the achievement of national values is an important goal, one can also consider just what happens to the cultural ideals of proud workers and independent, self-determining citizens when those values are immersed in a bureaucratic system of social control.

The most striking example of this bureaucratic system is the initial eligibility interview. A glimpse of this one- to three-hour interrogation is crucial to understanding how poor mothers experience welfare. By the time the potential client reaches this point, she has already filled out a 14-page form asking about every aspect of her familial and financial situation. Much of the "intake" interview simply repeats those questions. Among the many intake interviews I sat through, this one, conducted by a highly competent and thoughtful caseworker named Gail, went quite smoothly, in part because Gail was so experienced and in part because the client was so well-prepared, polite, and compliant. Like all eligibility interviews, it began with a jumbled mix of inquiries:

> *You're applying for yourself and who else? Your children's names? Their social security numbers? Are you working? Are you going to school? Where? Are there any medical reasons why you are not able to work at this*

> point? Do you receive any money for your children of any kind—child
> support, disability benefits? What is your address?
>
> And have you ever gone under any other last name? Is this your
> maiden name? Does your mother receive welfare? Where were you born? Is
> anyone you're applying for pregnant, blind, disabled, needed at home to
> take care of someone who is disabled?
>
> Is your child in day care? Have you come up with an agreement or
> signed an agreement for the cost? Do you have a contract? Do you have
> any children that do not live with you that you have to pay child sup-
> port for?

Some of these questions seemed reasonable enough, but by the time
this portion of the interview was over (about a half hour later) the client
and I were having a hard time determining the point of all these in-
quiries. Still, it wasn't difficult to surmise that the client's primary job
was to offer simple answers and passively comply.

The next set of questions involved the all-important issue of "re-
sources"—that is, the prospective recipient's current and potential
sources of income. Many of these questions have been added over time
as politicians and the public have become more and more worried
about welfare cheats (with Cadillacs and rental properties on the side):

> Do you have any cash right now, like in your purse, at home? Do you
> have a checking account, or a savings account? Where? Do you have your
> recent statements? Do you have anything like stocks or bonds, U.S. savings
> bonds, retirement plans? Any houses or land? Or is your name on someone
> else's property, like your parents have a joint deed with you or anything
> like that?
>
> Do you own any cars or trucks, motorcycles, campers, boats, motor
> homes? Do you have any kind of health insurance at all? Any life insur-
> ance policies? In the last two years have you traded, sold, or given away
> any of these resources that we talked about or listed on the application?
> Any lawsuits you might be receiving a settlement on?
>
> Do you receive any kind of commissions, bonuses, tips? Do you receive
> any money from doing baby-sitting or day care? Do you receive any in-
> come from farming, fishing, raking leaves, mowing lawns, any kind of odd
> jobs like that? Do you have any kind of contract income, like our school
> bus drivers, they get a contract and they pay x amount of dollars, any-

thing like that? Are you self-employed in any way? Do you have a private business on the side, do you do hair or nails or that sort of thing? Okay, any other kind of self-employment where you have stuff that you sell, at the flea market or anything?

You've indicated no other money coming into the household. Is that correct? And, anyone outside of your household, like parents, aunts, uncles, anyone like that paying your rent? Now, do you have any scholarships or grants to pay for school? Are you expecting any changes coming up in your income?

Gail knew that many of these questions were intrusive, and she also found some of them completely unnecessary.* But she pressed on. At this point in the interview, she began reviewing the checklist of required "verifications," one of the more tedious and time-consuming portions of the intake process. In order to receive benefits, the client must produce, for instance, children's social security cards, birth certificates, and immunization records; rent receipts or a lease from the landlord; a verification of the number of people living in the household; statements from banks and insurance companies; childcare contracts; utility receipts; and school enrollment records. Most Americans would have a hard time coming up with everything on this list. If a welfare client should fail to do so, she will be deemed ineligible for benefits.

And this is just the beginning. The intake was less than one-quarter of the way through. There would be many more questions, more forms, additional explanations, and preliminary calculations.

Some people might argue that welfare recipients deserve to be made humble, to pay homage. The conservative critics of welfare have implied

* I later asked Gail if she'd encountered any welfare clients with rental properties, boats, or campers, or if she'd come across any who fished or farmed for profit. She responded in the negative. Of the welfare mothers I met, a good number were without checking accounts, almost all had spent any savings they had before coming to the welfare office, and none were holding stocks or bonds. Although it is true that many welfare clients supplement their (inadequate) welfare checks with aid from relatives and boyfriends and with minor side jobs (like "doing hair"), and although it is true that a tiny proportion of welfare clients engage in serious fraud, Gail was well aware that this line of questioning was probably not the most effective way to uncover fraud. "But," she said, "I just do my job. This is what the state wants me to do." (See Edin and Lein [1997] and Chapter 7 on the broad and ambiguous label of welfare "cheat.")

as much.[13] But none of the welfare caseworkers I met saw it this way. They empathized with clients' discomfort, and they were sorry that the system had become so bureaucratic. In fact, the massive number of rules faced by contemporary recipients are primarily the result of decades of welfare "reforms"—no intentional humiliation, just too many fingers in the pot for too long, and too little attention to how complex it has all become. This latest round of welfare reform has increased the rules and requirements by about one-third, coming with hundreds of specific regulations and nearly doubling the size of state procedural manuals. Very few of the rules that were there before were changed, and all that came after 1996 were simply *added*, as they had been so many times before. All this has created an impossible bureaucratic morass.[14]

For caseworkers as well as clients, one of the central consequences of welfare's bureaucratic maze is that it often becomes difficult to remember the larger social and moral purposes of those endless rules and regulations.[15] Once again, the welfare eligibility interview provides a useful illustration of the nature of this problem. By the time we got to the long-winded explanation of welfare reform, we were nearly an hour into the intake, about halfway through. Our caseworker, Gail, was speaking quickly now, partly because she knew this speech by heart, and partly because she knew how tiring this process can be. (My only job had been to listen quietly, and I was already feeling dull-witted.)

> *The program TANF stands for Temporary Assistance to Needy Families. It was called AFDC before, welfare checks, lots of names for it. Now it's Temporary Assistance for Needy Families, and that's because of changes with welfare reform.*
>
> *With federal welfare reform, over the course of your lifetime, you can receive assistance for a total of 60 months. And what happens is that you have a big clock that ticks. Each time you receive a TANF check, one month of that clock is used up. Let's say this time you need assistance for six months, you finish your classes, and you're doing fine. Three years from now your child will be six, you lose your job for some reason, you receive assistance for another three months. That will be a total of nine months. Each time you get a check, your clock is ticking. And when you hit that magic number of 60 you can no longer receive TANF assistance for your lifetime.*
>
> *Okay, that's the federal requirements. In this state we have our own system of welfare reform, and what we have is another big clock that ticks.*

> *This clock says that you can receive TANF assistance for a total of 24 months. And when you hit that magic number of 24 months, there's then a two-year period where you cannot receive TANF checks at all.*

Gail then went on to explain the job search, the unpaid workfare placements, the income disregards, the supportive services of childcare and transportation, and the fact that finding a job is the best way to avoid the "hassles" of welfare. Finally, without pausing to take a breath, she concluded this first round of introductions to welfare reform with the following:

> *The enhanced disregards, the transportation services and the day care you will get. So we're not gonna just put you out there working. You'll have the supportive services. At the end of those 24 months, you continue with your day care, you continue with the medical assistance, you continue with the transportation, though it might be a little bit more limited, and the supportive services are even more limited than before.*
>
> *At the end of this one year transitional, you then have that two years off of assistance completely. That's two years on, with us doing all we can do to get you a job or keep you employed. Okay? So this is all under the regular monthly check. Okay?*

The client looked at me quizzically. Our heads were spinning. Federal requirements? State requirements? Supportive services? Transitional services? Ticking clocks? Enhanced disregards? The magic number? *What did you say?*

Clearly, in this context, it is difficult to decipher the central point of welfare reform. Every step of the way, for both clients and caseworkers, the higher goals they strive for are repeatedly muddied and obscured by the unrelenting stream of complex rules and requirements. Although welfare mothers ultimately read welfare reform as the insistence that they find paid work, what they experience initially and most acutely is this system of social control.

This returns us to the cumulative impact of the welfare bureaucracy—the contradiction between demanding individual autonomy and exercising social control. The symbolic logic of the Work Plan implies that reform will overcome welfare dependence by training clients in "personal responsibility," yet the routines and procedures of the wel-

fare office systematically require of recipients obedience, deference, and passive compliance.[16] How can welfare caseworkers convince their clients that they recognize them as independent, assertive, self-seekers while simultaneously demanding their unquestioning deference to an impossible system of rules? How will clients understand their paid employment as a positive individual choice when it is presented as one of many absolute demands, backed up by multiple threats of punishment? As many scholars have pointed out, the operations of bureaucracies are simply not conducive to instilling a sense of individual self-determination.[17]

Even though welfare's combination of bureaucratic control, behaviorist methods, and demands for autonomy is a very odd one, it could be interpreted in a different, less contradictory light—though not one that supports most politicians' rhetoric about the goals of welfare reform. If we really want to include welfare mothers as active citizens, full-fledged participants in society, and the social equals of both men and the middle class, it doesn't make sense to use bureaucratic mechanisms to mentor and inspire them. If, on the other hand, what we are actually preparing them for is to serve our fast food, clean our toilets, answer our phones, ring up our receipts, and change our bed pans, the bureaucratic operations of welfare could be construed as a very effective route. Deference and obedience are, after all, important qualities for many low-wage workers.[18] And the message that getting a job, any job, is better than staying on welfare is certainly congruent with this interpretation. Similarly, the "work first" model used by Arbordale and Sunbelt City, as expedient and realistic as it may be for some welfare clients, precludes the possibility of the kind of education and training that could offer lasting financial stability and self-determination rather than inadequate, unskilled, low-paid labor.

Thus, the trouble with bureaucratic welfare is not just that its procedures are demeaning and degrading, picturing welfare recipients as childlike and manipulative and burying the goals of reform in a bureaucratic swamp. There is also a real danger that the more valuable versions of the principles of independence and citizenship have been debased by this process, transformed into a demand for a new form of wage slavery, where the lives of welfare mothers and their children are treated as worth far less than those of the American middle class.

Complications on the Road to "Self-Sufficiency"

The bureaucratic rigidity, the interrogation, the time limits, the sanctions, the unpaid workfare placements of the Personal Responsibility Act certainly do not offer an unequivocally positive image of the values of the nation. Still, this system has contributed to a dramatic drop in the number of welfare recipients nationwide. Further, as the proponents of welfare reform so regularly emphasize, it is also true that 60 percent of former welfare clients had at least temporary jobs by 2002. These two facts—the decline of the rolls and the employment of former welfare mothers—are the central basis for the positive national assessments of welfare reform. These two facts, however, hide a much more disturbing reality. By 2002, a full 40 percent of former welfare recipients remained unemployed. Of the 60 percent who were working, half were without sufficient wages to raise their families out of poverty.[19] At the same time, many of the mothers who had left welfare with jobs had lost them and were returning to the welfare office once again. From where I stood, it seemed that the glass was at least half empty.

In the welfare offices of Arbordale and Sunbelt City, caseworkers and I witnessed these realities in a direct and immediate way. It wasn't easy to keep track of the proportions from that vantage point, but we could tell that some families were doing well and a larger portion were not so lucky. Of course, the triumphs mattered. Everyone in the welfare office was happy about all those families who were significantly better off as a result of the training and material support offered by reform. But in considering the long-range prospects for the majority of poor families, the view from the welfare office left me and most of the people who worked there with a much less optimistic outlook than those who have unequivocally embraced reform. In fact, it was apparent to us that many of the former welfare recipients categorized by national statistical renderings as "successful" looked little different from those who were marked as failures. A few introductory examples will help to clarify the nature of some of the problems involved.

Andrea, who had a found a job and left the rolls, would be labeled as one of the "success" stories of the Personal Responsibility Act. When I met her in 1999 she was making $5.75 an hour, working a 35-hour-week at a Sunbelt City convenience store. Twenty-eight years old, with two children, she paid $475 a month for housing and utilities and $200 for

food. This left her with about $50 to pay for clothing, transportation, medical bills, childcare, laundry, school costs, furniture and appliances, and cleaning supplies for a family of three. She couldn't make it. Her kids didn't have proper shoes. Her oldest daughter wanted a new outfit for the school year. Her phone had been turned off the month before. She wasn't sure if she'd be able to pay the current month's rent. She worried about what would happen when winter came. She stayed on the "transitional benefits" offered by the welfare office that provided her with continued help with the costs of childcare and transportation, even though she knew this strategy was not only time-limited but would also ultimately prolong her period of ineligibility for welfare.

If Andrea did not have children, her $5.75 would still be inadequate, but its consequences would be altogether different. The depth of her worries about rent and utility bills and shoes and winter coats and even the availability of a telephone had everything to do with her concern for those children. What would happen to her children if she was laid off her job? What was going to happen when she got too far behind in her bills? What if one of the kids got sick? What kind of career ladder was available to her, as a convenience-store clerk, that might guard her against future hardship? When last I saw Andrea, she had used up 16 months of her lifetime welfare benefits and was deeply in debt. Her youngest child was then two years old.

Clara would be considered a "failure" by the standards of the Personal Responsibility Act. She found herself in the Arbordale welfare office after the delicatessen where she worked for five years was closed down. Thirty years old, with a three-year-old daughter and a nine-year-old son, her caseworker sent her to a job at McDonald's. I first met her two weeks later when she came into the welfare office to tell her caseworker that she just couldn't manage the required speed of fast-food service: "I know how to make sandwiches," she anxiously explained, "but this work is just too fast. My boss keeps telling me to 'pick up the pace.' But I can't do it!"

"Just hang in there," her caseworker replied, "and we'll see if we can't find you something better soon."

Clara was sobbing by then, and talking about how the stress of the job was taking a toll on her two kids as well, "I have to get them up at five in the morning, and they don't want to go. I yell at them. They don't deserve it. *Please* don't make me go back."

Her caseworker could only repeat the suggestion to "hang on" (even

though she later told me how much she wished there was some other option). Five days later Clara quit her job. Her caseworker empathized, but rules are rules, and since Clara had quit without "good cause," she was sanctioned, leaving her and the kids without any income for a month. By the time I saw Clara again she was back on benefits and looking for a new job (40 contacts in 30 days). She was broke and exhausted, and owed money to all her family members and friends. She had used up six months of her lifetime welfare benefits.

Kendra, one of the first clients I interviewed, would be categorized among the "successes" of reform in that she was no longer on the welfare rolls. But hers is a story that continues to break my heart. Nearly everyone in the Arbordale welfare office knew and loved Kendra. She was very sweet, and shy, and deeply earnest. At the time I met her in 1998, she was 26, with two daughters aged six and eight. After a long history of working part-time, on and off, in unskilled jobs, she had finally landed a secure and meaningful job, she thought, working at the homeless shelter run by the Salvation Army. It was the night shift, but she was happy about it, since it made her feel especially good to be helping out the homeless. Given her own experiences, she thought she had a special empathy for their hardship. Additionally, the graveyard shift worked well, she said, because it allowed her to have time with her two daughters during the day. She had worked out childcare with a neighbor who worked the day shift. She was not making enough money to get by without the extra help from the welfare office and public housing, but she was planning on asking for a small raise, thinking that she could work her way up, or maybe take a second job. She was also studying for the high-school equivalency test. She was hopeful, cheerful, and she was proud of herself. She felt particularly grateful to her welfare caseworkers and to her foster parents, who had been kind enough to raise her and her two brothers from a young age. She wanted these people to be proud of her as well, and she felt that she was on her way for the first time in her life, largely thanks, she told me, to all the supplemental services and caseworker support she experienced as a result of welfare reform. We talked about strategies for how she might make ends meet without the help of the welfare office.

Two months later, all Kendra's dreams came to a crashing halt. Her brothers got into an argument, and one brother shot and killed the other. One was dead, the other was on his way to prison. She fell apart

emotionally, missed too many days at work, and lost her job. She left the welfare rolls and moved out of public housing. Although Arbordale caseworkers made a special effort to track her down (a rare undertaking and one that was certainly not a part of their job descriptions), no one could find her. All of us worried about what would become of Kendra and her daughters.

A failure to embrace the values of the nation is clearly not the malady from which these women suffer. Of the array of welfare mothers I met, some were more or less responsible, noble, personable, and well organized than others, but all of them faced a core tension that they share with most American parents today—the push toward work and self-sufficiency and the pull toward home and the care of one's family. Unlike their middle-class counterparts, however, welfare mothers must face these demanding dual commitments with many fewer financial assets, marketable skills, and familial resources backing them up, and under much more powerful economic and logistical constraints.

In 1999, the bottom 10 percent of the U.S. labor force made just $6.05 per hour; the 10 percent above them just $7.35.[20] Given the employment characteristics of the largest proportion of the welfare population—low skills levels, a high school diploma (or less), and a work history of relatively unskilled jobs—most are bound for jobs in the bottom 15 percent. Such wages are simply insufficient to raise a single parent and her children out of poverty.

Reinforcing welfare recipients' odds of winding up at the bottom is the fact that our labor market (whether we like to admit it or not) continues to discriminate by race and sex. Since the welfare population is overwhelmingly female and disproportionately nonwhite, they face a sex-segregated market and racial discrimination in seeking work, both of which systematically contribute to keeping their wages low.[21]

Further, in considering the low wages of former welfare recipients, it is important to recognize that they occur in the context of rising income inequalities. Throughout the economic boom of the 1990s, income inequality increased: the earnings of the top fifth of the population rose 11.4 percent; the incomes of the bottom fifth actually declined by 3.4 percent.[22] A vivid representation of this trend is the fact that the average CEO is now making 209 times the income of the average manufacturing worker. If the wages of all U.S. workers had gone up at the same rate as

those of CEOs over the last 15 years, poverty scholar Joel Blau has calcu-
lated that workers earning the minimum wage could now be expecting
to bring home over $39,000 a year.[23]

Until the wages of low-income workers actually keep pace with the
earnings of CEOs, and until the earnings of women and nonwhites ac-
tually match those of white men, the incomes of most of the people who
pass through the welfare office will remain insufficient for the achieve-
ment of financial stability. Welfare reform, offering slogans like "any job
is a good job" and "work is always better than welfare," completely ig-
nores these realities. Although a welfare check had never raised such
families out of poverty either, the time spent on welfare was always a
time of steady and *reliable* hardship. The welfare check comes every
month, rain or shine. Low-wage work, on the other hand, not only
comes with added costs for childcare, transportation, and medical care,
but it is also much more precarious—with changing hours, changing
demands, and the constant risk that the contingencies of life and the
labor market might force you to quit, cause you to get fired, or leave you
laid off. This brings added strain.[24]

As is true of all working parents today, a large part of the stresses and
strains faced by the working mothers I met were the result of their worries
about their kids and the struggle to maintain a stable family life. First,
there is the issue of finding and retaining good, safe, nurturing, affordable,
and convenient childcare. Then there is the problem of children's emo-
tional needs which, as every parent knows, do not fall neatly into eight-
hour shifts. Then there are the difficulties associated with children's health
and their physical well-being. For welfare mothers, like all single parents,
this juggling of paid work and childrearing is made all the more difficult
by the fact that it must be done without the help of a partner. For the poor,
these family concerns are further compounded by the nature of their liv-
ing situations and the inflexibility of the jobs they are likely to find.

Low-wage workers, especially desperate ones, are much more likely to
end up with odd work schedules, graveyard shifts, weekend work, and
changing work hours.[25] They are much less likely than the middle class
to have the flexibility at work that will allow them to take time off to care
for sick children, meet with school officials, manage doctor and dentist
appointments, and cope with the other contingencies that arise in rais-
ing kids. Poor single mothers are also much more likely to live in dan-
gerous neighborhoods, adding further worries relative to the supervi-

sion of children. These mothers are additionally much more likely to be indebted to and dependent on family and friends (who have helped them in time of need), and they are therefore more likely to be affected by hardships that befall those family members and friends.[26] Add to these a litany of problems in transportation, housing, and other aspects of material sustenance—cars that break down, buses that don't run on schedule (or don't run at all during the nighttime hours), overdue power bills that leave the family without winter heat and must be paid during business hours, plumbers who demand that a household member be at home when they come to fix the backed-up toilet, and slum landlords that force mothers to move when they find new tenants without (troublesome) children. Given all this, single parents who are low-wage workers are *always* at risk for losing their jobs, or losing their sanity.

The problem for most welfare clients, then, is not getting a job, but finding a job that pays enough to bring the family out of poverty, offers benefits, and is flexible enough to make room for the circumstances of single parenting. The odds of finding that job—and keeping it—are not good when you are a woman with low skills and children to care for.

In the city of Arbordale in 2000, $6.76 an hour was the average wage for people moving from welfare to work. In Sunbelt City that same year, the average wage was $6.80. Nationally, it is estimated at about $7.00 per hour.[27]

Yet the hourly wage does not fully capture the difficult employment situation of most former welfare recipients. Nationwide, most welfare mothers find jobs in food preparation, sales, clerical support, or other service sector jobs. Many are part-time or temporary workers, one-quarter work night or evening shifts, 75 percent are without medical benefits, most do not receive sick leave or paid vacation. And most welfare mothers who are working are not getting full-time jobs year round. Thus, although the $7.00 an hour rate would amount to over $14,500 a year (bringing a family of three just above the poverty line), the average annual earnings of former welfare recipients are actually estimated at only $8,000 to $10,800 per year.[28]

Much of this material hardship was prophesized by the single most systematic comparative study of welfare mothers and low-wage employment ever conducted. In *Making Ends Meet*, published just one year after the Personal Responsibility Act was passed, sociologists Kathryn Edin

and Laura Lein demonstrated that low-wage work does not—and cannot—solve the problems of welfare recipients. Comparing the monthly budgets of 214 welfare recipients against 165 single mothers working for low wages (in four different cities), Edin and Lein found that although jobs paying $5 to $7 per hour offered more money than welfare benefits and food stamps combined, the additional income was more than offset by the extra expenses of work and childcare. In the end, when budgets were balanced against expenses, the working mothers remained without sufficient income to cover their bills and, overall, experienced *more* material hardship and insecurity than their counterparts on welfare.[29]

The desperate situation of many former welfare recipients comes out in a peculiar internal irony of the Personal Responsibility Act, and one that struck me as particularly telling in light of the work and family issues embedded in reform. In some rural counties outside of Arbordale, the *average* wage for former welfare recipients in 1999 was $5.05 per hour, ten cents below the minimum. Welfare caseworkers explained to me that what this impossibly low wage actually indicated was the number of former welfare recipients who were taking one of the few jobs that could legally be paid below the minimum—the job of in-home childcare worker.* In many cases, this meant that the very same mothers who were being offered childcare subsidies to go to work and leave their own children in the care of others were capitalizing on the existence of those subsidies to eke out a meager living for themselves. They were caring for the children of other welfare recipients—and receiving their salaries through welfare reform's subsidy. Hence, not only were they doing the same caregiving work they did while on welfare (with just one or two extra kids), but their income was also coming from the very same source. For some of the welfare mothers who took this route, it was the only job they could find. For others, they specifically made this choice because it allowed them to continue to care for their kids at home. In either case, this job left them living well below the poverty line, with no benefits, little hope of wage increases, and, since their customers relied on welfare's time-limited childcare subsidies, a job that was highly un-

* This job can be paid below the minimum because the more kids you take in, the more you make. Therefore, it is reasoned, in-home childcare workers who make less than the minimum simply need to be caring for additional children.

stable. The irony of this situation was not lost on Arbordale casework-ers. But according to the terms of welfare reform, these desperately poor childcare workers were counted as "successful" former recipients.

One final problem, often invisible in national statistical accountings, was quite evident to those of us who experienced reform at ground level. Given the structure of paid work, the particularly unstable nature of low-wage jobs, and the realities of single parenthood, many former welfare recipients who had managed to find work, sooner or later, found themselves unemployed again. Nationwide, as noted, it is estimated that about 40 percent are unemployed at any given time. Of those who were working previously, many discovered that they were ineligible for un-employment insurance (as a result of strict rules regarding length of employment, wage levels, hours of work, and other state-level require-ments).[30] Some of those mothers quickly found other jobs, some turned to alternative sources of help, others returned to the welfare office—as long as they had not yet used up their time.

Inside the welfare office, repeat clients and issues of "job retention" became constant problems. By 1999 one of my favorite caseworkers in Arbordale told me that of her 80 clients, only four had been able to keep the same job for a full year. For another caseworker, of the 75 welfare mothers she oversaw, only 12 had kept a job for three months.[31] Overall, about half the clients in Arbordale managed to stay employed (at one job or more) for a full six months; less than 10 percent kept one job for an entire year. By 2000, a full three-quarters of employed former welfare recipients in Arbordale's state were making wages below the poverty line.[32] Despite the significance of these kinds of statistics, Sunbelt City had not been keeping such counts.

The work and family issues that underlie these realities explain why, as the economy boomed throughout the 1990s, as national employment rates climbed, as the welfare rolls went down, and as the overall poverty rate decreased, the poverty rate for the poorest of the poor did not fol-low suit. Based on 1999 Census Bureau figures, the Center for Budget Priorities calculated that nationwide, the annual income of the poorest fifth of female-headed households (roughly the welfare population) fell an average of $580 per family, a decline of about 7 percent in a situation of already desperate poverty. It is estimated that the bulk of this income loss was the result of declines in the receipt of welfare and food stamp benefits. And again, this increase in the depth of poverty occurred be-

fore the economy began to stall and before welfare recipients began to reach the first wave of time limits following reform.[33] As I will demonstrate in the final chapter, it will take many, many years before we see the full impact wrought by this reform.

Assessing the Work Plan

Watching the ongoing political celebrations of the decline of the welfare rolls in the years following reform, I had to wonder if I was missing something. There were certainly some successes involved, but the applause of the proponents of reform seemed both premature and neglectful of much of the ground-level hardship faced by poor families. It was also apparent to me that those proponents were ignoring a number of additional complicating factors.

First, there was the question of how much of the declining welfare rolls of the late 1990s could be credited to reform and how much of it to the then–booming economy. Scholars continue to debate this question. Historically speaking, the relative number of welfare recipients has always been connected to fluctuations in the economy, and this connection seems to be confirmed by the rapid decline of welfare receipt in the late 1990s and the slowdown of that decline when the economy began to stall in 2001. But it also makes sense that the new law and the new procedures of welfare offices have had an impact. The best historical comparison in this case is the major policy changes of the late 1960s that clearly affected the size of the welfare rolls in the 1970s and 1980s. Still, conclusive figures on the comparative importance of the law and the economy are hard to come by, and vary widely. Taking into account the range of existing literature on this question, and recognizing that many welfare mothers left the welfare rolls with jobs long before the passage of reform,[34] one could optimistically credit the Personal Responsibility Act with half the welfare employment exits that occurred from 1996 to 2002.[35]

On the positive side, as I've suggested, there is little doubt that the system of training, supportive services, and income supplements provided by reform has heightened the employability of some welfare mothers— offering just the kind of temporary economic support and training needed to create a financially stable work and family life. For the majority, however, these programs are not a sufficient basis for lasting stability.

The 40 percent of former welfare clients who were without work in

2002 had *no* discernible source of income. And, as noted, of the 60 percent of former welfare recipients who were employed, only half had found jobs paying above-poverty wages. Even more disheartening, national studies estimate that about two-thirds of those who do find work will, for one reason or another, lose those jobs over the course of a year. Hence, the 40 percent who are without jobs or welfare include not just those who never found work, but also all those who once had jobs and lost them. This 60/40 split of employed versus unemployed former welfare recipients has remained fairly steady from 1998 to 2002. This means that every time someone in the nonworking 40-percent category finds a job, some family in the working 60-percent category loses their job.[36] And remember, of the jobs that these parents are competing for, only half pay enough to support their families above the poverty line.

Thus, what we are actually seeing when we look at the decline of the welfare rolls is millions of mothers desperately striving to work their way out of poverty and continuously moving in and out of low-wage jobs. Some of these women and children are managing to rise above the poverty level, at least for a time, but most are not. Some keep their jobs for longer than others, some have better jobs than others, some have found little work at all. Very few—optimistically 10 to 20 percent—have achieved relatively permanent, above-poverty stability. Of those who go long periods without work or welfare, given that they are no longer in the "system," there is currently no reliable data on their fate, though there is every reason to believe that most are in situations of dire poverty.

All these consequences of welfare reform were measured during a period of tremendous economic prosperity. And all the celebrations of the declining welfare rolls ignore not just the hardships of unemployed and underemployed former welfare recipients, they also ignore the millions who are still on welfare, still trying to cope with the rules of reform, and still trying to comply with Americans' stated demand that they leave the rolls as fast as they can.

It is also important to recognize that the hardships and chronic instability we are talking about have not only impacted the 12 million temporarily poor and persistently poor families who were on welfare in 1996. This law has also impacted all the millions of newly poor, returning poor, and temporarily poor who have ended up on welfare since then—and tens of millions more will be affected by this law over time. Although there is some good news in this, overall, it is surely not a rosy

picture of happily employed, independent women who are effortlessly juggling their work and family lives.

In the end, the results of the Work Plan of reform tell us a story not just about the hardship of present and former welfare recipients but also about the nature of the American labor market—and about deeper problems in achieving the American dream. Recognizing the realities of low-wage work, one could argue that the underlying logic of the Personal Responsibility Act is either punitive or delusional. On the punitive side, the work rules of reform might be interpreted as implicitly aimed at creating a vast population of disciplined and obedient workers who are hungry enough (and worried about their children enough) to take any temporary, part-time, minimum-wage job that comes their way, no matter what the costs to themselves or their family. More positively (but nearsightedly), one could interpret the Work Plan as following from the assumption that there is an unlimited number of career ladders available for every American to climb. The time-limited nature of welfare reform's childcare, transportation, and income supports, for instance, suggests a middle-class (and increasingly mythological) model of working one's way to the top. From the file room to the front office, from flipping burgers to managing one's own franchise, from cleaning toilets to running the county maintenance division, from sorting mail to programming computers—everyone, this model implies, has the chance to achieve financial success. But given the nature of most of the low-wage jobs available in the United States today, the supportive benefits required to enable recipients to make ends meet are very unlikely to be covered by the wage increases that most clients will receive by the time they become ineligible for further welfare help. And given rising income inequalities and the widening division between low-wage service workers and the educated, technologically savvy professional class, it is very unlikely that the majority of welfare mothers will have a chance to climb permanently out of poverty—at least for as long as they have children to care for.[37]

Whether intended or not, it may ultimately be true that the Work Plan of welfare reform is more effective as a form of punishment than it is as a positive strategy for independence. Of course, the Work Plan *is* somewhat effective at pressing mothers into jobs. The Work Plan *can*, as national statistics testify, contribute to a significant decline in the absolute number of people on welfare. And this plan *has* provided some

welfare families with valuable supportive benefits and new hope. Yet given the realities of low-wage work and single parenting, the Work Plan will not elevate the majority of welfare families above the poverty line. In the long run, many will need to go back on welfare or will need to be dependent on the help of men, extended family members, friends, charitable community services, or illegal activities. Whether the latter forms of dependence are, by some measure, superior to "welfare dependency" is a matter of one's goals, and a question I will explore further.

Many policymakers were well aware of existing research from the start, and they knew that the odds of raising welfare recipients out of poverty were not good. But arguably, the symbolic message that paid work *should* lead to independence was, from the beginning, more important than the practical issue of poverty itself. What we have achieved with the decline of the welfare rolls is, in fact, the *appearance* of independence. This has surely helped to maintain faith in our system, but it is nonetheless insufficient if we are truly committed to the values of familial stability and inclusive citizenship.

In the meantime, the work rules of reform have suggested to the nation that we have no responsibility to address the inadequacy of low-wage work. And the individualistic logic of these rules has also ignored the fact that something more than "personal" responsibility is at stake here. Children, these rules imply, can be managed by simply putting them aside in childcare centers. In fact, if work requirements were the only feature of welfare legislation it might appear that mothers in American society have been completely "freed" from the responsibility of parenting. We need to ask ourselves what has happened in this process to the cultural ideals of independence and commitment to others.

In the face of the Work Plan's moral and practical inadequacies, we might be tempted to change our angle of vision, and perhaps set our sights on some alternative plan. One might, for instance, begin to hope that welfare mothers will simply find themselves a good man—to help them with the bills and to help them care for their children. As it turns out, prior research suggests that finding a good man and marrying him is, indeed, a very good way to get off and stay off welfare.[38] So what do family values look like when they are instituted at the level of the welfare office? Is the Family Plan the answer?

With all these changes, many clients are in shock. Some have had their families on welfare for generations. They don't know what is happening. They are absolutely paralyzed by this. It is a tremendous struggle. The state doesn't care about the quality of their lives. The state doesn't care what happens to their children. The model is work first.

—Nancy, Welfare Division Supervisor (and welfare caseworker for 21 years), in the first months after implementing welfare reform in Arbordale

Chapter 3

Promoting Family Values

AT FIRST GLANCE, ONE NOTICES FEW REPRESEN-
tations of the family in the welfare office. But look again. The
overwhelming majority of caseworkers, like the overwhelming
majority of clients, are women. Most of the caseworkers in Ar-
bordale and Sunbelt City have pictures of children on their
desks or on the walls of their cubicles. And most of these offices include
at least one or two toys for the children of welfare recipients. In Arbor-
dale, a giant stuffed gorilla sits in one of the reception area chairs when
he's not being toted around by one of the visiting children. On the wall
hangs a poster of Babar, the friendly elephant. In one section of the
waiting area all the furniture is built for people under four feet tall, and
children's books, projects, and toys are scattered about, on chairs, tables,
the floor. In the Sunbelt City reception area for welfare-to-work clients,
the television is always on, perched over a giant Fischer-Price activity
center with positions for doodling, building, and climbing. There are
crayons, playthings, and books.

Children are a constant presence. Although mothers are not allowed
to bring children to their life skills classes, they bring children to the
welfare office on just about every other occasion. And the caseworkers,
almost all of them women, often participate in caring for the children—
carrying them around, playing with them, trying to quiet those who are
unhappy. In fact, the world of welfare often looked to me like a big fam-
ily gathering. Women and children were everywhere. The only thing
missing was the men.

In the very same waiting room that pushes employment and reminds welfare mothers that their "clocks are ticking" there is a secondary, potentially contradictory message. At one end of the banner inquiring "how many months?" there is a portrait of a family—mother, father, and child—holding hands. At the other end is a drawing of two clasped hands. Like the ubiquity of children in this otherwise businesslike setting, one might read this banner as a message that achieving success is a process that takes place in the context of mutual aid, and a process undertaken, at least in part, for our children and for our collective future.

Although welfare reform's Work Plan takes center stage in the welfare office, the opposing messages of individualism and caregiving, paid work and childrearing, self-sufficiency and shared obligations have not disappeared altogether. The importance of familial connections persists in the welfare office, in large measure because the people it serves *are* in families, no matter how much welfare reform's congressional framers have deemed those families deviant and inadequate. The principles of family life have also entered the welfare office, I soon discovered, because the requirements of reform have had the (unintended) consequence of turning many caseworkers into guidance counselors in work and family life. These welfare workers understand themselves as providing help and encouragement, they want clients to recognize them as (familylike) mentors who can support and guide them through hard times, and they know that the care of children is a part (albeit a private and secondary part) of the work that welfare mothers must do.

This reality of the welfare office as a family-friendly setting of caregiving, aid, and cooperation, however, not only conflicts with the bureaucratic structure of welfare, it also bears little relation to the explicit goals of welfare reform. The vision of family life contained in the Personal Responsibility Act is a much narrower one. According to Congress, the family edicts of welfare reform are specifically designed to

1) reduce out-of-wedlock pregnancies,
2) promote marriage as a route off welfare, and
3) allow children to be "cared for at home."[1]

The kinds of families that Congress had in mind, in other words, must include breadwinning husbands—ideally the type with sufficient earnings to allow mothers to stay at home.*

As central as these goals might be to welfare reform's framers, I found no one in the welfare office, neither caseworkers nor clients, who imagined that happy marriages and warm familial ties were something that could be achieved through the routinized enactment of rules and regulations. All of them were also quite certain that the work requirements of reform made it increasingly unlikely that poor children would be "cared for at home." And not a single welfare caseworker or client suggested to me that the Personal Responsibility Act operated to positively promote lasting relationships with financially solvent men.

The version of family values that *is* enforced in the welfare office is an image of the proper behavior of mothers. Using the same behaviorist methods as the work requirements, mothers are required to provide financial support for their children, seek out and manage childcare arrangements, make certain that their children receive all the proper vaccinations, and see to it that their children attend school every day. These women are also obligated to participate in identifying, locating, and demanding economic assistance from the fathers of their children (no matter how financially insolvent those men might be). And Arbordale mothers (like those in nearly half the states nationwide) are additionally expected to control their fertility to keep it in line with their financial resources. As is true of work requirements, if mothers should fail in any of these tasks, they and their children can be left homeless and destitute.

In the pages that follow, I explore the enactment of welfare reform's Family Plan at the local level. In a parallel to the work requirements, welfare policies aimed at instilling proper familial behavior are designed to reflect a cultural image of how all people should behave with respect to childbearing, childrearing, marriage, and family. Set against the work requirements, these familial policies also offer an implicit story about the tensions between work and family life in American society today. At the same time, in examining welfare reform's rules for family life I mean to draw attention to the difficulties involved in attempting to enforce a vision of proper familial commitment. The central question, in these terms, is whether the system of familial edicts executed by the welfare

* By 2002, the Bush White House was developing additional proposals for promoting marriage through welfare reform—including monetary bonuses to welfare recipients who wed and training programs in familial commitment (see Horn and Sawhill 2001, Toner and Pear 2002B, Toner 2002).

office ultimately adds up to something we can proudly embrace as the promotion of "family values."

Enforcing Proper Parental Behavior

Ever since the inception of government-funded programs for the poor, policymakers have believed that the giving of benefits comes with the right to interfere in the family lives of the poor.[2] This is a notable exception to our strong cultural and constitutional prohibitions against state interference in private lives, particularly familial behavior. As political theorist Gwendolyn Mink argues in *Welfare's End*, the legal guarantee of privacy has been central to protecting basic family rights: to marry or not to marry, to make choices about reproduction and childrearing, and to determine living and custodial arrangements. Exceptions made in the case of the welfare poor have historically allowed, for instance, proper home requirements to determine the "suitability" of living arrangements and childrearing practices, "man-in-the-house" rules prohibiting men from sharing homes with welfare mothers, and attempts to control the reproductive behavior of poor women, including cases of forced sterilization. As Mink and others have noted, these policies often operated to discriminate against women (disproportionately nonwhite women) who were considered lacking in moral "virtue." All the most blatantly discriminatory policies have been struck down by the courts.[3] A few questionable family regulations have remained, however, and welfare reform has strengthened those and added more, reasserting the right of government to interfere in the familial life of the poor.

Welfare caseworkers therefore dutifully enforce a series of policies aimed at compelling responsible maternal behavior. The least intrusive is the demand that all children be properly vaccinated—verification is mandatory if the mother is to receive government aid. More onerous are the truancy requirements: all mothers with children aged 5 to 18 are held responsible for their children's school attendance. If a child misses three days in a row, five days in a month, or seven days over a longer period, the child is considered truant. The mother is called into the welfare office, where she must provide an account of the problem and formally outline a "plan" for getting the child to go to school. If the mother fails to control her child's school attendance, the child's portion of the family's welfare benefits will be cut. Yet another policy, this one newly insti-

tuted with TANF, requires that all welfare recipients who are teenage parents must maintain full-time school attendance and remain under the watchful eye of more responsible adults, living with their own parents or another adult relative.

Although these policies may not seem particularly unreasonable on the surface, they are absolute and strictly enforced, with such stiff penalties that there is no room for difficult circumstances or individual choice. If a 16-year-old child is truant and beyond his mother's control, for instance, there is no exception available. If a mother would like to avoid the vaccination of her children (as some contemporary mothers do), she cannot. Or if a 17-year-old teenage mother wanted to drop out of school to seek work, hoped to move in with her boyfriend, or needed to escape a difficult family situation, she would be deemed ineligible for welfare benefits. Like the rules of the Work Plan, the inflexibility of these familial regulations belies the claim that welfare reform is aimed at the promotion of "personal responsibility."

Especially significant and debatable are those policies created by reform to stem the tide of out-of-wedlock childbearing that the law holds responsible for the "crisis in our nation." Three federal regulations directly address this issue; a fourth is offered as a state "option." First, the Personal Responsibility Act sets aside $50 million per year to subsidize state programs of "abstinence education" to teach "the social, psychological, and health gains to be realized by abstaining from sexual activity." These programs, Congress declares, will serve to remind the "at-risk" population that sex is only appropriate in the context of heterosexual, monogamous, marital relationships.[4] Next, our legislators direct attention to "predatory men," calling on the Justice Department to conduct a study of "the linkage between statutory rape and teenage pregnancy, particularly by predatory older men committing repeat offenses." In line with this, law enforcement officials are to be educated on the "prevention and prosecution" of statutory rape.[5]

The culmination of these efforts is rewarded by the third directive attacking unwed parenting—the so-called illegitimacy or antiabortion bonus. Every year, $100 million will be shared by the five states that do the best job of decreasing the number of out-of-wedlock children born *without* raising the abortion rate.[6] Significantly, the law does not include the slightest hint of further funding for birth control or family planning education, even though scholars have consistently demonstrated that

affordable, easily accessible birth control is the one public policy that has proven most effective in lowering rates of nonmarital childbirth.[7] From a literal reading of the law, one would be forced to surmise that Congress imagines abstinence training and the prosecution of statutory rapists will do the trick. While this policy decision cleverly avoids controversy over birth control, most members of the American public are thoughtful enough to recognize that hunting down men who have sex with younger women and suggesting to the young and poor that they should avoid sexual activity altogether are insufficient solutions to the historical rise in the number of single parents.[8]

There is, however, one provision of the Personal Responsibility Act that addresses nonmarital births in an immediate and forceful way. This provision, which directly impacts life in the welfare office, is the "family cap"—barring from welfare receipt all children born to mothers who are already on welfare. This policy had been mandatory in the Republican version of welfare reform, but was made a state "option" in the version that finally passed the legislature. Almost half of the states, including Arbordale's, have instituted this plan.[9] The underlying logic is that women who consider becoming pregnant while on welfare will know that their progeny would be ineligible for benefits and hence will think twice before having more children.

The reality of this policy is faced by women like Joanne, a 29-year-old mother I met at a follow-up interview in the Arbordale welfare office. Joanne received welfare benefits for herself and her five-year-old daughter, Amanda. Her six-month-old son Tony, however, was conceived while she was on welfare—he was therefore a capped child. Joanne was physically abused by Amanda's father, so she left him when her daughter was a toddler (and when she began to realize that the abuse was affecting her baby girl as well as herself). While on welfare Joanne met a new man who seemed to offer stability: he had a steady job and he did not beat her. When she became pregnant with their son, she was hopeful that the child would solidify the relationship, bring the family together, and get her off welfare. Initially, this seemed to be working—Tony's father moved in, and Joanne got off the rolls for a brief time. But less than a month after Tony was born his father left them, apparently unable to face the responsibility of supporting the whole family. Joanne and the two kids had since moved back in with her parents, sleeping in their living room.

Tony was a curious and alert little boy, with smiling blue eyes and dark curly hair. On the day I met him, he was playing with a stuffed panda as the caseworker talked to his mother. Both the caseworker and Joanne were referring to him as "the capped child," as if he wore a little beanie on his head embossed with the word "ineligible." That cap is not insignificant. Not only will he receive no benefits, but by welfare policy he doesn't actually exist, and hence the 18-month exemption from work requirements that is generally provided to new mothers in Arbordale does not apply to Joanne.

She was in the office that day because she had refused to work when Tony was still an infant; she was therefore sanctioned. She hadn't quite understood the reason for the sanction at the time, but she had obediently appeared in the welfare office as a result of a letter she received telling her that her one-month ineligibility was complete and she should report in. The caseworker explained the reasons for the sanction and told her she must find a job. Joanne asked instead to have her welfare case closed and her benefits discontinued. She said that Tony was just too young to be left in childcare; she did not feel that he would be safe. Given that there are no exceptions in welfare policies for mothers who are worried about the safety of their children, Joanne's case was closed and her benefits terminated. It was unclear to me how she and her children would survive.

There is no question that the family cap's impact on poor mothers and children is extremely harsh. For those who are less concerned about its cruelty, the family cap has two additional problems. First, as Gwendolyn Mink points out, this policy is arguably unconstitutional in that it systematically operates to penalize women for exercising their right to reproductive choice.[10] Second, the family cap provision is relatively ineffectual in meeting its stated goal of teaching poor women to control their fertility in that it suffers from both procedural inadequacies and a failure to understand the life circumstances of poor women.

The procedural failure of the family cap policy that is obvious to anyone who has spent any time in a welfare office is the implicit assumption that all welfare mothers know welfare rules, keep track of them, and plan their lives accordingly. As I have discussed, the rules and regulations of welfare are so complex that most welfare caseworkers cannot remember them all, and even the most conscientious and compliant welfare clients tend to keep track of only those that have an immediate

impact or assert an immediate obligation. To correct this procedural flaw, one might recommend massive and ongoing national advertising campaigns to establish the necessary awareness, but even this would be inadequate. To the extent that welfare mothers are aware of welfare regulations, they generally make reasoned choices regarding the rules with which they will comply. Those choices, as well as the lack of prior knowledge, begin to explain why this provision has had no demonstrable impact on the rate of out-of-wedlock childbearing in the one state where the family cap program was in effect long enough to study outcomes.[11]

Yet, more important than the procedural barriers to the success of the family cap is a much broader cultural barrier. *Welfare mothers have children for reasons other than the desire to get a few extra dollars in their welfare check.* As the tension between the Work Plan and the Family Plan illuminates, the idea of a calculated weighing of children against dollars is an apples and oranges equation. It is as culturally offensive to most Americans as the practice of seeking personal profit through the selling of babies on the open market.[12] On this score, most welfare mothers are no different from most Americans. Welfare mothers' decisions to have children arise from many sources, but they are generally not based on self-interested analyses measuring the size of their welfare checks against the value of raising a child. Research has repeatedly shown that rising rates of out-of-wedlock births have very little to do with rates of welfare benefits. In fact, national and international studies consistently demonstrate that attempts to lower rates of single parenting by lowering welfare benefits have been, and will be, generally ineffectual.[13]

Overall, the immunization rules, truancy requirements, teen supervision, abstinence education, and family cap policies are a mixed bag of attempts to impose standards of familial behavior on the poor. Meant to enforce an idealized middle-class model of the appropriate approach to family life, these policies effectively preclude a fundamental principle of middle-class family practices—the right to make *choices* regarding reproduction, parenting, and living arrangements. The problem here is not just one of denying welfare mothers the right of individual choice, it is also a problem of denying them the social *inclusion* that is implied by choice.

When we have finished enforcing this particular set of policies, we would be hard pressed to proclaim them the harbingers of a new era of familial commitment. Imagine a visitor from some far-off land trying to "read" these provisions for a vision of how American family life is appropriately ordered. The implicit message, so far, would simply state this: individual mothers are solely responsible for the health, education, and welfare of their children; all women without the financial resources, marketable skills, and stamina necessary to raise children alone should be assigned a life of celibacy. If these edicts were all we had to show as a representation of the family values we wish to champion, our nation and our families might well seem to this visitor cruel, unjust, or at least grossly underdeveloped.

There are, however, two changes brought by welfare reform that appear, on the surface at least, to be positive and forward looking, directly addressing the issues of shared parental responsibility, the predicament of employed mothers, and the difficulties involved in the integration of work and family life. These are the massive expansion of childcare subsidies and the added requirements aimed at making "deadbeat dads" support their progeny.

Subsidizing Market-Based Childcare

All states have experienced a massive influx of childcare dollars since the passage of the Personal Responsibility Act. In both states I visited, all welfare mothers in training or jobs are eligible for subsidized childcare; they need contribute only 10 percent of their gross income for this service. Many states also offer childcare as a "transitional" benefit—allowing former welfare recipients to receive help with childcare for up to one year after they get off the rolls. To the extent that one believes all mothers should have the option of participating in the paid labor force, these childcare subsidies seem generous and genuinely helpful. Yet there is one central problem in the symbolic and fiscal logic of this policy, and there are many, many problems that arise in its administration.

The federal support of paid childcare for the poor makes obvious one of the central cost-benefit contradictions in the logic of welfare reform. *The costs of subsidizing childcare for the poor far outstrips the state and federal costs of paying a welfare mother to raise her own children.* It is cheaper, by far, to give a mother her monthly welfare check than it is to

subsidize her childcare at market rates. In Arbordale, where welfare benefits are $354 a month for a family of three and $410 a month for a family of four, it costs $904 per month on average to purchase care for two children, $1,356 for the care of three.[14] Even if we include the supplementary benefit program of food stamps, placing welfare children in subsidized care for 40 hours per week is far more expensive than (inadequately) supporting their mothers to care for them 24 hours a day, seven days a week. The good news for taxpayers, and the bad news for poor single mothers and their children, is that the majority of welfare clients never actually receive childcare subsidies.

In Sunbelt City, only about one-quarter of eligible clients receive childcare subsidies; in Arbordale the figure is approximately 40 percent. Nationwide, less than one-third of eligible families actually receive the subsidy. In many locales there are simply not enough childcare facilities to go around. In situations where there are sufficient facilities, states keep running out of money to serve the seemingly endless stream of customers lining up for this valuable service.[15] Thus, in most places, welfare clients face long waiting lists either for the available childcare slots or for the subsidies.

It is important to remember that for these welfare mothers the question is not whether they *want* to put their children in childcare, they *must* do so in order to meet federal work requirements. Although states have the option of "exempting" from work requirements those mothers who are unable to find childcare (if their children are under age 6), neither Arbordale nor Sunbelt have used exemptions for this purpose. Given that federal regulations require 50 percent of welfare mothers to be in work or training, even the most generous state could not come close to exempting the two-thirds (or more) of mothers who are without a childcare subsidy.* Yet, as is true of nearly all things welfare related, the problems at ground level are even more troubling than any broad statistical accounting can convey.

* As much as it would be impossible to exempt from work requirements all those welfare mothers who are without childcare, to exempt even 50 percent would mean that all those recipients with newborn infants, disabilities, and serious barriers to employment could not be exempted. (The Bush administration's 2002 proposals for higher work rates, if passed, will make this situation even more desperate [see Parrot et al. 2002].)

The three-quarters of Sunbelt City mothers who are without subsidized childcare face a number of roadblocks, even though the welfare office, technically speaking, has no one on the waiting list for subsidies. The state has contracted out the administration of childcare to a private, nonprofit organization. One effect of this contractual system (a system used by many states for many of the services that welfare reform is obligated to provide) is that some welfare mothers are never properly referred for services, and some others don't fully understand that they are eligible. For the larger group who do seek out childcare help, they must travel long distances with poor public transportation just to get to the childcare office. Once they arrive, they are confronted with a bureaucratic process that rivals their experience of welfare.

The childcare administering agency requires an extensive application process, with piles of forms to be completed, many of which demand that clients provide the very same documentation they have already provided at the welfare office, including birth certificates and vaccination records. Clients must also produce, among other things, certification of eligibility and compliance from the welfare office, a separate letter from their employer stating their hours and pay-rate, and proof of a full physical examination and medical records for each of their children. Generally, this application process takes a number of trips and a number of weeks for clients to complete, and some are never able to provide all the documentation required. Those who are certified and do make use of the subsidy are then subject to the same kind of reporting obligations they face at the welfare office (change of hours, change of jobs, change of living situation, and so on). If they fail to comply, their subsidy will end.

Furthermore, the Sunbelt City childcare system allows children to be placed only in childcare facilities certified by the state. There are relatively high standards for state certification: extensive record checks on the provider, health and safety training, childcare training, and an on-grounds inspection of the home or facility. These requirements sound like a good thing, designed to protect children and ensure that they are well cared for. Unfortunately, these requirements present a number of problems for welfare mothers. First, as studies show, poor mothers (more than middle-class mothers) tend to want to have their children cared for by family members and friends, yet their family and friends are very unlikely to have the resources required for certification.[16] Sec-

ond, although there are no waiting lists to receive subsidies, the demanding certification requirements limit the number and availability of childcare options and therefore mean that there are waiting lists for childcare providers, especially the most desirable and convenient ones. Hence, the childcare placements that do remain available to Sunbelt mothers tend to be at distant or odd locations. If mothers take one of these providers, they are often forced to spend an extra hour or more in transportation each day to manage the trip from home to childcare to work and back again—and their children spend that much more time in a childcare center that was not the mother's preferred provider in the first place.

Sunbelt mothers, therefore, tend to drop out of this program at one of four points—either they don't know they are eligible, they never make it through the initial application process, they can't keep up with the reporting requirements, or they have too much trouble accepting or managing the available childcare slots. And, as one might guess, it is just those mothers who are the most needy, the least educated, the least emotionally stable, the least physically able, with the most difficult children who are the most likely to drop out of the program. Thus, Sunbelt is putting lots of mothers in a position where they must refuse to comply with the work requirements (and therefore be sanctioned), find some alternative childcare arrangements and manage to pay for it themselves, or leave their children at home alone during the workday. Over half of Sunbelt welfare mothers are without any form of childcare at all, subsidized or not. Since caseworkers in the Sunbelt welfare office don't handle childcare placements themselves, they tend to be unaware of these problems, and in any case, are relatively powerless to change them.

Arbordale, on the other hand, is without these particular difficulties. The system of providing childcare is run out of the welfare office, much of the necessary documentation is already in the welfare office computer, the separate application is very simple, and the state has extremely low-level requirements for certification. Just about anyone can be a childcare provider, as long as they do not have a felony record of violent crimes and as long as they are willing to fill out one form and complete a safety checklist. This system, of course, has its own set of problems. It means that lots of kids end up in substandard care. There are reports of neglect and abuse. And welfare mothers who ex-

perience this, I found, often feel it is the welfare office that has betrayed them.

Early in my time in Arbordale, one welfare mother, Catherine, came into the welfare office screaming and crying. She yelled at the receptionist and was wailing so loudly that nearly all the caseworkers knew her story within ten minutes. Her youngest daughter had been abused in day care. She blamed the welfare office, "You people put her there!"

Her caseworker tried to calm her down, "We'll find another place for your daughter."

But Catherine was distraught; her daughter had been traumatized, and she needed to be at home with her mother. Her other two children were frightened too, she sobbed, and she was absolutely *not* going to put them back in childcare, at least for a while. "I'll just *have* to quit my [food service] job. I need to be with them! They need their mother."

Other caseworkers had come over to help out by this time, some were trying to soothe Catherine's children who had begun to cry as well, others were trying to explain to Catherine that quitting work would bring a sanction and hurt her kids even more. Catherine, it seemed, was too upset to hear what any of them were saying; her little girl had been hurt, she deserved her mother's protection, and no welfare rules were going to change her mind. When Catherine left the office, she was still crying, and still angry. Soon after that, I was told, she quit her job, and she was sanctioned.

As Arbordale's childcare supervisor pointed out, since this system does not require all household members to be certified for childcare, children can be placed in homes where the boyfriend or husband has a history of pedophilia or domestic violence. And since the system excludes only violent offenders from certification, the provider can have a history of drug abuse, theft, or fraud. Caseworkers told me about one childcare provider who had no criminal record herself but was living with a man who had a history of child abuse. Another childcare provider was a locally known drug addict, but since she had no violent crimes on her record, the state had certified her. Many of the caseworkers wished there was some way to strengthen the childcare licensing requirements, but these were state-level laws over which they had no control. They wished they could tell mothers which childcare providers to avoid, but they were officially barred from doing so.

If both the Arbordale and the Sunbelt City systems are inadequate in

different ways, they are also both inadequate in some of the same ways. There is a large group of mothers for whom the system is completely unable to provide service, since no services exist. There are, for instance, no childcare centers to serve mothers who work swing shifts or grave- yard shifts. There are no childcare services available for children with se- rious mental, emotional, or physical problems. I encountered welfare children with major physical disabilities, severe cases of attention deficit disorder, Down's syndrome, and crack cocaine addiction. I saw others who were truant and wild, and could not be controlled by their moth- ers, let alone a standard childcare provider. The mothers of all of these children must find work according to the rules of the Personal Respon- sibility Act. Those who lose their jobs for failure to appear at work on time, failure to be properly energetic while they are at work, or failure to concentrate single-mindedly on their work, will be sanctioned. Worries about children, in other words, are considered an unacceptable (unbusi- nesslike) distraction. Many caseworkers are sympathetic to their prob- lems, but none can offer solutions that do not exist.

These multiple difficulties with the welfare childcare system point to the larger problems that *all* women in our society face in combining work and motherhood. The implicit federal answer has everywhere been the same: "This is a family matter. It is therefore your problem, and your personal responsibility." In the context of the welfare office, however, where government interference in family life is so readily ap- parent, the contradictory (and unjust) nature of this response is also apparent.

Making Fathers Pay

One of the largest signs in the Sunbelt City reception area mimics a criminal "wanted" poster. When you first see it you expect that the men pictured there are perhaps on the F.B.I.'s list of the 30 most dangerous. And these men certainly *look* like criminals—unkempt, beady-eyed, mean, manipulative; you think you might even detect violent tendencies in their stares. The poster reads: "WANTED IN SUNBELT STATE FOR FAIL- URE TO PAY CHILD SUPPORT." Each picture is captioned with the "crimi- nal's" age, height, weight, occupation, county where last seen, and the amount owed—$27,274, $11,106, $48,925. Below the portraits of these 30 or 40 men the poster states: "These people are not taking care of their

children. They have avoided their court-ordered child support." These are evil men, it seems. And it appears that if we could catch them all, we would be rich. There must be nearly a million dollars listed on this one poster alone.

It was interesting to see this "wanted" sign there, in a room filled with woman and children. And I looked at those children, playing with one another, quietly doodling, or cuddled up in their mothers' laps, and I knew what they were there for, and I said to myself, "Yes! Get those men! Make them pay a million bucks!" For a moment, I thought I understood why so many women in Congress voted in favor of welfare reform. With the exception of the law's attack on those "predatory" statutory rapists (an attack that somehow rings hollow and unrealistic), the requirements for enforcing child support are the *only* provisions of the federal law that seem to hold men accountable.[17] But then I paused for a moment, took a breath, and remembered that I knew the story behind this poster, and I knew the story sitting in that waiting room, and both are far more complicated than they first appear.

As is true of childcare subsidies, child support enforcement is *not* cost effective. Since 1989 it has been costing federal taxpayers millions of dollars each year. In 1996 alone, counting both federal and state costs, the child support enforcement program showed a net loss of $745 million.[18] This is true even though the program itself has become increasingly effective at tracking down fathers and obtaining court orders requiring them to pay. Experts argue that, even if the system were perfect—which it could never hope to be, given the low incomes and the transient nature of many of the absent parents in question—it would not be sufficient to lift most welfare children off the rolls and out of poverty.[19]

Yet child support enforcement, as the House Ways and Means Committee points out, serves a symbolic as well as practical purpose.[20] It sends a message to fathers that they cannot shirk their responsibilities. And many welfare clients strongly agree with this symbolic logic, and many are also very happy when their child support checks finally begin to arrive. The trouble is that for a relatively large proportion of welfare mothers this system actually generates greater financial hardship, or serious emotional distress, or even physical abuse, as I will show.

Welfare reform strengthened the child support program by tightening the already existing requirements for mothers' cooperation in identifying and locating the fathers of their children, establishing strict

penalties for failure to comply. Welfare recipients first learn of these rules as yet another portion of the welfare eligibility interview. I observed Holly (a very friendly and compliant prospective welfare mother with a part-time job and a two-year-old son) as she faced the preliminary stream of paternity questions at the Arbordale office:

> You must give us the first and last name of the child's father and three pieces of information that will help us locate him. And, if you have to go to court for any reason, you must agree to show up for court. If they need a blood test to establish paternity, you have to agree to do a blood test on the child.
>
> What is the father's name? Does he have any nicknames or any other names he goes by? Any address that you know of? You say he's in jail. Was it a misdemeanor or a felony? And what address was he living at before he went to jail? Do you have the street name? Do you happen to know his social security number? Do you know his birth date? And is he black or white? Do you have any idea where he was born? Do you know a telephone number where he was? What's his father's name? Do you know an address for his father? Do you have a telephone number?
>
> Now, was he working before he went to prison? What's his usual occupation? Construction work? Was he receiving any benefits—unemployment, Medicaid, workman's comp, disability? Has he been in the military? Does he have any bank accounts anywhere? Does he have any cars or trucks that you have the license information on?
>
> We have the information on his dad. Do you have any information on his mother? Is there anybody he would stay in touch with if he got out of jail and didn't come back to you or his parents? And does his sister have a telephone number?
>
> Anybody else? Do you have any idea what high school he went to, college, anything like that?

As you can see, the caseworker asked Holly for a good deal more than three pieces of information. It is also important to note that in this case the client had only one child; in cases of multiple children with different fathers, this whole series of questions must be repeated as many times as necessary. And this is just the start. If the mother is unsure of the identity of the father, she must list five possible fathers and agree to genetic testing until paternity is established. She is also re-

quired to sign a series of oaths, provide a set of verifying documents, and cooperate at all times with child support enforcement personnel— including making scheduled appointments, taking blood tests, reporting any new information on the father, appearing in court, and providing all supporting documentation requested. If she doesn't provide the necessary information, if she doesn't cooperate with child support enforcement in every way, she will be sanctioned or deemed ineligible for welfare benefits.

Even though this is the one portion of welfare law that seems to be holding fathers accountable, one immediately notices that it is *mothers* who are initially forced to endure these regulations. Watching this process also brings to mind the question of why the pursuit of child support is forced on mothers—why aren't these women given a choice? One part of the answer may be that although taxpayers and the federal government lose money on child support enforcement, states can actually make money, since the federal government subsidizes state programs and allows states to keep a portion of support payments where welfare is concerned.[21] Another part of the answer is built into the nature of the welfare bureaucracy and its treatment of welfare clients as immature and incapable of making such choices on their own. Yet another part of the answer is that disciplining mothers is an underlying goal of the Family Plan. Connected to all these is a central, initially curious, fact—a good number of welfare mothers are reluctant to comply voluntarily.

One reason that some mothers would like to avoid enforcing child support is the reality of the paltry financial gains that mothers can expect from this process. As recipients quickly learn, for as long as they are on welfare the most they can expect to receive is a $50 per month "pass-through" of child support collected; the rest will go to the state to cover the costs of welfare.[22] Mothers must be very patient, and lucky, to get even this much. If things are running smoothly (which they rarely do), it takes about six months just to get a court order for child support. And even if the fathers have jobs, even if they are willing to pay, and even if they actually pay the full amount, the child support payments welfare mothers are likely to receive are generally inadequate to care for children. On one caseload, fathers who did pay child support were paying the following monthly amounts: $93, $38, $127, $5, $54, and $172. In 1996, the *average* amount received by single welfare parents nationally was $68

per month. And only about one-fifth of welfare mothers receive any child support at all.[23]

These figures give you an inkling of the status of the men who are the fathers of children on welfare: primarily poor men, some are in jail or prison (10 to 20 percent, caseworkers tell me), many are unemployed, others are employed only intermittently. In a number of locales, judges are ordering these men to pay back (previously unpaid) child support. This demand for back payment accounts for the tens of thousands of dollars owed by those fathers on the Sunbelt wanted poster. In many cases, this is support owed not to children but to the state in return for welfare benefits previously paid to those children. This situation means that many fathers owe far more than they can ever hope to pay.* Many of these absent fathers already offer more or less regular (under the table) support to their children, providing money, gifts, and services whenever they are able. Others have additional women and children that they support, and they are trying their best to fulfill those multiple obligations.[24] A number of them are very unhappy when they learn that the money they owe will actually go to the state rather than their own children. All are at risk for being jailed for their failure to pay.

When all this is taken together, it is not hard to understand that many fathers of welfare children experience fear, anger, resentment, and even desperation when confronted with the legal enforcement of child support. This explains why a number of absent fathers will go to a great deal of trouble to avoid being served with a court order for support. When they can be served, and they are ordered to pay, some will change jobs or go into hiding to avoid making their payments. As their circumstances should make clear, the responses of these men do not necessarily mean that they are bad men who care nothing for their children. Their actions often simply represent the reality that they are poor men who are already having a hard time scraping by with their current obligations and resources.

In the Sunbelt City welfare office I met Cassandra, whose position highlights some of the problems involved. She was a 27-year-old

* One study, conducted by a program serving low-income fathers, found that the fathers faced child support arrears averaging $2,000—even though the average total earnings of these men was only $2,800 over the preceding nine months (Sorenson et al. 2000). See also Edin (1995) and Garfinkel et al. (2001).

mother of three children, all of them fathered by Eric, who had since moved in with another woman and fathered two more children. Eric was providing for this second family. He continued to visit Cassandra and the kids regularly and offered them money and gifts when he could. Yet Cassandra knew that if child support enforcement personnel were able to find him and order him to pay, Eric would flee, and the visits to her children as well as the gifts and occasional support would end. Cassandra and Eric had remained good friends, and Cassandra also knew his current girlfriend and children. She was painfully aware that he couldn't afford to take care of all five kids. And she knew that there were two children who would be left without his help at all if he should feel forced to run from the burden of regularized support payments. So Cassandra wished that she could avoid the enforcement process altogether. But she had no choice.

This trade-off between good relations with the father and gifts, visits, and intermittent aid for the family on the one side, as against regular child support payments on the other, is often a central catch-22 for welfare mothers.[25] One of the many ways that mothers make ends meet on a welfare check is by getting that additional (under the table) help from the children's fathers, or from the father's family. At least half the welfare mothers I encountered received such support. In a larger study of recipients' finances, nearly 60 percent received either regular (unreported) payments or in-kind support from absent fathers.[26] Many women are therefore resentful of child support enforcement rules. They are not only resentful that this process will ultimately result in a net financial loss, they are also resentful of the law's interference with their ability to maintain family ties.

Welfare reform's paternity and child support requirements also cause problems for the smaller group of women who are simply *unable* to comply. I heard from caseworkers the story of a mother who cried throughout her eligibility interview. She didn't know who fathered her child; she was high on drugs at the time. She was clean now, she said, and she desperately needed the help of the welfare office. No support was possible, however, unless she could provide the name of the father. Another woman was gang-raped. All the alleged fathers would have to be tested. The mother was terrified that this would bring on further violence. Then there was the young mother who was date-raped at a fraternity house party. She did not report it to the police, she had no proof,

and she knew only the first name of her assailant. She and her friends attempted to conduct their own investigation into the father's identity, but they were unsuccessful. She was ineligible for welfare benefits, and it was unclear how she would get by.

Finally, fathers' difficulties with formal child support are the basis for the most frightening and worrisome of this policy's unintended consequences. There is a group of women who are *afraid* to comply with child support requirements. These mothers worry that violent or drug abusing or criminally dangerous men will be brought back into their lives. At the heart of this problem is the prevalence of domestic violence. It is estimated that approximately 60 percent of welfare mothers were, at one time or another, sexually or physically abused. The U.S. Department of Health and Human Services estimates that 15 to 34 percent of welfare mothers are *current* domestic violence victims.[27] In this context, court orders regarding child support may incite further violence. Although the law technically allows a "good cause" exemption from child support enforcement for mothers who are in this situation, such exemptions not only require mothers to disclose their circumstances, but in some cases they also require legal proof that a dangerous situation exists. Of the welfare mothers who told me they had suffered domestic violence, only half had disclosed the abuse to their welfare caseworkers; of those who needed legal proof, caseworkers estimated that less than a quarter were able to provide it.

Of the perhaps 15 Arbordale and Sunbelt welfare mothers with whom I specifically discussed the connection between child support and violence, two had been seriously beaten by the fathers of their children after the fathers had been served with court papers. In another case, the father of one mother's children had come to her home while she was out and had kidnapped their eight-month-old daughter, pushing aside her screaming grandmother. Yet another mother had a gun aimed at her head the day her ex-boyfriend learned she would be taking him to court:

> He came to my apartment after he got the papers. He came and held a gun to my head. And my [two-year-old] daughter was in the room. And he was yelling, "I'll kill you, I'll kill you."
> And I was like, "Just kill me. If you're gonna kill me, kill me now. Don't make me suffer."

And he said, "I should. I should kill you now." Just because he got the child support papers. And he did it right in front of our daughter. And one month later, he killed a guy! He got put in jail. He did it right in front of the welfare office. He killed the guy right in front of there, next door, at the place that used to be a [night] club.

This welfare mother's ex-boyfriend is now in prison for murder. She will not be receiving child support payments any time soon.

Thus, the attempt to utilize the child support enforcement system as a means to create sustainable family life and shore up family ties does not seem to be the solution. Although middle-class mothers are perhaps less likely to have guns aimed at their heads when they request support from the fathers of their children, and although most who are awarded child support receive more than $68 per month, the problems that poor mothers and fathers face relative to child support closely resemble prevalent patterns in the larger society. Of all parents raising children alone in the United States, only about one-quarter are actually awarded and receive full child support.[28] These child support payments generally do not cover the costs of raising children, and in many cases the financial issues involved cause strain and unhappiness in familial relations.

No one thinks this is a pretty picture. These problems, of course, do not negate the genuine help provided to the welfare mothers who actually receive regular child support. Similarly, the troubles many welfare clients experience with child support regulations do not negate the moral principle of shared parental responsibility. Like the rest of us, most welfare mothers believe that family ties, including paternal support, are, at least in principle, central to the well-being of children and an important nucleus for wider social connection and commitment. As should now be evident, the problems they encounter in realizing these principles, like the problems encountered by families throughout our society, are not generally the result of their personal failure to embrace the proper values. At the level of welfare policy, the central difficulties in child support enforcement mimic the legislative inadequacies of child-care subsidies. They involve inflexibility and a failure to provide choices as well as a failure to understand the circumstances of the poor.

Beyond the welfare office, the story of welfare reform can also serve

as a reminder that there are much deeper and more complex social issues at work in the support of American children than the individual, selfish irresponsibility of a few deadbeat dads. No single piece of legislation is likely to solve them all. But the dilemmas encountered by welfare mothers offer us clues regarding how we might begin to address them.

The Tangled Web of Maternalism, Bureaucracy, Family Values, and the Work Ethic

One might be tempted to argue that the Family Plan and the congressional claim that "marriage is the foundation of a successful society" are just so much hot air. The family-related provisions of the Personal Responsibility Act appear relatively ineffectual in stemming the tide of single parenting and promoting happy and stable nuclear family relations. Indeed, in some cases these provisions seem more effective in driving a wedge between parents rather than drawing them together. Following the same pattern, even though the legislature makes two-parent families eligible for welfare, it has also retained its old "marriage penalty" in income eligibility requirements and created an additional penalty by establishing stricter and even more onerous work requirements for the few that qualify.[29]

Another apparent indication that family values are merely a decorative facade for the Personal Responsibility Act is the fact that the work requirements and the time limits for attaining self-sufficiency are far and away the primary values promoted in the welfare office. As I've noted, the vast majority of caseworkers I met did not see the regeneration of traditional family arrangements as part of their job description. They did not see themselves as couples counselors and did not urge their clients to go out and find marriageable partners. They did not read the rules of welfare reform as generating strong familial relations. In fact, almost none were aware that the law's preamble names marriage as foundational. Although many recognized the rise of single parenting as a serious social problem, few imagined that the practices of the welfare office provide a family-oriented solution.

In this light, it appears that the social tension between the values of work and family have been resolved in favor of work. To the extent that welfare reform's Work Plan is the only model that is left, the more worthy goals of work—its promise of independence, citizenship, and valued

contributions to the collective good—have been debased or discarded. What remains is the individualistic ethic of self-sufficiency and an image of the "good society" as one full of unfettered individuals busily pursuing their daily bread in the marketplace, fending for themselves without a care or concern for others. After all, we could interpret the childcare subsidies as simply market-driven mechanisms provided solely for the purpose of pressing poor mothers into employment. The attack on deadbeat dads could be read as just another form of subsidy, supplementing poor mothers' paychecks in order to keep them out of the welfare office and in their jobs. The provisions for vaccinations, truancy, and teen education could similarly be interpreted as edicts directed toward an image of mothers who must efficiently minimize their concern for children so that they can concentrate more fully on developing their earning potential. The abortion bonus and abstinence education are, in this vision, attempts to minimize the number of (always expensive and troublesome) children born.

Yet this picture is incomplete for a number of reasons.

The reality of family life, and the values of family life, simply refuse to disappear. First, and primarily, these values and realities suffuse the atmosphere of the welfare office. Part of this results from of the ubiquity of children—the cries of hungry or frustrated or sad or disgruntled children, the laughter and chatter of playing children, the "inconvenience" of children whom you trip over, children who are seeking amusement, and children who demand a space in your lap. These "dependent" children serve as a constant reminder that caring for others is a central part of everyday life. Family values are also always apparent in that children and caregiving are a part of almost every sentence that comes out of the mouths of welfare mothers: nearly always a part of the stories they tell, the explanations they provide, the dreams they render, and the services they seek. And everyone in the welfare office, be it caseworkers, supervisors, receptionists, or cleaning personnel, are simply unable, no matter how hard they might try, to forget that the work they do is work on behalf of mothers with children.

It is also important to remember that the Family Plan is more than a matter of explicit edicts. It is intended to operate at a secondary level, coming in through the back door so to speak, and making use of the work requirements in a way that is different from the Work Plan. The Family Plan implicitly holds that by sending mothers out to work at

low-wage jobs while simultaneously expecting them to manage the responsibilities of parenting, such mothers will eventually figure out that the most sensible life strategy would be to seek out assistance from men. Thus, the problems of previous welfare policies that had made it easier and more rational to remain single rather than married will be turned upside down, and marriage will become the rational choice for the poor. Although this may create temporary hardship for some welfare mothers and their children, proponents argue that future generations of the poor (as well as the rest of society) will be much better off as a result of this change.[30]

As much as the complete triumph of the Work Plan would offer a disturbing vision of selfish individualism, the alternative offered by the Family Plan is equally narrow and disturbing. Marriage is pictured as little more than an economic transaction, and one where women are necessarily economic dependents. As is true of much of the logic of reform, the burden of creating new nuclear families is placed squarely on the shoulders of individual women: it is their job to use whatever skills they may have to seek out suitable men and enlist their aid in the support and rearing of children.

Nonetheless, there is good reason to believe that women who are sanctioned off the welfare rolls, who have been suffering through low-wage jobs and bouts of unemployment, or who have already reached their initial time limits on welfare receipt, will, in fact, seek out the help of men. After all, many of them have long relied on the help of boyfriends and the fathers of their children—and with welfare reform, their need for such help becomes increasingly pressing.[31] But larger questions remain as to whether women's efforts to find financially stable, marriage-ready mates will be any more successful than they were in the past, and whether reform can ultimately both decrease the rate of unwed childbearing and create warm, happy, and sustainable families.[32]

There is one final way that the principles of family life have entered the world of the welfare office with reform. This is through newly reinstituted caseworker discretion—a programmatic change that ultimately engenders among welfare workers a stance of caring maternalism.[33] Although the bureaucratic system of rules and regulations remains central to the operations of welfare offices, the expansion of services with reform has added a number of caseworkers who have a good deal of deci-

sion-making power and who are charged with offering more personalized service. In Sunbelt City these are the (certified) social workers hired to help welfare mothers who are having special difficulties in securing employment; in Arbordale they are the counselors hired to serve as employment mentors.[34]

Ironically, it is this very group that has taken on the work of caregiving. That is, just as these caseworkers are engaged in the task of curtailing the caregiving activities of welfare mothers, they are also the group of caseworkers most likely to understand themselves as nurturing caretakers. The caring stance of these workers was prompted by the requirements of reform: to counsel clients on how to find a job, how to behave while on the job, how to manage their childcare and family problems, and how to handle their bills and their living arrangements. The result has been a group of caseworkers who work closely with clients, serving as advisors, and offering emotional as well as practical support. At the same time, these workers have the power to make determinations on who will get supportive services and who will be sanctioned.

Such caseworker discretion has a special role in the history of welfare. It was once used to discriminate (relatively systematically) against nonwhites, immigrant groups, teen parents, unwed mothers, and others whose behavior, for one reason or another, was deemed inappropriate.* By the 1970s, the struggles of welfare rights organizations and other advocates for the poor had effectively curbed many of the particularistic judgments that had allowed caseworkers to pick and choose how generous or miserly they would be. This process included, for instance, the removal of suitable home requirements, man-in-the-house rules, and the practices of providing different services and different levels of income support depending on how worthy individual clients were deemed. It also included, significantly, the removal of most social workers and counselors from the welfare office. By the 1980s, the welfare bureaucracy, with its rigid rules and lock-step procedures, reigned virtually supreme.[35]

* Unwed mothers, for instance, were once denied assistance based on their "immoral" behavior; blacks were historically denied assistance when they were needed to pick crops in the South; shortages in domestic servants meant that particular immigrant groups were left without welfare aid; and nonwhites and non-native-born women were historically more likely to be identified as rule-breakers and punished for their bad behavior (see Goodwin 1995, Abramovitz 1988, Mink 1998).

The reversal of that trend is one of the most dramatic organizational changes wrought by welfare reform. Although it is likely that care and concern for the lives of welfare families never disappeared from the welfare office, welfare reform has once again made it possible for welfare workers to *act* on that concern by defining the mentoring process and determining what kind of support is needed on a case-by-case basis.

The connection between caseworker discretion and the atmosphere of caring maternalism is evident in caseworkers' responses to welfare reform. In Arbordale and Sunbelt City, staff meetings became strategy sessions on how to solve the problems of welfare mothers, workers celebrated welfare reform as a new opportunity to actually help their clients, and caseworkers regularly met in hallways and took long lunch breaks to express concerns about particular cases and ponder the appropriate course of action for this or that client.

A genuine sense of maternal concern infused those discussions. Joellen, an Arbordale employment caseworker, worried about whether she should sanction a client for quitting her last job: the rules say she should, but for this client it would be the third sanction and she'd be six full months without benefits. Teresa, a Sunbelt City social worker, had a drug-abusing client who had been through two rehabilitation programs, and she just couldn't seem to stay away from the drugs. Teresa was concerned that she might have to report the client to the state program for child protection, but this would put the client at risk for (temporarily) losing her children. Would that be too big a blow to the client's psyche? Anne, an Arbordale employment worker, worried about an ex-client who was $1,000 behind in rent, $700 behind in utilities. In order for the welfare office to provide help with those bills, the client would have to quit her job (to meet TANF eligibility criteria). "The system is crazy!" Anne proclaimed, but then she was also infuriated that the client didn't do a better job of budgeting. All the social workers in Sunbelt City were dismayed—how could they possibly manage to protect all those clients who spoke no English? With the two-year time limit, there just wasn't enough time to both establish linguistic proficiency and train them for work. As I listened to these caseworkers' expressions of care and concern, I found myself adding the refrain, "And what's a mother to do?"

During one of my last visits to the welfare office, three of the caseworkers left work early to grieve together. One of their favorite clients,

and one of their most successful, had just gotten her life together after years of hardship. It was only nine months ago that she was finally able to leave her physically abusive husband and the father of her two children. But she had a good job now, $7.50 an hour, and was making it work. A few months back the caseworkers had demonstrated their commitment to this client by using discretionary funding (and the help of a local automobile dealership) to buy her a used car. She had been so happy, and she was feeling strong and independent. This sense of confidence, they told me, was what led her to agree to see her ex-husband, hoping she could work something out so he might visit his children sometimes. He took her out for a drive. The car crashed—she was dead, he was in critical condition. The caseworkers felt certain that he crashed the car on purpose. A sense of sadness filled the welfare office.

This caregiving stance clearly impacted decisions regarding training programs, workfare placements, and the provision of supportive services. "Should we pay to fix Elizabeth's teeth?" "Should we subsidize the repair of Terry's car?" "Should we help Carey out with some furniture since her apartment burned down?" "Do you think Janine should take the general office course, or would a workfare placement be a better idea?" Some of the outcomes of these discussions were particularly telling in light of the Family Plan. More than once, caseworkers used discretionary funding to help clients leave the men who fathered their children—because these men were recognized as abusive or because they were simply deemed "bad news." Two different caseworkers (both of them recognized by their co-workers as very caring people, and considered by some to be "over-invested" in their clients' lives) told me that they had used discretionary money to fund abortions—one for a client's teenage daughter, another for a welfare mother of three. In both cases, the money was officially marked as spending for "work-related expenses," but the clients and caseworkers knew its real purpose. These instances are a clear reminder that caseworkers' visions of family values can be very different from that of some of welfare reform's (abstinence-oriented) congressional framers. They also show just how far some caseworkers will go to take care of their clients.

As these cases imply, most of the time Arbordale and Sunbelt caseworkers used their discretion and bent the rules to favor the welfare mothers in their charge. Even when this decision-making power was used in ways that might appear to harm clients—including, for in-

stance, Arbordale caseworkers' decision to increase the use of sanctions and Sunbelt City caseworkers' decision to institute a diversionary program (that I will discuss further in Chapter 4)—these strategies were justified according to an ethic of care or framed as provisions that would ultimately serve the larger good.[36]

Unfortunately, there are also potentially negative consequences to the reinstitution of discretion and maternalism, as the history of welfare suggests. First, discretion assumes the superior judgment of middle-class caseworkers, allowing these workers to impose personal standards of behavior on poor mothers. Like the bureaucracy, this system can also perpetuate the problem of treating welfare mothers as childlike dependents. And to the extent that the use of discretionary power involves bending the rules, it also sends a contradictory message. After all, if clients are caught bending the rules they will be sanctioned, disqualified, or sent to the fraud division for investigation.

I want to emphasize that I never witnessed obvious discrimination in the use of discretionary power within the welfare office. But I do know that many caseworkers (unsurprisingly) tend to be more favorably disposed toward those clients who are compliant, soft-spoken, nonconfrontational, articulate, and better educated. It is possible that welfare mothers who are aggressive or adamantly independent or those who have "attitude" problems will suffer, as might all those women whose lives seem most bizarre when viewed through middle-class eyes. To the extent that race or immigrant status enters into these largely unconscious judgments, the potential problems loom even larger.

The abuses of power that can follow from discretion might make one wish for the more fair-minded, egalitarian treatment that comes with bureaucracy. Bureaucracies, after all, see only numbers and files; technically blind to individual differences, they tend to treat everyone according to the same rules. Further, since bureaucratic rigidity and maternalistic discretion regularly come into conflict within the welfare office, one might wish for a more streamlined and straightforward organizational structure.

Yet the system of discretion and maternalism clearly contributes to sustaining the logic of a familial ethic of care. Arguably, this caring ethos is nearly as important as the more tangible supportive services in engendering the genuine expressions of hope that I so frequently heard from welfare mothers as well as caseworkers. The practices of mothering and

care also provide a visual and practical reference for thinking about commitment to others. They reiterate the story about how "independence" is achieved only in the context of human relationships and connection. And, in an important way, these practices speak to just how difficult (and how unfortunate) it would be to completely bury the logic of nurturing under the routines of bureaucracies or the pressure for absolute self-sufficiency.

Balancing Independence and Care

Although the analogies are imperfect, there are important ways in which the tensions between bureaucracy and maternalism in the welfare office mimic the tensions between the congressional Work and Family Plans and mirror, in turn, the larger social tensions between individualism and commitment to others. On the one side we have a system that values efficiency, control, predictability, uniformity, clear hierarchy, and formal, goal-oriented success. On the other side we have a system that values warmth, nurturing, and care, engenders flexibility, and ideally recognizes diversity. While we may embrace both sets of values in different contexts, they emerge as at odds within the welfare office just as they often do in daily life.

To the extent these become either/or trade-offs, we are hard-pressed to determine the proper choice. People everywhere are struggling to find the appropriate balance between their concern for children's well-being, familial intimacy, and trusting social connection on the one side, and on the other side, their desire to achieve independence, success, and full social recognition in the world of paid work. Just as millions of dual-earner couples are discovering that juggling work and home is fraught with layers of complexity, hidden dangers, and unexpected contingencies, a similar story has been taking place in thousands of welfare offices across the nation.

Welfare workers at every level told me that what they liked best about their jobs was "helping people." Meanwhile, following federal and state guidelines, they are pressing welfare mothers to find paying jobs and leave the care of their children to others. Like most Americans, most of the caseworkers I met had not completely resolved the tensions between individualism and commitment, self-sufficiency and caregiving, autonomy and social control. These pushes and pulls were played out in their

practices as well as their ideology. In general, they managed those tensions by attempting to privatize their care-work—treating both the care of children and the care of clients as a matter of personal "choice," while treating the procedural enactment of welfare reform's employment mandates as the "real" work they do. But there is an underlying contradiction in this logic, and I would argue that most caseworkers could feel this contradiction, even if they did not fully express it.

Privatizing the work of caring for others, sustaining it outside the realm of public support and debate, and treating it as a simple matter of individual "choice," helps to keep it both hidden and devalued.[37] This privatization is precisely the process that leaves not just welfare mothers, but all of us struggling individually to find a balance between the cultural principles of independence and care. On the other hand, the many problems faced by poor mothers as a result of welfare reform's family edicts are an indication of just how difficult it is to legislate family life, especially given the narrow and rigid vision of family life embedded in the Family Plan. Even in the very best of circumstances, with the most benevolent and thoughtful policymakers and caseworkers, it would be a daunting task to determine the appropriate policies, manage all the contingencies, and provide equitable and appropriately flexible treatment for all. Yet, given our collective commitment to the values of care and community, public and legislative support for family life is an absolute necessity.

In making sense of this, I want to emphasize that one of the most interesting and important features of observing the experiment of welfare reform at ground level is to witness the resilience of the logic of care in the face of formidable forces maneuvering to bury it. That is, even though the Work Plan takes precedence, even though many of the Family Plan's policies are punitive or ineffectual, and even though the bureaucratic machinery is overpowering, family life and the positive valuation of caregiving lives on in the welfare office. Welfare mothers insist on bringing it back in, and welfare caseworkers find themselves unwilling and unable to ignore it. This tells us that humanitarian commitments and obligations to others are far from dead in American society today. And this also means that the tensions between the Work and Family Plans, like the pushes and pulls of work and home, will not be easily resolved.

Having examined these results at ground level, it is difficult to interpret the Personal Responsibility Act's attempt to promote family values and the work ethic as a resounding success. But the story of how welfare reform plays out in the welfare office is not yet complete. The responses of caseworkers and clients to the unfolding process of reform, as these chapters have suggested, extend well beyond the simple enactment of, and obedience to, a system of rules. The dreams and hopes, frustrations and despair of welfare clients and caseworkers as they grappled with the new world of welfare is the topic I turn to next. Their responses, as it turns out, underline not just the inadequacy of this reform effort, but also the persistent cultural significance of the higher moral ideals for which it stands.

Welfare is completely crap because they give you the runaround. It's like you take two, three, four steps forward and they pull you back two or three more. It's like they don't help you to grow, they want you to depend on them, they want you to sit there and cry. I'm not gonna sit there and cry and beg you not to sanction me. And they just can't understand that for some of these girls to get a job, they don't even have GEDs, so what are they gonna get but McDonald's? And that's not gonna pay the rent. McDonald's is not gonna make ends meet.

—Annette, a 23-year-old Arbordale client, unemployed

I think welfare's better now. They've got the programs there to help you. You can get your GED and stuff like that. They're actually giving you an opportunity. They help you with childcare. They helped me get clothes for this job. I'm working and I feel like I can make it on my own. There's other people that may really need that help, and I want them to have it.

—Sally, a 26-year-old Sunbelt City client,
working at the phone company

Chapter 4

Fear, Hope, and Resignation in the Welfare Office

THE WORLD OF WELFARE IS A WORLD OF MIRRORED dualisms—the Work Plan and the Family Plan, the punishments and rewards, cold bureaucracy and caring maternalism, individualism and family ties, social inclusion and exclusion. At the local level, I watched those dualisms play out in reflected responses of distress and optimism, fear and hope, cynicism and idealism, rational calculation and moral reckoning, resignation and dreams for a better future.

As I read the policy reports and federal accountings of the declining welfare rolls in the late 1990s, the tale of welfare reform often appeared straightforward, orderly, and controlled. As the rolls declined by one million, two million, four, six, then seven million, one could conjure up a picture of a compact, homogeneous group of formerly "dependent" welfare recipients meeting up with a precise set of rules and an efficient and clear-headed set of welfare caseworkers, and hearing the message that it was time to go. They then stood up straight, smoothed over the wrinkles in their attire, and simply went out and got jobs, or otherwise found a way to take care of themselves and their children. The distance between that image and the reality I found in the welfare office was immense.

Just as the welfare rolls are not static but instead involve thousands of new or returning customers every month, just as the Personal Responsibility Act carries not a single univocal message but a set of complex and sometimes contradictory commands, the decline of the welfare rolls was not a steady and even process or a clear and straightforward path. The

implementation of reform was messy and complicated, and involved a mixture of responses that changed not just over time and across persons, but sometimes from moment to moment. Inside the welfare office, as much as the bureaucratic regulations and the steady stream of desperately poor clientele engendered a sense of constant repetition, the realities of the lives of individual welfare mothers and their children, alongside the increased sense of uncertainty that came with the enactment of reform, meant that the situation was always changing, and it was hard to get one's balance or maintain a steady foothold.

There were, nonetheless, a few clear patterns in the emerging process of reform. At a practical level, both caseworkers and clients regarded the massive number of new rules and regulations that came with reform as a "hassle" and a "pain in the neck." Some even imagined those relentless and unforgiving rules as a series of landmines purposively installed as a test of their courage and fortitude. In any case, everyone in the welfare office struggled mightily to negotiate a way through (and around) those rules and regulations.

For most of the welfare caseworkers I talked to, the journey from implementation to the time limits turned out to be a journey from optimism to increasing resignation. The problems in the logic of reform became more and more apparent to these workers over time. And as much as they struggled to find new strategies, new loopholes, and untapped resources that might protect or strengthen or rehabilitate more welfare families, and as much as most continued to believe that reform offered some real improvements over the old system, by the time I left the welfare office in early 2001, most had either redefined their vision of success or resigned themselves to the inadequacies of reform.

For welfare clients, their experiences differed depending on their education, health, employment history, childcare situation, and other circumstances. Virtually all the mothers I encountered were grateful for the more supportive measures instituted by reform; none had an easy time managing the more demanding and punitive rules and regulations. Some were bound for long-term self-sufficiency, some experienced short-term gains, larger numbers faced ongoing hardships with insufficient wages, substandard childcare, and the stresses of raising children on bottom-end jobs. Not surprisingly, their positions on this continuum often impacted their assessments of the new welfare system.

Overall, the people I met in the welfare office complained about the

costs and celebrated the benefits of reform. On this level, one could say they were simply maximizing their self-interest, just as any theorist of rational calculation and profit-maximizing behavior would predict. Yet, practical calculations of immediate interests were not the only thing that affected the responses of caseworkers and clients to welfare reform. One of the most striking elements in the ground-level enactment of the Personal Responsibility Act was the amount of time and thought that many caseworkers and clients invested in considering the larger moral purposes of reform. I watched as both caseworkers and clients attempted to decipher just what the nation was hoping to accomplish, and reflected on what they might contribute to this effort. Although I was surprised to find this attention to national ideals in the context of desperate poverty and an overburdened government bureaucracy, and although the reasoning involved didn't always match my own, I couldn't help admiring the efforts of caseworkers and clients to see their way through the difficulties of reform in order to retain some sense of serving the common good.

The story of welfare reform is thus simultaneously a tale of hassles, hardships, and the road to resignation, and a vivid cultural representation of the lengths to which people will go to discover and enact shared ideals. In particular, I found that the values of work and childrearing, and the promise of social equality, inclusion, and citizenship are so powerful in American culture that they persisted through all the inadequacies of reform. Just as most Americans have looked for some positive elements in the message of the Personal Responsibility Act—whether it be the hope of diminishing poverty, the ideal of stronger families, a belief in the work ethic, or simply the commitment to overhauling a bad system—most of the welfare caseworkers and clients I met did all they could to find promise and purpose in welfare reform.

There are some costs to this strategy, however. To manage this principled stance, as you will see, regularly required caseworkers and clients to carefully *separate* their values and hopes from the practical realities of poverty and from the relentless state and federal pressure to decrease the number of welfare recipients (at almost any price). Both groups found this tiring and stressful, and for poor mothers, especially, the costs are likely to grow over time. In predicting the long-term consequences of the ongoing process of welfare reform, it is worth considering just how long and how many welfare caseworkers can continue to live with this

pressure, and just how long and how many welfare clients can continue to separate their ideals from their circumstances. In the final analysis, after all, moral principles are not enough to feed one's children, nor are they sufficient to dissolve the dilemmas in contemporary American work and family life.

The Road to Resignation

Early on in instituting reform, caseworkers in Arbordale and Sunbelt City were anxious. The new procedural complexities and impossibly detailed requirements were a regular basis for lunch-time complaints, and the completely revamped computer systems that came with them, I quickly learned, were a "nightmare." Some worried that the Personal Responsibility Act would so drastically cut the welfare rolls that it would ultimately cost them their jobs. Others wondered if the law would be changed before any of their clients actually reached the time limits. And even those who felt certain this reform was going to last remained concerned about how they'd convince their clients that time limits and work requirements were here to stay.[1]

Still, most of the caseworkers I interviewed were initially quite hopeful about welfare reform. This law promised them an opportunity to finally make a difference. This was a substantial change. This meant *action*. Sam, an Arbordale eligibility worker I interviewed ten months after the full implementation of the Personal Responsibility Act, mirrored the enthusiasm of many of his colleagues when he told me:

> *I really enjoy feeling like I'm doing something to help people. People are seriously trying to understand what's going on and trying to do something better. I get a kick out of seeing some of them think. We've got a lady, she's been out of the workforce for two years, and we sent her back to school for six months and she brushed up on her computer stuff and is now working and making two grand a month!*
>
> *I think it's really good. And I'm looking at their kids and realizing that if I can get their mothers out of this habit, things will be so much better for them—get her thinking more about herself and how she can take care of her family. People have a chance to feel better about themselves, taking some pride. I think it's better for the country. I think it makes them better citizens.*

In those early months of reform, it appeared to many caseworkers, as it did to Sam, that their dreams were coming true. The rolls were coming down, their individual caseloads were declining, and many clients were getting jobs.

By the end of the first year, all of that had begun to change. Many workers found themselves frustrated and concerned. Unlike those states where welfare caseworkers and clients experienced the luxury of a five-year span before time limits on benefits were reached, when Arbordale and Sunbelt hit the end of year one, they were at the halfway mark. Everyone was busy measuring the time left before the first clients would be forced off welfare. Caseworkers began to see problems. They had witnessed the hardship of many clients—wages too low, employers too demanding, childcare too impossible, disabilities insurmountable, debts mounting, cars breaking down, eviction notices, and overdue power bills. The more caring the caseworker, the deeper the frustration.

Most caseworkers could see that it was no longer solely an issue of getting these mothers into jobs, it was also the problem of helping them to keep jobs, and trying to find them jobs that would pay enough and offer enough flexibility to allow for the contingencies that inevitably arise when raising kids. Further, as the rolls declined, those clients who had the largest number of problems became even more visible and distressing. All the most employable mothers who would have left relatively quickly prior to welfare reform were leaving even faster now. At the same time, many of those who had other potential means of getting by—relying on the help of extended family members, under-the-table jobs, or illegal activities—were now choosing those other options, and the costs that went with them, rather than face the complex labyrinth of work requirements and bureaucratic demands. In the meantime, many clients with "attitude problems" were getting sanctioned, and many clients with disabilities, low skill levels, and difficult family situations were struggling in earnest but still having trouble finding and keeping jobs.

Then, welfare mothers who had left earlier started coming back. Eighteen months into reform, the majority of clients walking into the Arbordale welfare office were repeat customers. People who had left with jobs had lost them and were seeking help once again. In fact, there were so many repeaters in this relatively small city that the life skills classes were temporarily discontinued, since it seemed that nearly the entire population of poor single mothers had been through them by

now. In Sunbelt City, the population was so large and the clients so mobile that no one was keeping track.

There were now four groups left on the rolls. There were those who had just arrived and were still trying to negotiate their way through the work requirements. There were those who had returned after failing to manage on the first jobs they got after reform and were starting over with job searches or training programs or unpaid work placements. Then there were those who had jobs with wages so low that they were still using supportive (childcare and transportation) services or income disregards in hopes of getting a head start against future hardship. Finally, there were those who had so many problems that they had not yet been able to find work. This last group of mothers came to be known as the "multiple barrier cases," or the "hard-to-serves," or the "non-co-ops" (noncooperatives). A number of these difficult recipients already had more than one sanction on their records.

Despite the growing recognition that work was insufficient and childcare problems were serious, caseworkers in both Arbordale and Sunbelt City remained unified in their belief that putting welfare mothers to work was the best strategy—none of them were recommending marriage as an alternative route off welfare. Betty, a Sunbelt caseworker, explained the inadequacy of marriage in very simple terms: "Their husbands can leave them, their employment experience won't." Furthermore, seeking out the help of men wasn't just regarded as a relatively useless strategy; it was regularly considered a *bad* strategy. Domestic violence, for instance, was widely recognized as a central problem by the caseworkers I met, as Holiday pointed out: "The relationships they're in are abusive. If their relationships were gonna work, they'd be working now. Education and training is what they need; they can do without the men."

Underlining the multiple difficulties involved in imagining marriage as a solution, Terry, an Arbordale employment worker, had this to say:

> I think that a tremendous number of men are not worth it, even though they're fathering these children. I don't believe it would be good to even have these men in their homes, let alone marry them. Like, there's a phenomenal number of fathers of our clients' children who are in jail right now, and the ones who aren't in jail are beating and abusing their girlfriends. Promoting marriage? [He laughs.] That would be a very bad idea.

Reinforcing these sentiments, Tim, a Sunbelt supervisor who regularly offered inspirational speeches in clients' life skills workshops, told me he made it a point to explicitly advise welfare mothers to steer clear of problematic men:

> *I tell them, pursue your dreams, and help your kids to dream dreams. Your significant other can always walk out, but your children are with you forever. These significant others, these husbands, if they don't have your best interests at heart, you don't need them. If they pull you down, you don't need them. They keep you dependent. It's like domestic violence, you stay because they make you think you have nowhere else to go, they make you think you aren't worth it.* You don't need these men.

Most welfare caseworkers, in other words, whether right or wrong in their assessments, had very different ideas about the value of marriage in this context than did many of the politicians who penned the Personal Responsibility Act.

But if work wasn't enough and marriage wasn't a viable strategy and the time limits were fast approaching—what was the answer? Caseworkers were becoming increasingly disillusioned. Evren, an Arbordale employment counselor was particularly unhappy, and working on an innovative strategy:

> *Basically all we're doing is taking the poor and making them work. So we're making them the working poor—that's all. It is no longer, "We'll make people's lives better." Now it's just "We'll get people jobs and we'll make it cheaper to run welfare."*
>
> *When the time limits come, I'm gonna get out of the state. I'm telling all my clients that they can move to another state where there's a five-year time limit. I'm trying to think of a way to give all of them plane fare to Chicago.*

Evren never did find a way to offer plane fare to her clients, but she did quit her job at the welfare office, as did a number of caseworkers in both locales. By the end of the second year of implementing reform, the caseworkers who remained tended to be those with thicker skins.

Welfare reform evolved. Staff meetings became strategy sessions on how to handle the hard-to-serves, how to keep the working clients in

their jobs, how to get others into jobs that would pay above the mini-
mum wage. Maybe the increased use of sanctions would help. Maybe
welfare recipients just needed better people skills. Perhaps we should
work on their "attitudes." If only childcare wasn't such a problem.
Maybe classes on financial planning and budgeting would be useful. Su-
pervisors, listening to the suggestions of caseworkers and watching the
experiences of clients, established new policies and procedures.

In Arbordale, the in-house job developer began to urge employers to
set up "employment-buddies" to counsel welfare clients on good work
habits and issues of job retention. The employment caseworkers over-
seeing the life skills course added time-management exercises to the
curriculum, hoping to make it possible for clients to more efficiently
juggle the care of their children and their responsibilities at work. Case-
workers found a local banker to teach a session on how to devise and
stick to a monthly budget, imagining that more careful financial man-
agement might help clients to get by on those $6.00-an-hour jobs.

The childcare supervisor, Laurel, concerned about the placement of
so many children in inadequate and sometimes dangerous childcare sit-
uations, offered clients tips on how to choose the right providers and
created checklists for them to use in interviewing prospective caregivers:
"I tell them to ask about the kind of food they're serving, how many
hours the television is on, what kind of training the provider has been
through. Are there child seats in her car? Does she believe in spanking
children?" Still, Laurel knew these questions were insufficient, and she
remained angry about the lack of state regulations for childcare
providers. By the end of the second year, when we met for lunch, she was
almost bitter. She told me:

> *If you're flipping burgers at McDonald's and you have no money to
> feed your children at the end of the month, then going on welfare is a* re-
> sponsible *decision. Three years from now, five years from now, we're
> gonna have women and children in dire situations: no resources, nowhere
> to turn. Who's gonna care for them? Who is gonna make the general pub-
> lic wake up and understand that it is not acceptable to do this to an en-
> tire population in our culture?*

Just two months after that lunch, Laurel, like Evren, quit her job and left
the profession.

Life continued in the Arbordale welfare office, and many workers were still trying hard to make the best of it. A new position was created for a special caseworker dedicated solely to the most difficult clients, the ones with multiple problems and few skills. But this experimental position lasted less than one year; the staff collectively decided that it was better to share equally this hard and painful work. Caseworkers became more rigid in enforcing the rules, hoping that might make a difference. It was agreed that all would be less flexible regarding the regulations on sanctioning—maybe the "tough love" approach would help, especially with those clients who still seemed to be in denial regarding the time limits.

In Sunbelt City, caseworkers were using a different set of strategies. Welfare mothers who were formally identified as having "barriers" to employment—those with problems of mental health, domestic violence, physical disabilities, substance abuse, an inability to speak English (as their second language), very low skill levels—were all referred to welfare social workers. Those social workers acted as personal counselors who invested a tremendous amount of time trying to find solutions to their clients' problems. And all the mothers in their charge were temporarily exempt from the work requirements. Yet, given the finite number of social workers, they could only manage about 20 percent of the caseload, so regular caseworkers had to be careful not to identify too many of their clients as needing this extra service. At the same time, this separation of social work cases from "mainstream" cases meant that regular caseworkers tended to have less sympathy for the welfare mothers they served, since these clients were consequently viewed as without serious barriers to succeeding on their own.

Contributing to this pattern was the fact that Sunbelt's state had not only contracted out the management of childcare; it had also contracted out the task of employment-retention services to a private company, moving it outside the control and observation of welfare workers. Six months after the job retention program was instituted, most welfare mothers were still reluctant to use the service—after all, like the childcare program, it required transportation across town, more paperwork, and dealing with a new group of strangers and a new set of rules. Making matters worse, the few clients who did use the program were not getting better jobs or keeping the jobs they had any longer than the rest. Even though reports from this contracting agency provided clear evidence that the program was underutilized and relatively ineffectual, no

one in the Sunbelt City welfare office had any authority to remedy the situation. Most caseworkers in Sunbelt therefore took little responsibility for this failure and instead tended to blame the recipients themselves or, with equal frequency, the state politicians who, they said, were irresponsible and insensitive to local-level problems.

In the summer of 1999, at the same time the Arbordale welfare office began experimenting with the greater use of sanctions, the Sunbelt City welfare office instituted a "diversionary workshop." Like the diversion programs established in 20 states across the country, this workshop was designed to "divert" prospective welfare clients from ever completing the process of applying for welfare—encouraging them instead to seek out work or find some alternative means of survival.[2] Sunbelt's state policymakers had suggested that localities experiment with the use of diversionary programs, and Sunbelt City decided that it would be one of the first.

Prospective recipients were given an appointment for the diversionary workshop the minute they walked in the door of the welfare office. On the day of their scheduled attendance, they arrived in the diversion classroom (often with their infants, toddlers, or pre-teen children in tow), to find a blackboard offering them a comparison of welfare benefits against a monthly salary at minimum wage. They were reminded of how much money they could make if they were working, and how little money they would receive if they went on welfare. At the three diversionary workshops I attended, little mention was made of welfare's supportive services or training programs or income subsidies or the additional supplements of food stamps and Medicaid, nor did the caseworker comment on the costs associated with work (such as childcare) or the taxes one pays on wages. Instead, the attendees learned the rules of welfare—the strict eligibility criteria, the job search that they would be expected to start immediately, the complex and demanding requirements they would face, the unpaid workfare placements, the child support rules, the sanctions. Some of the poor families present simply listened quietly and left without a word. Others asked questions that indicated misunderstandings about the rules, sometimes in tones of desperation: "But I just wanted to get the medical for my kids." "How will I pay my bills?" "I'm eight months pregnant—who would hire me now?" "Do you guys have a childcare center?" "My husband's in jail. How can he pay?" Some of these questions were answered clearly, but given the generally high level of confusion (with 6 to 15 mothers in at-

tendance, along with their hungry or bored or distracted kids), most were not. At the workshops I attended, nearly half of those present left without completing an application.[3]

The diversionary system is the clearest and cruelest symbolic representation of the newly reformed welfare system's reluctance to support the nation's most vulnerable members. But as much as it pained me to watch this process, I also knew that caseworkers in Sunbelt City were overworked and faced constant and intense state-level pressure to keep the welfare rolls down. When I asked Melissa, the TANF supervisor, to explain the reasoning behind the workshops, she replied, "The ones that leave don't *really* need our help. They have other resources. And besides," she continued, "it helps us to avoid the waste of paperwork and manpower. It gives us more time to concentrate on the people who really need us." The diversionary program seemed, in other words, a rational strategy in a difficult situation. It was Sunbelt's version of the "tough love" approach.*

Hitting the Wall

As the two-year point drew near, almost all the welfare caseworkers in Arbordale and Sunbelt City began to fear what would happen when welfare clients came up against their time limits. In Arbordale, caseworkers started referring to the time limits as the moment when welfare clients would "hit the wall": "Clara is due to hit the wall in June," "I wonder what will happen to Jena when she hits her wall," "When will Elaine hit the wall?"

In Sunbelt City, the date of the first time limit took on a very special

* As I've hinted, Sunbelt City caseworkers, overall, tended to be somewhat more distant from welfare clients than their Arbordale counterparts (though there were certainly exceptions to this, especially among the social workers). It seemed to me that this was partly the result of state practices of outsourcing services and of separating out the most disadvantaged clients. I would also guess that the relatively less empathic attitude of some Sunbelt caseworkers followed in part from the fact that Sunbelt is a big city. In smaller and more community-spirited towns like Arbordale, connections between people are much more apparent than in places like Sunbelt— where virtually everyone seems like a stranger, cars are always locked, purses are always guarded, and levels of social trust are much lower.

meaning as it corresponded to the coming of the new millennium, falling on January 1, 2000. Some Sunbelt caseworkers believed (or hoped) that the Y-2K computer problems would erase the time limits on all welfare cases, and everyone would be spared. Other caseworkers imagined that New Year's Eve celebrations in poor neighborhoods would quickly turn into riots, and welfare offices would be torched or vandalized. One Sunbelt worker, Jessie, elaborated: "You hear things about people going nuts and blowing people away and driving trucks into walls and stuff like that. You've got a potential for some big-time action here. I'm just glad that Y-2K occurs on a Saturday, and we won't be here. That's the one stroke of luck we've had."

The first time limits arrived, and they passed, without dramatic incidents. There were no major riots, and all seemed relatively quiet. In fact, in both offices in the first month less than two dozen families had their welfare benefits stopped due to time limits; in the second month only a few dozen more. Although by April of 2001, over 120,000 clients had "hit the wall" nationwide, at any given local welfare office, in any given month, the numbers were much smaller.[4] In all locations nationwide, every client walks in the door at a different moment, some are exempted while they care for infants, many get jobs for some period of time before their time limits run out, and some leave quietly before they reach the limit. In welfare offices like Arbordale and Sunbelt, serving only about 400 to 500 cases each, with "work first" policies (that push clients off the rolls more quickly), and using two-year time limits (that ultimately stretch the five-year lifetime limit out to nine years), the monthly numbers will always be smaller and occur over a longer period of time. In states with high unemployment rates, five-year time limits, and an emphasis on using more training and more workfare programs, larger numbers of welfare families will hit their walls simultaneously. But long before reform and the booming economy, most welfare clients left welfare within two years (at least for a time). So it is not surprising that, in almost all locales, the impact of time limits is an unfolding process rather than an explosion.

Back in Arbordale and Sunbelt City, where the time limits hit less like a flash flood and more like a slow-flowing river, the caseworkers were relieved. By the third or fourth month after the initial group had their cases closed, seeing a few more welfare clients pushed off benefits each month simply seemed old hat.

In both offices, the initial relief was quickly followed by new patterns of organization. Strategies were developed to protect the most "hard-to-serve" poor mothers and children from destitution and homelessness. In Sunbelt City, caseworkers used all the federal "hardship exemptions," allowing them to protect 20 percent of their caseload from time limits. Most of those exemptions went to the clients of the social workers. Nearly all of them involved physical disabilities and mental health "barriers"; for many in this group, social workers were continuing to work on applications for Social Security Disability benefits. There was no room left in those exemptions, however, for the mothers who had neither childcare subsidies nor sufficient income to pay for childcare themselves. And there were no exemptions for those caring for disabled family members, or those with no work experience and no high school diplomas. Among the mothers who spoke little English, I was told that about half were spared.

In Arbordale, the state eligibility requirements for "hardship" were so strict that no welfare clients managed to qualify in the first months and only a handful over time. Eighteen states have followed this pattern, allowing few time-limit exemptions for TANF recipients regardless of circumstance.[5] At the local level, Arbordale caseworkers began to devise clever methods for "stopping the clocks" of those mothers who were having the hardest time, using the loopholes in state policies and the flexibility that remained in federal work-participation rates. Given that the welfare supervisor in Arbordale was very concerned about protecting the poor families in her charge, and given that these methods were technically "legal," this strategy would continue to work as long as participation rates were maintained or until the state ran short on welfare money.

As the realities of time limits and client hardships set in, caseworkers began to treat more and more of the problems as routine. By the time I completed my research in 2001, some caseworkers wished they could go back to the way things were before the law was passed, but most did not. No one thought that the old system was a good system. Still, as their multiple (and sometimes frantic) shifts in strategy suggest, most welfare caseworkers recognized that welfare reform had not been "successful" in the most positive sense. The enthusiastic optimism of the first year of welfare reform was gone in the welfare office, and the overall tenor was one of resignation. Caseworkers were therefore attempting to readjust their vision in some fashion.

Some focused on the fact that the old system was a bad system. At least reform provided training and childcare, at least it avoided paying poor mothers to simply stay at home, at least it offered some hope, and it surely seemed to make life better for some poor mothers and their children. Others focused specifically on the moral ideals behind reform and tried to minimize the practical costs. Lillian, a Sunbelt City employment mentor represented this version of the longer term response to reform—an attempt at principled optimism: "People were abdicating their responsibility for themselves under the old system—and I *believe* in personal responsibility. Most of us have a survival instinct, and they'll get jobs or they'll do what they need to do to get by. Everyone for the sake of human dignity should be self sufficient. This reform had to happen; it's a good thing."

The larger proportion of caseworkers, however, were less certain about the extent to which the Personal Responsibility Act offered an adequate response to the position of America's poor, either practically or morally. Although few expressed it to me in precisely these terms, many caseworkers implied that the more worthy versions of family values and the work ethic—those versions focused on stable home life and the good of children, decent jobs, and adequate wages—had ultimately been diminished by the rules of welfare reform. David, a Sunbelt City caseworker who specialized in sanctioned clients, had this to say:

> *This reform is going to mean a lot more tragedy—the stories that we don't see. The people that are evicted, the people that are abusing their children, people that aren't getting enough to eat, their children aren't getting enough to eat, they're not going to be able to pay their power bills. There will be food lines. The politicians think we can save these families with time-limit exemptions?! Ha! How many lifeboats were there on the Titanic?*

This sense of an insufficient number of lifeboats was evident in the words of others as well. A few months after the first time limits had come and gone in Arbordale, Ellen, an employment supervisor, described the road to resignation and the sense of moral ambivalence that attended it:

> *When we started out with welfare reform I had this thing about trying to help people. And new staff were coming in, and they're saying, "We're really gonna be able to help somebody!" In the past, you just gave them a*

check every month—it was just paperwork and phone calls and data entry. Then, with reform, we had all that money to really help clients. And we're getting them out there working, and hopefully that makes the client feel good, and their children are proud of them, and the kids at school don't say, "Oh you're on welfare." That's a really good thing. It makes them proud, and their kids are proud. So I definitely think the system needed overhaul.

But what I see happening right now is that we're trading the TANF benefits for all this money we're pouring into day care, support services, transportation, clothing. And after two years these people are gonna be faced with the same kind of hardships, juggling your job and your family—and all that help is gone all of a sudden. I don't know whether people realize that there's all these people on TANF with no education, no GEDs. And then forcing somebody to get a job at $5.15 an hour is not gonna cut it. They can't make it on that.

It's just not right. So I just come here and do my job and I don't question it.

Given that caseworkers did keep coming in to do their jobs each day, they developed one final strategy for coping with the realities wrought by reform. This strategy, which emerged from the federal requirement to maintain an accounting of the work participation rates of welfare clients, involved an interesting redefinition of caseworkers' original hopes for reform. Just as a cancer patient is considered "cured" if doctors can expect five years disease free, so a welfare mother who could get a job, any job, and keep it for six months came to be considered a "success."

Separating Hope from Hardship

Most welfare mothers do not have the advantage of observing the process of welfare reform over time and across persons in the same way that caseworkers do. Their vision of this reform effort therefore tends to be shaped, first, by their more immediate circumstances—their desperate financial position, their worries about their kids, and their concern about how they will manage the rules and regulations, punishments and rewards of welfare reform. At the same, like most caseworkers and most Americans, welfare mothers' vision of welfare reform is shaped by the wider culture. It isn't just that they've seen the media coverage and know by heart the negative pubic stereotypes of welfare recipients. More than

that, as will become increasingly apparent, most of the welfare mothers I met shared Americans' broad concerns about changes in work and family life, and hoped that reform could provide the beginnings of a solution. Given their circumstances and concerns, and their differential abilities to comply with the terms of reform, welfare mothers' response to reform followed a diamond-shaped pattern, with positive and negative reactions to the practical changes brought by the Personal Responsibility Act reflecting off of positive and negative sentiments regarding the moral implications of reform. I begin here with the negatives, both practical and moral, and move on to consider the positives.

Within the immediate context of the welfare office, the poor mothers I met expressed an unsurprising mix of fear, resentment, and indifference when they first encountered the new rules of reform. Lifetime limits seemed distant, and initially even the two-year time limits seemed abstract. The increased use of sanctions sometimes brought anger—especially, of course, to those who were thus punished and found themselves unable to pay their rent or power bills. The additional reporting rules were experienced as both demeaning and intrusive. "I'm sick and tired of having these people know all my business," was a comment I heard frequently. A few welfare mothers told me that the unpaid workfare placements were a newly instituted form of "slavery."

Many clients referred to the new system as the "work rigmarole." They complained about the confusing requirements and the complicated procedures. Some simply waited patiently for their caseworkers to tell them what hoop they would need to leap through next. Others busily attempted to decipher the requirements and prepare for their next move. A few tried to discover a way around the rules.

Given the demanding nature of the changes instituted by the Personal Responsibility Act—the job search, participation rules, unpaid workfare placements, life skills classes, reporting requirements, child support enforcement demands—I was not surprised to find that some welfare mothers simply went through the motions, resentful of the requirements, hoping that something would turn up. I was also not surprised that some became so discouraged in facing so many problems with childcare, transportation, illness, or so many difficulties with employers, landlords, boyfriends, drugs, or piled up debts and bills, that they failed to keep appointments, failed to turn in necessary paperwork, or failed to make sufficient job contacts.

Among those who expressed their discontent with the inadequacies of the system were women like Ebony, who was sanctioned for failing to complete her life skills course. Twenty-two-years old, with three kids to care for, no work experience, and a 10th-grade education, she just couldn't see the point of attending a life skills class.

> I went to two classes and, I mean, it wasn't like you learned anything; it wasn't like there was really any job skills that they was teaching you. I told my caseworker I could accomplish nothing by going to those classes. But I didn't have a steady caseworker, so they sanctioned me. They push you around with different people, you know. They got too many people quitting and they keep switching everybody, so don't nobody know what's going on. They say, "Get this! We don't have that. Do this! You gotta come back. Call us later." They don't really want to do anything for me. They said they was gonna help me get my phone turned back on, but they didn't.

Reflecting this same unhappiness about the demeaning treatment and the lack of attention to practical hardship, Marianna, a 34-year-old Sunbelt mother with two children and two years of college, told me:

> They have our check in their hands and they do humiliate us. If they don't wanna give us our check that month they won't give it to us. There was a client I gave a ride to, and she didn't go to an appointment [with her caseworker], so the welfare took away her food stamps. And she didn't have any food in her house! I mean zero.
>
> They make us kiss up to them. They do it—it's a fact. I think that they should help us more because we live in total poverty. (But I guess I also think we should do a little more for ourselves.)

Other common complaints included troubles in negotiating the childcare system, managing the costs and the quality of available transportation, coming up with all the required paperwork, reporting in, waiting in line, being threatened with sanctions. These kinds of problems, welfare mothers' comments implied, reflected not just a failure to recognize difficult individual circumstances, but a more general *moral* failure to consider the needs of the disadvantaged and to treat all people with human dignity. At the same time, this treatment seemed to under-

line the stigma of welfare receipt. Most welfare mothers, like Marianna and Ebony, were therefore anxious to exit "the system."

The most dramatic negative response to the hassles and demands of welfare reform was the number of welfare mothers who found those demands so onerous or disheartening that they simply gave up and left the rolls. This included women who made it through some portion of the job search, or the workshops, or even took a workfare placement, but just couldn't keep up, just couldn't manage the pressure. Some of these welfare mothers were sanctioned off the welfare rolls; others simply disappeared. National statistics suggest that as many as one-third of the welfare population have left as a result of discouragement or sanctions.[6] Connected to this group, but even more difficult to count, are those desperately poor women who gave up before they even got started. Although there has been no official tracking of their numbers (since they never formally apply), eligibility workers in Arbordale estimated that as many as one-quarter of those who started the application process did not complete it. Caseworkers in Sunbelt City guessed that about one-third of the mothers who attended their diversionary workshop were ("successfully") diverted from applying for benefits.

Included in this group of discouraged potential welfare clients were women like Sarah. Sarah was the full-time caregiver for her grandchild on a lung machine, her terminally ill father, and her own two young children. The boyfriend who had been helping her out had recently left her. Her ailing father, whom she cared for daily and who had been scraping by on his social security checks, was now in debt himself. Sarah discovered at her initial eligibility interview that since neither her father nor her grandchild was technically a part of her welfare case, there was no possibility for a disability exemption from the work requirements (and, in Arbordale, almost no one received such exemptions in any case). Sarah was also told that she must make 40 job contacts in 30 days. But she had no transportation, and there was no one else available to care for her father or her grandchild so, she said, it just didn't make sense for her to get a job. I met her as she conveyed this story to her friends in the Arbordale waiting room, fluctuating between tones of anger and sadness. "I have to swallow my pride, and come in here, and these people just don't want to help you no more," she told us. As she left the welfare office, she vowed never to return: "I'm not gonna let these people treat me this way again. Not ever." As was true of so many others, it was unclear to me what she would do.

* * *

For all the hardships and discontent, for all those clients whose experiences with reform were unequivocally negative, most welfare mothers, most of the time, remained positive, chin up, eyes to the future. As much as almost no one was happy with *all* the rules and regulations, and although almost everyone recognized some problems, the largest proportion of the poor mothers I talked to were genuinely hopeful about reform and tried hard to make the best of it. They knew what the welfare office and the nation were asking of them, and they did whatever they could to get training, seek out work, find good childcare, manage their budgets, and get off the welfare rolls.

For those who clearly benefited from the programs instituted by reform their positive attitude was easy to understand. If they found both suitable childcare and decent jobs with regular hours that paid above the minimum wage, it made sense that they were grateful for the increased benefits offered as "transitional" (time-limited) assistance with childcare, transportation, medical insurance, and clothing. They were even more appreciative of the welfare checks they continued to receive if their wages were low in relation to their family size. Those benefits meant that this group of clients was, temporarily at least, clearly better off than they would have been prior to welfare reform. And, for some, this was just the boost they needed to achieve familial financial stability.

More surprising was the sense of hope that I regularly encountered among those who were having a harder time. This included mothers who ran through one training program after another, hoping that the next one would prove the "right" one—the one that would help them to get a good job, the kind that offered some flexibility and paid wages sufficient to support their family. It included all those women who took jobs paying minimum wage, jobs with irregular schedules, and jobs that were less than full time. It even included many of those who were forced to take unpaid workfare placements and who interpreted these placements as a chance to get much needed work experience.

Overall, for every client who complained to me of ill treatment and of the inappropriate logic of reform, there were at least two others who responded to my questions about their experiences by recounting positive encounters and emphasizing the helpful services. Shannon, a Sunbelt mother with two kids, was particularly enthusiastic. She'd been out of

work for over a year before reform and, when I met her, she'd just started a three-month temporary job as a bill collector:

> *I think welfare reform is great! It helps with the transportation and the day care, so it helps out a lot. And my caseworker is so nice—she takes care of me, and she tells me stuff. The classes teach you how to prepare yourself to go out for a job and have the right attitude. They taught me how to do my resume and things like that. And you learn how to feel good about yourself too. And, you know, things get tough sometimes, so the welfare office has helped me. I thank God for that.*

Julia, pregnant with her second child, was equally positive. Even though she had not yet found work, she was still feeling hopeful, and grateful for the help that came with reform:

> *They've been very good to me; I've never really had a problem with anything. I mean, the only thing that holds you back is you. My caseworker got me into classes for computer skills. I was looking at the lists and it's like $1,000 for a course like that! So welfare is really forking out the bucks. You know, people are saying, "This is our tax dollars!" and I think they're being put to good use.*

Despite the rigmarole, the bureaucratic maze, the intrusions, the sanctions, and the massive number of strict requirements, many of the women I encountered expressed similar sentiments. Although I had read the statistics reporting that welfare recipients are nearly as likely as other Americans to support reform, in the context of the welfare office, I was more surprised by this fact than any other.[7]

This ability to retain hope surely speaks to a resilience of the human spirit. And part of that hope, as I've suggested, clearly arose from practical calculations—no matter what one's circumstances, the supportive services and income disregards could make it feel like Christmastime, with gifts and pennies falling from heaven. Similarly, although the content of the training programs in computers, food service, and general office skills often bore little relation to what is actually required to achieve financial stability, and as often as I heard clients complain about bad teachers or demanding schedules, I also witnessed, firsthand, the way some of those programs offered some participants a sense of collec-

tive purpose and a feeling that they might actually have a better shot at the brass ring. Along the same lines, the new discretion and maternalism that entered the welfare office with reform meant that a number of clients established warm ties with their caseworkers and came to understand them as important life mentors. Those welfare mothers who made their way to the protection of Sunbelt's social workers often felt especially grateful for the help they received. In all this, there was no question that this welfare office was indeed different from the one where eligibility workers used to just "pass out the checks."

Practical considerations and warm ties, however, were not the only source of welfare mothers' positive assessment of reform. As you can begin to hear in the words of Shannon and Julia, the supportive programs offered by reform were also important because, for some welfare mothers, they seemed to indicate that not just the welfare office but also the nation as a whole wanted to help low-income families to achieve a *better* future. When Julia commented on those $1,000 training courses, even though she knew that Americans were primarily interested in getting her off the welfare rolls, she was also feeling that those Americans were standing with her, rather than against her.

Nonetheless, to maintain this positive attitude, this "ideal" vision of reform, often required welfare mothers to sustain a protective mental and emotional barrier between their hopes and their circumstances. The $6.00-an-hour jobs, the troubles in caring for one's children, the bureaucratic regulations, after all, didn't offer a perfect image of financial stability, happy family life, and a nation dedicated to the common good. But maybe, just maybe, many welfare mothers seemed to say, such a world was possible.

The most striking example of this phenomenon emerged from my interviews with sanctioned welfare clients. Most sanctioned welfare mothers, facing a month or more with no welfare benefits, unequivocally told me that they hated, despised, and abhorred "the system" that sanctioned them. Yet often those very same women told me that they liked welfare reform. Listen to the following mothers, all of whom were sanctioned at the time of the interview, and all of whom were busily gathering their resources to struggle through the sanction without welfare income.

Darla was sanctioned for failing to show up at a life skills course; she said she was having a hard time finding someone to take care of her two

kids. The sanction and her childcare difficulties, however, had not affected her vision of the benefits of reform.

> I think welfare reform has made it better because a lot of people were abusing the system. And I can appreciate it now because I can go ahead and save up a bit of money once I'm working [with the income disregards]. You have to look for a job. Most of us are single parents out here. And if we let our children see us all just staying on welfare, it's bad.
>
> Oh yeah, I think it's gonna work a lot better. It's gonna make a big difference. And I think something is gonna happen for the ones that are really trying to do something and have had trouble getting by. There's all the job training and everything that's out there. There's a lot of resources out there. So if you're not working or doing something within 24 months, there's gotta be something that's holding you back. They'll be able to pinpoint the ones that have that problem.

These three themes—people should work, it's good for kids to see their mothers working, and it's important to help and protect those families who are having the hardest time—were repeated again and again among the mothers I talked to.

Chrystal offered another variation on these themes. She had been sanctioned because her 25-hour-a-week job with UPS was insufficient to fulfill the 30-hour federal "participation" requirements, and she was told that she would have to take an unpaid work experience placement instead. Convinced that UPS was too good a job to let go, she refused the placement, knowing she'd be sanctioned. Although she was angry about what she considered an unjust rule, her anger did not extend to her view of welfare reform:

> I think welfare reform is a good way to help people. I don't think people should be on welfare unless they really, really have to. So I don't see a problem with it at all. People like me, I have no problems, I can work.
>
> When the time limits come, though, there's gonna be a lot of drama, a lot of people fighting each other, a lot of people getting robbed. But a lot of people can work that's on welfare. I can understand why people want to get them off quicker. It's gonna be a mixed up world, really truly kicking people off welfare, but I still think it's a good thing. If a woman really loves her kids, she'll be able to afford to take care of those kids. If you

> *work, you'll honestly be able to take care of your own kids. If you love*
> *them, you've got to be able to take care of them. That's how I see it.*

And finally, to punctuate the ubiquity of this kind of reasoning, consider Sandy's response to my inquiry regarding her assessment of reform. At the time I interviewed her, Sandy had been sanctioned for her failure to make timely contact with her caseworker about changes in her work situation. She told me this was her fault—she'd been transferred from the swing shift to the graveyard shift and became too busy rescheduling her transportation and childcare and simply forgot. Even though she and her three kids were facing four weeks without the help of welfare's childcare, transportation, and income supplements (to her minimum wage, 30-hour-a-week job), she was convinced that welfare reform served a larger, more important goal.

> *I think welfare reform is there to teach us a lesson, a lesson about taking a little more responsibility. I look at this as a great opportunity. To make it, you've gotta get out there. It gives you something to look forward to. One day people will look back and say,"I've been on welfare all my life, but now I'm off of it." And people have got to learn that you can't make all these babies and expect a father to take care of them. The thing is that the new rule that you've gotta find a job, I think it will make a lot of people wake up. And you always hear on the news that they're having these job openings here, there, here, there. (But where's these jobs at?) I've got to work.*
>
> *It's a great law. Nobody said that life was gonna be smooth as a highway. A highway has some bumps and humps, right? That's life. And welfare is not gonna always be there. It's just something that gets you going. And the welfare reform makes you say, "Oh, I can get off of this. I can make it on my own."*
>
> *I want to be independent. I thank them for that help. But I want to say, "I do not need this anymore. Maybe somebody else needs it. Give it to somebody that needs it more than I do."*

What these women say about welfare reform reflects the widespread and deeply felt importance of the higher principles of independence and productive citizenship, of commitment to children, to one another, and to the good of the nation as a whole. These principles are so impor-

tant that they can—symbolically and for the time being, at least—drown out the harsh reality of months without the help of welfare.

Yet, I had to wonder, how long will such women be able to separate their hopes from their hardships? Just as valuing the work ethic is not enough to pay the rent, and valuing the family is not enough to hold one together, imagining that the logic of welfare reform should succeed in an ideal world is, unfortunately, not the same as saying that it does.

Serving the Common Good

In *Beyond Entitlement*, Lawrence Mead, a prominent critic of the old welfare system argued that the problem with the principle of a citizen's "entitlement" to welfare benefits was that a good society requires a system of *reciprocal* obligations. Americans, he wrote, had made a good faith commitment to helping the poor, but the poor had failed to live up to their part of the bargain. They were without a sense of obligation to others or to the nation. Hence, the problem was not that Americans in general had become too self-centered and forgotten about the common good; the problem was that welfare recipients had. The "permissive" logic of the old welfare system, he concluded, had turned the poor into a vast population of nonworking free-loaders.[8] The more I came to know welfare mothers, the more I was sure that Mead's rendering was deeply off-key.

From the perspective of values, the most significant element in the responses of welfare clients, as well as welfare caseworkers, was their reluctance to give up on the more idealistic version of reform. And as much as both groups sometimes framed this vision in the language of "personal responsibility," the logic of their arguments was almost always actually focused on their commitment to caring for others and to serving something larger than themselves. They emphasized their hopes for contributing to the well-being of children, bettering the lives of the most disadvantaged, and responding to the concerns of hard-working Americans.

From the perspective of practical realities, however, there are reasons to worry about the continuing disjunction between the ideals that welfare caseworkers and clients seek to serve and the circumstances of their work and their lives. The sense of hope that I found in the welfare office in those early years was generated, in large measure, by the perfect coin-

cidence of a national economic boom and national enthusiasm for re-
form of the welfare system—both of which offered a promise that every
worker could achieve the American dream of success, and every mother
could be a perfect supermom. Yet, even under those conditions, in the
very best of times, two-thirds of the families leaving the welfare office
were still living in poverty, and millions more remained on welfare,
struggling to meet the demands of the nation. And those poor families
were just the tip of an iceberg. By 1998, a full 41 percent of children liv-
ing with single moms were surviving (somehow) on earnings of less
than $12,500 a year, and millions of American children were living in
working families with incomes below the poverty line.[9]

As I was finishing this book in 2002, the Bush administration, focus-
ing on the "success" of reform, was busily proposing increasingly de-
manding requirements for welfare offices and welfare clients across the
nation. With little attention to caseworkers' knowledge and the realities
of welfare mothers' lives, legislators were considering, for instance, fur-
ther incentives for marriage that included financial "bonuses" for those
who wed and training sessions in "marital enrichment." At the same
time, with less funding (in constant dollars), those White House pro-
posals would require welfare caseworkers to more than double the
number of welfare mothers they sent out to work. If passed into law,
such proposals would also mean that caseworkers in Arbordale and
Sunbelt City and in thousands of other welfare offices across the United
States would be left with far fewer loopholes and exemptions for all
those families who were having the hardest time. All this was being sug-
gested at the very same moment that unemployment rates were rising,
states were experiencing fiscal crises, and ever greater numbers of wel-
fare clients were due to hit the wall of time limits.[10] The gap between
ideals and circumstances would most certainly widen.

In *Regulating the Poor*, Frances Fox Piven and Richard Cloward argue
that, historically speaking, the relative generosity of aid to the poor has
always been dependent upon the balance between two competing social
interests. On the one hand, benefits for the poor operate to protect
against civil disorder by placating the disadvantaged. On the other
hand, policymakers often want to push the poor into the labor market
in order to provide employers with a disciplined and hungry labor
force. According to this logic, it makes perfect sense that welfare reform

was instituted during an upswing in the economy. But when fewer jobs
are available and aid to the poor remains limited, Piven and Cloward
would predict that the nation will experience rising levels of civil dis-
obedience—just as the Sunbelt City caseworkers had expected on the
New Year's Eve of the first time limits.[11]

Over the long run, it is quite possible that many welfare mothers will
lose their admirable idealism, and larger numbers will organize and mo-
bilize against the system that, to many, had seemed so right during those
early years of reform. In any case, it's not just a question of whether ris-
ing rates of civil disobedience, race riots, and street violence will ulti-
mately force policymakers to loosen requirements and provide a guar-
antee of (inadequate) aid to the desperately poor once again. As this
chapter has suggested, just as most caseworkers had long hoped to do
more than simply "pass out checks," most poor families are hoping for
something more than just a handout.

To further consider the likely long-term impact of the Personal Respon-
sibility Act and to examine how this law might affect our collective
chances of finding public solutions to contemporary social problems, a
deeper understanding of the circumstances of welfare families is neces-
sary. The following chapters focus on the factors that led so many
people to seek out the help of welfare in the first place and on what this
can tell us about the increasing disjunction between the nation's more
worthy ideals and its more mixed and troubling economic and familial
realities.

Chapter 5

Pyramids of Inequality

AMONG ALL MAJOR INDUSTRIALIZED NATIONS, the United States now holds the noteworthy position of being the country with the greatest gap between rich and poor. According to the Congressional Budget Office, the wealthiest 1 percent of American households made an average annual income of $1,016,900 in 1997, and the entire top one-fifth were also doing quite well with an average of $167,500. The bottom fifth, on the other hand—representing about 57 million people—earned an average of just $11,400 that year. Thirty-one million people lived in poverty in 2000; over 12 million lived in dire poverty. Welfare mothers and their children are situated at the very bottom of that hierarchy.[1]

The mere mention of welfare, for many people, brings to mind not just poverty but a whole series of daunting social problems: teenage pregnancy, unwed parenting, divorce, abortion, drug abuse, unsafe streets, volatile race relations. This is clearly dangerous ground. And it is, in fact, the ground upon which most welfare mothers walk.

This connection between welfare and widespread social problems provides the foundation for the cultural demonization of welfare mothers. The image of these women as deviant and dangerous people, suffering from forms of immorality that seem almost contagious, is so ubiquitous that it tends to seep into one's consciousness almost unnoticed. Opinion polls show that the majority of Americans believe, for instance, that welfare mothers are lazy, abuse the welfare system, commit fraud,

are sexually promiscuous, and are afflicted with the parasitic condition of "dependency." These stereotypes are so powerful that many welfare recipients share them with the American public and, as I've suggested, readily accuse other welfare mothers of immorality and sloth.[2]

The widespread image of welfare recipients as perverse noncon-formists was one of the central assumptions underlying the Personal Responsibility Act. And the debate over welfare reform acted to rekindle long-held stereotypes of welfare mothers as "wolves," reckless breeders, and cheating "welfare queens," caught in the "trap" of welfare, and fail-ing to seek a way back into the American mainstream.[3] This process of cultural distortion, this use of negative stereotypes and simplistic slo-gans to categorize welfare mothers as deviant outsiders, has been fueled by multiple sources. In all cases, it hides a different story about the val-ues of welfare mothers and about the broader basis of the social prob-lems that welfare reform accused them of creating.

Part of the process of distortion is elucidated by Sheila, a 30-year-old welfare mother from Sunbelt City. Referring to the crack cocaine dealers who work the sidewalk in front of her housing-project apartment, she said, "See, I think this is the reason why we have such a bad reputation. We've got a couple of bad apples in the apple cart and then the next thing you know, everybody says, 'All welfare recipients are drug users, all welfare mothers are lazy, all welfare mothers are bad.' Most of us are not bad." Welfare mothers are simply thrown into the cart of "ghetto cul-ture" along with all poor people (whether they live in inner-city condi-tions or not, whether they are men or women or children, good or bad), and left there, only to have their image spoiled by a few bad apples.[4]

Demonizing welfare mothers, labeling their values and behavior as deviant and therefore distinct from the American "mainstream," is also an understandable cultural phenomenon in that it implicitly allows us to wash our hands of this population. It is to claim that their values, be-liefs, and practices bear no relation to our own. The problems they face are therefore not our responsibility. After all, if we can say that all the difficulties they encounter are simply a result of their bad behavior and immorality then we don't even have to look their way, or see their lives. The fact that the welfare system has been judged by some to be inade-quate, and even harsh, is similarly washed clean by the implicit claim that the people it serves are hardly worth our time and attention. And, if all the social problems faced by welfare mothers are confined to this

group, then we don't have to reexamine our culture, or the structure of our economic and political systems.

These are not the only reasons that politicians and members of the American public might easily be convinced to think ill of welfare recipients. The purpose of this chapter is to provide a further rendering of the cultural processes by which welfare mothers came to have such a negative reputation, to examine the central arguments and social problems that motivated it, and to offer the beginnings of a more comprehensive and clear-headed vision. By positioning welfare mothers' lives in their broader social and historical context, this chapter also serves as an introduction to the stories of welfare mothers that form the basis of the chapters that follow.

Just as welfare policy can provide a window onto our nation's values, just as the operations of welfare offices can illuminate the economic and cultural difficulties involved in achieving independence and familial stability, so a look at the basis of the demonization of welfare mothers says a lot about contemporary American society. The Personal Responsibility Act was propelled, in large measure, by the dramatic simultaneous rise of welfare receipt and single parenting that occurred between 1960 and 1994. The proportion of single-mother families more than tripled between 1960 and 2000, rising from 8 percent to 26 percent of American families with children and translating into the fact that one in three children today lives with a single parent. The number of welfare recipients rose even more dramatically, from 3 million in 1960 to 14 million in 1994 (when it reached its peak).[5] An examination of the story that lies behind these increases in single parenting and familial poverty ultimately offers a vivid picture of the massive changes in work and family life that have left us all a bit disoriented and searching for someone to blame.

In this context, it is certainly fair enough to hold individual welfare mothers responsible for their *own* choices (to the extent they actually have a reasonable array of options). But the social changes that led so many women and children to need the help of welfare cannot be blamed on today's welfare recipients, nor were they the result of a spontaneous eruption of individual immorality or the overly generous provision of public aid. The changes in work and family life that propelled the contemporary attack on welfare mothers have impacted many more people than the population of welfare recipients. And these problems

cannot be solved by simply reforming poor mothers or the system that has served them.

Caricaturing the Poor

The notion that the poor themselves, through their deviance, are responsible for the problem of poverty has a long history. In one form or another, it has been a part of the rhetoric of politicians and social reformers ever since the first poor laws were instituted in this country.[6] And in the last 30 years, one particularly powerful version has been very effectively disseminated by a group of influential conservative scholars, including Charles Murray, Lawrence Mead, and George Gilder.[7] These scholars all argue that poverty is the result of giving money to the poor. That is, welfare policy causes welfare deviance and thereby causes welfare poverty. One cannot help but notice the circular nature of this argument—the poor are deviant because we give them money because they are poor; as long as we give them money, they will be deviant, they will be poor, the more money they will need, and the more they will arrive at our doorstep to claim it. It is surely true that the elegant simplicity of this analysis is part of its allure. Underlying this logic, however, are more serious and haunting questions: Does the offer of financial aid actually cause people to eschew work? Does it serve as an incentive to choose single parenting over marriage?

Although these thinkers arrive at their answers from different angles, they agree that past welfare policies actively encouraged immorality and sloth. The more attractive welfare became, they say, the more people were invited to become nonworking single parents. Murray, for instance, imagines the poor as a group of "rational actors" who carefully weigh the costs and benefits of marriage and work against single parenting and welfare, and realistically, but dangerously and unethically, choose welfare as the more lucrative option. Mead focuses on the immoral "culture" of the poor that is encouraged by the availability of welfare—a culture of illegitimacy, incompetence, and immaturity marked by a lack of discipline and a lack of commitment. Together, they claim that our nation's welfare laws bred promiscuity, a declining commitment to family, financial and emotional "dependence," and a belief that one is "entitled" to support without any obligations to the community or the nation. It was the generosity of our former welfare system, these

theorists agree, that not only supported the immorality of the poor and reproduced poor people with bad values but actually caused the number of such people to proliferate.[8] Their solution—stiffer rules and the end of entitlement to welfare benefits—is the solution the nation enacted with welfare reform.

These arguments resonate perfectly with a widespread sense that our nation suffers from deepening social problems and overall moral decline.[9] This analysis also fits well with one central piece of social science evidence—the historical coincidence of the disturbing rise in welfare usage and rates of single parenting. Hence, the arguments of such scholars are not only charming in their simplicity but they also seem to make sense of alarming social changes and offer to reclaim the nation's moral principles, putting an end to poverty, single parenting, immorality, and indolence by simply dismantling the welfare system. As an added benefit, the solution they offer promises to save taxpayers a good deal of money.

It also makes sense that the demonization of welfare mothers would find a strong foothold in American culture in that it follows smoothly from the ethos of individualism. If people become poor, if they find themselves seeking aid at the welfare office, we say, it must be because of something they, as individuals, did or did not do. The cultural power of this analysis cannot be overestimated. The relatively comfortable American middle class tends to ask three questions about welfare mothers. How did this woman wind up on welfare in the first place? How did she become a single parent? And once she became a welfare recipient, why didn't she just find a job or get married and get off of welfare?

I know these questions and their variations quite well. Not only did I hear them asked time and again by people with whom I discussed my research but I found myself asking them over and over with each new welfare mother I met. The impulse to seek individual-level answers to what are often social-level questions is so strong in American culture that despite all my training as a sociologist this framework would draw me in again and again. The trouble is, given that all the women we ask these questions are, in fact, single mothers on welfare, no matter how many harsh circumstances they might recount, the implicit standards behind the questions mean that the poor women thus interrogated always end up looking individually culpable for the problems of single parenting and welfare usage. In other words, the questions themselves

are set up in such a way as to produce a circular logic. When we ask, "Why did *you* become a single parent? Why did *you* go on welfare?" we are not seeking social causes; we are looking for an individual-level response. Therefore, no form of answer can be provided that won't make the respondent look guilty and ultimately responsible for all the larger social problems associated with welfare and single parenting.

The Personal Responsibility Act captures perfectly the spirit of this individualistic logic. It also explicitly relies on the claim that past welfare policy encouraged bad behavior. And there is no question that this reasoning is extremely alluring. The trouble is, from a sociological point of view, it is simply wrong. It is wrong for three central reasons.

First, the wholesale demonization of welfare mothers is wrong because there is actually wide variation in the values, beliefs, and practices of welfare mothers. Having spent time with scores of these women, I can tell you—and I will show you in the following chapters—that the majority of welfare mothers are not wolves, reckless breeders, and cheats, nor are they primarily calculating profit-maximizers, passive dependents, or lazy couch potatoes without any sense of obligation to their communities or the nation. It is also true that welfare mothers are not all noble victims and self-sacrificing heroes. They are ordinary people. Their moral characters are as varied as those of the people who live in my neighborhood, the consumers who share my grocery store, or the college students who attend my classes. Some are lovable, some are not; some are heroic, most are not.

When attempting to measure the morality of welfare mothers, however, two small caveats are in order. As a group, most of the welfare mothers I met tended to be a bit more tolerant of individual failings than most of my neighbors, fellow consumers, and college students. This, I would argue, is precisely because they have hit the bottom, and they know what it feels like. And morally speaking, most of the welfare recipients I encountered had one leg up on most of my college students—precisely because they are mothers. Their mothering tends to teach them a moral lesson about taking care of others and sacrificing for the ones we love. That is a lesson the depth and reality of which most of my students have not yet fully grasped. But, of course, welfare mothers' position at the bottom and welfare mothers' mothering are two of the things that the American public is worried about.

Second, arguments that demonize welfare mothers, laying the blame

for widespread social ills at their doorstep, completely ignore the broader social and historical bases of poverty, single parenting, and welfare use. All welfare mothers, like all individuals, are embedded in, and socialized by, social institutions; all are shaped and constrained by the structures of our economic, cultural, and political systems. When we make use of the "personal responsibility" framework and find them guilty, we are simply allowing the proverbial "trees" to obscure our view of the larger forest.

Finally, although the argument that our nation's welfare policy corrupts welfare recipients' values is more theoretically sophisticated than the individualistic framework in that it recognizes the institutional shaping process, this analysis remains profoundly nearsighted. It operates on the faulty assumption that welfare institutions *alone* impact the values and behavior of poor people. The form of cultural distortion taking place in this case is akin to allowing a single species of trees to cloud our awareness of the multiple layers of life in the forest. From a scientific point of view, analyses that blame the welfare system for the creation of welfare recipients require us to believe that the rise of welfare usage and single parenting took place in a social vacuum. It is as if the rest of the world stood still while the nation increased the availability and attractiveness of welfare.

The clearest indication of the faulty logic of this analysis is the fact that, as it turns out, there is little causal connection between the attractiveness of welfare benefits and the size of the welfare rolls or the rate of single parenting.[10] These phenomena did, at first, appear to be linked: in the 1960s the value of welfare benefits, rates of single parenting, and the welfare rolls all went up together. Since then, however, the value of welfare benefits in the United States has decreased dramatically (in constant dollars), yet single parenting and welfare usage have continued to rise steadily. In fact, the most rapid and historically unprecedented rise in single parenting and welfare receipt occurred between 1970 and 1995—yet, during that same period, the value of welfare benefits decreased by 50 percent.[11] Studies comparing welfare benefits over time, across states, and across nations have repeatedly demonstrated this point. Miserly states (e.g., Alabama) have spawned just as many single-parent households as the more generous ones (e.g., Connecticut). And industrialized nations that offer higher welfare payments do not face any higher growth rates of single parenting than nations that spend lit-

tle (and sometimes, as is the case with the United States, the reverse is true).[12]

The historical rise in the welfare rolls had little to do with economic calculations of the "benefits" of nonwork and single parenting. The rise in welfare receipt followed, in part, from the 1960s' revolution in civil rights that allowed equal access to welfare benefits for *all* desperately poor families, no matter what their race, residence, or state-determined moral virtue. Beyond this, the primary fuel that kept those rolls rising well beyond the 1960s was the simple fact that increasing numbers of single mothers and children were living in dire poverty.

Thus, the story behind the rising welfare rolls over the last 40 years ultimately boils down to this: growing economic inequalities met up with revolution in family life. More specifically, the participation of women in the labor force, the decline of the breadwinner wage, and changing norms regarding marriage, sex, and family life led to rising rates of divorce and unwed childrearing and confronted, in turn, inequalities of gender, race, and income, and the continued privatization and implicit devaluation of the care of children. Together, these factors led many families to the welfare office. They also led all of us to a difficult situation that the reform of welfare alone cannot repair.

The Linkage of Single Parenthood, Gender, Race, and Poverty

Welfare reform affects very specific sets of people. They are predominantly women and children, disproportionately nonwhite, and overwhelmingly single parents. As I've noted, most welfare recipients are children, most of these children are cared for by their mothers, and black and Hispanic Americans are overrepresented on the welfare rolls.[13]

That these particular groups of people are so deeply poor as to be eligible for welfare benefits is no accident, no mere historical footnote. Their membership in these social groups is, at this historical juncture, the primary basis of their poverty. The backdrop for their poverty is persistent gender and race inequalities. The new additions to this scene are the growing number of mothers who raise their children alone and the declining number of people who make a wage sufficient to support a family.[14]

One-half of all marriages in the United States today will end in di-

vorce. One-third of all children born will be born outside of marriage. In 1900, less than 5 percent of children lived in households headed by a single mothers. By the 1970s, that number had more than doubled, reaching 13 percent, and the public was already expressing serious concern. Yet, by today's standards, that 13 percent is a paltry figure. One-third of children are now living in single-parent households, and nearly half will live in a such a home at one time or another during their lives. Almost no one thinks this is good news.[15]

The vast majority of these single-parent households are headed by women, one-third of all single-parent households are poor, and one-half the young children living in these families are poor. This is the basis for what has come to be called the "feminization of poverty."[16] The connection between single parenting and poverty is not hard to figure out. Once you become a single parent, no matter who you are or where you start out, no matter if it is divorce or unwed parenting that brought you there, your financial resources are stretched and, simultaneously, your ability to make money is diminished by the added pressure of caring for children without the help of a spouse. These difficulties are exacerbated if you are a woman or if you are nonwhite, since women and nonwhites systematically make less money than men and whites. The average woman with a high school diploma, for example, earns 55 cents on every dollar earned by her male counterpart; a woman with a college education earns just 64 cents on every dollar earned by a college-educated man.[17] Earnings among nonwhites follow the same pattern. The average black woman, for instance, makes 85 cents to each dollar earned by a white woman, the average black man makes 78 cents relative to his white counterpart. Black Americans are also consistently less likely than whites to have the economic assets to see them through hard times.[18] As is true for women, these income differentials are also indicators of other forms of disadvantage in their working lives, including more inflexible schedules, less room for advancement, and fewer fringe benefits. In short, women and nonwhites are simply more easily pushed below the poverty line in cases of single parenthood, and their disadvantaged circumstances make it all the more difficult for them to climb out of that position.

Women, the economically disadvantaged, and nonwhites are not only more likely to suffer dire poverty if they become single parents but they are also more likely than their white, male, wealthier counterparts

to become single parents in the first place. Women are more likely than men to be single parents because our culture has long seen women as the proper persons to carry out the job of rearing children. They are more likely than men to become the sole caregivers for children born out of wedlock; they are more likely to have custody of the children in cases of divorce. The poor are more likely than the rich to become single parents in part because their position at the bottom means that they are less likely to encounter viable, financially stable, marriage partners. Research also suggests that working-class and working-poor people, relative to their wealthier counterparts, are more likely to value their family over their paid work, following largely from the fact that raising children can offer a great deal more satisfaction, fulfillment, and social status than a job in fast foods, cleaning bedpans, or manufacturing widgets. Hence, the idea of foregoing the chance to establish a family is virtually unfathomable at the same time that being financially "ready" to have children is that much more unlikely. This simultaneously makes divorce more common and increases the chances of having children without a marriageable partner.[19]

Middle-class blacks with comparable income, economic assets, and education have marriage rates that are nearly the same as their white counterparts.[20] But blacks in general are at greater risk for single parenting than whites, largely because the history of discrimination means that they are more likely to have low incomes and therefore don't have the same reasons to focus on family life and worry about viable marriage partners as do similarly positioned whites. Following the logic of William Julius Wilson's well-known account of the lack of suitable mates for black women, recent research suggests that for every three unmarried black women in their 20s, there is only one unmarried black man with earnings above the poverty level. Yet black Americans are in an even more difficult situation than such statistics on earnings can capture. Relative to white Americans, they are much more likely to suffer discrimination in housing, health care, and loan availability. More than that, they are much less likely to have economic assets to back them up in trying to establish or sustain stable families. (In 1995, for instance, the average net worth of white families was $49,030; for black families it was $7,073.)[21] When all these factors are taken together, it is not surprising that low-income black men and women are likely to "wait" longer to find the right mate.

It is important, at this point in the argument, that one not fall into the trap that Congress fell into in composing the Personal Responsibility Act. To say that single parenting is systematically linked to poverty is not the same thing as naming single parenting as the *cause* of poverty. Poverty existed long before single parenting became prevalent, and without major changes in social policy or a reconfiguration of our economic system, we have every reason to believe that it will continue to exist even if all single-parent households disappear. The faces of the people at the bottom of the economic pyramid have changed over time, yet the relative number of positions at the bottom has remained fairly stable. Waves of European immigrants once filled this category, but most are now dispersed throughout the class structure. Our most recent historical example of the changing face of poverty is the changing position of older, retired Americans who once held the "leading" role as the largest group of people living in poverty. They have now been "replaced" in that role by women and children living in single-parent households.[22]

With this logic in place, we have come halfway toward understanding the social basis of the rising welfare rolls in the second half of the twentieth century. Women, children, and nonwhites have long been at greater risk for poverty than males, adults, and whites. If they become members of single-parent households, their risk is greater still, and a larger proportion of them will need to seek out the help of the welfare office. Although there are certainly questions of justice involved in this portrait, we can nonetheless make sense of the central social forces operating to increase the usage of welfare without resorting to any argument regarding the immorality of individual welfare recipients. If we stop at this point in the argument, however, we might still be tempted to imagine that single parenting itself is the root of all our problems and thereby ignore the processes that led to its rise.

The Revolution in Family Life

The dramatic rise in the number of single-parent households has occurred in every Western industrialized nation in the world.[23] Hence, we have good reason to believe that there is a close connection between the processes of advanced capitalism and the rise in single parenting. This connection is certainly worth pondering in its own terms, but like the

conservative attack on welfare recipients and the old welfare system, it leaps too swiftly over the multiple intermediary processes involved.

First, it is important to note that the rise in single parenting does not represent a historical increase in the number of children women are having. That is, it is not as if unmarried people are having "extra" children just to get a welfare check (or just to pass the time). Rather, people who (by historical standards) would have been raising children anyway are now simply more likely to do so outside of marriage. Couples today are having children later and having fewer of them, but they are also getting married later and getting divorced a lot more often. Thus, everyone is spending more of their adult years outside of marriage.[24] Looking at the trends in single parenting from this angle, one could argue that there is actually a culturally induced, age-graded "urge" to produce (at least some) children, and men and women are simply "unwilling" (or unable) to put it off until they have found a suitable mate or until they are absolutely certain that their marriages will last for life.

There are four primary social trends impacting people's cultural "willingness" and "need" to become single parents:

- The rise in women's paid labor force participation
- The decline of the family (breadwinner) wage
- A "revolution" in sexual practices
- And a corresponding (ambivalent) cultural acceptance of these changes

These social trends—not the availability of welfare or some mysterious rise in individual immorality—ultimately brought us higher rates of divorce, out-of-marriage childbearing, the feminization of poverty, and the rising number of families who must seek out the aid of welfare.

Nearly all scholars of family life agree that these trends played a central role in changing marriage and childrearing patterns. Most also agree that the primary factors are the increasing number of employed women and the declining availability of wages sufficient to support a family.[25] These two changes reinforce one another in their effects: at the same time women's work offers them more choices regarding marriage and childrearing, men's declining ability to be financial "heads" of households influences their marital behavior. Both changes create fewer incentives to get married and stay married, more problems in finding

suitable partners, and an increase in the potential for conflict within marriage. To the extent that women's struggle for equality is a crucial factor in these trends, the outcomes relative to welfare mothers are all the more (darkly) ironic.

In the crudest terms (for the sake of simplicity) the story runs as follows. The historical rise of single parenting follows close on the heels of the rising number of wives and mothers who go out to work for pay. These women enter the labor force because they live in a society that values independence as one of its highest goals and marks the achievement of this goal by one's ability to make money. These wives and mothers also enter the paid labor force because changing labor market conditions offer them an opportunity to do so and because the changing economy makes it increasingly necessary for women to work to maintain familial standards of living.[26] Hence, while only 28 percent of mothers worked for pay in 1950, today 73 percent do. While just 31 percent of mothers with infants were employed in 1976, today these mothers are in the majority at 59 percent.[27]

The decline of the family wage occurred right alongside the rise in women's labor force participation. Working people fought hard throughout the twentieth century to gain wages sufficient to support a family, and though they were never fully successful, by the 1950s, more men than ever before were making a breadwinner's income. Yet the more that women went to work for pay, the less employers felt pressure to provide a wage large enough to support a family. This has been good news for American business, since lower wages generally translate into higher profits. Of course, workers at the top of the income pyramid can still command a family wage, but those in the middle and at the bottom are not so lucky. The increasingly tough position for those at the lower levels is apparent in the exponential growth of the income gap between ordinary workers and high-level managers, and the fact that no one in the bottom fifth of American households today (averaging $11,400 a year) makes a wage high enough to support a family.[28]

The decline of the family wage and rise in women's paid work have obviously had significant consequences for men. These social changes mean that men feel less able, and less compelled, to take the role of the primary breadwinner. In 1973, a full 60 percent of marriage-age men earned a wage high enough to support a family of four above the poverty line. By 1995, the majority of male workers were without the

means to support their families on a single salary. The situation at the bottom of the hierarchy is dire: only 25 percent of men with less than a high school diploma earn a wage sufficient to support a family; only one-third of all black men do. There is every reason to believe that for these men their sense of identity has suffered right along with their pocketbooks.[29] And there are indications that men's interest in taking on the breadwinner role has diminished as well. In the 1950s, two-thirds of families had a breadwinning husband and a stay-at-home wife, and we might guess that at least some men in the remaining one-third wished that they could also be successful breadwinners. Today, according to a study by sociologist Kathleen Gerson, only about one-third of marriage-age men are strongly committed to the breadwinner role; of the others, about one-third hope to have a dual-earner household, and one-third distance themselves from family life.[30]

The so-called sexual revolution, although not as central as the massive changes in gender roles, likely played some part in the rise of single parenting. And this cultural phenomenon, which had many sources and quite mixed consequences, was clearly connected to changing gender roles. It gave women and men the right to fulfill their individual sexual desires and, simultaneously (and unintentionally), created the assumption that women could be held individually responsible for their own fertility. At the same time, in breaking the culturally prescribed linkage of sex, marriage, and childbearing, the sexual revolution meant that controlling fertility became that much more crucial. Today, over three-quarters of unmarried women in their 20s are sexually active. The chances of a contraceptive failure run from 2 to 14 percent depending on the method, and three-quarters of pregnancies to unmarried women are unintended. A number of these women are left to raise their children alone.[31]

In all cases, these processes lead to higher rates of divorce as well as higher rates of childbearing outside of marriage. It's not just that marriages become more economically unstable for those in the bottom ranks of the income pyramid. Couples at all income levels increasingly face a double shift of work and family responsibilities. This creates a time crunch at home, and one that disproportionately impacts women (who are most likely to be faced with the bulk of domestic duties). Issues of breadwinning, housework, and childcare thus become central sources of conflict in marriage, as sociologist Arlie Hochschild so pow-

erfully illustrates in *The Second Shift*. At the same time, given that both men and women are independent wage earners, both have less reason to feel committed to the marital bond. All these factors are sources of marital strain; all ultimately lead to a higher incidence of divorce.[32]

Of course this story of the revolution in family life is far too simple, and there are many secondary processes involved. One could easily, for instance, focus on the interests of employers and consider how they capitalized on women's desire for independence to create a situation where labor would be cheaper and more readily available. One could also argue, as Barbara Ehrenreich does in *The Hearts of Men*, that men had grown quite tired of their responsibility for breadwinning and therefore dropped the ball, went off to pursue their individual dreams, and left women scrambling for jobs just to save themselves.[33] Similarly, the sexual revolution's message that women are individually responsible for their own fertility could be interpreted as useful to both men and capitalism—no more worries about breadwinning (or finding sexual partners), no more worries about the family wage. If women want to make babies, then they can support them.

These are not, of course, self-conscious conspiracies; they are slow social processes with interconnected cultural, economic, and political feedback loops that nudge one another forward. All these processes have had unintended consequences. The central point is that multiple—and highly significant—wider social changes all played a part in establishing the dramatic rise in single parenting. By these standards, the system of welfare support was a miniscule player on the historical stage—and its primary impact was to provide minimal support for those most adversely affected.

Taken together, these changes add up to a revolution in family life. This social transformation means that more people are having sex outside of marriage more often. It means that more people are feeling less willing to commit to marriage in general, since it is no longer an absolute cultural or economic requirement that women and men take up prescribed positions of domestic wife and breadwinning husband. It means that the idea of a family wage has virtually disappeared, the minimum wage has declined, and the earnings of ordinary workers are increasingly insufficient to support a family.[34] At the same time, this transformation has meant that more women are economically independent than ever before.

The more these changes take place, the more socially acceptable they become, and the more they come closer to being the norm. The trouble is, in the end, alongside the very real social benefits of some of these changes, there is also a large number of very real social costs. And no one has yet figured out exactly what to do about them.

Who's to Blame?

All of us, our parents, and our grandparents, collectively participated in these changes, wittingly or unwittingly, for good or ill. If we're looking for someone to blame, that is one direction in which to turn our attention. But in doing so we would make that same mistake of blaming individuals for what are, in fact, social processes that no single individual, or even group of individuals, has orchestrated or controlled.[35] To blame women, the poor, and nonwhites for these problems is simply to blame those for whom the consequences have been most negative and most dramatic.

There is one final point that should not be missed. The outcomes of the family revolution would have been very different if the rise in women's employment and the decline of the breadwinner wage had resulted in a society where everyone considered children just too expensive and too much trouble, and no one bothered to have them any more. If this were the case, we wouldn't have seen the rise in the double shift of family and work responsibilities, the rise in single parenting, and the rise in welfare receipt. Yet, despite all the changes in work and family life that occurred in the second half of the twentieth century, neither men nor women have given up on their desire to have children and their certainty that children are our future. Opinion polls show that the vast majority of Americans agree that having children is a central life goal, an important route to adulthood, and a valued protection against loneliness.[36]

What we have today, therefore, is a striking mismatch between the private valuation of children and the lack of public support for the work of raising them. As much as children are highly prized, there is little institutionalized support for their care: employers don't pay for it, politicians provide little more than lip service to it, and women get almost no cultural or economic "bonuses" for being the primary persons to carry it out (and, in fact, often receive quite the opposite).[37]

Putting it all together, what we are seeing when we look at the welfare

rolls is the interaction of the revolution in family life with inequalities of income, gender, and race and the privatized value of children. This is what brought us large numbers of single-parent households, headed primarily by women, overrepresenting nonwhites, at a high risk for poverty and welfare use. It is as simple (and formidable) as that.

The primary point I want to drive home is that all the welfare mothers I have and will describe are not the *causes* of the rise in single parenting or the rising number of women and children living in poverty. They are its *consequences*. If we want to change the number of people who are forced to go on welfare, if we want to change the rate of single parenting, if we want to change the color of welfare, if we want to undo the feminization of poverty, then we must squarely address those larger phenomena. If we approach these social problems only by attempting to "fix" all the individual women currently using welfare, our efforts will fail. The social system that created their plight will simply spawn a whole new generation to take their place.

Although it may sound contradictory at this point, it is for precisely these reasons that understanding the lives of individual welfare mothers is so important. It is not so much because their life stories can answer those particular questions about why this or that woman ended up on welfare—why she wasn't smarter and more conscientious about birth control, why she didn't have an abortion, why she was so naive as to think that pregnancy would lead to a happy marriage, why she failed to get married, why she was divorced, why she didn't get better grades in school, why she didn't go on to college, why she didn't get a job, why she didn't get it faster, and why she didn't get a better job. The answers to these questions are meaningless if the focus is solely on changing this or that woman. Welfare mothers' lives are significant because they follow social patterns, and those patterns are significant because they can provide a useful angle of vision for viewing the more extreme consequences of the social transformation we are all experiencing. They offer us, in this sense, an exaggerated image of difficulties faced by all Americans today—difficulties that have taken an especially dramatic toll on women, on children, and on the most vulnerable among us.

My parents were always telling me to look up at the world; to look straight at people, particularly white people; not to let them stare me down; to hold my ground; to insist on the right to my presence no matter what. They told me that in this culture you have to look people in the eye because that's how you tell them you're equal. What was hardest was not just that white people saw me . . . but that they looked through me, as if I were transparent.

By itself, seeing into me would be to see my substance, my anger, my vulnerability and my raging despair—and that alone is hard enough to show. But to uncover it and have it devalued by ignore-ance, to hold it up bravely in the organ of my eyes and to have it greeted by an impassive stare that passes right through all that which is me—this is deeply humiliating.

—Patricia Williams, Professor of Law
from *The Alchemy of Race and Rights*[1]

It's good that you're writing this book about welfare. People need to know what's happening here.

—Sydelle, 28-year-old Sunbelt City welfare mother

Chapter 6

Invisibility and Inclusion

INVISIBILITY WAS A PROBLEM EXPERIENCED BY the majority of the welfare mothers I encountered. Most emphasized, in one way or another, that they were not "born to welfare" (as one put it), and almost all felt fairly certain that— time limits or no time limits—they would find some way to survive. These mothers did not, in other words, tell me their stories primarily to convince listeners that they were worthy of continued welfare receipt. Many did, on the other hand, share their tales because they wanted people to understand how they came to participate in one of the most universally despised social programs in U.S. history. They had heard more than once the stereotypes labeling them as lazy, dependent, ignorant, promiscuous, and manipulative cheats. They told their stories, therefore, with the hope that they would be recognized not simply as a composite of clichés, but as whole persons. In this, it seemed to me, like Patricia Williams (quoted above), they implicitly asked to be treated as citizens and social members. No special protection or dispensation was requested. It was the visibility and the inclusion that mattered.[2]

The stories of mothers I share in this chapter and the next are meant, in part, to offer these women an opportunity to "make their case." These stories also serve to underline the wide variation in the lives of welfare mothers and in the paths to welfare—lives and pathways that no single stereotype could possibly cover. Above all, I share these tales to illuminate the very real, and very significant, social and moral costs of leaving these mothers and their children invisible.

At the bottom, where welfare mothers sit, widespread social problems and social inequalities come together in their most striking form. The patterns in welfare mothers' lives thus provide a vivid and concentrated portrait of the multiple consequences of the social changes we have all experienced. Their hardship, in cold-hearted terms, is an instructive analytical tool for examining the world we have collectively created, of fragile families, widening income disparities, and persistent gender and race inequalities. The lives of these mothers can also help us to see clearly the consequences of mounting tensions between individualism and commitment to others, and the difficulties underlying attempts to enforce rigid conceptions of "self-sufficiency" and "family values." These stories similarly serve as a powerful corrective to simple-minded frameworks suggesting that greedy economic calculations or narcissistic individualism are the root causes of welfare receipt and high rates of single parenting. In their lives and their words, welfare mothers offer a much more nuanced portrait of the meaning of the work ethic, independence, and obligations to one's family, one's community, and the nation.

In the following pages I introduce a series of individual mothers whose lives represent a series of the more common patterns I found among welfare recipients. Of the primary people you meet in this chapter, two are white, one is black, one Hispanic, and another of American Indian heritage. They are teenage mothers, divorced and separated mothers, and unwed mothers. Some suffer from problems that affect a limited portion of welfare recipients—including physical disabilities, mental illness, and what has been dubbed welfare "dependency." Others have faced hardships that are common to vast numbers of poor and working-poor families. All of them, however, have experienced the pushes and pulls of work and home, independence and commitment, the longing for financial success and the desire to build strong and lasting families. In this, they are no different from the majority of American mothers today.[3]

I want to point out in advance that a large number of the following stories include domestic violence. It may begin to appear as if I carefully picked these stories to emphasize such violence, ignoring all those women who had experienced only happy and healthy relationships. But I chose these particular stories because they represent the diversity of patterns in welfare mothers' lives: domestic violence is only one of those

patterns, though it is a highly prevalent one, impacting at one time or another over half of all welfare mothers.[4] The number of women profiled who have suffered abuse is solely a by-product of the prevalence of that problem.

I also want to note that I have been careful not to hide any of the more disturbing features of these women's lives, and attempted to avoid painting them in an overly sympathetic light. Some skeptical readers may still wonder if these women, in talking about their lives, set out to portray themselves in such a way as to legitimate their behavior and convince me that they were good and worthy people. To some extent this is probably true. Yet, as Erving Goffman points out in *The Presentation of Self in Everyday Life*—all of us, to some extent, "construct" the stories of our lives in such a way as to persuade listeners of our worthiness.[5] We are all, in this respect, imperfect reflections of the selves we present to the world. Arguably this does not diminish the values and beliefs that we use to construct the public image of our "better" selves. The fact that welfare mothers may not always practice the ideals they proclaim, I would suggest, makes them neither more nor less morally virtuous than anyone else.

Finally, in telling these stories as individual stories, I realize that I run the risk of reinstating the logic I am seeking to dismantle. That is, I run the risk of allowing these individual "trees" to obscure the "forest" of larger social trends in single parenting, gender and race relations, and economic inequality. I also run the risk of reinstating the notion that these women are the cause rather than the consequence of the problems they face. I take this risk because I believe it is important to make visible the human face of welfare and to illuminate patterns in contemporary work and family life. I can only hope, with them, that in offering a window into these women's lives and allowing them to "look you straight in the eye," they will not be humiliated.

The Domino Effect

It's a downward spiral. And once you hit bottom, you hit hard.

The spiral for Sheila began just after she finished high school. Sheila is white and was 29 years old at the time I met her in the old and notoriously dangerous housing project where she lived, not far from the Sunbelt City welfare office. From a working-class background, she was

raised in a small town "with small town values." She was engaged to be married to her high school sweetheart. The summer after they graduated he was killed in an auto accident.

> I wish that then and there I had just said, "Okay, forward," instead of sitting and mourning and moping and weeping and thinking about what could have and should have and would have been. I should have just gone on ahead to college like I had intended. And I didn't do it. But you know what they say, hindsight is 20-20.

She moved to Sunbelt City with her parents and took a part-time job. Less than a year later her father left her mother.

> It was in February. He left a note on the kitchen table. It said, "I'm leaving you for good." And he left the keys to the car that was not paid for. He left one month owing in rent. My mom at the time was not working, and I was still mourning my boyfriend.
>
> Shortly after that me and my mom found jobs at a dry cleaners. We opened it in the morning, and we worked for 15 hours a day. We'd come home, go to sleep, get up, and go right back there. Six days a week. And we were doing good. We had paid up the back rent, and the car was being paid for.
>
> And then my mother got blood clots. She almost lost her leg. And the doctor said she shouldn't work any more. This meant we lost $1,500 a month in income and we were trying to make it on my little $1,200. With the medical bills and the car payments, I got a month behind on rent, and they evicted us.
>
> We were homeless. In all the hoopla and everything, I lost my job. It just kind of dominoed. We were actually homeless, living with friends and things like that. And I mean we went hungry—we ate the throwaways from McDonald's.
>
> A lot of people don't realize how close they live to being homeless. I mean, you're just one or two paychecks away from the street. And once you hit bottom, you're gonna hit and you're gonna hit hard. But you have to remember that once you hit bottom you're as low as you can go. There's only one way to go, and that's up.

Unfortunately for Sheila, the downward spiral had not yet reached its lowest point. It was while she and her mother were homeless that she

met the man who was to become the father of her daughter. He was, at that moment, her savior, but only a temporary one:

> I met Sam, and I thought he was a very nice gentleman. Sam was living with a friend, and they took the two of us in. I found another job. We were hopeful; even though my mom still couldn't work, we were beginning to get back on our feet.
>
> Sam had told me he was divorced. I was still young; I was 21 at the time. And, like I said, I come from a small community. Well, after we'd been together for almost a year, I got a phone call one morning—and it was his wife! So I used the money I had to put him on a bus back to his wife in Florida. And that's the last I heard of him.
>
> A month later I found out I was pregnant. Sam still doesn't know he's got a daughter. The child support people haven't found him yet.

Putting Sam on that bus meant that pregnant Sheila and her disabled mom were homeless again. And then Sheila was raped:

> For a while I wasn't sure if Sam was the father. There was the small issue of the fact that three weeks almost to the day after he left I was raped. That's a part of living on the street; that's a danger for women who live on the street.
>
> And that's how I came to find out I was pregnant—I went to the clinic to check a few weeks after the rape. So there were two possible identities to the father. I had a hard time knowing what to do. But as soon as she was born I saw what she looked like and I knew who she was; I knew who she belonged to. She looks too much like her dad.

Sheila was just 22 years old when she gave birth to her daughter. If things had gone as she had originally planned, she would have been starting her last year of college at that time.

Sheila first went to the welfare office in the last months of her pregnancy, hoping to get medical coverage for the birth.

> I was a high-risk pregnancy all the way through my pregnancy. I went down to the welfare office and applied for medical assistance. My mother and I were still homeless. I worked a part-time job until things [with the pregnancy] got too bad. My mother had gotten a job [against her doctor's

*advice] and we managed, with my first welfare check, to finally get our very
own small studio apartment. Just two weeks later my daughter was born.*

Sheila's daughter (who was busy with her homework during most of my
visit), was seven years old when I met her.

From the time she gave birth to the time of our interview, Sheila had
a string of jobs. She went back to work when her daughter was just three
months old. That job she described as a "really good one," where she
worked her way up to a management position in a fast-food restaurant.
The rest of the jobs were temporary or low-paying jobs, mainly entry-
level fast foods and unskilled clerical work. She left every one. She quit
the good one after more than two years, and she's still sorry about it,
even though she remembers well all the time she spent agonizing over
that decision. She left because the hours and the bus rides were so long
that she was spending over 12 hours a day away from home, and she
never had a chance to see her daughter. "My daughter was nearly three
years old and she was calling my mother 'mom' and calling me 'Sheila.' It
was just too hard. I just wanted to get to know her, to do her ABCs and
her 1-2-3s. I wanted to be there."

She went back on welfare and spent almost a year getting to know her
daughter before again seeking work. She spoke nostalgically of that time
with her three-year-old, but she also emphasized that leaving that job
was her "third big mistake," alongside mourning rather than continuing
on to college, and getting involved with a married man.

Sheila left subsequent jobs because she hurt her back, loading boxes
("the doctors say I'm not allowed to lift over 15 pounds now"), because
the pay was too poor, because the jobs were only temporary (through a
"temp" agency), and most recently, because her mother was diagnosed
as terminally ill and needed to be cared for. Her mother suffered respi-
ratory failure first, then a massive heart attack and, by the time I met
her, Sheila was afraid to leave her alone most of the time. "That's my
greatest fear, that I'll go to work, and I'll be at work, and something will
happen to my mom. I don't know what to do."

Sheila's combined time on welfare, including the time when her child
was born, between jobs, and since her mother's illness, added up to
about three and a half years, including the last year and a half since wel-
fare reform. She'd been using the resources offered by the welfare office
to train herself on computers and in accounting skills. She told me

about the contacts she'd made with state agencies that might hire her, and she was feeling somewhat optimistic, though still quite worried about her mom. Her primary goal was to find an employer flexible enough to allow her to care for both her daughter and her mother.

The sheer number of tragedies in Sheila's young life—her fiancé's death, her father leaving, her homelessness, her affair with a married man, her rape, her high-risk pregnancy, and now her mother's terminal illness—testify to the unique circumstances that led her to go on welfare. But every mother I talked to had a story of hardship to tell. And every mother I met had experienced some version of the domino effect: one problem leading to another and compounding it, until too many dominoes fall and the situation becomes impossible to manage. In this, Sheila's story represents the most prominent pattern in the road to welfare.

A second, partially hidden, pattern that Sheila shares with many welfare mothers who have children out of wedlock involves the issue of birth control. Most observers of Sheila's life would agree that she has had some very tough luck. Yet many would also want to know why she allowed herself to get pregnant. After all, it is clear from this vantage point that the last thing Sheila needed was a child to support. She answered, "I did use birth control, but it must not have worked. I don't know what happened."

The truth is, it could very well be that Sheila simply did not use birth control faithfully enough, or that the methods she and her partner used were not sufficiently foolproof. The crucial point here, however, is that a substantial number of sexually active young men and women do not use birth control faithfully enough. This fact does not appear to vary significantly by one's race or economic status. About 50 percent of female teens are sexually active. About 70 percent of those say they used birth control the last time they had sex. But this percentage is based on self-reporting—in which case Sheila, for instance, would be included as a "yes." And equally important, having used birth control recently is not the same thing as using it consistently. There tends to be a good deal of variation in answers to the questions "used at most recent sex," and "used at first sex," for example, which confirms that "recently" is not the same as "always."[6] Putting all this together, it becomes clear that a large number of sexually active young people do not use foolproof birth con-

trol every time they have sex. Sheila, in this sense, is a member of the majority.

The central factor separating poor and working-class youth from the middle and upper classes on this score is that financially privileged young women who find themselves pregnant before they are ready are more likely to get an abortion.[7] I asked Sheila if she had thought about having an abortion.

> *Oh no, no. Well, I can't say it didn't cross my mind. But I'm a person who believes if you're gonna play, you're gonna pay. And it's not her fault. I'm the kind of person who thinks that, as soon as they have that heartbeat, which is like ten days after conception, then that's a live human being. I just couldn't do it. I love my daughter.*

No matter what we might think of the consequences of this choice in the context of Sheila's life, the vast majority of Americans agree that she has a right to make this decision. And few would argue that her problem, in this instance, is a problem of bad values.

There is a third important pattern that Sheila shares with the majority of welfare mothers—the pushes toward work and the pulls toward home. The stress associated with those pushes and pulls is something welfare mothers have in common with parents of all classes and backgrounds. Sheila's desire to stay at home with her daughter is no different from all the other working moms who long to have more time to spend with their young children. Her longing for a job flexible enough to allow her to care for her child is shared by most working parents today. Her sense of regret over taking off those career-building years in order to be with her daughter mimics all the stay-at-home mothers who worry that they will never be able to recoup their lost time in the labor market.[8] And the fact that Sheila feels committed to staying at home with her terminally ill mother puts her in the same position as the millions of (mainly) women who care for their aging parents—many of whom suffer serious economic hardship because of it.[9] What makes Sheila's case distinct is solely that these realities landed her in the welfare office.

No matter what the edicts of welfare reform might mean to Sheila in the coming years, and no matter what we might think of the paths she chose at the multiple crossroads of her early adulthood, the difficulties she has faced speak to much larger social problems. To the extent that

the Personal Responsibility Act is our collective cultural response, it is clear that this law has done little to address the underlying causes of the strains Sheila has experienced and the choices she was forced to make.

Unexpected Tragedy

Elena, a 40-year-old Sunbelt mother, was the daughter of Mexican immigrants who began their lives in the U.S. as itinerant farm-laborers and worked their way up to the working class. Elena married at age 20, went on to have three children, and, with two incomes, she and her husband were able to achieve a well-ordered middle-class life. But her husband became abusive as the children grew older. "He was violent. And he drank a lot, and drugs and all that. I'd called the police on him. All my neighbors were witnesses to the way he treated me. After the third serious beating, I said, 'One of these days I'm gonna wake up dead or something.' I had to get away from that. He was dangerous."

Elena filed for divorce and moved to Sunbelt City with her 12-year-old son (leaving her 16-year-old with her dad and high school friends, and her oldest daughter off at college). Working two jobs as a skilled hospital technician, she made $45,000 a year. She and her son were living well in a beautiful, spacious home which she owned. In the context of my research on welfare, it was stunning to visit this home—furnished in earth tones, decorated in a sparse and tasteful southwestern style, a kitchen equipped with all the newest appliances, Spanish terra-cotta tiles on all the floors, and a living room that was larger than the apartments of most welfare recipients (and almost certainly more opulent than that of many welfare caseworkers). Elena's perfectly coifed toy poodle sat on our laps throughout the interview, occasionally yapping a request for attention or treats.

On one very memorable day, nine months before I met her, Elena's carefully constructed life was changed dramatically.

> One morning, driving back home after I dropped off my son at the bus stop for school, I got hit by a truck. It totaled my minivan. It was a "semi," one of those big ones. Actually I'm really lucky to be alive, because that truck dragged me a good 50 feet. I ended up nearly hitting the house next door. It was really scary. As I was being smashed up against the steering wheel and pushed down the road, I kept thinking, "What if I hit that

> *house? What if I hit the bedroom? There may be people asleep in there!"*
> It's funny how you think things like that.

Her injuries were severe.

> *I smashed up both of my knees really bad, broke my ankle, messed up
> several vertebrae, and had some other internal injuries. But it's my head
> and back and neck that are the problem now. I'd keep getting these
> headaches and back pain that was just excruciating. It turns out I have
> two bulging disks. The doctors have me on all sorts of pain medications,
> and I'm in physical therapy, and then I take steroid and cortisone shots.
> The shots give me a high fever, and I have to stay in bed for three or
> four days after every one.*

At first she was covered by her medical insurance through work, but
after six weeks that ran out. She tried to go back to work, but the
headaches kept getting worse, the medications were debilitating, and the
doctors told her she just had to stop. No long-term disability coverage
was available from either job. And precisely because she was technically
"unavailable to work," she found that she was also ineligible for unem-
ployment benefits. She applied for federal disability but was turned
down, given the tight and demanding eligibility requirements (includ-
ing absolute proof that the disability will be a long-term disability). She
had spent all her savings, including all the insurance money on her ve-
hicle. She still wanted to sue the trucking company, but the lawyers she
contacted were asking for money up front, and she didn't have it.[10]
Then, three months after the accident, a friend suggested that she go to
the welfare office.

> *I didn't want to go to the welfare office, but I really had no choice, so I
> went. I applied, and right away they gave me medical insurance for my son
> and myself. I mean I appreciate everything that the welfare office has done
> for me and my son. But it's hard. Hopefully it's just one or two more sets of
> injections. I'm more concerned about my son than anything else, but I just
> hope I'm gonna get better and get back on my feet and go back to work.*
> *I mean, welfare it's got its good and it's got its bad. It has helped a lot
> of people. It has helped me get by. I've gotta say "just" get by. And I thank
> God for my family. They've helped me out with the mortgage payments.*

> *And so far the welfare office has allowed this. My house is $1,400 a month. They know it's only temporary. I have doctors' letters.*
>
> *I've never, ever applied for welfare before. I've always been on my own. It kind of hurts sometimes. And I do feel pressured, and there are times that I get very depressed. There's times that it feels like "am I ever gonna get better?" But I know there's people worse off than me; I've worked in hospitals and I've seen people that have really been down at the bottom. So, I try to push up my spirits.*

At the time of our interview, Elena had been on welfare for six months. If not for the financial support of her family and the welfare office, she and her son would be out on the street.

There is every reason to believe that once Elena's medical problems are solved, she will be fine, able to go back to work and pick up where she left off. She has a strong work ethic, she helped her parents in the fields from the time she was very young, and she had worked steadily at regular jobs since she was 18 years old. She had plenty of work experience. Both of her former employers wanted to hire her back again. And her now 14-year-old son had been taking care of himself after school since he was 12 (in safe neighborhoods and with good after-school programs), so Elena felt relatively free of childcare woes.

Overall, Elena was fully recognizable as a member of the middle class—in her demeanor, her mode of dress, her mannerisms, her verbal style, and her absolute expectation that welfare caseworkers would, and should, treat her seriously and as a social equal. And she had been very successful in demanding her rights ever since she entered the welfare office. In listening to her story, it seemed to me that her middle-class cultural skills as much as her disabilities had protected her from the work requirements—she had not been asked to do a job search or attend training courses or take an unpaid workfare placement. Certainly Elena inspires more sympathy because she fell from middle-class status. But to flip over that coin, one could also label Elena as a certain kind of welfare "cheat": given that her family was financially able to cover her mortgage payments, she might well have moved out of her lovely home into a small apartment and used that familial assistance to cover her monthly bills, avoiding welfare altogether. Of course there are very good reasons to argue that Elena had suffered enough, had worked hard for all that she had, and should not be forced to give it up. The point is, even

though she fell from the middle class, Elena is arguably neither more nor less "deserving" than any other welfare recipient.

The pattern of Elena's life is a widespread pattern mimicked by all those women who have proven themselves perfectly capable of getting and keeping jobs, but have nonetheless landed in the welfare office as the result of unexpected tragedies. This pattern is similar to "the domino effect," yet points to the reality that a single major life event is sufficient to push a mother over the edge and on to welfare. And this can happen even to a middle-class woman.

Elena is at the extreme end on a continuum. It is fairly unusual for someone with a $45,000 income to end up on welfare. But the majority of welfare mothers have demonstrated their capacity to manage on their own, as national statistics testify.[11] Connie, an Arbordale welfare mother I met, had been working for nine years as an activities coordinator for a convalescent home, but state policy changes turned up a juvenile record of criminal activity (a record that would have been sealed but for a bureaucratic snafu) that lost her that job and, with three kids to care for, sent her to welfare. Jillian had ten years of work experience and 6-month-old twins when her husband left her; they had just relocated to Arbordale and she had no friends, no family to turn to, so she turned to the welfare office. Leslie was living comfortably until her messy divorce led her angry husband to put sugar in her gas tank and left her simultaneously without a car and forced to move to escape further incidents. The pattern in these life events is not a mystery to welfare researchers who consistently note that the two central paths to welfare are changes in one's family situation and changes in one's work.[12]

Most welfare mothers get back on their feet sooner or later. But all these women also sit at different points along the continuum. The group at the top, with Elena, will move out of poverty and most will never return to the welfare office. Another group, in the middle, will find work but a good proportion of them will never move out of poverty, no matter how many hours they put in on their jobs. A third group may be able to find some kind of work, but personal and familial difficulties coupled with low skill levels are likely to lead them right back to the welfare office in a relatively short period of time.

One instructive analysis for considering this spectrum is research conducted by the Educational Testing Service (ETS, the organization that constructs and oversees college entrance exams). According to ETS

evaluations, a full two-thirds of welfare mothers lack the skills to escape poverty given current wage rates and the fact they have children to support. At the top of the scale are the 32 percent of welfare mothers who have the advanced or competent skills that will allow them to escape poverty. In the middle are the 37 percent who have basic skills, similar to high school graduates—these women can get jobs, but the jobs will not pay enough to raise them out of poverty and will also not be the kinds of jobs that allow for advancement. At the bottom are the 31 percent of welfare recipients who have minimal skills, similar to high school dropouts, and are qualified for only the very lowest paying jobs, if any.[13]

This ETS rendering closely matches the outcomes for former welfare recipients thus far—about one-third move off the rolls and out of poverty, one-third work but remain in poverty, and one-third leave the rolls without work (see Chapter 2).[14] Yet, skill levels are not the only thing represented by these proportions. On the one hand, ETS figures neglect those women whose determination and survival skills and actual talents extend well beyond what is measured on standardized tests. On the other hand, these testing service estimates also neglect the families who have problems that extend well beyond their measured skills—problems with serious disabilities and unexpected hardships, and problems in managing simultaneously the care of children and the demands of the workplace. Thus, as competent and determined as many of the poor mothers I encountered were, the ETS ultimately provides a strong indicator of the results we can expect from welfare reform over the long term.

In any case, the continuum of welfare recipients, like the continuum of the ETS, clearly highlights the inadequacy of the "work-first" incentives of the Personal Responsibility Act. And the contingencies of day-to-day living illuminated by Elena's case further underline that hard work and dedication are insufficient for avoiding welfare. The central point, not to be missed, is that none of these women are "born to welfare," and the categories of poverty and welfare receipt are constantly moving targets.

Problems of Mental Health

Diane had been depressed for a very long time. From what I could tell, she had been suffering from mental health disabilities for nearly 20 years. At the time I met her, she thought that she was beginning to come

out of it. She was 43 years old. She started on welfare at age 40, right after she gave birth to her second child, a son.

She lived in an old and run-down housing project in Sunbelt City. The staircases were unsafe, the parking lots were full of trash, the buildings hadn't been painted in what seemed like decades. Inside, the drapes were tattered and torn, the carpets were stained and full of holes. Diane's apartment was sparsely furnished with a ragged mix of odds and ends. But it was clean, or as clean as one could make it. Her three-year-old son was napping through most of our interview. Diane fed him dinner as we finished up.

From a cursory glance at her history and present circumstances, Diane might appear to lack both a work ethic and family values. She hadn't worked more than part-time for many years; she was once divorced with a full-grown daughter from that marriage, and now a young son born out of wedlock. She was overweight and seemed sloppy, with ill-fitting clothes and uncombed hair. She left the TV on throughout the interview and on the surface didn't seem to take much more pride in decorating her home than she did in dressing herself. Even when she laughed, which she did often, she seemed almost too boisterous, too crude. And her sense of humor was dark and sarcastic. But after spending time with her, it was clear to me that she cared very much about both work and family.

Her parents were school teachers, and her dad worked a second job to support their seven children. Her mom was an American Indian, her father white. Diane told me that her mother "always wanted to have a big family, and she thought her mother role was to have as many children as she possibly could. But she was a mean mom. She didn't really like kids; she didn't really want to spend any time with them." As the oldest daughter, Diane helped to raise all her younger siblings and proudly recalled how she had regularly cooked dinner for the whole family from the time she was 11 years old.

Diane started working at a discount store chain at age 15 to help with the family finances. She told me she was also highly successful in school and had a clear sense of her own potential: "I thought I was going places. I was going to *be* someone." But at age 17 her parents found birth control pills in her room, and "forced" her to marry her boyfriend. "My parents called him up and told him that we were getting married. He said 'okay.' And a month later we were." Although this was a sort of

"shotgun wedding," Diane wanted to make it clear that she was *not* pregnant at the time.

Her husband turned out to be physically abusive, and also had multiple affairs with other women over the course of their marriage. They had a baby daughter when Diane was 24. By that time, Diane was the manager of three discount stores. Hoping it would improve her marriage and stop the abuse, she quit her lucrative position to become a stay-at-home mother and housewife. In the years that followed, her husband, who had started out as an auto mechanic, eventually became a well-paid professional, supervising all employees of the state maintenance division. They lived in a beautiful home which Diane kept "immaculate": "You could eat out of the toilet if you wanted to. It seemed like the perfect life—from the outside. And I was a good stay-at-home mom. Girl scouts, brownie leaders, all that."

But that marriage was the beginning of Diane's emotional problems. The abuse did not stop.

> *He beat me really bad, for a long time. Once he locked me in a closet for two days. I ended up in the hospital more than once. And he was a real big cheat. I always knew he was a cheater, for years and years. It got to the point where it was like, "just tell me because I really am getting humiliated here." And I developed my own method of madness. I was like a very depressed person for a lot of years.*

After 13 years of marriage, and 13 years of violence, she finally left her husband. She was then 31 years old. She was devastated. Although she and her husband had joint custody of their (then seven-year-old) daughter, her daughter stayed primarily with her father: "He had more money, he could buy her anything she wanted, and it was more stable." As she later explained, she began drinking heavily at the time of her divorce, and she knew that her husband had never been violent with their daughter, "so it seemed best for her to stay with her dad." But this was clearly a difficult time for Diane, and the memory of it brought her to tears. At that moment in time, her life seemed emptied of all she had ever known.

After the divorce, she took a job as a topless dancer. It was one of the best-paying jobs available, and it also seemed to fit her state of mind. The drinking problem continued.

It had been a really terrible divorce, and I saw the way men were and the way men treated women. And I thought, "Well, I better just go work at a topless bar because I know already what the scoop is. Maybe that way I'll get cash." I mean, I could just say to men, "If you want to talk to me you've got to give me some money. Otherwise, I've got better things to do." Of course I had to take my clothes off and make my money doing that. But I could tell those men if they wanted to sit down and spend some time with me, they had to give me some money.

It was such a horrible time for me. I drank a lot. I made like 400 or 500 dollars a day and I blew it all. Blew every dime. It was horrible. And I had been a full-time mom, a housewife! Now I've changed my lifestyle completely. I've been there. I won't go back.

She quit working as a topless dancer after four years. She applied for food stamps and subsidized housing. She stopped drinking, cold turkey, and never took it up again. She had a string of low-wage, temporary jobs, and took in boarders to make ends meet.

I basically just cleaned houses and stuff. I had manual jobs, nothing really challenging. The way I survived was the fact that I had subsidized housing. I'd have somebody staying here, and I would charge them rent. So I'd pay my power bill with that. They were all just fly-by-night people; most of my furniture comes from the fact that I confiscated stuff when they left. I'd get my $200 in food stamps. And then I bargained and stuff.

Then Diane met and fell in love with the man who became the father of her son.

I thought we would get married. I thought I could build a new life. But he left, went back to Mexico for all I know. I have no clue where he went.

I would have gotten an abortion, but I had no money. Medicaid wouldn't pay for that. And those people say they want to stop single parenting! But now, well, I couldn't live without my son. I'd never give him up. I needed somebody in my life.

The day her son was born, at just 3 pounds, 5 ounces, a hospital social worker suggested to Diane that she apply for welfare benefits, to allow her the time to properly care for the fragile health of her underweight baby.

Diane had been on welfare for three years by the time I interviewed her. Since reform, she'd participated in one training program after another. She wished that she could have just stayed at home with her son, "at least until he was three; it's just not right to put him in day care when he's so young." Still, in listening to her, it became clear that the opportunities offered by welfare reform had been good for her, despite all the hassles, all the buses, and all the problems with childcare she recounted. She took an unpaid workfare placement at the welfare office, answering phones ("I now know all the rules") and also completed an unpaid placement as an assistant to the dean of a local community college ("that was my favorite; it was really challenging"). She took a course in medical assisting ("I passed with flying colors, only to find out there were no jobs"), a course in computers ("my typing skills have really improved"), and finally a class in medical billing and client services. She excelled in that course as well, and "they offered me a job right away, but I just couldn't coordinate the hours they wanted with the buses and the childcare schedules." Diane summed up her training experience positively (unlike nearly every other topic we discussed, with the exception of talk about her son): "All that was great. It was. I really learned a lot. Everyone thought I was very smart."

At the time of the interview, Diane had a job in phone sales. She'd been working there for a little over a month, and she hated it: "It's just bilking little old ladies out of their credit card numbers." She had also put herself on the employment lists at a number of hospitals for billing services, and she expected to hear something soon. She was still collecting her welfare check, thanks to the income disregards, but her two-year time limit was due to run out in four months.

If one were to simply take a snapshot of the last ten years of Diane's life, some people would find it easy enough to label her as undeserving. She'd been "using" the system of subsidized housing and food stamps for years. She did nothing but clean a few houses and operate an illegal flop house. And then, a full-grown able-bodied woman, she went on welfare after getting pregnant with some fly-by-night man whom she thought she loved. She only went to work when she was forced to.

Yet that portrait ignores the problems she has faced in trying to recover from her disastrous, abusive marriage. And from Diane's point of view, she was doing better than ever. She wasn't being beaten, she wasn't drinking, and she wasn't taking her clothes off for men. She was getting

out, learning new things, and caring for her son: "I read him two books a night, and fix his breakfast and lunch every morning. I spend every minute I can with him." And she was imagining, for the first time in nearly 20 years, that she might have a better future. From this perspective, welfare reform had been very good for Diane, as had the birth of her son who, she said, "gave me a reason to live." Of course, if she faced further emotional or financial setbacks as her son was growing up, the requirements of welfare reform might have a very different long-term impact.

The road to the welfare office was clearly a downward spiral for Diane. Her life was a story of a balancing act between seeking independence and caring for others. And the problems she has had in her relationships with the men in her life are, as I've suggested, quite prevalent.

Furthermore, Diane's mental health problems, though relatively invisible to the casual observer, were nonetheless serious and matched by those of many other welfare mothers. The depression she spoke of was more than a run-of-the-mill unhappiness, and it had persisted through to the present. She told me that she could barely get out of bed during the first year and a half of her son's life. Before the welfare office made her take a workfare placement, she would just stay home all day: "We'd just eat and sleep and eat and sleep. That's when I put on all the weight [over 100 pounds]. I just couldn't leave him alone for an instant. And sometimes I wouldn't take a shower or wash my hair or go out of the house for weeks." Overall, Diane's behavior fits quite well with clinical definitions of mental health disorders—from the "method of madness" she devised in her marriage, to the drinking and topless dancing, on to the massive weight gain and shut-in practices after her son's birth. Although Diane had never visited a specialist, she knew full well that her life had been off-kilter.

Official statistics compiled for the U.S. government estimate that from 4 to 39 percent of welfare mothers suffer from mental health disabilities serious enough to make it difficult for them to get and keep jobs. Other reports, reviewing local-level studies, offer ranges from 12 to 56 percent. The wide variation in these percentages, drawn from local, state, and national sources, results from just who is doing the counting and what, exactly, they consider sufficiently serious. Nonetheless, as the official accounting notes, welfare recipients are at least twice

as likely as nonrecipients to "meet the diagnostic criteria for an affective disorder." The National Institute of Mental Health concurs, finding that low-income individuals are two to five times more likely to suffer from a diagnosable mental health disorder than those in the highest income groups. And people who have these kinds of mental health problems, no matter what their class position, have unemployment rates that run as high as 70 to 90 percent.[15]

Sonya, a 20-year-old black woman from Arbordale with two children and a tenth-grade education, was another welfare mother with mental health problems. Like Diane, she had not been officially identified by the welfare office, and given her shy, compliant, and private demeanor, I was not surprised. Sonya was a compulsive cleaner and organizer. She told me that she felt compelled to rearrange her entire apartment at least once a month and sometimes once a week. And her apartment was, in fact, perfectly arranged and absolutely spotless, ready for any white-glove inspector who might appear. She fed her youngest son lunch during our time together, and she could not continue our conversation until she had made sure that every crumb was cleaned up and all counters were disinfected, twice (for good measure). She also had a hard time imagining how she would ever manage to keep a job, since she found it necessary to take four showers every day. She thought she might be able to time the showers for just before work, at her lunch break, and then a couple of times after work, but that would have to be very carefully planned. And she didn't know how to drive, so she'd have to rely on buses running on schedule. More than this, there was an additional problem—she was absolutely convinced, and actually nearly terrified, that if she left her house with wet hair, she would catch a cold, or pneumonia, or worse. Thus, she always stayed inside for at least an hour after each shower.

Sonya had been employed only once in her lifetime, and managed to keep that job for just four months. A prolonged illness got her fired—an illness brought on, she guessed, as a result of wet hair. In responding to a question about the men in her life, Sonya also let me know, quietly and in an emotionless tone, that her father had sexually abused her as a child. At the time I met her, Sonya was being sanctioned for her failure to carry out her job search.

Another mother, Ines, had survived sexual abuse at the hands of her stepfather only to have her own daughter, at age four, face the same

form of repeated abuse from her great-uncle. In the meantime, Ines had just escaped a physically abusive relationship and had moved in with her alcoholic male cousin. Ines was completely unable to identify any men she knew who lived working lives free of drugs, alcohol, criminal behavior, or violence. She was not the least bit bitter about this; she was simply resigned and somewhat curious as to whether it could be otherwise. Her daughter was sweet, shy, and withdrawn.

Unlike Diane and Sonya, Ines' problems had been identified by the welfare office. Her concerns about placing her daughter in childcare led her caseworker to probe further; this brought out the story of the sexual abuse of her daughter and the sexual and physical abuse Ines herself had suffered. Under the special services offered in Sunbelt City for domestic violence survivors, Ines and her little girl were both in therapy and temporarily immune from the work requirements of welfare reform.*

Taking into account the wide range of statistical measures, one could safely say that 10 to 20 percent of welfare mothers suffer from mental health problems sufficiently serious to prevent them from maintaining stable employment. Alongside the shut-ins, the profoundly obese women, and the incest and domestic violence survivors, I encountered women on lithium, ritalin, and powerful antidepressants that left them unable to work a full day. The Personal Responsibility Act leaves it up to the states to deal with all these cases as they see fit. But, as is true of problems with childcare subsidies, the limitations on exemptions along with the pressure to maintain work participation rates and decrease the size of the welfare rolls make it virtually impossible for state programs to exempt all mothers with mental health disorders from the requirements of reform.

I was glad that Ines and her daughter were (at least temporarily) under the protection of Sunbelt's social workers, and I was hopeful about Diane, since she was capable, smart, and not the least bit shy, and she really did seem to be on the road to piecing her life back together, barring some unforeseen setback. But I worried a lot about women like

* It is worth noting that Ines, 21 years old and a first generation U.S. citizen who came from Mexico at age five, found the language and logic of therapy foreign and would have preferred to spend her afternoons seeking work. Still, she was glad her daughter had someone to talk to. On the prevalence of sexual abuse in the lives of welfare recipients, see DeParle (1999) and Browne and Bassuk (1997).

Sonya. She was so quiet and shy that people were very unlikely to even notice her.

Observers might wonder whether mental health disabilities are the causes or the consequences of the hard lives that these women have experienced. From the broadest perspective, it makes sense to think of these emotional difficulties as consequences, but consequences that often operate in a reciprocal fashion, leaving one at the bottom of a well from which it is difficult to emerge. In any case, it's nearly certain that mental health problems will interfere with the ability of some of these women to sustain economic self-sufficiency under the terms of welfare reform. It matters not how much they would like to be independent or how much they wish they could achieve a stable family life. Their dreams and good intentions, at least for the time being, are likely to prove inadequate.

Physical Disabilities

Christine is blonde, blue-eyed, and beautiful. At the time I met her, she was 24 years old and living in a relatively new apartment complex in Arbordale, with her rent subsidized by the state. She'd never been married and she had an eight-year-old daughter. When she told me her story, she emphasized that she came from a good and stable home. Her father was a military man who later became a police officer; her mother was a stay-at-home mom, caring full-time for Christine and her two sisters. At age 15, Christine's life was turned upside down—her mother was diagnosed with advanced-stage cancer and told she had less than a year to live. In the midst of the turmoil, Christine took one too many risks, and became pregnant.

Just a few months after her mother died, Christine had her baby at age 16. But it was not the unwed childbirth that led her to the welfare office (at least not directly). Just six weeks after giving birth, Christine had suffered a severe stroke.

> *I had a real, real bad headache at school one day. I remember I laid my head down. And I was like, "I just need to go home." I tried calling my dad, but he wasn't there. Then I just fell on the floor. I was in a coma, right there, at Desert Sands High School. I had had a stroke.*
>
> *I was in a coma for six days. My dad and my uncle were gonna take me*

off the machines. And then I came out of it. I stayed in the hospital for six weeks. I still don't have any use of this arm, and this leg is a little bit bigger just because I had to build all the muscles back up.

That stroke had led to long-term disabilities, as will become clear.

At first it was the medical bills that led Christine in the direction of the welfare office. Her father had medical insurance from both the military and the police department but, given Christine's prolonged hospital stay, they were still left owing well over $100,000. With the help of her father and others, Christine eventually managed to have a portion of those bills paid through Medicaid and began to receive food stamps at the same time. Christine was eligible for her mother's social security insurance as long as she remained in school; she went back to finish high school and went on to take courses at the local community college. These educational institutions were sympathetic to Christine's continuing medical problems, so she was able to take time off whenever she became ill.

Christine didn't begin to receive monthly welfare checks until she was 20 years old. Still, she realized that she started down the road to welfare the minute her baby was conceived. And she knew that she was way too young to have a child. She said she'd led a sheltered life—"I was daddy's baby girl"—and didn't know anything about birth control. And maybe, she reasoned, the fact that her mom was so ill with cancer at the time made her reckless. "But there's really no excuse for it," she added. Once she realized she was pregnant, she tried to hide it from her parents, especially given her mom's illness and her sense that the family was already facing more stress than they could handle.

Her father found out about the pregnancy only after her mother's death—and by that time Christine was already seven months along. Her father was initially determined to get her an abortion.

My dad took me to the doctor's and they gave him all these addresses for [a neighboring state] where they could do late-term abortions. I was freaked. I'm like, "I want my baby." But my dad wanted me to do it.

And we drove all the way to [the neighboring state]. We walked into this clinic that wasn't even as big as my house and it was dirty and dark. I'll never forget it. I was just sitting there, I was shaking. And my dad's this big Italian, strong guy, you know, and he's Catholic. He's just looking at all these little girls and stuff and he's like, "Oh my God, oh my God." I

started crying. My dad said, "You're not gonna do it." So we just left right from there; we left all our clothes and stuff in the hotel, and we just drove straight back.

And my dad kept trying. He took me down to the Catholic charity adoption place to put my baby up for adoption. We went there, but they needed Doug's [the father's] signature for me to put the baby up for adoption. Doug was not gonna do that. He went and bought me a big old jacket and a car seat and said, "No, I'm not signing the papers." So I really didn't have a choice.

And my daughter looks just like my mom. My dad calls her his "little princess." So we had tried, but now that I think about it, there's no way I could have ever given her away.

Christine loves her daughter and said she would go through it all over again just to have her, even though she wished things could have been different. Still, it is quite likely that the pregnancy is what brought on the stroke, and the stroke and its underlying causes led to the disabilities that had kept Christine on welfare for four years. Her medical condition made it difficult for Christine to work a full day.

Since my stroke, I've been in the hospital about 25 times for under a week, and about 10 times for a month or more. A year and a half ago I was in the hospital for over three months. My doctors keep saying, you can't go to work.

At one point I was like, forget it, I'm gonna go to work anyway, I don't care what the doctors say. And I went to work at a day care center. It was just as a sub, so they'd call me and I'd only work on days I felt good. But even then I would get my headaches, and fainting, and this would happen at just any point in time. I could just be standing there and all of a sudden my head would just go, and I would start to cry, and I'd have to leave work. So that was it. I couldn't keep the job. I was unavailable too often.

I was in the hospital just two weeks ago, for three days. I went in because my head was hurting so bad, and my dad walked in my house and saw me and said "Get in my car—now!" And my doctor was like, "Call an ambulance, call an ambulance!" And that's when I just fainted out. They thought I had spinal meningitis, but now they're saying they don't know again. They have no idea what it was.

I'm on four different medications, and I practically live on Lortab [a

powerful pain medication]. I don't even take them unless I feel like I'm gonna die, because I don't want to be addicted to 'em. It's hard.

The father of her daughter had not been of any help. From the start, he appeared unwilling to take responsibility for Christine or his child, and Christine broke up with him when their daughter was six months old. At the time of our interview he was in prison for murder.[16] It was clear that he was not the answer to Christine's problems, regardless of welfare reform's suggestion to the contrary.

With the help of her sister, father, the housing subsidy, and her welfare check, Christine had been living a fairly secure existence as a stay-at-home mother. She dedicated herself to her daughter, walking her to and from school everyday, baking cookies, helping her with her homework. She told me that she loved it, but also felt a bit guilty about it.

> *I wish I was married, 'cause I like being a stay-at-home mom. I have to admit it. I don't want to go out to work and have [my daughter] Jessica have to go to daycare every single day. I like to help her with her homework and spend time with her. And that's how it should be. I should be married so my husband would go out to work and I stay home. That's how America's supposed to be. It just doesn't work like that all the time.*
>
> *Jessica plays soccer, Jessica plays baseball, so I can take her to all of her practices. And it sounds kind of wrong but welfare's a good fallback. When her practices are at 4:30, some of the kids can't make it because their parents are at work, but I'm there, you know? And I'm there for her, when she's sick she can stay home, she doesn't have to go to daycare. When I was little my mom was always home, I remember my mom being there, and me calling my mom from school when I was sick, and it was good to have her there.*
>
> *But then I know it's not right to make other people pay for my mistake. Jessica's not a mistake, God forbid if she is, but it's just not right for me to have you pay for my mistake. It's not right for me to be able to be on welfare for so long. And I know that, but there's nothing I can do right now to change it.*
>
> *Me and Jessica, we spend so much time together. Today, at this very moment, she's being tested for the gifted program because she's so smart. She's on the fifth-grade reading level and she's only in second grade. She's doing division, multiplication and it's really cool. And I think a lot of it*

was me staying home and reading with her you know and working with
her. It made me a lot better mom because I got to spend time with her.

It appeared to me that Christine was not only apologizing to us for
spending our tax dollars, but it was almost as if she was promising to
pay us back by raising a "gifted" daughter. And Christine did more than
that to try to compensate for her welfare use.

Like a handful of other welfare mothers I interviewed who seemed to
act as local den mothers or camp counselors for the neighborhood chil-
dren, Christine regularly took care of her friends' children and many of
the children living in her complex. There was BB, for instance, the child
of one of her friends who spent her nights "partying" and "sleeping
around" and never seemed to have enough time to watch her seven-
year-old son: "She'll drop him off here at one in the morning, and it will
be a school night. And he knows how to open my front door with a
credit card! Now what is that?!?" BB spent most afternoons with Chris-
tine. And then there was Shantalle, the "sweetest little girl" who lives in
the "crack house" across the way: "There's ten people living in that
apartment! And there's never any food in that house, and they send her
out at all hours to do their errands. Last week I just had her sleep at my
place after they'd sent her to the store and then got so wasted that they
forgot and locked her out. I try to watch out for her." Christine was also
providing (unpaid) childcare for her working sister's five-year-old. And
Christine not only provided these kids with food and toys and her time,
but also discipline (of the sort, she implied, they didn't get at home).
"They pay attention to me. At my house you know that if you don't do
what I say, you don't get to play Super Nintendo, or you have to sit in the
corner until you're ready to behave. Time out; it works. BB never talks
back to me like he does to his mom." I had to wonder how these children
would fare without her.

Welfare reform was just about to change dramatically the life that
Christine had constructed for herself.

I understand the whole purpose of welfare reform. I understand. I
know a lot of people whose moms were on welfare, and now they're on
welfare. So I can understand the time limits. But, to tell you the truth, I
didn't even think about it when they did the two-year time limit. I didn't
actually even recognize it until one day my caseworker said, "Christine,

December is your last month." And I was like, "Oh my God, really?" I never thought of it. I guess that's how people stay on it so long.

I realize that the whole reform thing came about because everybody's taking advantage of it. Sixteen-year-olds are having babies (like me). I understand. I think people should think about it, plan their kids, that's what I think. I mean I also understand there are accidents. But I completely agree that you shouldn't bring someone into this world when you can't survive in it yourself.

And for Jessica, I don't want her to think that it's okay to get welfare, because it's not. Welfare's supposed to be a temporary thing, it's not supposed to be a permanent thing. When she was little I didn't care, but now that she has all her friends and everything, you know, I don't want her to see me on welfare.

For all her reflective understanding of reform, Christine was nonetheless worried. She continued.

Still, right now I've been having three and four doctors' appointments a week. How am I supposed to keep a job? And how will I handle the medical insurance? Nobody will cover me because of my stroke and how I'm so sick. My dad has even tried Budget Health Care Company, and nobody, nobody will cover me.

It's not that I don't want to work, because I totally want to work, make my own money. Like, I tried to join the military because that's what Dad did and it answered all his prayers. But I tried it when I was 22 [two years ago] and they wouldn't accept me because of my stroke, and my medical condition.

I can get a job, the problem is holding it. That's my big fear is to get off the system and everything else, but then if I lose my job I'm gonna be right back on it, and that's something I don't want to do. If they could just find out what I have and figure out a cure, then it would be a whole different story.

And I want to work. I really do. But what should I do?

What should she do?

Information prepared for the U.S. Department of Health and Human Services estimates that from 10 to 31 percent of welfare clients suffer

from physical disabilities that either limit their ability to work or make them incapable of working. As before, this range is based on different sources with different estimations of severity. Another review of existing research drawn from multiple local-level studies estimated that over one-fifth of current recipients have physical impairments limiting their capacity to work. A recent study by the U.S. General Accounting Office, following the same methods used to track disabilities nationwide, found that a full 44 percent of welfare mothers report some form of physical or mental health disability—a rate that is over three times as high as the national disability rate (16 percent). Some of these impairments are temporary, some more lasting. For more than one-third of TANF recipients, the General Accounting Office notes, these disabilities are "severe enough that the individual was unable or needed help to perform one or more [simple, everyday] activities, such as walking up a flight of stairs or keeping track of money or bills."[17]

Thinking about the disabled welfare mothers I met, I remembered Julie—I was at the Arbordale welfare office when she came in for a follow-up interview. She had been working full time and making ends meet until she injured her knee during a weekend softball game. She lost her housekeeping job, and had to undergo knee surgery. At that Arbordale meeting, she was on crutches and still trying to heal. She couldn't walk, stand, or sit comfortably. As was true for Elena, federal disability wasn't available for such a short-term case, and there was no coverage from her former employer. Her Arbordale caseworker told her that she must immediately go on a job search. Julie asked what kind of work she could hope to find, since her only experience was in food service and housekeeping, both of which would require her to spend long hours on her feet. "I have three kids to worry about! What am I going to do?" The caseworker could offer no alternatives, and simply told Julie that if she failed to comply she would be sanctioned. Julie hobbled out of the office, angry and discouraged.

Celia, another Arbordale welfare mother I met, was 26 years old and had recently been diagnosed with cancer. Her doctors wanted to start chemical and radiation treatments soon. She had a four-year-old son and a six-month-old daughter. With her eighth-grade education, she had what she described as a "good" job, working at a local photo shop for minimum wage. She lived in a tiny studio apartment with her two kids and remained connected to the welfare office solely to receive the

temporary help with childcare and transportation. One could only guess what she would do when the treatments began. But she had already asked, and her employer was unwilling to be flexible about her work schedule—she was too easily replaced. I told her about Social Security Disability, but I also told her it was a long shot even in severe cases like hers, as I'll explain in a moment.

I also encountered a number of welfare mothers who were taking care of disabled others. You will perhaps recall, for instance, the mother in the Arbordale waiting room who cared for both her grandchild on a lung machine and her terminally ill father. There was Sheila who was afraid to leave her wheelchair-bound mother at home alone. Another mother I met had a five-year-old daughter with a heart ailment so severe that she had recently been diagnosed as terminal. The fact that this little girl required full-time, round-the-clock care had forced her mother to give up her (relatively) well-paid secretarial job and apply for welfare. She had nowhere else to turn.

Based on existing research, it is safe to say that at least 15 percent of welfare mothers are in a position in which physical disabilities will leave them unable to work or will limit their capacity to keep jobs for some period of time—either as a result of their own disabilities or the illness of a loved one for whom they are the only available caregiver. Clients with physical disabilities are perhaps more likely to be identified by the welfare office than those with mental health disorders, but again, the federal law reforming welfare provides no special place for them. Whether they receive special help is ultimately dependent on both the empathy of their caseworkers and the number of exemptions the state is willing to provide. The U.S. General Accounting Office report found that a full one-half of the local welfare offices they contacted (in a random sample) were unable to offer *any* information on the number of disabled welfare recipients they served—those offices did not, in other words, have any procedures for identifying and tracking clients with disabilities.[18] So far, Christine had not been exempted. As I've noted, Arbordale provided few exemptions (by state rules); Sunbelt offered some, but physically disabled mothers had to share them with those who had mental health problems, domestic violence problems, childcare problems, literacy problems, and problems with English (as a second language).

No matter how benevolent the state, it is likely that some women will

fall through the cracks. And the new, less flexible, work participation rules that were making their way through Congress in 2002, would make such exemptions even harder to come by (see Chapter 8).

A related issue that is falling through the cracks is brought to mind by Christine's case. I was able to reassure her that the state would continue her medical coverage as long as she was indigent, even after her TANF time limits were reached. Given her condition, it may seem surprising that no one had informed her of this, but this omission appears to be a relatively common one. Welfare reform, which left Medicaid and food stamp eligibility relatively untouched for most welfare recipients, has nonetheless been accompanied by a steep and largely inexplicable drop in Medicaid and food stamp usage. Part of that drop is a result of the five-year ban on benefits to legal immigrants who came here after 1996, and part of that drop is the result of welfare reform's more general pressure to keep people away from the welfare office. Although this may be saving taxpayers some money, policy institutes have warned that this is leaving many poor and working-poor families without sufficient food and medical care and has contributed to the increase in extreme poverty among the poorest of the poor.[19]

There is one final very important story behind the existence of disabled people on welfare. Many disabled welfare clients and disabled family members, including all those who suffer from serious mental health disorders, would have once had a better chance to receive federal disability benefits. The eligibility requirements for disability payments have been progressively tightened since 1981, leaving many disabled people with nowhere to turn but the welfare rolls.[20] The Social Security Disability system officially defines disability as an "inability to engage in substantial gainful activity" that is expected to last for at least a year, or result in death. As the General Accounting Office points out, benefits are provided only for people who cannot engage in "any kind of work that might exist in the national economy." And the disability system makes its own determinations on who meets these criteria. The system also requires a lengthy application process and is so complex that many law firms specialize in nothing other than helping people make disability claims.[21]

Since most welfare mothers cannot afford to hire their own attorneys, it is perhaps not surprising that many are deemed ineligible for this federal program. Sheila's mother, with an oxygen tank, a wheelchair, and a terminal condition, did receive disability benefits. Welfare case-

workers assured me that the five-year-old with the heart ailment was nearly certain to be eligible since she was also terminal, but her mother was still waiting to hear and, even if the results were positive, she would still need to be on welfare until all the paperwork was processed and the first check arrived.*

On the other hand, like Elena, Christine's application for federal disability benefits was turned down. Both of these women (like many others I encountered) had multiple letters from doctors testifying to their condition, but these were apparently insufficient. At the time I met her, Christine and her father planned to find a lawyer who could help with the application process. No matter how you or I might feel about the relative severity of the disabilities suffered by these particular individuals, it is clear that the transference of disabled family members from the federal disability program to the welfare system is one of the many major, and largely hidden, problems of welfare reform.

There was one bright spot on the horizon for Christine. Her boyfriend of 18 months had recently been accepted to the police academy. If he was successful and got a job on the force, they planned to be married. If their relationship could weather Christine's illness and her upcoming struggle for medical assistance, Christine might well be able to realize her dream of "legitimate," unstigmatized, stay-at-home motherhood after all.

The Question of Welfare "Dependency"

The generational transmission of poverty and welfare receipt is a central concern among policymakers and the public. Particularly disturbing is the idea that poor women would have children out of wedlock specifically because they wanted to get a welfare check. Many welfare mothers agree that this happens and that it is a very serious problem. Yet, only one of the scores of welfare mothers that I encountered actually stated that she herself had become pregnant just to get a welfare check. This is how she told the story:

* When and if this mother did receive disability payments for her daughter, she would be required to reimburse the welfare office for the welfare checks she had received. Of course, by the time that happened, it is quite likely that her child would be dead.

Welfare is a cycle. My mother was a single parent, she hadn't been married. She had six kids. Welfare was a cycle with her, and then it went on to us. That's the way it happened, most definitely. It's just that people coming from single parents who were on welfare have less chance of making it or realizing they have to work. People who grew up in a family where the parents are married, and working, at least they know they have to have a job.

My mother worked on and off. I remember my mother had a job one time and worked at it for months. She used to walk miles to work and walk miles back. But other than that, and maybe one other job, she was always on welfare.

So of course when I grew up I figured, "Well, I can't get a check without a child." So there I was, I was 16, and I was saying, "I'm gonna have a baby to get that little check." Then I realized when I actually had a baby that when I tried to find a job I didn't have a sitter. And then I realized that the little welfare check that I was getting couldn't pay my rent. I didn't have anything.

But that was the type of mentality I grew up with. I thought somebody always has to take care of me or I'm just not gonna make it. I thought, "I got to get food stamps, I got to get that welfare check." I thought, "I'm not supposed to work for what I got." But you have to grow up sometime. You have to realize, here and now, you've got to work.

From the point of view of most people in this culture, it is horrifying to think of someone giving birth to a child just to get a welfare check. That Monique could say that she did this in a tone that was matter-of-fact (even if it was in the context of an ultimate condemnation) might seem all the more disturbing.

Yet this story of a calculated equation of babies and welfare checks is incomplete. Surely it is true that some proportion of poor women take welfare into account when they have their first child. And surely there are a smaller number, like Monique at age 16, who imagine that welfare is the only life path open to them. But in all cases the situation is more complicated. First, as an economic exchange, the trading of babies for welfare checks is always a lose-lose transaction. The average national benefit amount per individual is about $140 a month; in Arbordale or Sunbelt, adding a child to an existing family nets you approximately $60 a month.[22] The first check that Monique received for herself and her

newborn, in today's dollars, amounted to $220. With the exception of Monique, all the women I met knew full well the inadequacy of welfare benefits at the time they first became pregnant. All of them therefore assumed that they would get married or get a job—and if they ever had to use welfare, they imagined that it would only be temporary.

Monique's own initial account, as it turns out, actually hid another, more personal, and more complex set of circumstances. She had her first child at 17 with her high school boyfriend whom, she later told me, she had hoped to marry. They lived together, on and off, in the first year of their son's life, and they remained good friends. Even though he had since moved far away, he still visited sometimes and had been sending a small child support check every month for years. Monique did not, in other words, simply track down the first available sperm donor in order to get herself a welfare check.

Nonetheless, Monique was, in those early years, completely unsure of how to build a life for herself. As welfare's central detractors have argued, she seemed trapped in a "cycle of dependency."[23] After the birth of her son, she spent over three years on and off welfare, from age 16 to age 20. She found jobs every now and then—at McDonald's, Burger King, and a local convenience store—though she never found one that paid well enough or that she liked well enough to make a long-term commitment, and she kept going back to the welfare office.

In the long run, however, Monique is actually something of a Horatio Alger story when it comes to welfare use. By the time I met her, at age 26, she had a good job, paying $7.50 an hour, caring for patients as a nursing assistant at the local hospital. It was a day job, with regular hours and medical coverage and retirement benefits. She had begun working steadily in this profession at age 22 and had built up nearly four years of experience. She told me that she loved her work.

She had managed to stay away from welfare for almost six years, from age 20 to 26. The reason she'd gone back to the welfare office this time was because she had just been through a very messy separation, trying to escape from her physically abusive husband. Prior to the separation, she'd been working at the same Arbordale hospital where she was again employed; her supervisor knew about her situation and had planned from the outset to rehire Monique as soon as her problems were resolved. Monique's recent stint on welfare ultimately lasted only three months.

Monique is black; she has a tenth-grade education. At the time I met her, she had just settled into a rented house on the edge of Arbordale. It was a small "fixer-upper" in a poor and dangerous neighborhood, but she kept it very nice and she was proud and happy to have a place of her own. She lived with her two sons. The youngest, Milton, was just three years old, born to Monique and her soon-to-be ex-husband Carl, to whom she was married for over five years. Milton stayed with us throughout much of the interview, sometimes playing quietly, sometimes singing into my tape recorder, but always very patient and well behaved. Her nine-year-old son, fathered by the high-school boyfriend, was at school when I visited.

Marriage was what got Monique off welfare that first time. She was very reflective about her marriage, and about its connection to welfare dependence.

> I think that I have a lot to learn; I can't always blame all of my break-ups on the men because I'm sure that I have a lot to do with it. I just think it's a learning process. And when I got married I should not have gotten married. I mean that's one of those things that you need to be sure of.
>
> I'm not gonna say that I'm never gonna find a good man. But now I'm at the point where if I don't, fine, I'll be okay. And that's the thing of being independent, you know what I mean?
>
> There was a lot of dependency in my marriage. When my husband started wanting to treat me any way he wanted to treat me, well, I let him. It was an abusive marriage. I felt like I couldn't leave him because I needed to be there, because he had to take care of me. It's just like the thing with the welfare—it's a cycle. For a lot of women it's a cycle.
>
> A lot of these marriages are abusive and a lot of women do stay with these men. And it's the same thing with welfare. A lot of people stay on welfare because they are dependent on it. They feel like if they didn't have it they're not gonna survive. But you've got to be independent in yourself.

Monique's argument regarding the potential analogy of dependence on welfare and dependence on men was insightful (and heartfelt).[24] Given her emphasis on women's independence, I told her that the law reforming welfare states that marriage is crucial to social stability and points to single parenting as a major social problem. I asked her what she thought about this.

> *I don't think there's anything wrong with single parenting if you have the money to take care of yourself and your child. But I think that everybody should have two parents. You need two parents. Every child needs two parents. I wouldn't recommend to anyone to have a child without being married.*
>
> *Yes, honestly, I do think kids need a father around. I'm a woman; I can't raise my boys alone; I'm not a man. When my boys get older they're gonna have a lot of questions, questions that I'm not gonna know the answers to. I know what I read in books but that might not be enough. The man needs to be there for the children. Children are supposed to have two parents.*
>
> *But there's also that abusive thing, and it's just unhealthy for the child. You got a lot of abusive parents out there and a lot of drug-using parents. And maybe the mothers don't want to have anything to do with them. The welfare office has to know that. Even if this man is the child's father, he deals drugs or is a murderer or he's drunk or he's a drug addict or he used to beat her terribly. You need to weigh the fact that these women can't always depend on these fathers. And making these men get involved, it could be unhealthy for the women and the children. You have to weigh these things.*

On the one hand, Monique provided the perfect "mainstream" account of the importance of marriage, focusing on what's best for children. But her reasoning on this issue also included a recognition that the diversity of family circumstances ultimately requires a complex weighing of potentially contradictory goals.

An ironic, and telling, aspect of Monique's story was that it was her abusive ex-husband who actually taught her how to think about paid work, how to imagine building a career, and how to establish her own independence.

> *You know, my ex-husband he helped me a lot. He always told me, "You gotta work Monique. You gotta work in order to get what you want." And he worked with me to see what I might like to do. Before I met him, I didn't know how to really think about a career.*

And her husband apparently did a good job; it was hard to miss the clarity of her work ethic:

> *I care about people and I like what I do. And that makes a big differ-
> ence. When I was at McDonald's and the others I didn't really like that,
> so I didn't really stay. And I think it's important to like your job. But, you
> know, you make your own bed, as they say, and I got what I asked for.
> Sometimes I had to get jobs that I didn't like until I could get what I
> wanted. I worked with different nursing homes that I did not like. But I
> knew I had to work and eventually I would get where I wanted to be.*

Finally, like nearly every welfare mother I talked to, when Monique
talked about paid work, she spoke not just about her own independ-
ence and success, she also emphasized what would be best for her
children.

> *People may want to stay home with their children, and I understand
> that, but you need to work, and children need to see you work. I under-
> stand the first year especially, many people want to stay home. Thirty or
> forty years ago, yes, everyone could have stayed home with the kids. But
> then it was a different time and things were much cheaper and it was just
> the thing to do. Nowadays you need to be working.*
>
> *I work eight- and twelve-hour days. Sure I would love to spend more
> time with my children. But this is what I have to do. I mean, I think of
> how many times I have switched providers and daycare. It's a struggle be-
> cause when your children is involved you want the very best care.*
>
> *And I know I need to work in order to get what I want. Nothing's
> gonna come for free, right? I want my boys to see me working. I want them
> to see me working hard, and I want them to see me coming home tired. And
> I want them to realize that if you don't work, you don't get the bills paid.
> This is the type of mentality you need to set in your children from a young
> age. Somebody needs to show the children that nothing comes for free.*

* * *

On many counts, Monique's story followed the same patterns as many
other welfare recipients—in her difficult relationships with men, her ex-
perience with the pushes and pulls of work and home, and her early
trouble in finding and keeping jobs that paid well enough to allow her to
care for her family. She was also part of that category of welfare recipients
who had proven themselves capable of getting and keeping a job that was
likely to be stable enough, and offer sufficient benefits, to keep them

from returning to the welfare rolls. In Monique's case, her current wage rate left her and her children living just slightly above the poverty line.

Despite her current status, Monique's early history offered a vision of the worst case. At age 17, she fit perfectly the central stereotype of welfare mothers. She was a teenage mother, a high-school dropout, lacking any marketable skills, and without a clue as to how she might independently care for herself and her child. She was more than happy to simply use the welfare system and in fact had planned to do so from the start. As she suggested, she just assumed that someone else would take care of her. She seemed to be behaving, in other words, just like a dependent child.

Although this stereotype of welfare dependency is so widespread that it helped to convince the American public that they must put an end to welfare entitlement, Monique is one of only a handful of women I encountered who followed this pattern, and even then, she did so for only three years. Researchers who focus specifically on the question of whether welfare receipt is passed from one generation to the next point out that most children born to welfare mothers do not become welfare recipients themselves, and for those who do, it is primarily their poverty rather than their proclivity for dependent behavior that leads them there.[25] Nonetheless, whether raised on welfare or not, I did meet some women on welfare who were there because they were having a particularly difficult time and wanted to just rest for awhile and have someone take care of them. Depending upon how you measure it, I would guess that, at most, this represents one in 20 welfare mothers at any given time. As Monique pointed out, even dependent people "grow up"—absolute dependence on welfare is therefore almost always a transient state. The fact that most welfare mothers cycle between work and welfare and that all eventually leave the welfare rolls permanently is sufficient evidence to make this point.

But the labeling of "dependency" as a pathological condition from which welfare mothers suffer is, from the start, a twisted misrepresentation. Dependency, as a feature of social structure and as a stage in one's life course, is shared by all Americans. First, and significantly, sociologists Mark Rank and Thomas Hirschl have demonstrated that a full *two-thirds* of Americans will, at one time or another, live in households where someone is dependent on a government "welfare" program—including TANF, Medicaid, food stamps, low-income disability insurance, or some other form of low-income cash assistance.[26] More generally, all

of us are also "dependent" on government agencies to build us roads, offer us sewage systems, maintain legal order, and provide national defense. The attack on dependency further neglects the fact that all of us depend on others to take care of us, nurture and sustain us, at least part of the time. In labeling this a deviant psychological state, one misses the extent to which dependence is both widespread and the positive basis for social, familial, and community ties.

Beyond this, in pondering the position of welfare mothers it is important to remember that nearly every middle-class 17-year-old is dependent, as are most 20-year-old college students. Normally we do not name this a pathological or deviant condition. Furthermore, after facing their first real job, many middle-class youth wish nothing more than to return to the dependency of their childhood. And many of those middle-class youth will, at one time or another, return to the protective bosom of their parental home, if not fully, at least financially. In the same terms, most welfare mothers, like most middle-class youth, have likely wished for and sought out some protection from the harsh realities of the world, and some financial help to make it through hard times. But nearly all welfare mothers, like nearly all those youths, know better than to think that dependency is a socially acceptable adult status, or a desirable long-term option.

The welfare mothers I met who remained dependent on welfare for many years did so because they had come to believe, or come to know, that there were simply no other viable options for them. Given that almost all of them were "grown up" and recognized the stigma of welfare, they were also aware that their position as recipients barred them from full social membership and from inclusion as valued citizens of these United States. They were therefore hoping to change their status as soon as they were able.

Glass Houses and Imperfect Meritocracy

It is tempting to believe that the outcomes these women have faced are the result of bad choices. A number of these women *have* made bad choices. But one has to ask, against what standard are they being judged? If we held our own lives and the lives of those closest to us up to this kind of microscope, we would be hard-pressed to find any life that does not include some bad choices. Yet the consequences of our choices vary

greatly depending on where we sit on the social ladder and just what kinds of resources we have.

Most Americans want to believe that we live in a smoothly functioning meritocracy. A person who is smart, works hard, and holds the proper values will surely be able to climb the social ladder and achieve success. This vision of meritocracy stands in sharp contrast to the proposition that where people end up is a matter of fate, luck, accidental coincidence, and the socially structured position into which they were born.[27] In examining the lives of these welfare mothers, however, it appears that fate, bad luck, unforeseeable setbacks and, above all, the position into which they were born have been a good deal more important than hard work and dedication in determining their success. In other words, all those factors that Americans have long hoped were increasingly irrelevant remain very much in play.

If Sheila, Diane, Elena, Monique, and Christine were born male, all of them would be leading very different lives today. Although their life trajectories would still vary among them, the difficulties they faced and the choices they made would have been quite different for a similar group of men, as would the consequences of those decisions and experiences. Men, for instance, are less likely to find themselves parenting children alone, less likely to be obligated to provide daily care for their aging parents, less likely to be the victims of domestic violence, and more likely to have access to better-paying jobs. In the same terms, if any of these women had had the luxury of being born to middle- or upper-class parents who had sufficient resources to fully protect them in times of hardship, they would not be a part of this book.

Fate, luck, and accidental coincidences have also had a major impact on the course of these women's lives. And their odds for experiencing "bad luck" have surely been exacerbated by their position in the social hierarchy, just as their chances for recovering quickly have been diminished by that position. If, for instance, Sheila's father had not left her mother, or if her mother had not become ill, or if they had just a bit more money in a savings account, they would never have been homeless, she would never have met Sam, her daughter would not have been born, and Sheila might very well have gone on to college. If Diane's husband hadn't beat her, or if her parents had not forced her to marry, she would probably be a high-level manager for that chain of discount stores today. If Christina had not had a stroke at age 16, it is quite likely she would never have visited a wel-

fare office. If Elena had left earlier or later in driving her son to the bus stop that morning, we would never have noticed her.

Furthermore, these stories illuminate how holding the "right" values can actually have a very high cost. This seems to be particularly true if one treats the care of children as a higher moral good than one's calculated economic self-interest. It was their valuation of children that ultimately led Christine and Sheila to have their babies; without those children, they would likely be healthy working women today. If the young Diane had not given up her job to try to build a more stable family life, she could have escaped her abusive marriage more quickly and might well have been spared all those years of struggling to regain a sense of control and self-esteem. If any of these women had abandoned their children or given them away to their relatives, orphanages, or the foster care system, they would never have faced the humiliation of welfare.

No matter how you look at it, welfare policy itself was surely not the guiding principle behind these women's "choices" regarding work and family life. One would similarly be hard-pressed to name all these women as immature, undisciplined, and incompetent. And neither narcissistic individualism nor a dedication to profit maximization capture the central character traits of the majority of welfare mothers.[28] In other words, all these theoretical frames, most of them devised by scholars who have never spent time with welfare recipients in their lives, do not provide the answers to why so many American women and children ended up on welfare.

One further reality should be clear. If we were to somehow magically make this particular group of poor mothers disappear, if we were to successfully "rehabilitate" them with work-first policies and the suggestion that marriage is the answer, or if we could simply hide them away in some corner of the globe reserved for social deviants, the larger problems of inequality, unwed parenting, divorce, domestic violence, crime, poverty, and the pushes and pulls of work and home would not disappear with them.

Behind the [ghetto's] crumbling walls lives a large group of people who are more intractable, more socially alien and more hostile than almost anyone had imagined. They are the unreachables: the American underclass. . . . Their bleak environment nurtures values that are often at odds with those of the majority—even the majority of the poor. Thus the underclass produces a highly disproportionate number of the nation's juvenile delinquents, school dropouts, drug addicts and welfare mothers, and much of the adult crime, family disruption, urban decay and demand for social expenditures.

—"The American Underclass," *Time Magazine*, 1977[1]

When a critical mass of jobless people are concentrated in the inner-city community, various factors come together and conspire to produce an almost intractable result. . . . The most desperate people, particularly the young and aimless, become mired in a kind of outlaw culture. . . . And here dependency comes full circle. Welfare—or anything else of value offered by the wider society—is simply something to exploit, and one can gain status points for having done so.

—Elijah Anderson, *The Code of the Street*, 1999[2]

Chapter 7

Cultures of Poverty

EVEN IF THE MAJORITY OF WELFARE MOTHERS share the core values of most Americans, are the others still trapped in an "alien" culture of poverty? Taking this question seriously, I thought about how my middle-class neighbors might interpret the lives of some of the women I met.

Consider, for instance, Teresa, a 27-year-old white mother from Sunbelt City. With three children to care for, she received a monthly welfare check, food stamps, and Medicaid through years of working nights as a street-level prostitute. Without even a momentary break in the receipt of those government benefits, she changed her profession to the selling of marijuana. All her work in the underground economy never actually provided Teresa sufficient income to raise her family's finances above the poverty line for more than a few months out of the year, but the welfare subsidy offered crucial stability.

Darla, a young black woman raised on a military base, started sleeping with boot-camp soldiers when she was 16 and had three children by the time she was 21. She said she was "partying" hard during that period of her life and was happy enough to leave the babies with her parents while she went out for a good time. None of the fathers of Darla's children were aware of their progeny; they simply left town too quickly. At the time of our Arbordale interview, Darla was 35 years old and had been on and off welfare since age 18.

Joanne, a white welfare recipient with whom I shared a "sanction workshop," was a crack cocaine addict with four children. It was the

work rules of welfare reform that uncovered her drug abuse—her addiction made it difficult for her to attend the required training programs, and her absence sparked investigation. The welfare office subsequently sent her through two drug rehabilitation programs, but she was unable to stay clean and was back on the streets seeking drugs in no time at all. Joanne wouldn't be on the welfare rolls for much longer. Her welfare caseworker had arranged for her parents to take the two oldest children, and the younger two were to be transferred to the foster care system. Joanne would be on her own.

Tanya, a 29-year-old black woman from Sunbelt, was 15 when she had her first child. By the time I met her, she had three children from two different fathers and had been married to the second father. That marriage ended when she stabbed her husband with a knife after discovering that she had contracted venereal disease as a result of his sleeping around. She swore she would never get involved with another man for the rest of her life.

Depending on the behaviors you highlight, I would guess that such women constitute about one-quarter to one-third of the welfare rolls at any given time.[3] And depending on how carefully you examine their lives, armed with only the facts above it would be easy enough to interpret all of them as "aimless," "intractable," "desperate," or perhaps even "hostile." These characterizations of the poor arise primarily from the "culture of poverty" thesis. Like the related and more general demonization of welfare mothers, the culture of poverty thesis, first given a name by Oscar Lewis in 1961, has a much longer history and has taken many different forms. But the central premise is widely recognized and persistent—the poor remain poor because they are part of a unique culture with twisted, pathological values and practices.

According to this theory, it is the material circumstances and practical hardship of poverty—low incomes, few job prospects, substandard living conditions—that initially produce the cultural response of "deviant" values among the poor. But these distorted, yet adaptive, values are continually reinforced, theorists argue, not only by the conditions of poverty but also by the supportive cultural atmosphere thus created. For instance, as violence and illegal behavior and single parenthood become increasingly prevalent in poor neighborhoods, more and more of the poor are likely to accept these practices, and many will come to treat them as *legitimate* codes of conduct. This process is most pronounced,

we are told, in conditions of isolated, segregated poverty epitomized by the modern inner city, and generally coded as black. Most important, culture of poverty theorists argue, once deviant values and practices take hold in a community, they are passed down from generation to generation through otherwise normal processes of childhood socialization. No longer driven by material hardship, the cultural traits of the poor—cited as including a weak family structure, illegitimacy, apathy, and an inability to defer gratification—thus reproduce themselves, and thereby reproduce poverty. The result, these scholars argue, is an endless "cycle" of lazy, manipulative, and corrupted poor.[4]

Most liberal advocates for the poor have taken great pains to attack the culture of poverty thesis in all its forms. Their central concern is that this logic ultimately directs attention away from the structured economic inequalities that are the primary cause of poverty and instead leads people to blame the victims of poverty for perpetuating their own degraded position. By social science standards, there is simply no irrefutable evidence that homogeneous enclaves of cultural deviance actually exist, nor can it be definitively shown that inner-city conditions operate to culturally reproduce poverty over generations. Part of the problem is that it is virtually impossible to conclusively determine whether it is "bad values" or "bad conditions" that cause poverty in any given instance. But advocates for the poor are also quite worried that conclusive evidence (or the lack thereof) is not really the issue.[5] As I have argued, the cultural demonization of the poor is a good deal more convenient, inexpensive, and efficient than addressing the larger social problems that have created their plight.

For those of us who would like to avoid adding fuel to the fire, it is much safer and easier to focus solely on the majority of welfare mothers—all those "decent" women who so clearly share mainstream American values but who have faced hardships that prevent them from achieving mainstream stability.[6] Still, no matter how much I might be tempted to hide them from view, to keep them from spoiling the image of the whole bunch, there *are* women on welfare who seem to be bad apples, and who seem to hold at least some values and beliefs that appear alien and "deviant" according to the code of the American middle class. The purpose of this chapter is to complete the picture of patterns in the lives of welfare mothers by introducing these women, the least sympathetic of all welfare recipients, and exploring the extent to which they might be stuck in a culture of poverty.

* * *

Given all that scholars know about the operations of culture, it makes perfect sense that the conditions of poverty can produce, in the most general terms, a different culture. Social thinkers have long accepted, for instance, that one can find middle-class cultural patterns that are distinct from those of the working class.[7] But given that there are multiple middle-class cultures, multiple working-class cultures, multiple youth cultures, multiple religious cultures, multiple men's cultures, multiple women's cultures, and multiple ethnic cultures, it also makes perfect sense that there are actually *multiple* cultures of poverty.[8] The question, then, is not, "Is there a culture of poverty?" but rather, "How many cultural patterns does one find among the poor?" and "What forms do they take?"

Keeping in mind the more familiar cultures of yuppies, soccer moms, heavy metal listeners, and golfing retirees, the cultures of poverty are likely to be neither static nor all-encompassing. And, as the following stories will suggest, the cultures of poverty, like other subcultures, are *always* embedded in a particular context, are variable over the life course, and represent only one portion of the characteristics of the individuals involved. In like manner, although my opening characterizations of Teresa, Darla, Joanne, and Tanya are accurate, they neglect the complicated circumstances of these mothers' lives and the aspects of their value systems that would seem perfectly understandable (and sometimes even noble) to those neighbors of mine. The overall constellation of values, ideas, and behaviors of those welfare mothers with distinctive cultural orientations, in other words, are as multifaceted as those of any other individual, and they are just as likely to change over time. The culture of poverty thesis is thus far too one-sided and pretends to explain too much. Yet the idea that, in some cases, mothers in poverty hold some beliefs and values that are distinct from the "mainstream" middle class is both correct and significant.[9]

The more "deviant" cultures of poverty follow patterns with a particularly interesting story to tell—precisely because they represent striking forms of cultural *reaction* to massive changes in work and family life. As "socially alien" as this group of welfare mothers appears on the surface, and as much as they take positions that oppose the "mainstream," once you get inside their lives and come to understand them, it becomes clear that they are also telling us a story that is ultimately familiar. This is true

because even these women, the most "improper" of welfare recipients, provide a sharply accentuated image of broader cultural and economic trends that have impacted us all.

In the following pages I describe three mothers who illuminate the four most prominent (and often overlapping) patterns of nonmainstream beliefs and practices that I observed among welfare recipients. For shorthand purposes, I have come to call these patterns the "Burger-Barn Syndrome," the "Candy-Store Syndrome," the "System-Screwed-Me Syndrome," and the "Lorena-Bobbit Syndrome." The Burger-Barn Syndrome refers to those women who participate in a cultural orientation that legitimizes the use of welfare as a subsidy for stay-at-home single motherhood—a claim embraced by a subgroup of those welfare mothers whose relatively hopeless job prospects have been balanced against the hope and love and social inclusion promised by raising a child. The Candy-Store Syndrome refers to those welfare mothers involved in a pattern of narcissistic consumption that includes the illegal consumption of drugs and a sexually promiscuous "partying" lifestyle, and implicitly treats such behavior as a legitimate way to seek pleasure, dull the pain of life at the bottom, and obtain a certain kind of cultural membership. The System-Screwed-Me Syndrome is a cultural configuration that rationalizes the use and abuse of welfare for those women who see big government, like big corporations, as a system that cares nothing for the poor and therefore deserves neither respect nor compliance. Finally, you will see in the stories of all three of these women varying degrees of the Lorena-Bobbit Syndrome, a cultural pattern that redefines the "family" in such a way as to make men more or less superfluous. For these women, their negative attitude toward men and marriage is born of multiple and repeated problems in their intimate relationships with the opposite sex.

All these mothers can find cultural support for their positions among the many poor women who are their neighbors, friends, and family members. All of them can, in this sense, draw strength from their shared cultural orientations. Yet, of the women I met who follow these patterns, none were blind to the stigma attached to their ideas and behaviors, and almost none were without ambivalence about the path of their lives. At the same time, when you hear these stories it will become clear that the practices and beliefs of the most "deviant" welfare mothers are always a response not just to the material circumstances of life at the bottom but

also to the values of the wider society. The cultures of poverty, in this sense, are *our* cultures.

A (Seemingly) Reckless Breeder—and the Burger-Barn Syndrome

> *I know if I had no child I'd probably be in jail by now. Before I had them I was just robbing, and stealing, and hanging out with my friends, and stuff like that. I was just dealing with their values. I didn't know nothing.*

The argument that having children is what keeps you from being wild, keeps you from getting into crime or drugs or other bad behavior, is one that I heard from a number of welfare mothers.[10] And most mothers who said this had at least a few things in common with Nadia.

Nadia is tough, hard, relatively inarticulate, and unaccustomed, it seems, to talking about her life. She is black, with a tenth-grade education. She lived in the largest and most dangerous housing project in Arbordale. Nadia is "streetwise" in the terms of Elijah Anderson, an ethnographer of black inner-city life.[11] She knows the rules of the street, and she's ready to stand up for herself and her family, using violence if necessary. By the standards of many middle-class members, she would seem rude and too aggressive (especially for a woman), and perhaps even a little bit frightening.

At the time of our interview Nadia was 23 years old with four children, aged five, four, two, and four weeks. She became pregnant with her first child at age 17. The youngest two had one father; the second two had a different father. She had already broken up with the father of the baby when I met her. I asked her if the pregnancies were planned:

> *I thought I was in love at the time. Yeah, that's what it was. I guess that's why I had their children. And, when I was 17 [before the oldest was born], I had thought about how I wanted to have a child. But it wasn't really planned. It was just what happened. It was like fifty-fifty [planned and unplanned]. The rest of the kids, they were just accidents.*

Following a pattern you'll recognize by now, Nadia first went on welfare when she was pregnant with her oldest, to get medical insurance. She'd been "off and on, on and off" ever since: "You know, I just couldn't keep my leaving; I couldn't seem to stay off." Given that Nadia was al-

ready on welfare when she became pregnant with her youngest, he was a "capped" child, ineligible for welfare benefits. She was receiving just $410 per month in cash from the welfare office to maintain her family of five. She also had subsidized housing, and food stamps, and Medicaid. Her aunt, with a steady job, helped her out sometimes with cash. The fathers of the children brought disposable diapers for the youngest ones and occasionally bought gifts for the others, but they offered no regular support. She managed to scrape by, but it was hard. She had no phone, no car, no television. She told me that she refused to do anything illegal to get extra money precisely because she had those kids to worry about.

On the day I met with Nadia, her mom was visiting. They were about to go out shopping for two-year-old Mohammed's birthday.[12] The baby was asleep, and the other three children were all bundled up for this winter day, and anxious to go. Nadia let the three kids go outside to play in the common area of the housing project, but the oldest was admonished to report in every ten minutes. He dutifully complied (carefully noting the activities of the toddler) throughout our time together. Nadia's apartment was dark, drapes closed against the cold. The furniture was worn, there were toys scattered about, and we had to rearrange multiple piles of freshly-folded laundry to find a place on the couch to talk. Nadia's mom sat quietly at the kitchen table and smoked for the duration of the interview, occasionally getting up to check on the baby.

Listening to Nadia, it seemed that she had no dreams, no hopes, no ambitions. She had worked at only three jobs in her lifetime—fast foods, cashier work, and housekeeping—and all those were short-lived.

> I worked at Burger King and K-Mart. That fast food is not for me, they don't pay you nothing. And you gotta work hard. I was working at Burger King for four months and didn't get my raise. They are supposed to do it, but nobody did the paperwork. So I quit. I went home and put the paperwork in for welfare.
>
> I also worked at the Sheraton in housekeeping. I worked for two days and I quit. [She laughs.] I just couldn't do that; that was too much bending over. That's hard on the back, and I don't like that.
>
> I'd rather go to work, so I can maintain everything, pay the bills, pay my court fines. And you got that welfare check just once a month, and it's not enough. But I'm not ready to make a career right now. To make a ca-

reer will probably take some training, some education, or something. I
need to do it but I want to do something I'll remember.

I pressed her on this point. "Do you have a picture of a job that pays well and that you'd be happy about?"

"No."

"Do you know anyone that has a job that sounds like a good job to you?"

"No. Not really. No." She paused for a moment, as if to determine why I was asking these questions. In the end, she read me as a welfare caseworker, as if I was pressuring her to get a job before her time limit ran out. She continued, "I guess I could go back to Burger King. Housekeeping is too much bending and stuff like that."

Nadia didn't know anyone who had a good job. One might think that she'd have some sense of what a good job looks like, if only from television, books, movies, and the news. But there were no books, no newspapers, no movies, and no television in Nadia's life. Of course she wasn't completely shut off from the rest of the world. All her children were named after black movie stars, musicians, and athletes, and she went to the grocery store and the park and the shopping mall just like everyone else. Nadia was keenly aware that there is a larger culture out there, one in which she had not been included. And she also knew quite well that she was a failure by the standards of that culture.

Both of Nadia's parents were alcoholics. Her mother worked as a maid and in restaurant kitchens as Nadia was growing up; she was never on welfare. Her father left her mother and his three children when Nadia was 14. In the last few years, she had started seeing her dad again regularly, and he lived with her much of the time: "He's been living in my house for a while now. But he do me no good because he stays drunk all the time."

Nadia's family history surely did not offer her a vision of hope and happiness. And Nadia's experience of the world, given her lack of education and employment skills, did not offer her a vision of financial security and meaningful work. But there was one aspect of Nadia's life that seemed clearly positive and forward-looking—her child-raising.

I'm a single parent, and I work hard. I'm always with [my kids]. And
if I'm not with all of them together I'm always with one. Don't nobody
but my mother ever watch my kids. I work—the work I do is taking care

of my kids. I'm not on the street smoking that crack with everybody else. It's about staying with them. That's what I do.

There's a lady I know, she's in the projects, she's good for nothin', and she's got a big [welfare] check. She's got five kids, all girls. Her house is always dirty. The kids can wear whatever they wanna wear, and she's got an older daughter who needs bras and stuff and she don't get those kids what they need. And this lady, she be shining up herself [dressing up, looking sexy], and I feel that's not good for the kids. I feel like someone like her don't need no welfare.

Me, for my kids—oh, oh my God, I want a future for them! Getting them to school. I hope I can get their fathers to help out, to be there. I just hope that my kids don't follow in my footsteps in the future. I want more for them.

There is no equivocation in this image—Nadia's dedication to her children is solid and strong. And Nadia's ability to properly mother her children is central to her image of herself as a worthwhile person. Children are also central to her vision of family life, of commitment, and of obligations to others. In fact, one could argue that Nadia's children are her primary connection to the larger world and her sense of membership in it.

Yet, in another pattern among welfare mothers, her feelings about men were much more mixed. There was a pronounced sense that men are often unreliable.

They's just sperm banks. They is. Now, you want me to talk, I'm talking. Darnel [the father of the older two], he is, he's just a sperm bank. He's got six kids. Six! Two in New York, my two, and two others here in Arbordale. Six.

When Nadia said this, her tone as well as her language was tough and full of disdain. As she continued in her discussion of men, her tone fluctuated between that tough and angry stance, and a softer one, with the tenor of regret and hopelessness.

I can't face Darnel, I can't face myself. When he feels like it, when he wanna do something, he cares for them. Yes, he bought Pampers for his baby girl. But I don't know where he got the money. He don't work, he doesn't have a job.

> *I'm never gonna get married. I don't believe in it. All you're doing is*
> *changing your name, that's it. I mean, you just sign a piece of paper.*
> *Yadda, yadda. It doesn't mean anything. All it is is changing your name.*
> *And the same thing that marriage will make him do [in terms of obliga-*
> *tions], I'm already making him do.*
>
> *He and I get along at the beginning of the day, you know. We was get-*
> *ting along, but it wasn't like it should have been. They [the fathers] are*
> *all right. We just can't get along. We kept trying and trying and trying.*
> *And things just kept getting worse and worse and worse with both of*
> *them. Dealing with men, it's too many problems to me.*

Men's key failure, it seems, is their unwillingness to take an equal share
of familial responsibility. And it's sometimes just too much trouble to
keep them around. She continued:

> *I don't know. If I have the same amount of love for both of the fathers*
> *—and I probably thought I did at the time—I'd probably marry one of*
> *them. But I'm glad I didn't, I'm glad I didn't. Because they don't take re-*
> *sponsibility. They don't come and get the children, they don't spend time*
> *with them. They've got other girlfriends and they don't want their kids to*
> *mess that up. I'm not gonna get no money from them. Like I said, I did get*
> *one to buy her Pampers and stuff and shoes. But that's it.*
>
> *If you can't give to a child, if you can't be around for them, then you've*
> *got hardly nothing. My dad, he gave me birth, but I didn't see my dad. When*
> *I got older, I thought that's gotta stop. Now he's almost always around me.*
> *And I would like to have a good man around me. I want a daddy for my kids.*

There was a tremendous amount of ambivalence in Nadia's rendering of
men, marriage, and fatherhood. Just as Nadia had a hard time visualiz-
ing what a good job would look like, she also seemed to have a hard time
believing that she'd ever actually find a "good man," the kind of man
who would stick around and support his kids.

Given her dedication to her children and her pessimism about find-
ing a partner to share the work and costs of raising them, I was not sur-
prised to find that Nadia was troubled by welfare reform.

> *I don't like that two years you're on, two years you're off [Arbordale's*
> *time limits]. I don't think that's right. I don't like it at all. I think wel-*

fare's supposed to help us. What if someone did actually truly need more than five years, you know what I'm saying? If this person had been struggling, trying for something, stuff like that, they don't have nowhere to turn. It would be closed, and that's not right. They still got to take care of the kids even if they aren't working. And what if they've got young kids?

If they got a job and the money, they workin', then I feel that's good. If I get a job, then that's good. But then I need to take my GED, get some training. And what if a woman she was working and then something happened? What if something happened to her kids?!? You know, women need to have something to fall back on it. That welfare check—it does make a difference.

They [the public] just saying that we're lazy because we don't work. Now that's not true. I'm leaving welfare. I'm not lazy. They just saying that 'cause we getting the money. There's people that are getting it and abusing it. And there's people who are getting it and doing what they are supposed to do. If you're taking care of yourself and your kids, then you're doing what you're supposed to do. I'm taking care of my kids. That is work. That is my job. It's more than 9 to 5.

In making this argument, Nadia uses a moral logic that includes a clear calculation of the value of work and childrearing, and a knowledge of the contingencies that befall poor women. The central judgment she makes is a common one among welfare mothers—a condemnation of those women who are just "abusing" the system on the one hand, and, on the other hand, a genuine empathy for those mothers who are really "trying," who are raising their children and looking for a way to build a better life for themselves. The argument that welfare recipients should be both moral and ethical and do what they're "supposed to do" relative to their children and their work is an argument that Nadia shares with the vast majority of welfare mothers. Yet, in Nadia's case, as is true for one portion of the group that shares her circumstances, this logic includes the tenet that stay-at-home mothering *is* work, and morally speaking, can therefore serve as a fair exchange for a welfare check.[13]

At the time I met her, Nadia had just two more weeks until the welfare office would require her to begin her job search. According to the rules, she was allowed to stay at home until her capped baby was six weeks old. Nadia's two-year time limit on welfare was due to run out just six months later. Given her tough and independent spirit, I suspect that Nadia will find some way to manage without welfare. But given her

four young children, her work experience, the availability of childcare and public transportation, and the structure of the employment marketplace, the odds are she won't find much more than a minimum wage job, and probably one with less than family-friendly hours and policies. A position at Burger Barn on the graveyard shift will clearly be insufficient to meet her financial needs and will likely be rough on the kids. She will need to rely on the help of others, and if that does not work out, she may feel forced to give up one or more of her children, or turn to that illegal activity that she has been trying so hard to avoid.

The pattern of Nadia's life is familiar to me now, a pattern of early childbearing, of insufficient education and work experience, and of early, relatively continuous, prolonged welfare use. Although women like Nadia are in the minority among welfare recipients, they tend to stand out on the welfare rolls, just as they do in the public imagination. In the context of the welfare office, they stand out partly because they fit a stereotype, but also because they are on the welfare rolls longer than others and because welfare caseworkers will expend a disproportionate amount of time and energy trying to find solutions for them under welfare reform.[14] No matter what the perspective, few would question that Nadia's life constitutes a "social problem."

When you hear, through middle-class ears, the stories of women like Nadia—never married, with four children at age 23—you want to say to her, "Have you ever heard of birth control?" In fact, some people might want to shake her vigorously and shout, "HAVE YOU EVER HEARD OF BIRTH CONTROL?!?!"—as if she were so deaf and dull-witted that only violent action and shouting would work.[15] Although the children of welfare mothers like Sheila and Diane (from Chapter 6) might be recognized as understandable unplanned pregnancies, having four children appears an altogether different matter. And of course I did ask Nadia about birth control. Her answer was matter-of-fact: "You can see, I haven't been using it. I've heard it has side effects. But now, maybe now, I would use some protection."

A number of welfare mothers gave me answers, like Nadia's, that included some notion of the negative side effects of birth control as an implicit explanation for unwanted pregnancies. Of course, it is true that many young women lack information and easy access to the multiple forms of birth control, and it is also true that the use of birth control

can cause side effects, can be ineffectual, and can be inconvenient, awkward, and discouraged by partners. But by the fourth child, this explanation seems inadequate. As Nadia's case implies, and as other studies have shown, there is often more to the story than this.[16]

Nadia is a participant in a culture of poverty with a very specific etiology. Hers is the cultural configuration where a lack of job prospects, the relative absence of marriageable partners, the availability of welfare, the mainstream cultural valuation of childrearing, and an older valorization of "traditional" stay-at-home motherhood all come together to create, for some, a new, revised version of family values and the work ethic. This story bears repeating.[17]

No matter how strong their work ethic, the number of jobs that women like Nadia can imagine for themselves is limited. As I have noted, in Arbordale and Sunbelt most of the jobs offered to welfare recipients were in housekeeping, food preparation, cashier work, and other forms of unskilled service (as is true nationwide). The options beyond this seem out of reach for those young mothers with little experience and little education who sit, with Nadia, in the bottom third of the welfare population. Even retail sales or receptionist work, which often seem quite alluring ("it's clean, and you get to sit down sometimes"), tend to require a particular presentation of self, a certain look, a specific way of dressing, and a certain manner of speaking that are difficult for many welfare mothers in this group to manage, at least early on. Even jobs like medical assisting and data processing require certification or skills that take time and connections to acquire. And when I heard Nadia say, "If only I could get my GED," I knew that, following the statistical measures of likely outcomes for GED recipients, this would not assure her financial security.[18]

The world in which Nadia was raised, and the world in which she now lives, is a housing project world of segregated poverty. In this environment, it is hard for most people to remember at what age they first learned about welfare, since it seemed to "always" be there. And most of the people Nadia knows have some sense of the eligibility requirements, the monthly payment amounts, and the possibilities for prolonged use. This world is largely populated by people who do *not* consider welfare an honorable life choice.[19] Yet given the widespread recognition of its availability, it is possible for someone like Nadia to find a supportive subgroup of allies who treat welfare as being at least acceptable, if not respectable.

In this milieu, rates of unemployment are extremely high for men as well as women. A white-picket fenced, nuclear-family future is therefore hard to come by. As much as women like Nadia might wish that things were different, this reality is also implicitly accepted. Yet the longing for intimate family ties has in no way disappeared. As is true of the wider society, children are a preeminent symbol of love, hope, and connection. Also following a widely shared cultural logic, motherhood represents adulthood and the fulfillment of women's identity.[20] And, as Nadia suggested, children can have that special prophylactic effect—protecting one against life on the streets by providing a reason to live a moral life and be a good person.

Like most welfare mothers, Nadia's life is thus informed by a clear understanding of the wider cultural valuation of family and the work ethic. But by necessity and invention, those values are reshaped to fit the circumstances. Although Nadia is well aware that she is living in a society where most mothers have paying jobs, she can also draw on a valid cultural claim that mothering is work and that stay-at-home motherhood is what's best for children. Extending this just one step further and following the logic of welfare as it was once envisioned, she has a basis for arguing that she deserves public support. One could call this belief system an "alienated counterculture," but to do so would ignore its direct linkage to the values of the wider society.

At the same time, it is clear that Nadia's cultural style does not fit any mainstream, middle-class model of womanhood. Despite her valuation of mothering, there is little about Nadia that mimics the model of sentimental purity and subservient domesticity represented by June Cleaver or Donna Reed. Nadia is tough, strong, and self-reliant. It has been hard work and a serious struggle for her to stay out of trouble and to properly care for her kids. As strong willed as she is (and partly because of this), she also does not fit the model of the economically self-sufficient working woman. Nadia has little patience for people at the welfare office who suggest to her that she should refrain from street slang, avoid chewing gum during a job interview, and politely defer to employers. These rules of etiquette seem to her both trivial and demeaning. Her sense of decency is instead focused on caring for herself and her kids, avoiding criminal behavior, not "partying," sleeping around, or taking drugs. Given this, it is hard to know just what would convince her, at this point in her life, that the best choice of all would be to leave her children in the

hands of others while she went out to flip burgers, ring up receipts, or make the beds and clean the bathrooms of the higher classes.

A Drug-Abusing Thief—and the Candy Store Syndrome

Joy seems to have engaged in nearly all the forms of bad behavior that one could imagine. When you hear her story, it seems hard at first to uncover her redeeming qualities. Yet, if you met her, you'd likely find her charming—bouncy, upbeat, funny, enthusiastic. She has the look of a freshly scrubbed teenager: blonde hair, blue eyes, rosy-red cheeks, a dimpled smile. Joy is 25 years old and on her third stint on welfare. When I interviewed her she was seven-months pregnant with her second child. Her first child, a daughter, was five years old.

Joy initially went to the welfare office when her daughter was born. Shortly thereafter she married the father, got off welfare, and "everything was fine." But two years later she was divorced and headed back to the welfare office.

> I've been on it every now and then. I only needed it when I needed it. I mean, if I need some help picking up my feet I use it. And the medical, I need that for my daughter.
>
> But I really don't like going on welfare because it makes me feel weird. It makes me feel like I'm degrading myself. But then again I can look at it a different way. I need the help. I'm a single mother, I don't have my ex-husband helping me with her. I need it. So I use it.

Joy ended up on welfare this time around after being fired from her job at a telemarketing agency. "I was pregnant and bleeding and almost losing the baby," she explained. "They said that I missed too many days, but I had doctors' excuses for every one of them!" Unfair as this was, Joy was actually happy to have this opportunity to spend time with her daughter and to look for a better job.[21]

Like the previous one, this pregnancy was unplanned. Believing she was infertile, she had stopped taking birth control pills. Given her complicated sex life, Joy was unsure of the identity of her baby's father.

> This pregnancy was an accident; I was messing around. It's a long story. See, before that I'd been trying to get pregnant because I was with someone;

we'd been trying to have a child the last couple of years and we never did. I was told I couldn't have kids so I stopped using [birth control].

I walked into the doctor's office one day and the doctor said, "Oh, by the way, you're pregnant." I was like, "How could this be?" And then of course I'm pacing back and forth, saying, "How am I supposed to tell this to my family? I'm having another child?!?" I mean, I'm barely surviving with the one I have! Now I'm bringing another one in?

And the thing is, there's two possible fathers. It's weird. I went out with my friend Brad, we went out to dinner and we had a couple of drinks, one thing led to another, and then, well, that was that night. Then later me and my ex-husband Jeff were together and well, it was just a week difference between the two nights.

I inquired as to whether Joy ever considered having an abortion.

I didn't think of having an abortion because I've already had four of them. That's why I was told I could never even have any more children— I'm all messed up inside. Yup, four abortions. I was going to kill myself if I had another kid. But then where would my daughter be? She'd be motherless. So eventually I said, "Okay, I'll deal with it."

Multiple sexual relationships, multiple pregnancies, multiple abortions, and multiple "surprise" pregnancies were central to the story of Joy's young life. In some ways, they were also mirrors of her childhood. The history of her family was a history of what sociologist Judith Stacey has dubbed "recombinant families," marked by multiple marital breakups, serial stepparents, and an array of siblings from different marriages.[22] Her own father left her mother before Joy ever really knew him. She and her two older siblings grew up with a stepfather along with his two children from a previous marriage as well as the one child her mom and stepdad had together.

So there were six kids living in the family as I was growing up. Kids— hers and his and theirs. My mom pretty much stayed home. My [step] dad worked 16- to 20-hour shifts. He'd come home for four hours, get some sleep, and that's it. He was in concrete. Today he owns his own company with my step [step] mother. It's her company; it's like he oversees everything.

My mom and stepdad divorced when I was 12. Then my mother went

and married someone else, and then he died. She's been with a lot of men. I have a new stepdad now. She just married him; they've been together for three years. And my mom works now.

When I met her, Joy and her daughter were living with Joy's mom and her new husband (Joy's step-stepfather) in a cramped apartment in a safe, working-class neighborhood. They all shared one car, and Joy spent much of her day transporting her parents to work and back home again, and doing all the shopping and the cooking and the cleaning for this four-person household. In the meantime, the stepfather she grew up with had become quite wealthy, and lived in a mansion on the other side of town with a beautiful new wife, a new set of children, and all the comforts that came with his success.

Perhaps it is this disparity between her own financial hardship and the wealth of her stepfather that partially accounts for Joy's illegal behavior—she had been a drug abuser and a thief.

> *I stole money from my stepparents. Thirty grand [$30,000]. I took the money from my [step] dad and my stepmother— forged a signature, and took it out of their business account. And I used that money to do my little fun, my partying time. Thirty grand. That was just four years ago.* *
>
> *I had my partying life. I was addicted to cocaine. And I did weed too, but that was no big deal because I didn't have a problem with that. With the cocaine, though, I needed it; I always had to have more. When I started thinking that I could actually overpower a guy that could overpower me, I knew it was time to give up. And I quit cold turkey. I quit on my own. And you know, my daughter was seeing it, and back then I didn't realize what it was doing to her.*

Joy was a drug addict for almost two years—from the time her daughter was one year old until the time she was three.

Those drug-abusing years also marked the end of Joy's marriage and the beginning of a series of affairs with other men. It is clear that most

* If you're curious, as I was, Joy's stepfather ultimately forgave her for stealing the $30,000, and never prosecuted or asked her to repay him. In fact, he had since provided her with additional financial assistance.

of Joy's relationships with men have not been happy ones. And having heard the stories of so many welfare mothers, you will not be surprised to learn that Joy's ex-husband was abusive and a philanderer.

He just started working at a trucking company. And we were supposed to be trying to work things out. I got back together with him eight months ago, but it's over now. He has this thing that he wants to be with me and everything but then he's playing his games. He still calls me; he'll still tell me he wants to be with me, but he still has a girlfriend in another town. He's playing both of us. And the only reason he's playing me is because he wants to see his daughter. As far as I'm concerned, I don't want him to. It makes me feel really bad.

If I hadn't left him that first time I'd probably still be being beaten and molested (or whatever it's called when it's your husband that does it). Yea, he slapped me a few times and a couple of times he beat me bad. He actually, well, he decided to force himself on me. He raped me. And I wanted to prosecute him, but see, here in Sunbelt State the law says, "You're mad at him, you say no, and it doesn't matter. You turned him on, you're to blame, so that's that." I said no, but that's not enough. See, I should have done what Lorena Bobbit did.

And my friend Brad, he said to me that if this baby is his, he would help take care of it, no problem at all. But I don't want him. I don't want him even near. I don't want another man. Why should I have more of the same problems I've already had?

Joy had sworn off men for the time being, no longer trusting that she would be able to get, and keep, a "good one." She also worried that her marriage and her string of relationships had been hard on her daughter.

I just want her to be happy. She wants a daddy so bad. She says, "Mommy, why can't you go get me a daddy that will be there?" And I just want to cry. I tried finding him for her. There's just not many men out there that are willing to take care of another man's child and to love them like their own. And there's not many men who she warms up to. There was one she did warm up to; I was with him almost three years. And then all of a sudden he left, and my daughter had basically grown up with that boyfriend; he was a father to her, and I was like, "What am I supposed to tell your daughter? She wants her daddy."

And he said, "Tell her I'm dead." So that was that.

The other men that I've been with, the last couple of them have said that they loved her and then they leave. It's because of me but she thinks that it's because of her. It's just bad; it's just definitely bad. But I'm trying. I'm doing little by little what I can to make our lives better. And at least I can say my daughter is healthy, she's alive, she's in school.

Joy's history of sexual relationships, her drug abuse, and the theft sound like the story of a kid in a candy shop, just *consuming* everything because it looks tasty on the surface—never considering the consequences or pondering the problems of frivolous spending and overeating and tooth decay. When she talked about her work experience and job training, she seemed similarly clueless about the realities of career building. And the impulse to randomly consume was apparent here as well—in this case taking the form of multiple, disconnected, but glittering and expensive training courses.

> *Before I got pregnant I was learning about computers. That was a $10,000 course with Career-Builders, Incorporated that I heard about on TV. And before that I had a class in business administration; it was also $10,000. I want computers. Everything's run by a damn computer now. But I couldn't finish the course 'cause of the pregnancy.*
>
> *And my new stepdad—I'm grateful to him, he put me through cosmetology. That was a $10,000 course as well. But it's not what I want to do. I'd get some old person in my chair with a real bad attitude, and I'd burn them with a curling iron [she laughs]. That's why I got to go back to school again.*
>
> *I've paid a lot of money to schools. But it hasn't gotten me a good job. I graduated about nine months ago from the business administration course. I got my diploma. And there was another course I originally wanted that I didn't take. It was gonna cost me too much money—another 10 grand. And already there's 20 grand that I'll be paying for the rest of my life. Well, at least I have loans.*[23]

For all the misplaced enthusiasm in her stories of work and training, for all the apparent irresponsibility in much of her behavior, Joy was nonetheless committed to finding a good job and getting off welfare. She hated the welfare system; she recognized the social stigma and she

was hoping that the training and experience she now had would help her avoid past mistakes. Her argument about the importance of work also contained one final familiar element, so common among welfare recipients:

> You need to work for the sake of the children. If you can't have a good paying job, something that you like, you can't have a good family. If you are not happy, then they're not gonna be happy, and you'll all be miserable. And sometimes I think I would really like to spend more time with her if I could. But I'm a single mom. That ain't gonna work. I'm gonna have to find a job. I will find a job.

Although it would be easy enough to define Joy as a bad apple, on this point she falls directly in line with the logic of welfare reform and the principles of most Americans today.

As an illustration of subcultural orientations among welfare mothers, Joy's version of the cultures of poverty is a pattern of self-absorbed and apparently aimless consumption—of seeking pleasure and (at least temporarily) ignoring or denying the consequences. This story of consumption among such welfare mothers often includes, as it did for Joy, an appetite for good times—or what is regularly referred to as "partying." Partying includes not just drinking and taking illegal drugs; it also includes multiple sexual partners. In its worst-case versions, it ultimately takes the form of crack cocaine and heroin addicted mothers, alcoholic mothers, and mothers who have had so many sexual partners that they do not even try to keep track of the fathers of their children. Over one-quarter of the welfare mothers I encountered had done some serious partying in their lifetimes. As was true of Joy, for most this was a passing stage in their life course. But as was also true for Joy, in a number of cases this passing stage of life was when they had their first children.

Statistical measures of welfare mothers who abuse drugs and alcohol are even more varied than accountings of welfare mothers who are physically or emotionally disabled. Estimates of substance abuse problems among current welfare recipients range from 6 to 37 percent. The highest figure includes those who have engaged in binge drinking or used any kind of illegal drug (including marijuana) in the past year, and the lowest figure arises from a definition of daily alcohol use. Although public

opinion polls suggest that Americans believe drug abuse is one of the central problems of welfare recipients, nearly all government researchers agree that problems of disabilities and of domestic violence are both more prevalent. From the available evidence and my own research I would guess that, at any given time, about 10 to 15 percent of welfare mothers are having serious problems with drugs or alcohol.[24] In many instances, this abuse is linked to mental health problems. As was true of Diane (from Chapter 6), the use of alcohol or illegal drugs might well be understood as a poor woman's version of a Prozac prescription. In other cases, like Joy's, substance abuse, though arguably still connected to mental health issues, is also clearly linked to a quest for good times.

Although this thirst for good times surely contributes to the unfortunate position of women like Joy, it just as surely mimics much more widespread patterns in American culture. The fraternity scene on college campuses across the nation, for example, regularly includes the illegal use of drugs and alcohol and the practice of "hooking up" with sexual partners. Although those college students tend to be wealthier, more likely to get abortions in the case of unwanted pregnancies, and less likely to end up with children to support on their own, there are otherwise few distinctions in the pattern of their behavior. And arguably, both groups— the partying welfare mothers and the partying college students—are not just aimlessly seeking pleasure but are actually looking for the path to adulthood and social inclusion. They are declaring their independence from parental guidance, and they are claiming membership in a status group of, often popular, pleasure- and adventure-seeking others.

There is a second, connected form of consumption behavior that is evident in Joy's life. It is apparent in her search for a future through television-advertised training programs and her proud ownership of a cell phone and an extensive collection of movie videos. I met welfare mothers, living on their tiny welfare checks, whose lives also included all the latest sound and video equipment, or fine rented furniture, or expensive jewelry, manicures, and clothing, or children wearing the newest Nikes and playing all the latest video games. Many of these luxury goods were received as gifts or were purchases made when these mothers were working for pay—they did not necessarily represent the spending of welfare "cheats." But they also did not represent the portrait of frugality and careful budgeting that is true of most welfare mothers and is also what the American public wants to see among the poor. Like the quest

for good times, however, it is not hard to interpret such consumption as an effort to achieve social status and inclusion. It is also not difficult to read such behavior as a cultural response to the opulence of American society and the "candy stores" that seem to be everywhere.[25]

I also want to emphasize that Joy was 25 years old when I met her. While interviewing welfare mothers, I often forgot their ages.[26] They often seemed older to me, partly because they had children, partly because of the experiences they'd had. Sometimes they seemed wiser than their years, and sometimes simply tired and worn out. Less frequently— though, on occasion, simultaneously—they seemed far too young and immature to be caring for children. When I think of someone like Nadia, and wonder about her past and her future, I try to remind myself that she was *only* 23 years old. Joy, on the other hand, was one of those mothers whose life experiences made her seem old but whose attitude in other respects made her seem too young for motherhood. In any case, there is no turning back now from those children. But, as is true of all young adults, it is also clear that both Joy and Nadia will have many more experiences to shape their long-term chances of building a viable life for themselves and their families.

A Welfare-Cheating Man-Hater— and the-System-Screwed-Me Syndrome

Sandra, like Nadia, was tough, street smart, and independent. She'd lived most of her life in one of the most dangerous areas of Sunbelt City. All the homes and businesses had metal bars on the windows, groups of men claimed ownership of the street corners, burned-out buildings punctuated the landscape, and few nights passed without the sound of gunfire or other hostile encounters. Sandra protected herself and her children, in part, by maintaining good relations with the local drug dealers, pimps, and street hustlers as well as neighborhood business owners. Everyone seemed to know her, and all those men on street corners acknowledged her presence as we passed.

Sandra was also a standout for her strong spirit, her charisma, and her quick and biting tongue. She was 46 years old, black, and a mother of four. She had her first child when she was 20, a daughter who was 26 and recently married. Sandra also had a 16-year-old son, a 6-year-old daughter, and a four-year-old son. All her children had different fathers.

One could easily define Sandra as a welfare "cheat." She certainly was not driving any Cadillac (and actually had quite a bit to say about the inadequacy of the local bus system, with which she was intimately familiar). But Sandra clearly knew the rules of the welfare system and used them to her advantage. She was living rent-free in return for managing the fourplex where she lived, and the owner of the building colluded with her in deceiving the welfare office by claiming that she paid him monthly. She would never consider reporting the intermittent financial help that she received from her family and the fathers of her children, since she clearly believed that the welfare system was a rigid, uncaring bureaucracy to which she owed no allegiance. And she was perfectly capable of getting and keeping a job, but she was currently using the welfare system to take some time off to handle personal and family matters.

Sandra had worked for 21 years of her adult life—including four years of clerical work, 14 years as a factory worker, and three years as a small-machine repair person. She'd been on welfare four times prior to the latest stint, using it the first time when her second child was born with a "hole in his heart." ("I couldn't leave him; every time he'd get sick, he'd turn blue. I wanted to be there; I had to be there. So I quit my job.") She went on welfare this time around because she wanted some time to spend with her preschooler and to help her brothers take care of her mom who had recently suffered a stroke. In addition, she'd been looking for an opportunity to get the Medicaid card that would allow her to obtain her first set of (much-needed) dentures.

Sandra's attitude regarding her "entitlement" to welfare was evident in the way she talked about her experiences at the welfare office. She complained at some length about the "system," its punitive policies, and its lack of empathy for the people it served.[27]

> *Welfare is just that—it's welfare for your fare. Welfare is for people who need help with assistance with a child. I worked for 14 years on one job, paid taxes. And when you're at the welfare office they have a tendency to say, "Well, hold on, just wait a minute."*
>
> *And I say, "No. I'm the reason you have a job. Okay? So you with your nasty little attitude, you better just get it right. I'm here for help, I'm not here to deal with your bullshit. I've already had bullshit enough to have to be here in the first place. So I don't need you to be lookin' at me like*

you're all that [important]." Shoot. I've always gotten into problems with my mouth.

What I'm saying is that they don't do things the way things should be done. If you made an appointment with me, you made it with me, don't tell me, "come back another time." I mean, dang! I'm draggin' kids on the bus to the baby-sitter, come back to you guys and you can't give me an hour? You can't squeeze me in?!? Everything has to be like, procedures, procedures, procedures. It took me two weeks to get my food stamps because my light bill is not in my name. I had to go in three times, get the buses, get the childcare, just to show them. Nothing they do is to your advantage. They don't give me bus tokens. They tell me I have to go through training, but I can't get no childcare. They say, "Sorry, we have our rules and regulations." And then they tell you to come here, "right now!" and that's just not gonna happen. They just do things that way; they just don't care.

I'm not saying they owe me welfare. But it's not like I was born on welfare. And if they're gonna talk to me, but they're not gonna tell me anything, well, I'm not a violent person, but don't try to tell me the sky is green. 'Cause we're gonna argue until you see my point or we don't talk no more.

I got pride. I'm gonna get a job on my own. I'm gonna get off this again. I'm gonna beat the system. I'm gonna figure some kind of way to make it work for me. I've been having trouble getting that help with childcare [welfare reform's subsidy]. But I'm gonna make it work. I don't care if they're mad.

As I have noted, most welfare mothers like welfare reform, and most generally appreciate the efforts of their welfare caseworkers or at least understand and accept the constraints caseworkers face. Yet a number of welfare mothers had at least some criticisms of the welfare office, and a handful I met (like Nadia) also softly suggested that some women, especially those with disabilities or multiple young children to care for, might be "entitled" to welfare benefits. But no one else I interviewed was quite as outspoken as Sandra. Nonetheless, Sandra's criticism of welfare and her argument that this uncaring bureaucracy is meant to be taken for all one can get out of it would strike a welcome chord with a number of welfare mothers, and for a smaller group, would be seen as a useful legitimation for various forms of fraud.

Sandra was noteworthy not only for her street smarts and her strong

critique of the welfare system, but also for her rather extreme attitude toward men. Connected to this was the fact that, although a good number of the welfare mothers I met had children by more than one father, Sandra's four kids from four fathers was unusual. All her pregnancies were unplanned; she explained that she'd had difficulties with birth control.* Yet, as will become clear, Sandra would never have considered remaining childless or waiting to have sex until she found the "right" man to marry.

By the time we met for this interview, Sandra and I had spent a good deal of time together, so she knew me well enough to know that I would not judge her harshly. Given this, and given Sandra's general willingness to speak her mind on just about any topic, it was interesting that in our discussion of the men in her life I had to prod her forward every step of the way. And there was a tremendous amount of anger and resentment in Sandra's voice when she spoke about these men. Almost everything she said on this topic, she said with a sneer.

Our conversation began with my question, "What about the fathers of your kids?"

"The daddy of Jason [the youngest] is paralyzed. I had an appointment with social security to try to get money for Jason. All his daddy would have to do is sign the papers and Jason could get money. But the social security people tell me he just won't sign."

"Why not?"

"Because he says that he wants to be able to give Jason what *he* wants to give him. He's *stupid*. He just wants to control the money, and me. He's getting disability himself. But he can't work and I can't get child support. And he thinks that he can get social security to pay *him* his son's check. That's how stupid he is. So, I'm just gonna have to figure out a way to make him do the right thing."

"And so the latest dad, he's paralyzed from some kind of accident?"

"He got shot. A drive-by shooting. He runs in that crowd."

"Do you still like him?"

* This was how Sandra explained her multiple children: "Well, you know, they were all surprises. The last two especially. I don't believe in abortions. And birth controls, well, I took birth controls, and it made me sick. I had the shot, it made me sick. I had the IUD, it caused blood clots. Everything I took made me sick, sick, sick. And see, I had wanted to get my tubes tied, but I had no medical assistance."

"No. I don't like any of my baby's fathers. I just had children by my-self. I've never liked him; I've never liked any of them."

"But you must have liked them once, didn't you? I mean, you slept with them, right?"

"Well, I mean I don't believe in abortion, so I just had kids. But I don't like the fathers. I don't like none of the men."

"How about the other fathers, where are they?"

"The one before Jason's, he's in prison. The next one, he's in Louisiana. And the oldest kid's father, my daughter's father, he's around, he helps out his daughter. But he *never* gave money to me to raise her."

"Do the others help out?"

"The father of my 16-year-old son, the one in Louisiana, he's like 'Well, what do you need?' But he says it just to say it. He's not giving me income, or giving me some money. No, never. And I've always said, as long as I can take care of them kids myself, I don't need anything. But now that I'm on welfare, and they're doing that [child support] stuff, I say, 'You know what? I'm gonna take you all to court and I want all of you to make sure I get a check!'"

"Did the Louisiana daddy give you money when your [16-year-old] son was younger?"

"No. He bought Pampers sometimes. He'd knock on the door and there'd be a box of Pampers and you know, stuff like that. What I'm sayin' is that he never gave us cash. But I was working back then."

"And you didn't want to ask him?"

"Well, I figured that I shouldn't *have* to ask him."

"And you never thought of marrying any of these guys?"

"I didn't even *like* them afterwards, so I sure knew I wouldn't want to marry them. I'm not gonna marry because I'm pregnant or had a child by him. They's stupid. I just do better by myself. Why would I want to be with someone who'd make me unhappy? Uh-uh. No. Never."

"You were never really in love with *any* of these men?"

"Never."

"Not even some non-daddies?"

"Not enough to marry. I mean, I feel, when you got kids, you got to think about whether the kids are gonna like them, if they'll get along. It's a lot to worry about. You just can't go 'alright, he's gonna marry me,' and then just think that you get married and it's happily ever after. That's not gonna happen."

Sandra appears quite unconditional in her approach to men and marriage. She seems to want to let us know that the only thing "stupid" men are good for is providing economic support, a task those she has encountered have carried out quite poorly. And the truth is, she'd rather not ask them for any support at all—since she'd just as soon they stayed uninvolved. As radical as she might appear in some respects, her idea that men's primary purpose is to provide economic support for their children and their mates is, obviously, not an idea she came up with on her own. It follows quite clearly from the image of the proper male breadwinner.[28] And the fact that she had found men unreliable on this score, especially given that nearly all the men she knows are poor men, is certainly not an other-worldly finding.

Sandra is nonetheless unusual in that she claims to have never liked the men with whom she was involved—not even, it seems, at the moment of procreation. No other welfare mother I encountered expressed feelings like this. But the negative experiences Sandra has had in her relationships with men follow a much more prevalent pattern among welfare mothers, as should by now be apparent. That Sandra is able to find cultural support for her rejection of men is also not all that surprising. Consider the large proportion of welfare mothers who have faced sexual abuse, physical violence, and abandonment. Surely these women would be happy enough to agree with Sandra that men can be more trouble than they are worth.[29]

As a representative of the welfare "cheat," Sandra is part of a majority from one perspective, but in a minority from another. Only a handful of the welfare mothers I encountered were, like Sandra, straightforward and almost "proud" of their ability to milk the welfare system. These women follow Elijah Anderson's characterization of women treating welfare as something there to "exploit" and interpreting successful fraud as a certain badge of honor. Yet, as the women I have profiled in this book testify, the majority of welfare mothers are not the least bit proud of using welfare. In the same terms, I met almost none who felt good about the extent to which financial realities led them to cheat the system.

Nonetheless, depending on the standards you use, well over half of welfare mothers are welfare "cheats." The category of welfare cheat is a very broad and inadequate one. On the one hand, women who collect more than one check, manage to claim more children than they actually have, or have well-paying jobs on the side are extremely rare (and I per-

sonally encountered no one who did this). On the other hand, most welfare mothers "cheat" the welfare system in that very few are able to cover the costs of living with their welfare checks alone. Some additional financial aid is within the bounds of welfare rules as long as it is officially reported—like the help that Elena and Christina receive from their relatives. But often this type of assistance goes unreported, as does that under-the-table employment—cleaning houses, doing hair, providing childcare, and other side jobs, including, less frequently, turning tricks and dealing drugs. In Kathryn Edin and Laura Lein's large-scale study of 214 welfare mothers, 8 percent worked in the underground economy selling sex, drugs, or stolen goods; 39 percent worked in some kind of unreported job; and 77 percent received covert financial assistance from family members, boyfriends, or absent fathers.[30] Only a tiny proportion of welfare mothers, however, actually climb out of poverty as a result of their combined income sources.

One of the central forms of cheating beyond unreported income is unreported cohabitation. That is, I would estimate that over one-quarter (and perhaps more than half) of welfare mothers live with men, full or part time, and pool their financial resources but do not report it. Studies of poor mothers' cohabitation rates seem to confirm this.[31] Although the Supreme Court ruled in 1968 that welfare mothers are allowed to live with men,[32] on a number of occasions I encountered a general "street sense" that the presence of men in their households would make mothers ineligible for benefits. Although there are no "man in the house" rules, this street knowledge could be based on the "marriage penalty" in eligibility requirements for welfare benefits. If these cohabiting women were to report the men living in their homes, their income would be recalculated based on a different set of rules and in many cases they would be deemed ineligible for welfare—based not on the cohabitation but on their income. A further reason for welfare clients to avoid reporting cohabiting men is the fragility of these relationships—if cohabiting partners come and go (as they regularly do), the welfare recipient would have to begin the application process anew each time, with each entrance and exit affecting the possibilities for, and the rate of, welfare benefits. The important point is that this form of "cheating" is actually quite reasonable. And if welfare reform is meant to encourage marriage and the building of stable families, the marriage/cohabitation penalty and the street knowledge that accompanies it are certainly a problem.

* * *

I do not want to simply leave Sandra as a gross caricature of a man-hating welfare cheat. Like all welfare mothers, no one-sided portrait can do her justice. As peculiar as many aspects of her values and beliefs may seem from a mainstream perspective, it was clear to me that she had her own strong code of conduct. On more than one occasion, for instance, I observed her acting as a powerful advocate for the poor. She was also a dedicated mother:

> *Your children are your greatest riches. So nobody's gonna tell me that I can't have a child because I can't afford one. You can cancel that idea. My kids, I mean, sometimes I just wanna take a rope and hang up each one, but in the long run, those children are my riches. My kids are my life. I know people who can't have children. Do you know how they feel? To not be able to have a child? It's sad.*
>
> *I'm an excellent mom. People know that. They see me walking with the kids at the park, making their breakfast. I go roller-skating with them, but I'm getting too old for that. We go swimming twice a week. And I catch a bus and I take them downtown. I know what they need. We have hot buns every morning. And I tell them to go to school, bring home A's. Both my babies are smart. My son always gets a little badge at school that he's really smart—because I take him to the library and the computer. That is so good for him. I sit there and read while he works with the com-puter. A mother is the best teacher in the world for her child. When they're like two and three and four, I want to be at home to teach my child. That's why I want to be home with my baby now. Some mothers don't even know what libraries are. My family is going to go to college.*
>
> *I do it all, 'cause I got kids and they teach me how to do it. And my son's 16, and I still go out with him. I go out to where he's hangin' 'cause I want to see what's happening. I want to know everything. Because these are my kids. They ain't got nobody but me.*

Sandra's attitude towards children, in other words, is 180 degrees op-posed to her attitude toward men and welfare. And as extreme and stub-born as she appeared on some issues, Sandra also had some real am-bivalence about the path she'd chosen. When I asked her to reflect on how she might have lived her life differently if she had it to do all over again, she replied:

I would not have four children; I'd have two. I would probably pick my children's fathers a little better than I did. I would. My morals with sleeping with them should have been thinking of the consequences.

In my parents' day, you got pregnant, you got married. Most of them, the mothers and fathers, were married. My mother and father were married. My kids' generation, no. But when I was growing up, everybody was married. There was no living with boyfriends. Kissin' friends, that's new. There was just mom and dad and the kids. Daddy would go to work, mom would raise us up. That's all. Everybody says that's old-fashioned. Oh sure. But that's what we need, I think. We need the old school back.

But other than that, I'm happy. I got a home. I got beautiful kids. I have an income. Money ain't everything. Happiness is within. I mean, I'm broke but I'm not minding. I'm just as happy as the man that goes by in the blue Mercedes. I'm happier than him, 'cause I have my kids.

From one point of view, Sandra is actually the perfect portrait of women's independence. It is not that she dumps the kids in the same way she dumps men; it is not that she is so individualistic that she knows nothing of care and nurturing and obligations to others. Her vision of independence is a vision that includes raising the next generation to be good people and good citizens. It is a vision that includes leadership, careful management, a pioneering spirit, a principled approach to the problems of everyday life and an ability to support herself and her family financially using whatever resources are available, including welfare. One could easily imagine her doing well as Robinson Crusoe stranded on a distant isle, and she would take Robinson one step further, by doing it all *and* caring for her children as well.

I have no doubt, given her work history, that Sandra did go out and get herself another job as soon as that dental work was completed, as soon as she had her childcare problems worked out and her mother's care was assured. I also have no doubt that if Sandra has trouble with her job, or if any of Sandra's family members should become ill, or if some other life change should impact her employment or her family, Sandra will not hesitate to head straight back to the welfare office. And when she does, she won't feel grateful, she won't be deferential, and she probably won't be apologizing to us, as American taxpayers, for spending our hard-earned money. Welfare, after all, is "for your fare."

Reconceptualizing "Independence"; Reinterpreting the "Family"

Though my labeling of the patterned maladies from which these women suffer—the Burger-Barn Syndrome, the Candy-Store Syndrome, the System-Screwed-Me Syndrome, and the Lorena-Bobbit Syndrome—is surely reductive, these labels nonetheless capture a certain version of the realities that have led these women and others like them to develop culturally specific strategies for coping with the realities of their lives. In every case, these strategies involve reconceptualizations of independence and family values. And in every case, these interpretations are shared by a sufficient number of women in the worlds that Nadia, Joy, and Sandra inhabit that they can be referred to as cultures of poverty. But these cultures are not intractable, nor are they "socially alien." They are direct responses to the circumstances of these women's lives, and they are directly connected to larger patterns in mainstream American culture.

The Burger-Barn Syndrome, of valuing childrearing (even unwed childrearing) over paid work and financial self-sufficiency, follows from a labor market that offers very limited options for young women with few skills and a less than adequate education. This reality then confronts the culturally mainstream promise of raising children, the culturally mainstream instability of families, and the class-specific paucity of financially suitable men. In worlds where many of your friends are in the same position, the road to adulthood, success, and social membership seems out of reach in almost every way—except through the fulfillment of your role as a mother. Paradoxically, then, it is "traditional" cultural values regarding women's place and the importance of family, alongside the hope for a certain form of social inclusion in the mainstream, that produces the countercultural legitimation of single parenting on welfare.

When Nadia legitimates her position on the welfare rolls by turning to the argument that her "work" is caring for her children, this is not simply a sly and manipulative move on her part. It is simultaneously heartfelt, rational, theoretically sound, and the result of practical circumstances. Weighing what is offered by Burger Barn against what is offered by her four loving and well-behaved children, and recognizing the time and energy she dedicates to raising those children and the sacrifices she makes on their behalf, it is also not hard to understand her

interpretation of work. Paying attention to the men she has encoun-
tered, it is not hard to understand her interpretation of family values.
At the same time, in telling us that she really wants to get her GED and
some training for a better job, and in her resigned response that she
could go back to work at Burger King if she had to (though she hopes
for a better, more "memorable" job), she is letting us know that she un-
derstands what "we," the American public, want from her, and she
wishes that she could comply. Although she certainly lives in a culture
of poverty, none of her ideas are drawn from some evil, other-worldly
source.

The Candy-Store Syndrome, the seeking of pleasure through con-
sumption (even illegal consumption), is so widespread in American cul-
ture that it hardly requires an accounting. Marx referred to it as "com-
modity fetishism" and suggested that capitalists would eagerly promote
it as a way to multiply the number and forms of consumer goods that
people would feel the urge to buy, thus expanding markets and increas-
ing profits. Some of the primary ways to sell those goods, as every
American television viewer knows, is to claim they will make you feel
better, happier, and more alive, be more beautiful, accumulate more
friends, have more fun, increase your sexual satisfaction, offer you
greater success, and make you the envy of all your neighbors.[33] This vi-
sion of consumption heaven also serves as a constant reminder that we
live in the richest nation in the world, and if you want to be a member,
you should buy, buy, buy.

It is not impossible to understand why women like Joy find this mes-
sage alluring and can easily translate it into a story about how the pur-
chase of drugs, alcohol, and sexual experiences, as well as consumer
goods and a career, will bring them the "Miller high life." Millions of
Americans suffer from unmanageable credit card debt. There are sup-
port groups for out-of-control consumers, and there are cable television
stations dedicated solely to the marketing of frivolous status markers.
The Internet sometimes seems to have been created as a venue for the
selling of sex, prescription mood-elevators are valorized in doctors' of-
fices and best-selling books, and the use of illegal drugs is so widespread
and intractable that the United States has declared itself at "war" with
Americans' quest for (chemically induced) pleasure and escape.[34] All
these are indications that the cultural orientation to which Joy sub-
scribes is not confined to a small group of social misfits. One might also

argue that all of these phenomena are connected to a more general sense of loneliness, alienation, and uncertainty created by fast-paced social change, deepening inequalities, a volatile global marketplace, unstable gender relations, and the sense that we can no longer rely on our families and communities for solace and grounding.

The-System-Screwed-Me Syndrome, the idea that over bearing, over priced (or overly profiteering), bureaucratic big government and big corporations don't care about the "little guy," and therefore do not deserve our allegiance or deference or ethical behavior is also not an unrecognizable vision of the world. Its widespread nature is evident, for instance, in Americans' stated mistrust of the politicians who are supposed to serve us, in the ever-declining number of people who are willing to go out and cast their votes in local and national elections, and in the millions of Americans who believe that manipulating the figures on one's income tax forms in order to save money is not "cheating" but instead a reasonable strategy for maintaining one's fair share. This cultural orientation can also be found in our willingness to grab a few towels and other mementos as we check out of hotel rooms and to name a few "extra" losses when we file an insurance claim. It is similarly evident in the proclivity of Americans to bring legal suits against major corporations and in the willingness of juries to participate in the condemnation of those profit mongers by awarding mammoth legal awards. In this light, it is not so surprising that Sandra implies, "I paid my taxes; they owe me welfare."

The Lorena-Bobbit Syndrome, the fantasy of castrating abusive and disappointing men, is an equally understandable pattern from the point of view of many women in American society today. This problem, like the others, is neither superficial nor irrational. The last half century has seen the emergence of the feminization of poverty, the growth of the welfare rolls, the glass ceiling, the mommy track, the pressures of the second shift, rising rates of divorce and single parenting, and a vitriolic backlash against feminism. These are all indications that the promise of women's independence and equality that accompanied the rise in women's labor force participation was a promise only partially fulfilled—and one that came with tremendous unforeseen costs. These costs, as I have argued, have been most pronounced for people at the bottom of the social hierarchy. It is virtually impossible to overstate this point.

Problems in gender relations and in the possibilities for creating stable and happy family lives are a central terrain on which poor women's hardship plays out. The sociologist William Julius Wilson argues that high rates of joblessness among poor black men may be the single most significant factor causing high rates of unwed parenting among black women.[35] Extending this logic, all poor women face a marriage market composed largely of unemployed, underemployed, or only intermittently employed men. I do not pretend to know the men with whom welfare mothers are acquainted, but given American cultural expectations, it seems logical that their economic position makes it virtually impossible for them to fulfill the masculine model of success, and that some would resent women's growing claims to independence and self-sufficiency. At the same time, many women in this situation resent men's inability to fulfill the breadwinner role, and some, like Sandra, are not the least bit shy about expressing it. This scenario does not make for healthy and happy gender relations.[36]

Domestic violence—the single most dramatic indicator of gender conflict—is also the single most prevalent cultural pattern in the lives of welfare mothers. Welfare mothers are more likely to share this experience in common than any other life condition (with the exception of poverty itself). As noted, about 60 percent of welfare mothers are estimated to have suffered such violence at some point in their lives.[37] Of the women I talked to, half told me stories of abuse at the hands of the men they once loved. Although most welfare mothers, unlike Sandra, are still searching for the "right" man, among those who have been abused it is likely that their ability to trust men and to imagine a happy family life has been forever diminished.

This pattern of domestic violence is also not unrelated to more widespread problems in American family life. In any given year, from 10 to 20 percent of all women in the United States are physically abused by male intimates; one in four will be abused during their lifetimes.[38] Yet, as is the case with physical and mental health disabilities, domestic violence victims are systematically *overrepresented* on the welfare rolls. It is their experience of abuse, in other words, that partially accounts for the fact that they ended up in the welfare office in the first place. Given this reality, one might argue that the welfare system, for a large proportion of its clientele, is actually operating as one giant economic "shelter" for domestic violence survivors. Welfare reform's premise that marriage is a

central path to success, from this perspective, is all the more ironic and troubling.

In all this, my central point is that the attitudes and cultural orientations of women like Sandra, Joy, and Nadia, are both understandable and familiar when one considers their larger social basis. These cultural orientations are also not incorrigible, nor are they necessarily bound to be part of the lives of the children these women raise. If their children do, in fact, end up participating in cultures of poverty, this is more likely to result from their material circumstances, their multifaceted life experiences, and their interpretation of mainstream culture than it is to be the outcome of explicit socialization by their mothers.

Nonetheless, I do not mean to suggest that women like Nadia, Joy, and Sandra are simply members of the "mainstream." As much as they draw on mainstream American culture, they also represent an *oppositional* response to that culture. They are explicitly refusing to comply with any of the three central models of proper American womanhood: they are not "virtuous," sexually abstaining single women; they are not domestic, marriage-oriented stay-at-home mothers; and they are not perfect supermoms. Given the cultural and economic options open to them, however, their oppositional stance should not be altogether shocking. What is more surprising, I think, is that women like these are in a minority among welfare recipients. Although many other welfare mothers once shared some aspects of the orientations of women like Nadia, Sandra, and Joy, they are today at a different stage of their lives. They are simply trying to find a permanent route out of poverty, or at least a way off welfare. All of them will eventually succeed at the latter task; smaller numbers will succeed at the former.

The cultures of poverty are our cultures. And the most deviant among them are not likely to be extinguished by welfare reform. Abstinence education, marriage bonuses, and family caps are certainly not the answer. And even though training sessions and support groups and individual mentoring and income supplements and childcare subsidies can and do make a difference in the lives of many individual welfare mothers, they do little to attack the larger cultural trends and social inequalities that shaped those lives in the first place. Just as the strategy suggesting that we might simply lock these women up or launch them on a trip to Mars

will not solve the problems in work and family life that produced the rise of the welfare rolls, so too attempts to modify the behavior of these women through the sticks and carrots of the welfare office may make a difference but are unlikely to evaporate the root causes of the "maladies" from which these women suffer.

Chapter 8

The "Success"
of Welfare Reform

MOST WELFARE MOTHERS HAVE NOT BEEN activists for the rights of the poor. Some have joined or established poverty advocacy groups to publicly protest the Personal Responsibility Act. Others have individually lodged their complaints against changes in the system, with the quiet determination of Nadia or the louder frustration of Sandra. But the majority of welfare mothers, like the majority of Americans, have expressed their support for the "end to welfare as we know it."[1]

Poor mothers' support for welfare reform is the single most striking indication that welfare mothers are not the social "outsiders" portrayed in the Personal Responsibility Act. Most welfare mothers share the core values of most Americans. They share a concern with contemporary problems in work and family life and a commitment to finding solutions—including the overhaul of the welfare system. The trouble is, welfare reform was founded on the assumption that welfare mothers do not share American values and are, in fact, personally responsible for *undermining* our nation's moral principles. The policies and procedures instituted by welfare reform have thus been aimed at "fixing" these women.

This paradoxical state of affairs raises questions of just who has the right to fix whom, and what, exactly, is broken and in need of repair. Still, as I have suggested throughout this book, the problems in work and family life that informed welfare reform are real problems that have impacted us all. Similarly, the broader moral principles implied in the cultural logic of reform—principles of independence, productivity, citi-

zenship, strong families, community spirit, and obligations to others—
are worthy and widely shared. Yet from the start, welfare reform was also
plagued by cultural distortions, exclusionary stereotypes, and a nar-
rowly drawn and internally inconsistent vision of what counts as the
proper commitment to work, family, and nation. And the policies insti-
tuted by welfare reform have left the nation's poorest mothers in a posi-
tion in which no matter how committed they are to the work ethic and
family values, under current conditions, the majority will remain un-
able to achieve either the model of the happily married homemaker or
the model of the successful supermom, just as the majority will remain
unable to lift their families out of poverty.

The inadequacies of welfare reform clearly follow from structured in-
equalities in American society. But the inadequacies of welfare reform
also follow from a serious problem in the cultural logic of personal re-
sponsibility itself.

The notion of personal responsibility denies the embeddedness of all
individuals in the wider society and their reliance on it. It is an image of
unfettered individualism—of every man, woman, and child as an island
unto themselves. This logic most obviously neglects the "dependency"
of children and the fact that no parent is "unfettered." It also neglects the
importance, the reality, and the necessity of wider social ties and con-
nections. It makes invisible, in other words, our interdependence.

It is this failure to take account of the full measure of our interde-
pendence that allows for the construction of "us-versus-them" scenarios
that not only demonize welfare recipients but also call into question the
values and behaviors of all of us who find ourselves unable to mimic the
mythological model of perfected self-reliance: seamlessly juggling our
multiple commitments without ever needing to depend on our friends,
our families, our neighbors, or the nation to support us. This individu-
alistic logic similarly undergirds our privatization of the work of caring
for others, leaving it hidden, undervalued, and inadequately supported.
And this logic upholds the privatization of the labor market, leaving it
insufficiently regulated by the public and allowing competitive, profit-
seeking employers to ignore the existence of children, circumvent the
minimum standards for sustenance, and exploit the most vulnerable
among us.

All this explains why, in the long run, the Personal Responsibility Act
will not be a law we can proudly hail as a national "success." Women,

children, nonwhites, and the poor will be hardest hit. But the consequences of reform will leave nearly all of us losers, in economic, political, and moral terms. To make sense of this and to examine how the road to hell can, in fact, be paved with good intentions (or at least a mix of good intentions, harsh realities, and incomplete moral reasoning), let me begin again, with the principles and problems that initially prompted this massive change in law.

Shared Values, Symbolic Boundaries, and the Politics of Exclusion

In responding to welfare reform, the welfare mothers I met often offered a perfect mirror of the complex mix of higher values, genuine concerns, exclusionary judgments, and cultural distortions that informed the Personal Responsibility Act. One mother, Denise, captured nearly all these elements in her response, offering the full range of the more prominent patterns I encountered and mimicking the words of welfare mothers you have heard throughout the book. A black woman with two daughters, at the time I met her Denise was recently employed at Mailboxes-R-Us for $6.50 an hour and was making ends meet with the help of welfare reform's (time-limited) income supplement, transportation vouchers, and childcare subsidy. This is what she had to say when I asked her for her overall assessment of reform:

> When I was younger, years ago, anybody could get on welfare. And I think that's what's good about welfare reform. People have to show some sort of initiative. Before, the welfare office didn't pressure you to find a job, but now they do. And I think that's a good system. They've really helped me out a lot.
>
> Plus, I think people are sick of having to pay their tax money. They say, "Look, I am out here working, and I don't make that much money, and I have kids of my own. I'm tired of having to take care of your babies." People are getting upset and it's rightly so. I think it's rightly so.
>
> And lots of people abuse the system. You see it every day. A lot of people that you run into and a lot of people that live in your neighborhood—I mean a lot of people do hair and get paid in cash. And I hear about these people who had children just to get a welfare check, just because they didn't want to go out and work. I've seen women that's on welfare, they're looking good and their children look poorly. I see that happening.

Some of them are lazy and don't want to work. I think that some just want to stay home with their kids. But then they should have thought about that before they had the children.

At this point in her argument, Denise had hit upon nearly all the concerns of hardworking Americans who conscientiously pay their taxes, raise their children, and struggle to make it all work. She had also hit upon nearly all the well-worn stereotypes of poor mothers—implicitly labeling them as welfare cheats, lazy couch potatoes, promiscuous breeders, and lousy parents. But Denise wasn't finished.

I think some people on welfare are being greedy—taking away from people that are homeless, people that really need the help. I mean there are truly people out there living at the Salvation Army. I hear tell that there are people who can't get in those shelters because they're so full. And I think that's the sad part about it. Those women that don't really need welfare shouldn't be taking money away from the homeless.

But there are gonna be problems. Like, there are women that want to go out there and get a job, but who's gonna watch their kids? And there are people who will still need that little extra help to pay the bills. So that's a glitch in the system. And some of these women are already pregnant, and they're already poor, and they really do need the help. I think that we have to weigh things and maybe investigate a bit more. There are a lot of people that are disabled and need welfare; there are women who have been abused. Some of those people that are in a lot of trouble, you know, their kids are gonna be the ones you see on TV, shooting up the schools and everything.[2]

I know a lot of people say that this welfare reform is a good thing— and it is really gonna help a lot of people. But in the end things are probably gonna get worse. There's gonna be more crime 'cause people can't get on welfare and they're not gonna have any money and they're gonna go out and rob people, and kill people. And it happens, it happens. So that's a problem with the system.

If Denise had been responding to a national survey, "Do you approve of welfare reform?" her answer would simply be coded as a "yes." Yet you can't help noticing that she has a number of mixed feelings on this question.

This same sort of ambivalence is evident in Americans' response to welfare reform. Although most are positive about reform, the majority of Americans also say that they are "very" concerned about poverty. Most additionally believe that the national standards for poverty are set too low, stating that a family of four with an income of less than $20,000 is, in fact, "poor," even if the federal government does not label them as such. More significantly, a majority of Americans are in favor of further aid to the poor—including the expansion of job opportunities, tax credits, medical coverage, subsidies for childcare and housing, and the provision of better schools. Still, Americans worry about the government's ability to appropriately and effectively provide that aid, and many don't want to have to pay higher taxes to subsidize the poor.[3]

Denise is also much like most Americans in that the central moral categories she uses to frame her response are work and family values, independence and commitment to others, self-sufficiency and concern for the common good. Women should take the "initiative," they should work, they should not rely on the help of others, they should support their own children, they should think twice before they give birth to children they cannot afford to raise. At the same time, people should not be "greedy," they should care for those who are more vulnerable than themselves, and they should consider the impact of their actions on the nation as a whole. All this makes perfect sense, and all this resonates perfectly with our nation's values. The trouble is that managing these commitments is hard enough if you have a spouse, a house in the suburbs, two cars in the garage, good health insurance, reliable childcare, a willingness to make compromises, a great deal of determination, empathy, and energy, and a household income of $60,000. The more items on this list that you lack, the tougher it becomes to live up to this demanding system of values. Denise, like most Americans, implicitly understands these "glitches." Yet her reasoning becomes a bit cloudy at this point—in large measure, I would argue, because of the loophole provided by the final significant element in her response to welfare reform.

It is hard to miss that Denise's support for the Personal Responsibility Act is predicated on the construction of a moral distinction between herself and all those "other" bad welfare mothers who fail to live up to social standards. Denise is making use of what Michèle Lamont has called "symbolic boundaries" to develop an implicit hierarchy of social worth. Like most people who use this strategy, she is not simply engag-



ing in a mean-spirited attack on others or a self-interested attempt to highlight her own virtues. These symbolic boundaries also allow her to positively affirm shared values and specify the proper way to live one's life.[4]

Yet, given that many observers consider Denise herself a member of the deviant group she describes, the fact that she and other welfare mothers persist in this technique is curious. It testifies not just to the power and ubiquity of boundary making as a social strategy, it also speaks to the power and ubiquity of the demonization of poor single mothers. When welfare mothers distinguish themselves from those other "bad" women, they are calling on widely disseminated negative images of welfare mothers. These images seem to match all those strangers, those loud neighbors, those people who appear to spend their lives hanging out on street corners. The lives of the women they actually know, on the other hand, seem much more complex, their actions more understandable, their futures more redeemable.

The demonization of welfare mothers and the dichotomy between "us" and "them" can thus provide a dividing line that allows Denise and other Americans to say, if some welfare mothers can't make it, it's not because the problems they encounter in trying to manage work and family and still keep their heads above water are that bad or that widespread; it's because they didn't try hard enough or weren't good enough. Symbolic boundaries thus become *exclusionary* boundaries—simultaneously offering a means to affirm shared values and a means to think of "outsiders" in terms of individual blame. The obvious problem, in Denise's case, is that her own logic might ultimately leave her as one of the "accused." In broader terms, this exclusionary process means that all those Americans who are suffering from childcare woes, second shifts, inadequate health insurance, precarious jobs, unmanageable debt, and unstable communities are left to feel that their problems are *personal* problems for which no public solutions can be found.

Reading the Good News

In the months and years following welfare reform, newspaper headlines offered a seemingly unequivocal vision of success: "10,000 Welfare Recipients Hired by Federal Agencies." "Number on Welfare Dips Below 10 Million." "White House Releases Glowing Data on Welfare." "Businesses

Find Success in Welfare-to-Work Program." "The Welfare Alarm That Didn't Go Off." "Most Get Work after Welfare."[5] The message was clearly upbeat, congratulatory. It seemed that one could almost hear the clucking sounds emanating from Capitol Hill.

Yet the newspapers also followed a second story, one more cautious and disturbing: "Most Dropped from Welfare Don't Get Jobs." "New York City Admits Turning away Poor." "Penalties Pushing Many Off Welfare." "Mothers Pressed into Battle for Child Support." "As Welfare Rolls Shrink, Load on Relatives Grows." "Welfare Policies Alter the Face of Food Lines."[6] The bigger picture, the one that could put a damper on all the celebrations, was carried in the stories behind these headlines. But overall, this reality seemed drowned out by the first story, the good news.

Given the inadequacies of the Personal Responsibility Act—the relentless bureaucracy, the sanctions, the unpaid work placements, the grossly insufficient childcare subsidies, the policies that operate at cross-purposes, and the genuine hardship suffered by current and former welfare recipients—why has welfare reform been deemed such a success? Part of the reason, as I've argued, is that the cultural message of reform has always been more important than its practical efficacy. A simpler answer is that the success of welfare reform has been measured by the decline of the welfare rolls. The trimming of the rolls from 12.2 million recipients at the start of reform to 5.3 million in 2001 is read as a sign that all those former welfare recipients are going to work, getting married, or otherwise taking care of themselves in the same (mysterious) way the poor have always taken care of themselves. But what, exactly, is behind the decline of the welfare rolls?

Financial success is clearly not the central reason that so many have left welfare. Although the booming economy of the 1990s had a crucial impact on welfare mothers' ability to get off the rolls and find some kind of work (see Chapter 2), even in that prosperous decade, the majority of former welfare recipients were not faring well. Between 1996 and 2000, the number of families living in desperate (welfare-level) poverty declined by only 15 percent, yet the number of welfare recipients declined by over half.[7] Although all the answers are not yet in, from the work of policy institutes, scholars, journalists and my own research, I can piece together the following portrait. In the context of a highly favorable economy, the welfare rolls were cut in half for four central reasons:

1) More welfare clients were getting jobs more quickly than they did under the old system.
2) More poor families were being discouraged from using welfare than was true under AFDC.
3) More were leaving welfare faster and returning more slowly than they did in the past.
4) More welfare mothers were being sanctioned or otherwise punished off the welfare rolls.

The best news in all this is the number of welfare mothers who have gotten jobs. Nationwide, as I've noted, researchers estimate that approximately 60 percent of all the adults who left welfare since reform were working, at least part of the time, in 2002. This reality not only offered good news to the proponents of reform; it also offered, for a time at least, a real sense of hope to many welfare mothers. On the other hand, only half of the former welfare recipients who found work were actually making sufficient money to raise their families out of poverty. Only one-third were able to remain employed continuously for a full year. A good number would thus end up, at one time or another, among the 40 percent of former welfare recipients who had neither work nor welfare. Some of those would go back to the welfare office again and start the process anew: policy analysts suggest that over one-third of those who left since reform had already returned to welfare at least once by 2002. In any case, even among those who were employed during that prosperous decade, according to federal statistics their earnings averaged only $598 a month for the support of themselves and their children. Other researchers have estimated average hourly wages at $7.00 an hour and average annual earnings at between $8,000 and $10,800.[8]

With the economy no longer booming, there is reason to worry that many will be unable to sustain even these levels of work and income over time. No matter how you look at it, such facts indicate very difficult living conditions for families. And most of the low-wage jobs acquired by former welfare recipients, as I've pointed out, are without health insurance, many are without sick and vacation leave, a good proportion are at odd or fluctuating hours, and many are only part time.[9] When the problems implied by these facts are coupled with the hardship of trying to find and keep affordable childcare and housing, worries about family health, how to pay the utility bills, and the everyday distress that comes

with managing life in the debit column, then one can understand why Barabara Ehrenreich, in *Nickel and Dimed*, referred to the lives of low-wage workers as not just a situation of chronic distress and insecurity but as a "state of emergency."[10]

The second group contributing to the decline of the welfare rolls is even less upbeat. This is the relatively invisible group of discouraged welfare clients—those poor mothers who have left or avoided welfare rather than face the increased stigma and the demanding "rigmarole" of rules and regulations that came with reform. This includes, first, all those mothers and children who never show up on any paperwork but have nonetheless been deeply affected by the law. These are the mothers who went to Sunbelt City's "diversionary workshop" and just headed back home without ever filling out an application. These are all the potential applicants in New York City and elsewhere who, by state rules, were not allowed to apply until they had completed their job search, many of whom simply never went back to the welfare office. These are also all those very poor families who have heard the stories on the streets and on the news and are now more reluctant to go to the welfare office than they were in the past. Finally, this group includes all the welfare clients who have filled out the forms, begun their job search, started the workshops, or taken a workfare placement, but then just stopped showing up—depressed, ill, angry, without childcare, without hope, unable or unwilling to meet the new standards. Some proportion of these women will eventually find jobs, and if they made it through the application process and if researchers are able to track them, they will be counted in the first category of "successes," working somewhere, for some period of time, for that $598 a month, no benefits.[11] For those who go long stretches without work or welfare, it is difficult to determine precisely how they and their children will survive (although I will speculate on their fate in a moment).

Once it becomes clear that welfare reform has resulted in both encouragement and discouragement, the third reason behind the decline of the rolls can be surmised. The Personal Responsibility Act has effectively transformed the process of "cycling." As I've noted, long before reform, most welfare clients cycled on and off the welfare rolls, moving between jobs and welfare. Now that welfare reform has instituted the "carrots" of supportive services and the "sticks" of time limits, sanctions, and work rules, the process of cycling has been altered—speeded up at

the exiting end and slowed down at the return end. That is, poor mothers are now getting jobs or getting off welfare faster than they would have in the past, and they are also entering or returning to the welfare office more slowly and reluctantly. Given that welfare rolls are counted from moment to moment, on paper this speed up/slow down appears as an absolute decline in the welfare rolls.[12] It says nothing, however, about the health and well-being of poor mothers and their kids.

Finally, about one-quarter of welfare recipients are now sanctioned or denied benefits for failure to comply with welfare rules. A 50-state Associated Press survey in 1999 found wide variations by state, with 5 to 60 percent of welfare recipients sanctioned (or procedurally penalized) at any given time in any given state—with rates twice as high as they were prior to reform. In one careful study of three major U.S. cities, 17 percent of clients had their benefits stopped or reduced as a result of sanctions or procedural penalties. In Wisconsin, the most carefully analyzed welfare program in the nation, 31 percent of the caseload was sanctioned in 1999, 21 percent in 2000. (Of those Wisconsin clients who had the wherewithal to appeal their cases, 70 percent of appeals were resolved in favor of clients, suggesting that many of these penalties were unfounded or improperly administered). Federal statistics find just 5 percent of clients under sanction but also note that 23 percent of cases are "procedural closures" (many of which could be penalties for noncompliance).[13]

These sanctioning practices, along with discouragement, faster cycling, and below-poverty wages explain why the number of welfare-eligible families who actually receive welfare benefits has fallen at a much faster pace than the rate of dire poverty. It is clear, in other words, that a substantial portion of desperately poor mothers and children are being punished, worn down, or frightened off the welfare rolls.

Putting it all together, in the context of a booming economy *more than two-thirds of the mothers and children who left welfare have either disappeared or are working for wages that do not meet federal standards for poverty*. At best, only 30 percent of the decline of the welfare rolls represents a "successful" escape from poverty—and many of those successes are only temporary, and many would have occurred with or without reform. The state of Wisconsin, marked as the most outstanding welfare program in the nation, matches these proportions precisely.[14]

In the meantime, there are still millions of poor women and children on welfare and hundreds of thousands coming in anew—or coming

back again, unable to find or keep work or to establish some other means of survival under the terms of welfare reform. All of them are desperately poor.

That all this information on the declining welfare rolls still leaves many questions unanswered is one indication that it will take many, many years before we can comprehend the full impact of reform. And almost all of what we now know pertains only to the period of economic boom and only to welfare mothers who had not yet faced the time limits on welfare receipt. Given that time limits do not result in a massive exodus from the rolls but rather a (relatively) slow trickle, it will take a very long time before all the consequences of "the end of entitlement" are surmised.[15]

One final related note is in order.[16] For those who were worried about the consequences of reform from the start, one source of protection against hardship appeared to be the federal rule allowing states to "exempt" up to 20 percent of their caseloads from the time limits. These exemptions, however, have proven severely inadequate, as I have argued. Some states have made the rules so complex and demanding that few clients can qualify. Other states have used all the exemptions available and still cannot fully protect all those recipients with serious physical disabilities and mental health problems, let alone all those who are at risk for domestic violence or who cannot find or afford childcare.[17] The number of families protected over the long haul will vary greatly depending on the rigidity or generosity of state and federal policies. But given what we know about those who have left already, it is clear that the exemptions available in 2002 are not enough to spare all the women and children faced with extreme poverty.

Looking on the brighter side, welfare reform, and the money that came with it—the income supplements, childcare subsidies, bus vouchers, work clothing, and for the lucky ones, the new eyeglasses, the help in buying used cars or making a down payment on an apartment—has been truly helpful, improving the lives of many poor mothers and children, at least for a time. Further, in some cases reform has meant that mothers are getting *better* jobs than they would have in the past, thanks to the education and mentoring offered by some state welfare programs. As I've suggested, as many as 10 to 15 percent of welfare mothers are in a better position now than they would have been had this law not been passed. Perhaps equally important, though harder to quantify, is the

positive sense of hope and social inclusion that many recipients experienced (in the short term at least) as a result of the supportive side of welfare reform.

The number of families that have been genuinely helped by reform is neither insignificant nor superfluous. At a practical as well as moral level, the services and income supports offered by the Personal Responsibility Act have clearly been positive. Yet in the long run and in the aggregate, poor mothers and children are worse off now than they were prior to reform. Among those who are working and still poor, among those without work or welfare, and among those who are still facing constant and intense pressure to find work and figure out some way to care for their children, we can only guess what impact this law will have on their ability to retain hope over the long term. Even the U.S. Census Bureau (not anyone's idea of a bleeding heart organization) has found itself answering the question, "Is work better than welfare?" in the negative, at least for those without substantial prior education and work experience.[18] With a slower economy and increasing numbers of poor families due to hit their time limits in coming years, there are reasons to expect that conditions will become increasingly difficult.

Empathy for the downtrodden is one reason to worry about these results. As the following sections will emphasize, enlightened self-interest, a concern with financial costs, and a commitment to our collective future are also very good reasons to be troubled by the consequences of welfare reform.

Winners and Losers

The extent to which the facts about the declining welfare rolls are read as a success ultimately depends on one's primary goals. If the goal of reform was solely to trim the rolls, then it has surely succeeded. If the goal was to place more single mothers in jobs regardless of wages, that goal has been met. If we sought to ensure that more welfare mothers would face a double shift of paid work and childcare, placing them on an "equal" footing with their middle-class counterparts, then some celebrations are in order. If the aim was to ensure that poor men are prosecuted for failure to pay child support, then welfare reform has been relatively effective. If the goal was to make low-income single mothers more likely to seek out the help of men, no matter what the costs, there

is some (inconclusive) evidence that this strategy may be working.[19] If the goal was to decrease poverty overall, there is no indication that anything but the cycle of the economy has had an impact. Beyond this, the answers are more complicated.

Thinking about losers, one can start with the families who have left welfare. One-half are sometimes without enough money to buy food. One-third have to cut the size of meals. Almost half find themselves unable to pay their rent or utility bills. Many more families are turning to locally funded services, food banks, churches, and other charities for aid. Many of those charities are already overburdened. In some locales, homeless shelters and housing assistance programs are closing their doors to new customers, food banks are running out of food, and other charities are being forced to tighten their eligibility requirements.[20]

Among the former welfare families who are now living with little or no measurable income, will those charities be enough? At ground level, Nancy, the supervisor in Arbordale's welfare office, told me more than once that she was deeply concerned about these families, particularly the children. Melissa, the supervisor in Sunbelt City, on the other hand, repeatedly responded to my questions regarding the fate of former welfare recipients with the simple statement, "They have other resources." Melissa was referring not only to all those (overloaded) charities, but also to all the boyfriends and family members who could help in paying the bills, and to all those unreported or underreported side jobs (doing hair, cleaning houses, caring for other people's children, selling sex or drugs).[21] Between these two welfare supervisors, both of whom have spent many years working with poor mothers, who is right? And what about Denise, who both agreed with Melissa that many welfare mothers didn't *really* need the help, and who predicted that welfare reform would result in frightening hardship, including a rise in crime?

Consider the "other resources" available to the women I have introduced in this book. In the case of Sheila, the Sunbelt mother who was caring for her seven-year-old daughter and her terminally ill mother, the three of them might be able to survive somehow on her mom's disability check (about $550 per month) with the help of food stamps and local charities. If worse came to worst, she might be able to find some work on the graveyard shift so that she wouldn't have to leave her mom and daughter alone during the day (but she would be faced with leaving them alone at night in that very dangerous housing project). Diane,

the Sunbelt mother with a three-year-old son and a long history of severe depression and domestic violence, could go back to operating that illegal flophouse and taking under-the-table housecleaning work (though it is not clear what impact this would have on her son, not to mention Diane). Nadia, the Arbordale mother with four children and no work experience, might rejoin her old friends in petty thievery and prostitution, or she could put further pressure on her employed aunt or the two unemployed fathers of her children, or she might consider turning her children over to relatives or to the foster care system (a worst case scenario recognized by many of the mothers I talked to). Monique, the second-generation Arbordale recipient who'd had her first child at 17, could probably manage on her current job, though one might be a little concerned that her abusive ex-husband would return, force her to move, and throw the fragile balance of her life into chaos. Of course, there are also women like Sonya, the compulsive house rearranger (and incest survivor), who have no family, no work experience, no marketable skills, and no idea about how to make use of local charitable institutions. Someone would surely notice such women eventually, if only because their children missed school or appeared too ill-kept or malnourished.

Most welfare mothers *do* have other resources. Yet many of those resources are only temporary, and many are, at best, inadequate. Most will likely add greater instability and uncertainty to the lives of these families. And nearly all these resources have their own price tags—practical, emotional, moral, and social.

As these negative effects begin to overburden ever-larger numbers of women, we can expect to see more crime, drug abuse, prostitution, domestic violence, mental health disorders, and homelessness. More children will end up in foster care, residing with relatives other than their parents, or living on the streets. These children will also be at greater risk for malnutrition, illness, and delinquency. At the same time, more sick and disabled relatives who once relied on the care of welfare mothers will find their way into state-supported facilities or be left to fend for themselves. Caseworkers in Arbordale told me that they were already noticing the rise in foster care cases and in child-only welfare cases (where mothers had relinquished their children to relatives—making those children eligible for welfare benefits until age 18).* In Sunbelt City, welfare clients told me they were already witnessing rising rates of

hunger, drug abuse, prostitution, and crime among sanctioned or discouraged former welfare mothers they knew.

All this hardship will affect poor men as well as women. Not only are these men faced with a more rigid and unforgiving child support system, but they are also very likely to face pressure from the mothers of their children and from the recognition that their children may go hungry or become homeless.[22] The desperation of some of these men could result in a greater incidence of violence, crime, and drug abuse among a low-wage, chronically underemployed male population that is already suffering from severe hardship.

The long-term consequences of welfare reform will also place a tremendous burden on other working-poor and working-class families. The upper classes can rest (fairly) assured that most desperately poor mothers won't come knocking on their doors, asking for cash, a meal, a place to stay, or the loan of a car. But many poor mothers will (reluctantly) knock on the doors of the working-poor and working-class people who are their friends and relatives. It is these people who will share their homes, their food, and their incomes and provide practical help with childcare and transportation. These good deeds won't appear on any income tax forms, welfare case reports, or analyses of charitable spending. But this burden on low-income working people will be one of the very real, and largely invisible, costs of welfare reform. And it will surely exacerbate existing income inequalities.

In the end, it is simultaneously true that most welfare mothers have other resources, many will face frightening hardship, and some proportion will turn to desperate measures. If nothing changes and welfare reform isn't itself reformed, by the close of the first decade of the twenty-first century, we will see the beginnings of measurable impacts on prison populations, mental health facilities, domestic violence shelters, children's protective services, and the foster care system.

* According to the rules of reform, there are no time limits on welfare benefits to children who live with relatives (or other adults) who are not themselves receiving welfare. This policy thereby offers welfare mothers an *incentive* to give up their children to other family members, since it means continued financial assistance for those children. Among "streetwise" welfare recipients, this is already a well-known rule. And the number of child-only welfare cases has, in fact, been on the rise since reform (U.S. House of Representatives 2000, see also Bernstein 2002).

This brings us to the goal of saving taxpayers' money. Given drastic cuts in food stamps and aid to legal immigrants as well as the declining number of welfare recipients, taxpayers are paying somewhat less in aid to the disadvantaged overall, though relative to the size of the welfare rolls, the 2002 per client costs are higher than they were in 1996.[23] Over the long haul, welfare reform is likely to become increasingly costly. Savings in welfare benefits will eventually be more than offset by the expenses associated with the social problems made worse as a result of reform. The average individual welfare recipient received approximately $1680 in cash and services annually in 1996; that same year, the annual cost of keeping one child in foster care was $6,000, and the cost of keeping one person in prison was $20,100.[24]

From this angle, the real winners in the story of welfare reform are all the restaurant, hotel, retail, and food service chains, and all the corporations, manufacturers, and small business owners across America who employ low-wage workers. These owners (and their stockholders) benefit not just from the availability of millions of poor women desperate to find work and willing to accept the lowest wages and the worst working conditions, they benefit not just from the additional availability of all those now more-desperate poor men, they also benefit because all this desperation creates more profitable labor market conditions overall. Welfare reform helps to convince all low-wage workers that they can be easily displaced by former welfare recipients and therefore makes them less likely to complain, change jobs, join unions, or demand higher wages. The logic of reform also means that low-wage employers can rest assured, for the moment at least, that no one will be calling into question the fact that their policies are less than family friendly and their workers are unable to support their children on the wages they take home.[25]

On a superficial level, the "end of welfare" appears to hold in place the symbolic messages that work is better than welfare and marriage is better than single parenthood. But by no stretch of the imagination could one argue that welfare reform brings with it anything resembling the triumph of "family values." And the practical reality of most low-wage employment no more offers "independence" and self-sufficiency to former welfare recipients than it does to all the middle-class teenagers who spend their summers working in fast-food restaurants and retail chains.

Although the negative results of welfare reform are dramatic, it is

nonetheless quite possible that a substantial number of former welfare recipients will simply be "absorbed" into the society without a great deal of fanfare. In the larger scheme of things, after all, 12 million or so desperately poor people in a nation of 285 million are not that many. On the other hand, it's important to remember that those figures include the many millions of American children who were once supported by welfare checks. Further, such figures are inadequate to capture the reality that welfare poverty covers an ever-changing group of citizens: in coming decades, tens of millions will be affected by changes to the welfare system. But given class and race segregation in housing, work, and services, many middle-class Americans will not actually witness the daily hardships of poor families, at least not in a direct and immediate way.[26]

Of course, as I've suggested, there is also a real possibility that as conditions worsen, the nation will see higher levels of civil disobedience, especially in those locales with high concentrations of the poor—including New York City, Los Angeles, Baltimore, St. Louis, Philadelphia, Washington, D.C., and elsewhere. In any case, over the long haul the reform of welfare will be costly—in its human toll, its fiscal toll, and its moral and political toll.

The Retreat from Controversy

I remember the stranger I met while visiting Chicago; we shared a cab ride from the airport to our hotels and I told him about my speaking engagement on the topic of welfare reform. Like many of the congressional members who voted for the Personal Responsibility Act, and Charles Murray who argued in *Losing Ground* that single parenthood is itself the cause of poverty, this stranger asked the questions that many others longed to ask. Why don't these women just get jobs? Why don't they just get married? Why did they have children in the first place, if they were without sufficient means for supporting those children? As I've argued, a recognition of the social foundations and complex circumstances leading women to single parenting and welfare makes it clear that these questions are too simple.[27] The problem is not that the nation's poorest women have systematically and capriciously passed up good jobs and good marriage partners. The problem is that there are significant economic and cultural inadequacies in the choices

available to them. And the problem is that most low-income Americans, like most middle-class Americans, continue to place a high value on children.

Through all the major changes in work and family life that led us to this point, the majority of Americans have held firm to the belief that children are our future and deserve an honored place and special care.[28] Most people still want to raise children, no matter how expensive they are, no matter how much they get in the way of unfettered individualism, and no matter how many practical difficulties and economic risks their rearing might entail. Similarly, the social value and centrality of children was a central propellant for welfare reform, just as this moral precept stands behind more widespread attempts to shore up the American family. The trouble is, as the inadequacies of the Personal Responsibility Act so clearly demonstrate, our nation is simultaneously celebrating the importance of children, holding high an ethic of care and commitment to others, while at the same time demanding that all Americans be completely self-reliant.

If our collective concern for children does not translate into public support for the work of caring for children, what happens in those cases when push comes to shove? What are we saying to the tens of millions of Americans who—given existing labor market opportunities and income inequalities—will, by the end of their childrearing years, have found themselves living in poverty at least once? Are we suggesting to them that they should remain celibate for life? And what are we saying to all those parents, especially mothers, who value their paid work and independence but still find themselves faced with taxing second shifts, worries about their children's well-being, childcare troubles, and an impossibly demanding time crunch at home?[29]

In a society where one of every three children is living with a single parent and more than a third of single mothers live in poverty, where the majority of mothers are working outside the home and the majority of two-parent households are dual-earner households, where suburban residential neighborhoods look like ghost towns during business hours—who is left to do the work of caring for "dependents"? What social position, what status, do these caregivers hold?[30] Is anyone assigned to support and finance and care for them? What should we do in those cases in which the American values of self-reliance and concern for others are not easily and smoothly reconcilable? Neither the authors of wel-

fare reform nor our society as a whole have completely resolved these dilemmas.

Not so long ago our society resolved these glitches by simply labeling all women as dependents, assigning them the job of care, and relegating them to socially subordinate status. As long as women's independence was not included among our nation's values, as long as our culture could maintain a story of satisfied breadwinners and happy housewives, we could solve the tensions between independence and nurturing by simply assigning men and women to different categories.[31] Women's labor force participation and the claims to self-determination and full social membership that went with it permanently disrupted this fragile cultural story and the mythology built up around the perfected "traditional" family.

The two-hundred-year-old family ideal of an independent breadwinning husband and a dependent domestic wife, bound together for life by their complementary roles, is, realistically speaking, outdated. No matter how much some people might wish it could be otherwise, the odds of turning back the clock on this one are not good. And there are also quite obvious reasons why we should want to avoid that solution. Yet, the revolution in work and family life that brought us to this crossroads has not been matched by a system of public support sufficient to protect families from the moral and practical dilemmas that came with it. In fact, we have intensified rather than lightened the familial demands on today's mothers, just as we have made it more impossible for low-income parents to support a family.[32]

In the midst of this, our nation's leaders pretended to take a stand in the form of the Personal Responsibility Act. Yet they ultimately did nothing more than retreat from controversy. This retreat is evident, for instance, in the law's failure to acknowledge that it is less expensive to pay a mother a welfare check than it is to subsidize the costs of having someone else care for her children so that she can go off to work an underpaid eight-hour shift. This retreat is evident in the fact that committed welfare caseworkers put their own jobs at risk by providing aid to women who need to escape from violent or dangerous partners, yet are forced by law to bury this reality under the category of "work-related expenses." This retreat is evident in the law's simultaneous proclamation of concern for children's well-being and its stamp of approval for family

cap provisions that effectively punish children for being born. This retreat is apparent in the fact that the law purports to champion marriage but actually contains a marriage penalty in both its eligibility requirements and its work rules. This retreat is further demonstrated in the promotion of abstinence education programs that systematically neglect contemporary work and family realities and further stigmatize the millions of women who will, at one time or another, find themselves both poor and raising children alone.[33] And the Personal Responsibility Act engages in the final retreat by holding up the values of independence, "self"-sufficiency, commitment to family, and concern for the common good while failing to address the tug-of-war and the very real glitches involved in realizing these principles.

Still, I have to admit that the impulse to retreat is one I recognize. On many of my long days in welfare offices, I wanted to simply shout, "STOP!!! Stop the madness! Can't we just go back to the way things were? Won't someone please just give these women their welfare checks and let them go home to care for their children?" And there are powerful arguments in favor of this position, emanating, in (quite) different forms, from the ranks of both feminists and conservatives. If we are going to continue calling upon women to take primary responsibility for raising the nation's children, and if we want to combat the rampant individualism that is tearing the nation's moral fabric, they say, then we must value, honor, and support the ethic of caregiving and women's commitment to childrearing. For conservatives, the required support for childrearing often translates into little more than symbolic support—that (proverbial) kiss on a mother's cheek that says "Thanks, honey." For feminists, that support must translate into, at the very minimum, the financial backing and familial safety net that was represented by the former system of welfare.[34]

Truly honoring the work of childrearing and the ethic of caring for others, and doing so in a public way that includes financial support as well as lip service is, without question, a central element in any solution to the glitches in our higher principles. On the other hand, implicitly or explicitly suggesting that women really *must* go back home to care for those children, or that some women, faced with low wages and the lack of suitable childcare, should simply be left without a choice, cannot be a part of this picture—if women's independence is a value we wish to uphold. When I found my mind wandering to a solution that included a

return to welfare in the "good old days" prior to reform, it would not take long for a welfare mother to correct me on this point.

Most welfare mothers, like most people, recognize that independence is not simply a matter of self-interested individualism or the pure "self-sufficiency" of an imaginary Robinson Crusoe. Their vision of independence is much more closely connected to the vision of this nation's founders, and the corrections produced at the 1848 convention for women's rights, following from the declaration, "We hold these truths to be self-evident." This is a vision of independent *citizenship*. It is a vision of the person who is not controlled or subjugated by anyone, and is therefore able to speak her mind, stand up for her rights, and think clearly about the common good. In its better versions, this image of independence takes into account that we are *inter*dependent members of nations, and communities, and families. It recognizes, in this sense, that no individual is "unfettered," and that all people ultimately "depend" on others.[35] And in this historical period at least, work in the public sphere, work as a contribution to the good of the whole, is a crucial element of one's citizenship. In fact, as welfare mothers so regularly reminded me, paid work is today a central ticket to social membership.[36]

If you listen closely, you can hear all this in Denise's rendering of her support for welfare reform. This logic is also part of the reason that so many welfare mothers are committed to reconciling the care of their children with the importance of paid work. A citizen should be able to simultaneously raise children, care for others, participate in determining the future of the nation, and be an independent, productive participant in the public world. The question is, what would it take to make this possible for *all* members of this society?

Building an Ethic of Interdependence

Under the old system that upheld our nation's values by separating men's independence from women's caregiving, our nation's citizens, our grandparents and great-grandparents—inadequately, but nonetheless with moral consistency—provided public, practical, and financial backing to uphold this vision. The welfare program established in 1935 with the New Deal called on the state to support those women who were without an "independent" breadwinner to care for them, and they called on the market to offer men wages that were adequate to support a fam-

ily of "dependent" wives and children. Under current conditions, both the state and the market operate as if children did not exist and as if there is no caregiving work left to be done.

If we are to be true to our principles, it is now time to call on the state and the market to provide all people with the means to do *both*. We could start by offering just the sort of programs that the majority of Americans endorse—increasing subsidies for childcare, housing, medical costs, and education, and expanding job opportunities. More specifically, we could, first, offer genuine public support for the work of caregiving, not just a kiss on the cheek and an imaginary pedestal, but substantial tax credits to caregivers, universal supplements to cover the costs of childcare, and national standards to assure the quality and compensation of paid caregivers. We could provide workplace family leave policies that positively value the work of care, and we could offer adequate flexibility on the job to allow all workers to respond to family responsibilities. These measures are crucial not just to all the women who have thus far been the primary persons engaging in the undervalued work of care. Such policies would also operate as an incentive for men to participate equally in the work and rewards of raising children and caring for family members.

At the same time, we need to make it possible for all adults to achieve financial independence. The fact that the nation has moved farther away from this goal is a central reason for the rise of single parenting and the rise of the welfare rolls that occurred from 1970 to 1995. In 1970, the bottom fifth of Americans earned just 14 cents on every dollar earned by the top fifth. By today's standards, however, that level of income would seem like great riches. According to the Congressional Budget Office, by 1997, the 57 million Americans in the bottom fifth were earning just *7 cents* on every dollar earned by the 57 million at the top.[37]

To address this tremendous income disparity requires raising the minimum wage to the level of a "living wage" that is sufficient to support children. It means reassessing tax burdens and tax breaks and government subsidies that disproportionately favor the wealthy. Further, to make the vision of independent, productive citizenship a reality, the creation of widely available, fully subsidized job-training programs and public works employment are not altogether unfathomable ideas. Although these policies would surely be more expensive than past welfare programs, costs could be recouped by lowered rates of

crime and foster care, for instance, and by resetting state and market priorities.[38]

As is true in many Western European nations where more family friendly, income-equalizing policies are already in place, many of these programs should operate as universal programs, available to all people at all levels of the class system. No one need think of them as "charity" or as "handouts" for the unworthy. They are simply the entitlements of citizens, no less than aid to the disabled, public schools, public parks, and our public highway and sewage systems.[39] All these programs could similarly serve as symbolic and practical representations of our recognition of human interdependence and our collective commitment to the common good.

It also makes sense to maintain a safety net of family aid for all those situations where broader social programs are inadequate or push has come to shove and the full-time care of children or disabled family members is either a necessity or the most dignified, practical, and cost-effective route. In creating a humane and successful family "welfare" system, there are many lessons to be learned from the Personal Responsibility Act. First, an emphasis on the supportive side of reform is crucial. The wage supplements and the funding for education, training, child-care, and work-related expenses provided by reform have all been positive. Reform has also demonstrated that childcare subsidies, training programs, domestic violence protections, and help for the disabled must be expanded and that a number of affirmative steps are required to include low-income fathers. At the same time, all those policies that have operated at cross-purposes with the broader, more inclusive ideals of reform should be removed. We could easily delete all the marriage and cohabitation penalties, the "work-first" incentives, sanctions, family caps, and the programs that "divert" poor families from receiving benefits. We might also consider trimming the bureaucracy, removing superfluous rules, increasing the flexibility of requirements, and including recipients in decision-making processes—and thereby treating disadvantaged men and women as worthy American citizens.[40]

At the same time, if marriage is to be a matter of choice rather than coercion, the provision of adequate income is key. Historical and contemporary research consistently demonstrates that a living wage is crucial for the formation and stability of families. The widely hailed (and

since discontinued) Minnesota welfare experiment that impacted marriage rates, improved parental relations, and added greater stability to the lives of children did so by systematically offering more income, more choices, and more dignity to the parents it served—removing time limits, increasing wage supplements, removing marriage penalties, and providing subsidized childcare to all eligible families.[41] When programs following this kind of model are coupled with more widespread national policies to support childrearing and economic security, we can expect to see the size of low-income family welfare programs remain low, and we will see many more families making their way out of poverty. The alternative is to face increased homelessness, crime, and hardship and to leave millions of women and children in desperate poverty, with substandard childcare, mounting debts, and nowhere to turn when push comes to shove.

At this writing, however, the cultural image of the Personal Responsibility Act's "success" remains triumphant. The 2002 Bush administration is proposing to intensify the pressure on welfare recipients and welfare offices across the nation. White House proposals suggest that increasing numbers of welfare mothers must be placed in jobs. Recommendations are being made to raise work "participation" rates from 50 to 70 percent and to simultaneously decrease the flexibility of states to manage these demands. Our president and his advisors are additionally recommending more programs to promote marriage, including the suggestion of monetary "marriage bonuses," the institution of training programs in marital commitment, and the expansion of abstinence education. In the meantime, grants to states will remain at current levels, thus allowing inflation to erode their value. And no additional funding will be provided for childcare subsidies, thus increasing the ranks of the more than two-thirds of welfare mothers who are already required to work without help in finding or paying for childcare.[42]

Thinking about the impact of these proposals inside the welfare office and remembering the struggles of caseworkers in Arbordale and Sunbelt City as they frantically devised strategies to make the best of an already difficult situation, I worry. I imagine the embarrassment and concern of welfare caseworkers as they are forced to participate in marriage promotion programs while simultaneously recognizing the number of domestic violence survivors who are likely to be in their audience. I can picture state policymakers being forced to decide, with the few op-

tions they have left, whether to exempt from work requirements those recipients who are severly disabled or those who are caring for two-week-old infants. I can visualize the number of unpaid workfare placements that will have to be used to meet the new, more rigid and demanding work rates in those contexts where there simply are no paying jobs available. And I can feel what such changes will mean to all those mothers who have no one to care for their children. How many more sanctions will be used? To what back-up "resources" will desperately poor families be forced to turn?

If we, as a nation, cannot figure out how to simultaneously support the independence of all women and men *and* support an ethic of caring for others, then it will be true, as Joel Blau has argued in *Illusions of Prosperity*, that the amoral logic of the profit-focused market has fully triumphed. And it will also be true, as others worry, that self-interested, competitive individualism has won, and the possibility of collective concern for the common good is dead.[43] As an expression of our awareness that the story of the "traditional" family no longer holds, welfare reform has been a grossly inadequate response. Rather than publicly acknowledging the value of commitment to others, we have buried it further. Thus, at the very same time Americans are expressing concern over the demise of civic trust, the Personal Responsibility Act has operated to pound more nails into its coffin.

Although the results of welfare reform may creep up on us slowly and almost imperceptibly, to proclaim this experiment in family values and the work ethic a "success" would be, at minimum, short-sighted. If we care only about our pocketbooks, the results of this reform will ultimately be more costly than the system that preceded it. If we care only about the nation's productivity, then the principles of enlightened self-interest would suggest that malnourished future laborers and caregivers stressed to the breaking point are not going to further that goal. If we care about the family, then tortured gender relations, double-shifts, family unfriendly employers, latch key kids, inadequately funded child-care centers, and high rates of domestic violence are nothing to celebrate. And if we care about the principles of independent citizenship and commitment to others, then it must be recognized that welfare reform represents little more than a weak-kneed retreat and a cowardly response to massive social change.

To confront the social problems that welfare reform was purported to solve requires public support for the work of care and directly addressing unjust social inequalities that leave so many Americans excluded from full citizenship. This is no small order. But this examination of welfare reform, I hope, can serve as a reminder that the effort required is important not only for those at the bottom of the social hierarchy, but for all of us.

Notes

Chapter 1

1. U.S. Congress (1996, PL104-193, Title I, Section 401).
2. Between July 1994 and January 2000, the real value of welfare benefits declined by 11 percent. Even though 16 states had raised their benefit amounts by 2000, most did not raise them enough to offset inflation. See U.S. House of Representatives (1998, 2000).
3. See Abramovitz (1999), Blau (1999), Mink (1998), Naples (1999), O'Neill and Hill (2001), Piven (1999), Women's Committee of One Hundred (2001).
4. See Bane and Ellwood (1994), Harris (1996, 1993) on the employment rates of welfare mothers and the practice of "cycling" between work and motherhood.
5. U.S. House of Representatives (1998).
6. See Dalaker (2000), Lamison–White (1997), and Pear (2002) on levels of desperate poverty and welfare. See Moffit (2002), U.S. House of Representatives (2000), Loprest (1999), Acs and Loprest (2001) on the circumstances of former welfare recipients.
7. In the early years of reform, billions of dollars were sitting idle as states attempted to determine how they would use the additional federal welfare funding, but by the time the economy stalled in 2001, many states had spent much of their federal allotment, and seven states were without any "rainy day" funds at all. The percentage of federal TANF money that was passed onto welfare recipients in the form of cash assistance had also declined, from 70 percent in 1997 to only 40 percent in 2001. (See Neuberger and Lazere 2001, National Campaign for Jobs and Income Support 2001A, Parrot and Neuberger 2002.)
8. The decline in the number of eligible people receiving food stamps and Medicaid has been even more dramatic. The calculation of the declining use of TANF is my own, based on the following sources: National Campaign for Jobs and Income Support (2001A, 2001B), Hinton (2001), Bernier (2001), and Weinstein (2001). For the rising use of charities that attended this change, see U.S. Conference of Mayors (2001), Ehrenreich (2001), Network Welfare Reform Project (2001).
9. Regarding continuing public support for welfare reform, see Public Agenda (2001) and National Public Radio et al. (2001).
10. For generalized renderings of this argument, see especially Durkheim (1984) and

Foucault (1979, 1972). For scholarship that focuses on the relationship between national values and policies aimed at the poor, see Handler (1991), Handler (1995), and Katz (1986). For scholarly treatments of this issue as it relates to welfare *mothers* (as women), see Abramovitz (1996), Fraser and Gordon (1997), Gordon (1994), Mink (1998), and Quadagno (1994).

11. In my use of the phrase "family values" I hope to recapture its more inclusive meaning, rather than the backward-looking (antifeminist) agenda with which it has unfortunately become associated.

12. In order of areas listed, the scholars I here refer to include Katz (1986), O'Connor (2001), Piven and Cloward (1993), Seccombe (1999), Zucchino (1997), Bane and Ellwood (1994), Harris (1997), Jencks (1992, 1997), Blau (1999), Ehrenreich (2001), Quadagno (1994), Gilens (1999), Gordon (1994), Abramovitz (1996), and Mink (1998).

13. See Public Agenda (2001), National Public Radio et al. (2001), Wertheimer et al. (2001), Draut (2001). See also Seccombe (1999), Gilens (1999).

14. For the composition of the welfare rolls, see U.S. House of Representatives (2000), U.S. Department of Health and Human Services (1999A), and Sorenson et al. (2000). A full 24 percent of welfare cases are "child-only" cases, where only the children receive welfare benefits (and the adult caring for them, usually a relative, is ineligible for welfare benefits). The racial configuration of any given locality varies widely. In Arbordale, about 70 percent of welfare recipients are black, 30 percent white. In Sunbelt City, about 55 percent are black, 30 percent white, and 15 percent Hispanic or other.

15. For conservatives, see Mead (1986), Murray (1984), Gilder (1981); see also Auletta (1982), Lewis (1966). Scholars who focus on economic hardship as the core issue are actually much more numerous than the conservative critics and include Edin and Lein (1997), Wilson (1987), Danziger et al. (1994), Harris (1997), Stack (1974), Jencks (1992), Conley (1999), and Anderson (1999) as well as all those listed in footnote 12 (above).

16. See Katz (1986, especially pp. 14–17) for these historical characterizations of the poor. On the significance of the distinction between "deserving" and "undeserving," see especially Gans (1995).

17. Skocpol (1992), Abramovitz (1996).

18. The 1935 law technically provided aid only for children; 1962 amendments changed the name of the program to Aid to Families with Dependent Children (AFDC). Until the 1960s states used criteria regarding "suitable homes," family size and structure, residency requirements, "employable mother" rules, and other methods to avoid offering benefits to otherwise eligible families. By these criteria, poor black families and unwed mothers and their children were the most likely to face discrimination in the receipt of benefits. For histories of the discriminatory practices of the welfare system, see Abramovitz (1996), Boris (1999), Goodwin (1995), Gordon (1994), Handler (1991), Mink (1995), Piven and Cloward (1993), Quadagno (1994), and Skocpol (1992).

19. A version of the food stamp program existed previously, but in 1964 was expanded

and revised into the program we know today. The Medicaid program was added in 1965. (The costs of Medicaid and Food Stamps, which serve a broader range of the poor and working poor, far outstrip the costs of the AFDC/TANF program.) For discussions of the rising welfare rolls, see Mink (1995), Abramovitz (1988), Bane and Ellwood (1994), O'Connor (2001), Katz (1993), and Chapter 5.

20. The federal suggestion that mothers should work began in 1967, becoming increasingly more adamant, and targeting mothers with younger and younger children in 1981 and 1988. Two-parent families were added in 1961, and further attempts to include them occurred in 1984 and 1990. The paternity requirements were included in reforms of 1967, 1974, and 1988, and the child support-welfare link was established in 1975 and enhanced in 1984 and 1988. (See Mink 1995, Katz 1986, Goodwin 1995, Bane and Ellwood 1994, U.S. House of Representatives 1998.)

21. See Bachu and O'Connell (2000) for mothers' labor force participation; see Hays (1996) for Americans' ambivalence about working mothers.

22. See, for instance, Blankenhorn (1995), Coontz (1997, 1992), Hochschild (1997, 1989), Popenoe (1988), Stacey (1996), Whitehead (1993).

23. See Adam Smith (1981) for a vision of classical liberalism; see Stanton (1848), Friedan (1963), and National Organization for Women (1967) for classic statements of liberal feminism. See Epstein (1988) for a treatment of issues of women's difference and sameness relative to men; see Gilligan (1982) for women's ethic of care.

24. By federal law, this requirement includes mothers with newborn infants. Most states, however, have exempted mothers with newborns from the work requirements. See Gallagher et al. (1998) and National Governors' Association (1999) for the range of state exemptions.

25. U.S. House of Representatives (1998 and 2000); U.S. Congress (1996, PL 104-193).

26. U.S. Congress (1996, PL 104-193, Title I, Section 101), emphasis mine.

27. U.S. Congress, (1996, PL 104-193, Title I, Section 401).

28. The preamble to the law reforming welfare is, in fact, pulled straight out of former Speaker of the House Newt Gingrich's clarion call to political conservatives—the 1994 "Contract with America" (Gillespie and Schellhas 1994). The argument regarding welfare reform made in the "Contract" was, in turn, largely derived from (conservative) Charles Murray (1984) and (liberal) David Ellwood (1988). Ellwood was also an advisor to President Clinton and a principal inspiration for Clinton's original version of the Personal Responsibility Act. But Ellwood's proposals were far more generous than the legislation that was finally passed, and he was always more concerned with the possibilities for lowering poverty rates than with the task of reinforcing family values. He resigned from the Clinton administration in disgust before the Personal Responsibility Act was signed (see Blau 1999).

29. Mink (1995, 1998), Abramovitz (1988, 1996), and Gordon (1994, 1988), especially, have long emphasized the connection between welfare laws and the cultural vision of "proper" womanhood.

30. U.S. Congress (1996, PL104-193 1996, especially Title IX, Sections 905 and 912).

31. See Burke (1910) for a statement of classic conservatism in these terms, Beecher (1841) for a classic gender version of this argument, and Blankenhorn (1995),

Popenoe (1988), and Whitehead (1993) for some contemporary variations on this logic.

32. See, especially, Blankenhorn et al. (1990), Etzioni (1993), Popenoe (1988), and Putnam (2000, 1995) for treatments of the decline in community values and social trust.

33. Sidel (1996A: 7), Mink (1998: 22–23), Fraser and Gordon (1997: 137).

34. See Bellah et al. (1985) and Fischer (2000) for portraits of Americans' commitment to these values; see also Chapter 8.

35. More specifically, by cultural distortion I mean the process by which social and moral complexity is translated into simple and recognizable claims and slogans that include, for instance, the notions that unemployed people are lazy, paid work offers independence, the only good family is a "traditional" family, single parenting causes poverty, and all women are naturally nurturing. These claims may capture one version of reality, but they do so by hiding and implicitly degrading other perspectives, other values, and other realities.

 By exclusion, I refer to the connected cultural process that similarly operates to make life easier by simplifying the complex and disturbing features of social hierarchies. By categorizing some people—welfare recipients, nonwhites, gays, single parents—as outside the American "mainstream" and therefore somehow beyond the realm of the "normal," members of the so-called mainstream can disassociate themselves from the fate of those outsiders. Drawing, as Michèle Lamont (1992 and 2000) points out, a symbolic boundary between "us" and "them," social exclusion offers a conveniently straightforward version of social reality, but it does so by systematically demeaning whole categories of persons and by hiding the very real social connections between "us" and "them."

36. Blau (1999), Hochschild (1995), Levy (1998).

37. See Hays (1996) and Hochschild (1989) for the pressures at home; see Schwartz (1989), England (1992), and Hochschild (1997) for gender inequalities and the pressures at work.

38. See especially Ehrenreich (2001), Blau (1999), and Piven (1999).

39. Murray noted: "The statistics for blacks in the United States [are] the best available proxy . . . for 'disadvantaged Americans'" (1984: 54). See Zucchino (1997: 64–65) for the full story of the welfare recipient that Reagan attacked; see Quadagno (1994), Hochschild (1995), and Gilens (1999) for the connection of racism and welfare.

40. The client-caseworker interactions I recorded included initial eligibility determinations, ongoing eligibility follow-ups, employment service assessments, employment follow-ups, and childcare interviews. The client workshops I attended included "job readiness" workshops, "life skills" classes, "diversionary" workshops (meant to dissuade clients from applying for welfare in the first place), and group meetings for "sanctioned" clients (who have failed to comply with welfare rules). My interviews with caseworkers included the whole spectrum—from eligibility to employment service to childcare to social work to fraud to supervisory personnel. I asked these workers questions on their interpretation of welfare reform, the ways they experience and understand the client population, their visions of the appropriate balance between family and paid work, and their image of the ideal con-

struction of welfare policy. Separate caseworker interviews were conducted to clarify policies, to develop a sense of the extent to which state and federal rules are rigidly followed, and to discover the amount of caseworker discretion involved.

My interviews with clients followed much the same format as caseworker interviews, with additional questions regarding clients' experiences at the welfare office and a focus on their personal history as mothers, employees, and welfare recipients. My sample of clients was drawn largely from contacts I made at welfare workshops; I also used some referrals from caseworkers and local community service organizations. The welfare clients I interviewed represent a diverse population with regard to race, education, and employment history, closely matching national statistics on the composition of the welfare rolls.

41. For a treatment of state differences, see Gallagher et al. (1998), National Governors' Association (1999).

42. U.S. Department of Health and Human Services (1999B).

43. The federal regulations of the Personal Responsibility Act allow vocational education for only one year. See Negrey et al. (2001) on the significance of this provision.

44. See Lerman et al. (1999) for cities where conditions for welfare recipients are particularly difficult.

45. The more sympathetic portraits of welfare recipients tend to be serious, helpful attempts to give us the full story and to counter existing stereotypes, and they have been invaluable to me in developing an understanding of welfare mothers. However, sometimes missing from these accounts are stories of welfare mothers who are less sympathetic, less noble, and more difficult for middle-class readers to understand. See, for instance, Dodson (1998), Polakow (1993), Sidel (1996A, 1986), and Zucchino (1997).

46. See Weintraub (1997) for a particularly incisive rendering of the multiple meanings of public and private.

47. See Spalter-Roth and Hartmann (1994) for an explicit treatment of poor mothers' dependence on men, the market, or the state. See also Fraser (1997B).

Chapter 2

1. These rates are complicated by exceptions, recalculations based on caseload declines, and different (higher) rates for two-parent families. Nonetheless, states have a clear financial incentive to get people off the welfare rolls (see Berlin 2000; U.S. House of Representatives 1998).

2. See, for instance, Fraser and Gordon (1997), Bellah et al. (1985), and Chapter 8.

3. See, especially, Bellah et al. (1985), Coontz (1992).

4. See Mead (1986), Gilder (1981), Auletta (1982).

5. Bane and Ellwood (1994), Edin and Lein (1997), Sidel (1996A), Harris (1996, 1997). See also Dodson (1998), Horowitz (1995), Seccombe (1999), Zucchino (1997).

6. U.S. Department of Health and Human Services (1999B).

7. This behaviorist model was explicitly suggested by Lawrence Mead (1986). For critiques of this model relative to welfare, see Ellwood (1988), Bane and Ellwood (1994), Marmor et al. (1990).

8. In Arbordale, caseworkers are allowed to spend up to $1,000 on each client beyond the child-care subsidies. Any single item over $200 has to be approved by committee. In Sunbelt City only the social workers have this level of discretion; employment caseworkers are limited to providing a narrow range of specified items directly related to the client's job readiness (e.g., clothes for work, tools, union cards). (For a discussion of the significance of caseworker discretion, see Chapters 3 and 4.)

9. In Arbordale and Sunbelt, where unemployment rates are low, about 10 percent of welfare clients are in (unpaid) workfare placements at any given time. In many other locales, rates are higher.

10. For ignoring some of the reporting rules (a number of which were in place prior to reform), rather than receiving a sanction, clients will simply be deemed ineligible for welfare and their cases will be closed. They are then allowed to reapply and start the process all over again.

11. There is a great deal of variation among states, and some disagreement on national rates (following from uneven definitions and uneven reporting among states). See Associated Press (1999), Bloom and Winstead (2002), Cherlin et al. (2000), Goldberg (2001), Toy (1998), U.S. Department of Health and Human Services (1999A).

12. Weber (1978).

13. Lawrence Mead (1986), Charles Murray (1984).

14. To call the welfare system a bureaucratic morass is an understatement. Welfare caseworkers must manage the combined rules of Medicaid, Food Stamps, and TANF. Each of these three programs has different rules and different eligibility requirements, different exceptions, and different procedures for different circumstances. The lack of coordination among them is the basis of frequent complaints among caseworkers. Every caseworker has a four-foot high pile of paper that provides the rules and another two-foot pile of forms, most of which must be filled out in triplicate (at least). On a regular basis caseworkers receive new piles, translating changes at the state and federal level into specific policies. And the new work requirements not only created a whole new handbook of their own; they also changed many of the previous manuals in complicated ways. (To make matters worse, the procedural manuals that organize these rules and regulations read like the manufacturer's instructions on electronic toys imported from non-English speaking countries.)

 Some of these rules are surely necessary. But a large proportion, I would argue—and nearly every caseworker I met would readily (and enthusiastically) agree—are there only because state and federal policymakers are without the time or inclination to carefully assess what is needed and what is not. If welfare were a profit-making enterprise, or if welfare clients were highly valued social members, it seems to me that the process of deleting relatively superfluous rules and streamlining the organization would have begun some time ago.

15. See Weber (1978) for the difficulties of seeing clearly the goals of one's actions in the context of bureaucracy.

16. For the historical consistency in the social control of the poor, see especially Gordon (1988, 1994) and Katz (1986).

17. See Ellwood (1988), Bane and Ellwood (1994), Handler and Hollingsworth (1971), Handler and Hasenfeld (1997).

18. See Bowles and Gintis (1976).

19. Moffit (2002).

20. Ehrenreich (2001: 3, 202).

21. See, for example, National Campaign for Jobs and Income Support (2001A), Wilson (1996), England (1992), Sapiro (1999), Greenstein et al. (2000).

22. National Campaign for Jobs and Income Support (2001A); see also Greenstein et al. (2000).

23. Blau (1999: 14).

24. See, for example, Edin and Lein (1997), Bauman (2000).

25. Parrot (1998) and Loprest (1999).

26. See especially Stack (1974).

27. All statistics on the two welfare offices I studied are drawn from internal documents prepared by the particular office, city, county, or state, and from newspaper accounts and policy reports. To protect the anonymity of people involved, these references are not cited. On national wage rates, see, for instance, Boushev and Gunderson (2001), Moffit (2002), Acs and Loprest (2001).

28. Loprest (1999), Parrot (1998), Boushev and Gunderson (2001), Moffit (2002), Acs and Loprest (2001).

29. Edin and Lein (1997). Since this study, the Clinton administration added a much more generous Earned Income Tax Credit (EITC), providing a tax break to workers with very low incomes. This EITC increase is crucial and will raise a good number of poor families out of poverty. Unfortunately, like welfare, there is a distinction between the availability of the EITC and the number of eligible families who actually receive it. It requires workers to understand their eligibility and employers to cooperate—both of which leave a good number of eligible families without the credit.

30. Moffit (2002), Loprest (1999), Tweedie et al. (1999), Sherman et al. (1998). See National Campaign for Jobs and Income Support (2001A) for a systematic analysis of why very few former welfare recipients are eligible for unemployment insurance.

31. These numbers only represent those adult welfare clients who are subject to work requirements. To clarify, all the teenage mothers who are still in school and all the caregivers who do not themselves receive welfare (e.g., the grandparents who are taking care of welfare children but who do not get a check for themselves) are exempt from such requirements. Beyond this, states vary on the particulars of the exemptions they allow.

32. Of those who are working in Arbordale, the average annual wage is $8,732; the federal poverty level for a family of three is $14,150.

33. Primus et al. (1999).

34. One study, focused specifically on the comparison of employment exits before and after reform, estimated that 21 percent of those who came in under the old system in 1989 were working a year later, compared to 32 percent of those facing welfare reform in 1997 who had jobs the following year (Sherman et al. 1998).

35. See Bell (2001) for an in-depth analysis of the (very complicated) debate over economy versus policy; see also National Campaign for Jobs and Income Support (2001A), Blank (1997). Only one experimental study has addressed this question directly. During the post-reform, booming economy (1996–2001), this Connecticut study compared a control group of welfare clients who followed the rules of the old (AFDC) welfare system against a like group of welfare recipients faced with the new (TANF) regulations and supports of reform. At the end of four years, 72 percent of those under the old system had left the rolls, compared to 81 percent under the new system—a positive difference of only 9 percent (Bloom et al. 2002). Although this is an imperfect experiment (if only in that all welfare clients, no matter what the system, have been affected by the national and local enthusiasm for reform), it is a clear indication that the economy had a major impact on the declining rolls.

36. See Moffit (2002), U.S. House of Representatives (2000), Loprest (1999).

37. On the changing character of the career ladder, see Blau (1999) and Levy (1998); see Ehrenreich (2001) on low-wage work.

38. See especially Bane and Ellwood (1994); for a friendly critique of their argument regarding marriage, see Harris (1997).

Chapter 3

1. U.S. Congress (1996, PL 104-193, Title I, Section 401).

2. Abramovitz (1996), Gordon (1994), Horowitz (1995), Katz (1986), Mink (1998).

3. See Mink (1998), especially pages 93–98. See also Solinger (1999) on reproductive rights and welfare; see Fineman and Karpin (1995) on the general importance of the constitutional right to privacy to all women and families.

4. The law specifically suggests that this abstinence education "focus on those groups which are most likely to bear children out-of-wedlock." One cannot be sure how states will interpret that directive. See U.S. Congress (1996, PL 104-193, Title IX, Section 912).

5. U.S. Congress (1996, PL 104-193, Title IX, Section 906; see also Section 905).

6. U.S. Congress (1996, PL 104-193, Title I, Section 403[a][2]). See also Cornell (2000).

7. As sociologist Kristin Luker (1996) points out, "Federal provision of family planning to poor women has been one of the most significant, and least heralded, public policy successes of the past half-century" (p. 60), and the enormous success of this program "has been rewarded by having its funding cut almost in half" (p. 184).

8. None of this is to mention the problems involved in the condemnation of homosexuality that is implicit in the Personal Responsibility Act's suggestion that sex is "only appropriate in the context of heterosexual . . . relationships." (See above.)

9. See Mink (1998) for the history of this provision. See Gallagher et al. (1998) and National Governors' Association (1999) for the states making use of it.

10. Mink (1998).

11. Regarding the much-debated outcomes of the New Jersey family cap, see Blau (1999: 148), Laracy (1994), Preston (1998).

12. See Hays (1996) and Zelizer (1985) for the cultural tensions between childrearing and the calculation of personal profit.

13. See especially Jencks (1997), Moffit (1992), Harris (1997), and Chapter 5.

14. Nationally, the average welfare family receives $357 a month in benefits (U.S. Department of Health and Human Services 1999A). Given that welfare mothers have an average of two children, this amounts to a $1.15 per hour, per child, rate for a 40-hour work week.

15. In 1997, only 1.25 million of 10 million low-income families nationwide received the childcare subsidies for which they were federally eligible. Studies suggest that welfare mothers are perhaps somewhat more likely to receive such subsidies than other low-income families, citing rates of 10 percent to 30 percent. See U.S. Department of Health and Human Services (1999B), Boushev and Gunderson (2001), Hernandez (1999), Weinstein (2001).

16. See U.S. House of Representatives (1998) and Uttal (1996). In Arbordale, where clients have the choice, 67 percent use individual providers (mainly family and friends) and 33 percent use childcare centers.

17. See Mink (1998, especially pp. 77–87) on feminists' (ambivalent) position relative to child support enforcement.

18. U.S. House of Representatives (1998). This is beginning to change, it appears, given recent reports that child support enforcement is becoming more effective in collecting payments from dads (Harden 2002).

19. U.S. House of Representatives (1998), Edin (1995), Legler (1996).

20. U.S. House of Representatives (1998).

21. U.S. House of Representatives (1998).

22. According to the Personal Responsibility Act, states are no longer required to "pass through" even $50 of child support collections, and many do not. Arbordale and Sunbelt, however, both allow clients to receive the $50 per month—that is, if a full $50 is collected in the first place. (At this writing, politicians are debating whether to loosen these rules and allow welfare mothers to receive a larger proportion of their child support checks.)

23. Sorenson and Zibman (2000), Edin (1995).

24. Edin (1995), Newman (1999).

25. Edin (1995).

26. Edin and Lein (1997). For further stories of how this works, see also Newman (1999), Garfinkel et al. (2001).

27. See U.S. Department of Health and Human Services (1999B), Bassuk et al. (1996), Raphael (1999), Kurz (1999), and Chapter 7.

28. 56 percent of custodial parents in the United States today have some child support arrangement; of those, 41 percent receive the full amount (Grall 2000).

29. Two-parent families' eligibility for welfare was federally mandated in 1988 (and had been a state option since 1961). Originally titled Aid to Families with Dependent Children–Unemployed Parent, this provision is now called Temporary Assistance to Needy Families–Unemployed Parent (or TANF–UP). The "unemployed parent" here referred to is, of course, the father—the language of the provision thus assumes that fathers are the primary breadwinner. The marriage penalty has been a part of this program since it was first installed in 1961 as an optional program: from

the beginning the eligibility criteria made it more sensible (economically speaking) to be a single mother than a married one. An additional penalty was instituted by the Personal Responsibility Act in that work participation rates require TANF–UP parents to find jobs faster and work more hours than is true of single parent cases. (See Sorenson et al. 2000, U.S. House of Representatives 1998.)

30. On the generational transmission of welfare receipt, see Bane and Ellwood (1994), Gottschalk et al. (1994), and Chapter 6.

31. Recent studies have, in fact, indicated that there is an increase in cohabitation among the poor (e.g., Cherlin and Fomby 2002).

32. See Garfinkel et al. (2001) and Edin (2000, 2001).

33. Scholars of welfare history have demonstrated that the logic of maternalism was central in establishing the original welfare system in 1935. Early in this century, middle-class women reformers and social workers were prominent in making the claim that poor single mothers needed to be mentored and protected by state programs in order to make these women better mothers (Gordon 1994, Abramovitz 1988). In that historical instance there was a perfect match between the maternalism of the advocates and the maternalism they advocated. With welfare reform, however, there is a new form of tension and implicit contradiction.

34. This also tends to create a new hierarchy within the office. Discretionary workers (employment counselors and social workers) tend to hold college degrees, are paid more, and have more status than the bureaucratic "clerks" (those workers who take applications and oversee welfare eligibility requirements), who are paid less and whose position often requires only a high school diploma.

35. This process is actually more complicated in that forms of discretionary casework began creeping back into the welfare office almost from the moment they were shut out. For instance, the series of voluntary work programs that came with rounds of reform in the 1970s and 1980s brought back certain forms of discretion. Nonetheless, the impact of the 1996 welfare legislation was far more dramatic in its reinstitution of caseworker discretion. See Bane and Ellwood (1994), Goodwin (1995), Handler and Hasenfield (1997), Gordon (1994).

36. I use Carol Gilligan's (1982) phrase, an "ethic of care," quite self-consciously in this context. As I noted in Chapter 1, Gilligan distinguishes between a female "ethic of care" and a male "ethic of justice," pointing to the nurturing, relational emphasis in women's moral reasoning and the abstract, individualistic emphasis of male reasoning. Although there are reasons to question the gendered nature of Gilligan's categories, there is no doubt that many welfare counselors and social workers (mostly women) make use of an ethic of care. (See also chapter 4.)

37. See, for instance, Hays (1996), Mink (1998), Hochschild (1997), Kittay (1999B), Held (1995), Okin (1989).

Chapter 4

1. See Lurie (2001) for another treatment of the patterns of caseworker responses to the emerging process of reform.

2. See Moffit (2002).

3. More than once, I witnessed prospective clients receiving misinformation leading them to believe they were ineligible for benefits. When I could do so tactfully, I found some way to correct it (even though I knew I was breaking the ethnographers' ethic of passive observation). I was reminded of the volunteer welfare advocates of the 1960s and 1970s who accompanied poor single mothers to welfare offices to ensure that their rights were respected, and I wondered just how many advocates would be required to provide such services to the millions of poor families who need it today.

4. National Campaign for Jobs and Income Support (2001A).

5. In Arbordale, not only were the eligibility requirements for a hardship exemption extraordinarily strict and complex, but the clients had to have both the knowledge and the gumption to apply for them. In Sunbelt, on the other hand, all such decisions were made by social workers and supervisory personnel. See National Campaign for Jobs and Income Support (2001A), Schott (2001) for state rules on hardship exemptions.

6. See, for instance, Loprest (1999), Moffit (2002), U.S. House of Representatives (2000); see also Chapters 2 and 8.

7. See National Public Radio et al. (2001), Wertheimer et al. (2001), Draut (2001).

8. Mead (1986).

9. Kantrowitz and Wingert (2001).

10. See, for instance, Horn and Sawhill (2001), Parrot et al. (2002), Pear (2002), Toner and Pear (2002A, 2002B).

11. Piven and Cloward (1993).

Chapter 5

1. Congressional Budget Office (2001), Shapiro et al. (2001). For further discussions of income inequality, see Blau (1999), Dalaker (2001), Bernstein et al. (2001).

2. See, especially, Sidel (1996B) and Gans (1995) on the demonization of welfare recipients. For a further treatment of welfare mothers' criticism of other welfare mothers, see Chapter 8.

3. See Public Agenda (2001) and National Public Radio et al. (2001) for opinion polls regarding welfare mothers and welfare. See Mink (1998), Sidel (1996A, 1996B), Fraser and Gordon (1997), Gans (1995), Seccombe (1999), Zucchino (1997) for the ubiquity of these stereotypes and their repetition in the debate over welfare reform.

4. For a rendering of this process, see especially Duneier (1992).

5. For the rise in single parenting, see Fields (2001) and U.S. Bureau of the Census (2001). Welfare recipients represented 1.7 percent of the U.S. population in 1960; when the number of welfare clients peaked in 1994, they represented 5.5 percent (U.S. Department of Health and Human Services 2001).

6. On the history of demonizing welfare mothers, see especially Katz (1986, 1993), Quadagno (1994), Gordon (1994), and Abramovitz (1996, 1988).

7. Murray (1984), Mead (1986), Gilder (1981).

8. This rendering of Mead and Murray glosses over further distinctions between them. Murray, for instance, sees welfare recipients as clever calculators, whereas

Mead sees them as incompetent and generally passive. Murray tends to be more focused on the instability in families, while Mead tends to emphasize the importance of teaching poor people the work ethic. Murray tells us that rising rates of single parenting are "caused" by the rising provision of welfare; Mead is responsible for the idea that welfare policy generates a sense of "entitlement" and thereby operates to cause a decline in one's sense of obligation to the nation as a whole. Both Mead and Murray draw from and elaborate Gilder's argument that what the poor need is work and marriage, and past welfare policy has provided them with incentives for avoiding both. All three scholars argue that the provision of welfare is the root of the problem, exacerbating poverty and perpetuating immoral behaviors relative to work and family. (See Mead 1986, 1992, 1996A, 1996B; Murray 1984, 1996A, 1996B; Gilder 1981.)

9. See, for instance, Hunter (1991), Popenoe (1988), Whitehead (1993, 1996). For commentary on this relative to family life, see especially Coontz (1992, 1997), Stacey (1996).

10. See especially Murray's famous rendering of the fictitious couple, Harold and Phyllis, attempting to calculate the relative benefits of welfare, marriage, and work (1984: 156–162). See also Gilder (1981).

11. Blau (1999: 147). See also Abramovitz (1996: 38).

12. See, for instance, Moffit (1992), Jencks (1997), Harris (1997), Abramovitz (1996) for analyses of the lack of a causal connection between welfare benefit rates and single parenting.

13. Among single-parent welfare families, 70 percent had their children outside of marriage, 30 percent are divorced or separated (U.S. House of Representatives 2000, U. S. Department of Health and Human Services 1999A). In the U.S. as a whole, 57 percent of single-parent households are the result of divorce; 43 percent are the result of out-of-marriage childrearing (Fields 2001).

14. To be more specific, the rise in the welfare rolls was simultaneously the result of a rise in population, a rise in single parenting, the changing face of poverty, and the equalization of the provision of welfare benefits. See especially Abramovitz (1996) and Luker (1996).

15. Gordon (1994), Fields (2001), Acs and Gallagher (2000), Ventura and Bachrach (2000). Of course there is a great deal of debate over whether single parenting is a serious social problem or just a (more or less) unfortunate social change (see, for instance, Whitehead 1996 versus Stacey 1996). This debate generally takes the form of scholars arguing about whether the negative effects we see among the children of single parents are caused by single parenting or by the poverty, conflict, and other conflating factors that often attend single parenting (e.g., Garfinkel and McLanahan 1986, Stacey 1996, Harris 1997, Furstenberg and Cherlin 1991).

16. Of families with children, 26 percent are headed by single mothers, 5 percent are headed by single fathers. Of children under age 6 living in single-mother households, 50.3 percent are poor; overall, 34 percent of single-mother families are poor (see Fields 2001 and Greenstein et al. 2000). The phrase "feminization of poverty" was first coined by Diana Pearce (1978).

17. See Acs and Gallagher (2000), and Sapiro (1999).

18. See Conley (1999) and Wilson (1987).

19. In other words, when so little status is offered by the working world and so little hope of building a better life, having children becomes all the more important. See Collins (1975), Rubin (1976), Collins and Coltrane (1995), Luker (1975, 1984, 1996).

20. Conley (1999), Cherlin (1996).

21. See Conley (1999), U.S Bureau of the Census (2001B). See also Wilson (1987, 1996), Hochschild (1995), Lichter et al. (1992), Tucker (2000), Oppenheimer (2000).

22. See Coontz (1997), Luker (1996), Rose (2000).

23. Jencks (1997).

24. See Luker (1996), Harris (1997), Cherlin (1996).

25. These include the analyses offered by Garfinkel and McLanahan (1986), Luker (1996), McLanahan and Sandefur (1994), Harris (1997), Stacey (1996), Coontz (1992 and 1997), Ehrenreich (1983), Cherlin (1996), Furstenberg and Cherlin (1991). Although all these scholars (and others) recognize the centrality of these trends, the rendering of the connections that follows is, of course, my own.

 Harris notes, "Among the various confounding factors affecting the trend in out-of-wedlock childbearing in the United States, the declining prevalence of early marriage has the largest impact over time" (1997:2). But, as Harris recognizes, the question then becomes, what caused the age of marriage to increase? The availability of (culturally defined) "suitable" marriage partners is central to the answer and leads us back to the social factors outlined above. It's also important to note that if lowering the age of marriage looks like a "solution" in these terms, couples who marry early in contemporary society are more likely to divorce, and hence, would simply raise the rate of single parenting once again.

26. On the history and present shape of women's labor force participation, see, for instance, Kessler-Harris (1982), Goldin (1990), Bentson (1984), England (1992), Weiner (1985).

27. Bachu and O'Connell (2000); U.S. Bureau of the Census (1996).

28. See Blau (1999, especially, p. 14), Luker (1996), Bachu and O'Connell (2000).

29. On men's declining breadwinner wage, see Blau (1999), Blank (1997), and Levy (1998). On the changing patterns of home life that may result from men's changing status, see, for instance, Brines (1994), Nock (1998), Risman (1998), Blumstein and Schwartz (1983), Rubin (1983, 1994).

30. Gerson (1993); see also Ehrenreich (1983).

31. For statistics on sexuality and childbearing, see Ventura and Bachrach (2000). For analyses of the "sexual revolution," see Coontz (1997) and Cherlin (1996).

32. Hochschild (1989). See also Furstenberg and Cherlin (1991), Hochschild (1997), Garfinkel and McLanahan (1986), Cherlin (1996), Rubin (1976, 1994), and Risman (1998).

33. This is a shorthand version of the insightful argument made by Ehrenreich (1983) in *The Hearts of Men*.

34. See Blau (1999), Levy (1998), Rubin (1994).

35. For the classical theoretical treatment of the tendency to miss social processes by focusing on individual cases, see Durkheim (1951).

36. Garfinkel and McLanahan (1986: 84).

37. See Hays (1996) for the contradictory position of children; see Mink (1998) and Kittay (1999B) for analyses of welfare reform that recognize its devaluation of the work of caregiving; see England and Folbre (1999) for the overall costs to women that are the result of these trends. The public devaluation of the work of childrearing is also evident in the fact that poor women, working-class women, and non-white women are doing the bulk of the caregiving work in this society—caring not just for their own children but working as the paid caregivers for middle-and upper-class families.

 A recognition of the connections among women's employment, the decline of the breadwinner wage, and the rise in single parenting helps to make sense of the global linkage between advanced industrialization and the rise of single parenting. Capitalism cares little about children and the nature and the strength of family ties, especially to the extent that these can cut into profit margins. From this point of view, it is interesting to note that the one social theorist to prophesize the rise of poor, single-parent households was a Marxist feminist. Writing in 1909 Russia, long before anyone had an inkling of the trend toward single parenting, Alexandria Kollantai (1909) suggested that the "liberation" of American middle-class women—to work for pay and to engage in "free love"—would have the effect, under capitalism and patriarchy, of putting working-class and poor women in a position where they would be left to raise their children alone, with little financial support from fathers, the state, or capitalism.

Chapter 6

1. Williams (1991: 222).

2. The argument I make here is well known to scholars of identity and of cultural forms of inequality. Many groups in American society—including gays and lesbians, women, nonwhites, the non-native-born, non-Protestants, and others—have been culturally "misrecognized," subordinated through attitudes and policies and practices that make their lives, their interests, and their humanity invisible. This invisibility is often coupled with a distorted and degraded image that operates to deny such groups equal respect and makes them the subject of discrimination and harassment and other forms of cultural devaluation. (See especially Fraser 1997A; see also Taylor 1992, Young 1990, Seidman 1996, Hall 1992.)

3. See Gerson (1985), Hays (1996), Hochschild (1997).

4. As noted in Chapter 3, about 15 to 20 percent of welfare mothers are estimated to be currently in abusive relationships, and about 60 percent have been the victims of assault in their lifetimes. See Bassuk et al. (1996), Gordon (1990), Raphael (1996, 1999), Kurz (1995, 1999).

5. Goffman (1959).

6. Terry and Manlove (1999); see also Luker (1996) and Waller (1999).

7. Luker (1996), Waller (1999), and Ventura et al. (2000).

8. See, for instance, Hays (1996), Hochschild (1989, 1997).

9. See Arno et al. (1999) and Harvard School of Public Health (2000) on the number of women caring for disabled or aged family members.

10. If she does successfully sue the driver of the other vehicle, part of her award will be owed to the state to cover the costs of the welfare payments she received.

11. See Chapter 2.

12. See especially Bane and Ellwood (1994), Harris (1997).

13. Carnevale and Reich (2000). Nationwide, 47 percent of adult welfare recipients are without high school diplomas (U.S. House of Representatives 2000); in Arbordale, 40 percent do not have high school diplomas and, in Sunbelt City, nearly half do not test above the eighth-grade level in reading and math.

14. See, for instance, Moffit (2002), Loprest (1999), U.S. House of Representatives (2000).

15. Johnson and Meckstroth (1998, compiled for the U.S. Department of Health and Human Services), U.S. General Accounting Office (2001: 3–4 cited above), Bourdon et al. (1994), Lennon et al. (2001). See also Olson and Pavetti (1996), Sweeney (2000).

16. As you might recall (from Chapter 3), this father put a gun to Christine's head when he discovered she had "turned him in" for child support.

17. Johnson and Meckstroth (1998), U.S. General Accounting Office (2001). See also, Sweeney (2000), Olson and Pavetti (1996).

18. As with mental health disabilities, under the terms of welfare reform, state welfare agencies have the power to exempt disabled mothers from the time limits, either by using the 20 percent federal "hardship exemption" built into the law or by using state funds to cover these mothers beyond federal limits. Different states have different policies on this matter, and local offices and caseworkers are also likely to interpret these policies in different ways. See the U.S. General Accounting Office (2001) for further information on the wide variation in the exemptions provided to disabled welfare recipients. As this study notes, the welfare office has long been a stopping place for poor disabled persons who are waiting for federal disability benefits.

In considering caseworker discretion in these matters, from my conversations with Christine and her caseworker, I knew that Christine's caseworker believed that Christine's life was far too easy, given the housing subsidy, her father's help, and Christine's good looks. I couldn't help but wonder if this was part of the reason that her caseworker had done nothing to protect Christine from the time limits.

19. Once again, this is actually more complicated. Food stamp rules were changed in a number of ways with the Personal Responsibility Act, including not just severe limitations for immigrants but also for single, able-bodied adults (and these changes were the basis for much of the tax-dollar savings in the law). But the drop in food stamp usage is more precipitous than can be explained by these changes, and it was accompanied by a similar drop in Medicaid use. (It remains to be seen whether poor people will eventually recognize that they remain eligible.) See National Campaign for Jobs and Income Support (2001A), Primus et al. (1999), Pear (2000), Becker (2001), Ku and Garret (2000).

20. Jencks (1997).

21. U.S. Social Security Administration (2001), Morton (2001), U.S. General Accounting Office (2001: 33); see also Sweeney (2000). The disability insurance available to poor people, called Supplemental Security Insurance (SSI), is distinct (more

miserly, with more stringent criteria) from the benefits available to people with sufficient employment histories, though neither is easy to get.

22. U. S. Social Security Administration (2001).

23. See Murray (1984), Mead (1986), and Gilder (1981) for the argument that welfare recipients suffer from this malady; see Fraser and Gordon (1997) for a theoretical analysis of the logic of dependency.

24. See Spalter-Roth and Hartmann (1994) and Fraser (1997B) for scholarly renderings of this analysis.

25. See Bane and Ellwood (1994), Edin and Lein (1997), Gottschalk et al. (1994), Harris (1997).

26. Medicaid is the most frequently used means-tested assistance program, followed by food stamps and TANF (Rank and Hirschl 2001).

27. See Hochschild (1995), and Lareau (forthcoming) for further notes on meritocracy and individualism.

28. See Chapter 5 for a discussion of these theoretical frames.

Chapter 7

1. Cited in Katz (1993: 4).

2. Anderson (1999: 320).

3. Although one might suspect that the most "deviant" welfare mothers would be less likely to talk to me, I worked hard to gain access to the full range of welfare mothers. In particular, I recruited a number of my interviews from welfare office workshops held solely for sanctioned clients (and even the "worst" welfare mothers would attend these workshops since they were threatened with prolonged ineligibility and lack of income if they did not cooperate).

4. See Lewis (1966), Moynihan (1965), Harrington (1962), and Auletta (1982) for various versions of the culture of poverty thesis. See O'Connor (2001), Katz (1993), and Wilson (1987) for renderings of the history of this line of reasoning.

5. For commentary on the culture of poverty thesis, critiques of its logic, and treatments of the extent to which it can be empirically demonstrated, see, for instance, Bane and Elwood (1994), Danziger et al. (1994), Duneier (1992), Edin and Lein (1997), Gans (1995), Harris (1997), Katz (1993), Stack (1974), Waller (1999).

6. Wilson argues that it is precisely this tendency to ignore "social pathologies" among the poor, and to "avoid describing any behavior that might be construed as unflattering or stigmatizing to ghetto residents," that has made the liberal perspective less convincing, and allowed the conservative view of poverty to gain ascendancy (1987: 6).

7. See Halle (1984), Domhoff (1967), Lamont (2000, 1992).

8. For a systematic treatment of the variable circumstances of the poor that helps to make sense of why there are multiple cultures of poverty, see especially Blank (1997).

9. For relevant renderings of subcultures and their operations, see Williams (1978), Berger (1981), Willis (1977), MacLeod (1987), Hebdige (1979), and Swidler (1986).

10. For arguments regarding the way that raising children offers lessons in obligations to others, see, for instance, Held (1995), Kittay (1999B), DeVault (1991), Okin (1989).

11. Anderson (1990, 1999).

12. A central reason that they could go out shopping is that I had promised her $20 for the interview (as I did with all the welfare clients I talked to).

13. This logic is well known among welfare rights advocates and feminists and was one of the central arguments made by the National Welfare Rights Organization. See Women's Committee of One Hundred (2001), Naples (1999), Mink (1998), Kittay (1999A), Abramovitz (1999).

14. See Bane and Ellwood (1994) for the dynamics of time on welfare. Likening welfare recipients to hospital patients, they explain how long-term patients ultimately take up a disproportionate number of hospital beds, even though they represent a relatively small proportion of those initially admitted to the hospital. Thus, if general "wellness" is the goal, there is always a question of whether we should concentrate equally on each new admittance or whether we should concentrate more on the long-termers.

15. Some readers may want to ask instead, "Why did she have sex; why didn't she just choose abstinence?" For this to be a viable scenario, one would have to turn back the clock on the liberation of sexuality and reinstate earlier marriage ages—a strategy that not only has some real social costs but is also a great deal more difficult to accomplish than access to and information on birth control.

16. See Luker, (1975, 1984, 1996).

17. See especially Luker (1996), Wilson (1987), and Anderson (1990, 1999) for versions of this story. See Chapter 5 for its historical basis.

18. See Loprest (1999) and Parrot (1998).

19. As I have argued, the vast majority of welfare mothers I encountered did not consider welfare a legitimate or honorable way to make a living. Other scholars studying the poor have the same finding. See Anderson (1990, 1999), Venkatesh (2000), Wilson (1987, 1996), Seccombe (1999).

20. Luker (1975, 1996), Anderson (1990), Hays (1996).

21. At a later point in the interview, Joy described that job, and how much she disliked it. *"That telemarketing job, it was bad. The [automatic] dialer calls all these people, and I have to ask them to do an application for an Internet stock exchange company. So I'm asking for their social security number, their date of birth, their street address— now who in their right mind is gonna give me that information?!? And you have to get a certain amount of applications a day. Then you get fired if you're not up to the speed with everybody else. I hated that. I'm really glad they fired me."*

22. Stacey (1990).

23. The price tags on these training programs are all $10,000 because all of them are offered through the same profit-making education "institute" regularly advertising on TV in Sunbelt City. (It could be that Joy is exaggerating their price, but probably not by much.) From welfare mothers, I also learned that these television-advertised training institutions are very practiced at getting federally subsidized student loans for the people who agree to sign up. As those who have seen such advertisements are likely aware, most of these operations make big claims about placing their graduates in jobs, but this promise rarely pans out.

24. For estimates of substance abuse among the welfare population, see Olson and Pavetti (1996), Johnson and Meckstroth (1998), and Sweeney (2000). On Americans' opinions on drug abuse and welfare, see Public Agenda (2001).

25. See also Anderson (1990) and Duneier (1992).

26. The average welfare recipient is 33 years old (U.S. Department of Health and Human Services 1999A).

27. Sandra's determined critique of the welfare system as well as her independent spirit were apparent to me from the first day I met her. We were both attending a workshop for sanctioned welfare clients—a workshop reminding clients that their "clocks" were still ticking and warning them to behave in such a way as to avoid future punishment. In this context, Sandra stood out early on as a leader, a fast talker, and a troublemaker.

 Before the caseworker was able to finish her rendering of welfare rules, Sandra began pestering her: "Why do you have to treat us this kind of way? We're not babies. We know what we're doing." She went on to question the logic of welfare reform and welfare sanctions, criticized welfare caseworkers for their failures to see clients at scheduled times, to provide them sufficient information, and to take into account the difficulties welfare mothers face in paying their rent, managing the bus system, coping with unfriendly Medicaid providers, and negotiating the problems of childcare. It was easy to see that she'd caught the attention of the other clients and, in no time at all, they were speaking up for themselves, asking questions, spoiling the caseworker's set schedule, and turning the workshop into a combination support group and gripe session. It was clear that all the other clients were very impressed by Sandra. For many of them it seemed that she had taken on the system, and she'd left the welfare caseworker (and by extension the welfare "system") under siege. For most of the mothers attending the workshop, this was experienced as a small victory on the side of the downtrodden.

28. Research suggests that black women are more likely than their white counterparts to think that men's breadwinning ability is a central quality for a suitable spouse (see Tucker 2000).

29. Kathryn Edin (2000, 2001) confirms the prevalence of these experiences and attitudes. See also Waller (1999, 2001).

30. Edin and Lein (1997: 43–45).

31. See Garfinkel et al. (2001); Cherlin and Fomby (2002).

32. See Mink (1998, especially pages 50–53).

33. See Marx (1887), Schudson (1986), Consumers Union (2001).

34. From 1970 to 1998, the inflation adjusted revenue of major pharmaceutical companies quadrupled, and the federal antidrug budget grew to over $17 billion per year (Boyd and Hitt 1999). See also Kalb (2001).

35. Wilson (1987: 73).

36. Rubin (1983) points specifically to this scenario as a basis for gender conflict and divorce—at *all* class levels.

37. See Kurz (1999), Browne and Bassuk (1997), Bassuk et al. (1996), Raphael (1996, 1999).

38. For rates of domestic violence in the general population, see Straus, Gelles, and Steinmetz (1980); Straus and Gelles (1986); Kurz (1995); Dobash and Dobash (1979). For a discussion of class differences in domestic abuse, see especially Kurz (1995, especially pages 64–67).

Chapter 8

1. See Abramovitz (1999) for welfare mothers' activism; see Public Agenda (2001), Wertheimer et al. (2001), Draut (2001), and Seccombe et al. (1999) for welfare mothers' opinions regarding welfare.
2. Denise is referring to then-prominent news stories on the Columbine school shooting and the other school shootings that followed.
3. See National Public Radio et al. (2001).
4. On symbolic boundaries, see Lamont (1992, 2000). For a connected, yet distinct, treatment of "moral boundaries," see Tronto (1993). For an analysis of the construction of welfare mothers as the "other" in the division between "us" and "them," see Gans (1995), Handler and Hasenfield (1997).
5. In order, these newspaper articles are Pear (1999A), Pear (1998), Pear (1999B), Havemann and Vobejda (1998), Goldberg (1999).
6. In order, these newspaper articles are Hernandez (1998), Swarns (1999), Associated Press (1999), DeParle (1999A), Rivera (1997), Revkin (1999).
7. Dalaker (2000), Lamison-White (1997), Pear (2002).
8. See U.S. Department of Health and Human Services (1999A), Holzer and Stoll (2001), Acs and Loprest (2001), Moffit (2002).
9. See Parrot (1998), Loprest (1999), Moffit (2002), National Campaign for Jobs and Income Support (2001A, 2001B). Arguably, the majority of jobs that pay sufficient wages to allow a woman to raise children on her own require at least an associate degree. Women with an associate degree average $12.46 an hour, almost double the $6.69 earned by women who haven't completed high school, and $3.34 more than women with a high school diploma (Sherman et al. 1998). According to a report by the Economic Policy Institute, a "living wage" for a family of one adult and two children is $14 per hour (Ehrenreich 2001: 213).
10. Ehrenreich (2001: 214)
11. Over 30 states nationwide either use diversionary programs or require prospective clients to complete specified work requirements *before* they may apply for benefits (Moffit 2002). See also Loprest (1999), Swarns (1999), and National Campaign for Jobs and Income Support (2001A, 2001B).
12. As noted, prior to reform, the process of cycling meant that the majority of welfare clients never stayed on welfare for longer than two years, though many would eventually return (e.g., Bane and Ellwood 1994; Harris 1993, 1996). There is no irrefutable statistical evidence to confirm or disconfirm my point regarding the speed up/slow down process caused by reform, though virtually all the larger trends suggest this reality, as did my experience in the welfare office.
13. See Associated Press (1999), Cherlin et al. (2000), Wisconsin Joint Legislative Audit Committee (2001), U.S. Department of Health and Human Services (1999A), Gold-

berg (2001), National Campaign for Jobs and Income Support (2001A). Putting this all together—and mimicking my analysis of the speed up/slow down—one report notes that the decline in welfare caseloads is not just a matter of the "best" or "easiest" clients (most educated and most employable) making their way off the rolls. Rather, welfare reform has effected a decline at both ends—with the most employable and the least employable leaving at the same rate. One could surmise that most of those in the former group leave with jobs, most in the latter group as a result of discouragement and sanctions (Cherlin et al. 2000).

14. See Wisconsin Joint Legislative Audit Committee (2001).

15. As of April 2001, just 120,000 welfare clients nationwide had lost their TANF benefits as a result of time limits (National Campaign for Jobs and Income Support 2001A).

16. Actually, one further note is in order. Although official government reports state that there is no change in the racial composition of the welfare rolls once population changes are taken into account, some commentators have argued that whites are leaving the rolls faster than other groups. The changing racial composition of the welfare rolls from 1996 to 1999 was as follows: whites at 30.3 percent, down from 35 percent; blacks at 38 percent up from 37 percent; and Hispanics with the largest increase: 24.5 percent, up from 21 percent. See U.S. Department of Health and Human Services (1999A, 1999B); DeParle (1998).

17. See Schott (2001:4) on state rules for hardship exemptions. See also Moffit (2002), National Campaign for Jobs and Income Support (2001A).

18. See Bauman (2000); Edin and Lein (1997) were the first to clearly demonstrate this point. Of course, the proponents of welfare reform disagree with this assessment. For a reasonable, careful, and well-informed positive assessment of reform, see Moffit (2002).

19. See Sorenson and Zibman (2000); Cherlin and Fomby (2002).

20. See Loprest (1999), Boushev and Gunderson (2001), Sherman et al. (1998), National Campaign for Jobs and Income Support (2001A, 2001B). A study of major U.S. cities found that from 2000 to 2001, requests for food had increased by 23 percent and requests for emergency housing were up by 13 percent (U.S. Conference of Mayors 2001).

21. See Edin and Lein (1997); see also Chapter 7.

22. See especially Waller (1999), Garfinkel et al. (2001), and McLanahan et al. (2001) on the ongoing ties between welfare children and their fathers.

23. This is actually more complicated, and the accountings are not always clear. For instance, I was unable to determine whether federal analyses of welfare costs since reform include the rising price of childcare subsidies and welfare-to-work programs. See U.S. House of Representatives (2000), Blau (1999), National Campaign for Jobs and Income Support (2001A).

24. For foster care, see Geen et al. (1999); for average welfare benefits, see Social Security Bulletin (2000); for prison costs, see Stephan (1999).

25. See, for instance, Newman (1988, 1999), Piven (1999), Blau (1999), Edin and Lein (1997), Ehrenriech (2001). One might also note that a number of profit-making

firms established quite lucrative state contracts for serving welfare clients. In some states, those operations profit directly from the number of welfare families they manage to delete from the welfare rolls (as was the case in Sunbelt City). For suggestive information on these operations, see Ehrenreich (1997) and the Wisconsin Joint Legislative Audit Committee (2001) report pointing out that some Wisconsin contracting agencies are under investigation for corrupt practices.

26. By 2000, there were still 12.2 million people living in desperate poverty, with incomes below 50 percent of the poverty level (Dalaker 2000); the comparable figure for 1996 (earlier on in the economic boom) was 14.4 million (Lamison-White 1997).

27. Charles Murray 1984; see chapters 5 and 6 for a further discussion of these issues.

28. See Hays (1996); Zelizer (1985).

29. See Rank and Hirschl (2001) for poverty over the life course. For an analysis of the broad tensions between American values of individualism and commitment, see Bellah et al. (1985). For theoretical treatments of these issues in their gendered (public/private) forms, see especially Okin (1989), Tronto (1993), Elshtain (1981), Fraser (1997B), Kittay (1999A, 1999B). For general treatments of women's double shift and the life of supermoms, see Spain and Bianche (1996), Hochschild (1989, 1997), Hays (1996), Risman (1998).

30. See Fields (2001); Greenstein et al. (2000).

31. Of course this story was always maintained at the expense of working-class and poor women who, unlike middle-class women, have long been expected to both raise children and provide for their financial support. See, for instance, Kessler-Harris (1982), Goldin (1990), Weiner (1985).

32. The two sides of this tug-of-war are regularly played out in family scholarship. See, for instance, Berger and Berger (1983), Blankenhorn (1995), Cherlin (1981), Coontz (1997, 1992), Hunter (1991), Hochschild (1997, 1989), Stacey (1990).

33. This is my own (conservative) estimate. For the rates of poverty and single parenting on which it is based, see, for instance, Rank and Hirschl (2001), Bane and Ellwood (1994).

34. For more conservative visions, see Whitehead (1996), Popenoe (1988), Blankenhorn et al. (1990); for feminist versions, see Kittay (1999B), Mink (1998), Women's Committee of One Hundred (2001).

35. Theorists of citizenship and individualism would point out that this story is more complicated, and there are actually multiple, distinct definitions of independent citizenship running through Western history. But it seems to me that the most *valorized* vision of independence draws its primary moral and cultural power from the independence of noble and contributing citizens. Of course, in the days when Aristotle was first thinking about this version back in ancient Greece, women, slaves, foreigners, and ordinary working people were automatically excluded from independent citizenship. See Aristotle (1946), Weintraub (forthcoming), T. H. Marshall (1950), Bellah et al. (1985). For the original "feminist" version of citizenship, see the 1848 "Declaration of Sentiments" (Stanton 1848); see also Elshtain (1981), Tronto (1993), Okin (1989).

36. As feminist scholars have correctly argued, valuing paid labor *over* the work of caring for others constitutes acquiescence to a male logic that distorts our recognition of the value of care (see especially Kittay 1999A, 1999B, Tronto 1993). However, treating women's work of (home-based, unpaid) caregiving as a *replacement* for participation in the public sphere is also a problematic strategy—not only because it runs the risk of reinstating women's subordinate status by treating women as properly confined to the home and to the work of nurturing others, but because it implicitly denies the significance of public work as connecting us to others beyond the relatively narrow confines of the family.

37. See Luker (1996: 101), Congressional Budget Office (2001), and Bachu and O'Connell (2000). These calculations are my own.

38. For renderings of these programs in their Western European forms, see Gornick and Meyers (2001), Seccombe (1999), Bergmann (1996), Smeeding (1992), Hochschild (1995). For government policies that disproportionately favor the rich, see Blau (1999).

39. See, especially, Skocpol (1991, 2000) and Blau (1999) for the importance of universalism and the limitations in this logic.

40. For recommendations on the kinds of programs that might work, see, for instance, Sweeney et al. (2000), Women's Committee of One Hundred (2001), Handler (1991), Blank (1997).

41. See Chapter 5 on the relationship between income and marital formation and stability; see Knox et al. (2000) on the Minnesota Family Investment Program. In addition to wage supplements, it is interesting to note, this Minnesota program provided food stamp benefits in cash rather than coupons (again providing for more discretion and personal choice).

42. See, for instance, Horn and Sawhill (2001), Parrot and Neurberger (2002), Parrot et al. (2002), Pear (2002), Toner and Pear (2002A, 2002B).

43. For the range of concerns regarding competitive individualism, see, for instance, Bellah et al. (1985), Blau (1999), Hays (1996), Whitehead (1996), Popenoe (1988), Putnam (2000).

References

Abramovitz, Mimi. 1988 [1996]. *Regulating the Lives of Women: Social Welfare Policy from Colonial Times to the Present*. Revised edition. Boston, MA: South End Press.

Abramovitz, Mimi. 1996. *Under Attack, Fighting Back: Women and Welfare in the United States*. New York: Monthly Review Press.

Abramovitz, Mimi. 1999. "Toward a Framework for Understanding Activism Among Poor and Working-Class Women in Twentieth-Century America," pp. 214–248 in *Whose Welfare?* edited by Gwendolyn Mink. Ithaca, NY: Cornell University Press.

Acs, Gregory and Megan Gallagher. 2000. *Income Inequality Among America's Children*. Assessing the New Federalism, Series B, No. B-6 (January). Washington, DC: Urban Institute.

Acs, Gregory and Pamela Loprest. 2001. *Initial Synthesis Report of the Findings from ASPE's "Leavers" Grants*. Washington, DC: Urban Institute.

Anderson, Elijah. 1990. *Streetwise: Race, Class, and Change in an Urban Community*. Chicago: University of Chicago Press.

Anderson, Elijah. 1999. *The Code of the Street: Decency, Violence, and the Moral Life of the Inner City*. New York: W.W. Norton.

Arendt, Hannah. 1958. *The Human Condition*. Chicago: University of Chicago Press.

Aristotle. 1946 [1958]. *The Politics of Aristotle*. Translated by Ernest Barker. New York: Oxford University Press.

Arno, Peter, Carol Levine, and Margaret Memmott. 1999. "The Economic Value of Informal Caregiving." *Health Affairs* 18: 182–188.

Associated Press. 1998. "Businesses Find Success in Welfare-To-Work Program." *Daily Progress*, July 21: A1.

Associated Press. 1999. "Penalties Pushing Many Off Welfare." *Poughkeepsie Journal*, March 29: A2.

Auletta, Ken. 1982. *The Underclass*. New York: Random House.

Bachu, Amara and Martin O'Connell. 2000. *Fertility of American Women, 1998*. U.S. Census Bureau, Current Population Reports, P20-526. Washington, DC: U.S. Government Printing Office.

Bane, Mary Jo and David T. Ellwood. 1994. *Welfare Realities: From Rhetoric to Reform*. Cambridge, MA: Harvard University Press.

Bassuk, Ellen L., Angela Browne, and John C. Buckner. 1996. "Single Mothers and Welfare." *Scientific American* 275(4): 60–67.

Bauman, Kurt J. 2000. *The Effect of Work and Welfare on Living Conditions in Single Parent Households.* U.S. Bureau of the Census, Population Division, Working Paper Series No. 46 (August). Washington, DC: U.S. Government Printing Office.

Becker, Elizabeth. 2001. "Millions Eligible for Food Stamps Aren't Applying." *New York Times*, February 26: A1.

Beecher, Catharine Esther. 1841 [1988]. *A Treatise on Domestic Economy: For the Use of Young Ladies at Home and at School.* New York: Harper and Brothers.

Bell, Stephen H. 2001. *Why Are Welfare Caseloads Falling?* Assessing the New Federalism 01–02. Washington, DC: Urban Institute.

Bellah, Robert, Richard Madsen, William M. Sullivan, Ann Swidler, and Steven M. Tipton. 1985. *Habits of the Heart: Individualism and Commitment in American Life.* Berkeley: University of California Press.

Bentson, Margaret. 1984. "The Political Economy of Women's Liberation," pp. 239–47 in *Feminist Frameworks: Alternative Theoretical Accounts of the Relations Between Women and Men*, edited by Alison M. Jaggar and Paula S. Rothenberg. New York: McGraw-Hill.

Berger, Bennett. 1981. *Survival of a Counterculture.* Berkeley: University of California Press.

Berger, Brigitte and Peter Berger. 1983. *The War over the Family: Capturing the Middle Ground.* Garden City, NY: Anchor.

Bergmann, Barbara R. 1996. *Saving Our Children from Poverty: What the United States Can Learn from France.* New York: Russell Sage Foundation.

Berlin, Gordon L. 2000. *Encouraging Work, Reducing Poverty: The Impact of Work Incentive Programs.* New York: Manpower Demonstration Research Corporation.

Bernier, Shaun. 2001. "Welfare Reform Five Years Later: Welfare Caseloads Declined at a Faster Rate than Poverty." Results Press Release (August 23). http://www.result-susa.org/media/alerts/WelfareReform.htm.

Bernstein, Jared, Lawrence Mishel, and Chauna Brocht. 2001. *Any Way You Cut It: Income Inequality on the Rise Regardless of How It's Measured.* Washington, DC: Economic Policy Institute.

Bernstein, Nina. 2002. "Side Effect of Welfare Law: The No Parent Family." *New York Times*, July 29: A1.

Blank, Rebecca M. 1997. *It Takes a Nation: A New Agenda for Fighting Poverty.* New edition. Princeton, NJ: Princeton University Press.

Blankenhorn, David. 1988. *Disturbing the Nest: Family Change and Decline in Modern Societies.* New York: Aldine de Gruyter.

Blankenhorn, David. 1995. *Fatherless America: Confronting Our Most Urgent Social Problem.* New York: Basic Books.

Blankenhorn, David, Jean Bethke Elshtain, and Steven Bayme, editors. 1990. *Rebuilding the Nest: A New Commitment to the American Family.* Milwaukee: Family Service America.

Blau, Joel. 1999. *Illusions of Prosperity: America's Working Families in an Age of Economic Insecurity.* New York: Oxford University Press.

Bloom, Dan, Susan Scrivener, Charles Michalopoulos, Pamela Morris, Richard Hendra, Diana Adams-Ciardullo, Johanna Walter, and Wanda Vargas. 2002. *Jobs First: Final Report on Connecticut's Welfare Reform Initiative*. New York: Manpower Demonstration Research Corporation.

Bloom, Dan and Don Winstead. 2002. *Sanctions and Welfare Reform*. Washington, DC: Brookings Institution.

Blumstein, Philip and Pepper Schwartz. 1983. *American Couples*. New York: William Morrow.

Boris, Eileen. 1999. "When Work Is Slavery," pp. 36–55 in *Whose Welfare?* edited by Gwendolyn Mink. Ithaca, NY: Cornell University Press.

Bourdon, K. H., D. S. Rae, W. E. Narrow, R. W. Manderschild, and D. A. Regier. 1994. "National Prevalence and Treatment of Mental and Addictive Disorders," pp. 22–51 in *Mental Health: United States*, edited by R. W. Manderschild and A. Sonenschein. Washington, DC: Center for Mental Health Services.

Boushev, Heather and Bethney Gunderson. 2001. *When Work Just Isn't Enough: Measuring Hardships Faced by Families after Moving from Welfare to Work*. Washington, DC: Economic Policy Institute.

Bowles, Samuel and Herbert Gintis. 1976. *Schooling in Capitalist America*. New York: Basic Books.

Boyd, Graham and Jack Hitt. 1999. "This Is Your Bill of Rights, on Drugs." *Harper's Magazine* (December): 57–61.

Brandwein, Ruth, A., editor. 1999. *Battered Women, Children, and Welfare Reform: The Ties That Bind*. Thousand Oaks, CA: Sage Publications.

Brines, Julie. 1994. "Economic Dependency, Gender, and the Division of Labor at Home." *American Journal of Sociology* 100 (3): 652–88.

Browne, A. and S. S. Bassuk. 1997. "Intimate Violence in the Lives of Homeless and Poor House Women: Prevalence and Patterns in an Ethnically Diverse Sample." *American Journal of Orthopsychiatry* 67(2): 261–278.

Brush, Lisa D. 1997. "Worthy Widows, Welfare Cheats: Proper Womanhood in Expert Needs Talk about Single Mothers in the United States, 1900–1988," *Gender and Society* 11(6): 1–47.

Burke, Edmund. 1910 [1951]. *Reflections on the French Revolution*. New York: E. P. Dutton.

Butler, Sandra Sue and Mary Katherine Nevin. 1997. "Welfare Mothers Speak: One State's Effort to Bring Recipient Voices to the Welfare Debate." *Journal of Poverty* 1(2): 25–61.

Carnevale, Anthony P. and Kathleen Reich. 2000. *A Piece of the Puzzle: How States Can Use Education to Make Work Pay for Welfare Recipients*. Princeton, NJ: Educational Testing Service.

Cherlin, Andrew J. 1981. *Marriage, Divorce, Remarriage*. Cambridge, MA: Harvard University Press.

Cherlin, Andrew J. 1996. *Public and Private Families: An Introduction*. New York: McGraw-Hill.

Cherlin, Andrew J., Linda Burton, Judith Francis, Jane Henrici, Laura Lein, James Quane, and Karen Bogen. 2000. *Sanctions and Case Closings for Noncompliance:*

Who Is Affected and Why. Welfare, Children, and Families: A Three-City Study, Policy Brief 01–1. Baltimore, MD: Johns Hopkins University.

Cherlin, Andrew J. and Paula Fomby. 2002. *A Closer Look at Changes in Children's Living Arrangements*. Welfare, Children, and Families: A Three-City Study, Working Paper 02–01. Baltimore, MD: Johns Hopkins University.

Collins, Randall. 1975. *Conflict Sociology*. New York: Academic.

Collins, Randall and Scott Coltrane. 1995. *Sociology of Marriage and the Family: Gender, Love, and Property*. Fourth Edition. Chicago: Nelson-Hall.

Congressional Budget Office. 2001. *Historical Effective Tax Rates, 1979–1997*. Preliminary edition (May). Washington, DC: CBO.

Conley, Dalton. 1999. *Being Black, Living in the Red: Race, Wealth, and Social Policy in America*. Berkeley: University of California Press.

Consumers Union. 2001. "Pushed Off the Financial Cliff." *Consumer Reports* (July): 20–25.

Coontz, Stephanie. 1992. *The Way We Never Were: American Families and the Nostalgia Trap*. New York: Basic Books.

Coontz, Stephanie. 1997. *The Way We Really Are: Coming To Terms with America's Changing Families*. New York: Basic Books.

Cornell, Emily. 2000. *State Role in Preventing Teen Pregnancy*. Health Policy Studies Division. Washington, DC: National Governors' Association Center for Best Practices.

Dalaker, Joseph. 2001. *Poverty in the United States*. U.S. Census Bureau, Current Population Reports, Series P60-214. Washington, DC: U.S. Government Printing Office.

Danziger, Sheldon H., Gary D. Sandefur, and Daniel H. Weinberg, editors. 1994. *Confronting Poverty: Prescriptions for Change*. Cambridge, MA: Harvard University Press.

DeParle, Jason. 1998. "Shrinking Welfare Rolls Leave Record High Share of Minorities." *New York Times*, July 27: A1.

DeParle, Jason. 1999A. "As Welfare Rolls Shrink, Load on Relatives Grows." *New York Times*, February 21: A1.

DeParle, Jason. 1999B. "Early Sex Abuse Hinders Many Women on Welfare." *New York Times*, November 28: A1.

DeVault, Marjorie L. 1991. *Feeding the Family: The Social Organization of Caring as Gendered Work*. Chicago: University of Chicago Press.

Dobash, R. Emerson and Russell Dobash. 1979. *Violence Against Wives*. New York: Free Press.

Dodson, Lisa. 1998. *Don't Call Us Out of Name: The Untold Lives of Women and Girls in Poor America*. Boston: Beacon Press.

Domhoff, G. William. 1967. *Who Rules America?* Englewood Cliffs, NJ: Prentice-Hall.

Donzelot, Jacques. 1979. *The Policing of Families*. New York: Pantheon.

Draut, Tammy. 2001. *New Opportunities? Public Opinion on Poverty, Income Inequality and Public Policy: 1996–2001*. New York: Demos.

Duneier, Mitchell. 1992. *Slim's Table: Race, Respectability, and Masculinity*. Chicago: University of Chicago Press.

Durkheim, Emile. 1951 [1979]. *Suicide: A Study in Sociology*. Edited by George Simpson, translated by John A. Spaulding and George Simpson. New York: Free Press.

Durkheim, Emile. 1984. *The Division of Labor in Society*. New York: Free Press.

Edin, Kathryn. 1995. "Single Mothers and Child Support: The Possibilities and Limits of Child Support Policy." *Children and Youth Services Review* 17: 203–230.

Edin, Kathryn. 2000. "What Do Low-Income Single Mothers Say About Marriage?" *Social Problems* 47: 112–133.

Edin, Kathryn. 2001. "Statement of Kathryn Edin: Testimony Before the Subcommittee on Human Resources of the House Committee on Ways and Means." http://waysandmeans.house.gov/humres/107cong/5-22-01/5-22edin.htm.

Edin, Kathryn and Christopher Jencks. 1992. "Reforming Welfare," pp. 204–235 in *Rethinking Social Policy: Race, Poverty, and the Underclass*, edited by Christopher Jencks. Cambridge, MA: Harvard University Press.

Edin, Kathryn and Laura Lein. 1997. *Making Ends Meet: How Single Mothers Survive Welfare and Low-Wage Work*. New York: Russell Sage Foundation.

Ehrenreich, Barbara. 1983. *The Hearts of Men: American Dreams and the Flight from Commitment*. New York: Anchor Books.

Ehrenreich, Barbara. 1997. "Spinning the Poor into Gold." *Harper's Magazine* (August): 44–52.

Ehrenreich, Barbara. 2001. *Nickel and Dimed: On (Not) Getting By in America*. New York: Metropolitan Books.

Ellwood, David T. 1988. *Poor Support: Poverty in the American Family*. New York: Basic Books.

Elshtain, Jean Bethke. 1981. *Public Man, Private Woman*. Princeton, NJ: Princeton University Press.

England, Paula. 1992. *Comparable Worth: Theories and Evidence*. New York: Aldine de Gruyter.

England, Paula and Nancy Folbre. 1999. "The Cost of Caring." *The Annals of the American Academy of Political and Social Science* 561: 39–51.

Epstein, Cynthia Fuchs. 1988. *Deceptive Distinctions: Sex, Gender, and the Social Order*. New Haven, CT: Yale University Press.

Etzioni, Amitai. 1993. *The Spirit of Community: The Reinvention of American Society*. New York: Touchstone.

Fields, Jason. 2001. *America's Families and Living Arrangements, 2000*. U.S. Census Bureau, Current Population Reports, P20-537. Washington, DC: U.S. Government Printing Office.

Fineman, Martha Albertson and Isabel Karpin. 1995. *Mothers in Law: Feminist Theory and the Legal Regulation of Motherhood*. New York: Columbia University Press.

Fischer, Claude S. 2000. "Just How Is It that Americans Are Individualistic?" Paper presented at the American Sociological Association Meeting, Washington, DC.

Foucault, Michel. 1972. *Power/Knowledge: Selected Interviews and Other Writings*. New York: Pantheon.

Foucault, Michel. 1979. *Discipline and Punish*. New York: Vintage.

Fraser, Nancy. 1997A. "From Redistribution to Recognition? Dilemmas of Justice in a

'Postsocialist' Age," pp. 11–40 in *Justice Interruptus: Critical Reflections on the "Postsocialist" Condition,* edited by Nancy Fraser. New York: Routledge.

Fraser, Nancy. 1997B. "After the Family Wage: A Postindustrial Thought Experiment," pp. 41–66 in *Justice Interruptus: Critical Reflections on the "Postsocialist" Condition,* edited by Nancy Fraser. New York: Routledge.

Fraser, Nancy and Linda Gordon. 1997. "A Genealogy of 'Dependency': Tracing a Keyword of the U.S. Welfare State," pp. 121–149 in *Justice Interruptus: Critical Reflections on the "Postsocialist" Condition,* edited by Nancy Fraser. New York: Routledge.

Friedan, Betty. 1963. *The Feminine Mystique.* New York: Dell.

Furstenberg, Frank F., Jr. and Andrew J. Cherlin. 1991. *Divided Families.* Cambridge, MA: Harvard University Press.

Gallagher, L. Jerome, Megan Gallagher, Kevin Perese, Susan Schreiber, and Keith Watson. 1998. *One Year After Federal Welfare Reform: A Description of State Temporary Assistance for Needy Families (TANF) Decisions as of October 1997.* Washington, DC: Urban Institute.

Gans, Herbert J. 1995. *The War Against the Poor: The Underclass and Antipoverty Policy.* New York: Basic Books.

Garfinkel, Irwin and Sara McLanahan. 1986. *Single Mothers and Their Children.* Washington, DC: Urban Institute.

Garfinkel, Irwin, Sara S. McLanahan, Marta Tienda, and Jeanne Brooks-Gunn. 2001. "Fragile Families and Welfare Reform: An Introduction." *Children and Youth Services Review* 23 (4/5): 277–301.

Geen, Rob, Shelley Waters Boots, and Karen C. Tumlin. 1999. *The Cost of Protecting Vulnerable Children: Understanding the Complexities of Federal, State, and Local Child Welfare Spending.* Washington, DC: Urban Institute.

Gerson, Kathleen. 1985. *Hard Choices: How Women Decide about Work, Career, and Motherhood.* Berkeley: University of California Press.

Gerson, Kathleen. 1993. *No Man's Land: Men's Changing Commitments to Family and Work.* New York: Basic Books.

Gilder, George. 1981 [1993]. *Wealth and Poverty: A New Edition of the Classic.* San Francisco, CA: Institute for Contemporary Studies Press.

Gilens, Martin. 1999. *Why Americans Hate Welfare: Race, Media, and the Politics of Antipoverty Policy.* Chicago: University of Chicago Press.

Gillespie, Ed and Bob Schellhas, editors. 1994. *Contract with America: The Bold Plan by Rep. Newt Gingrich, Rep. Dick Armey and the House Republicans to Change the Nation.* New York: Times Books.

Gilligan, Carol. 1982. *In a Different Voice: Psychological Theory and Women's Development.* Cambridge, MA: Harvard University Press.

Goffman, Erving. 1959. *The Presentation of Self in Everyday Life.* Garden City, NY: Doubleday.

Goldberg, Carey. 1999. "Most Get Work After Welfare, Studies Suggest." *New York Times,* April 17: A1.

Goldberg, Heidi. 2001. *A Compliance-Oriented Approach to Sanctions in State and County TANF Programs.* Washington, DC: Center on Budget and Policy Priorities.

Goldin, Claudia. 1990. *Understanding the Gender Gap: An Economic History of American Women*. New York: Oxford University Press.

Goodwin, Joanne L. 1995. " 'Employable Mothers' and 'Suitable Work': A Re-evaluation of Welfare and Wage-Earning for Women in the Twentieth-Century United States," *Journal of Social History* 29 (Winter): 253–274.

Gordon, Linda. 1988. *Heroes of Their Own Lives: The Politics and History of Family Violence*. New York: Penguin.

Gordon, Linda. 1990. "Family Violence, Feminism, and Social Control," pp. 178–198 in *Women, the State, and Welfare*, edited by Linda Gordon. Madison: University of Wisconsin Press.

Gordon, Linda. 1994. *Pitied but not Entitled: Single Mothers and the History of Welfare*. Cambridge, MA: Harvard University Press.

Gornick, Janet C. and Marcia Meyers. 2001. "Building a Dual-Earner/Dual Career Society: What Can Government Do?" Paper presented at the Conference on Carework, Inequality, and Advocacy, University of California, Irvine.

Gottschalk, Peter, Sara McLanahan, and Gary D. Sandefur. 1994. "The Dynamics and Intergenerational Transmission of Poverty and Welfare Participation," pp. 85–108 in *Confronting Poverty: Prescriptions for Change*, edited by Sheldon H. Danzinger, Gary D. Sandefur, and Daniel H. Weinberg. Cambridge, MA: Harvard University Press.

Grall, Timothy. 2000. *Child Support for Custodial Mothers and Fathers*. U.S. Census Bureau, Current Population Reports, pp. 60–212. Washington, DC: U.S. Government Printing Office.

Greenstein, Robert, Wendell Primus, and Toni Kayatin. 2000. *Poverty Rate Hits Lowest Level Since 1979 as Unemployment Reaches a 30-Year Low*. Washington, DC: Center on Budget and Policy Priorities.

Hall, John. 1992. "The Capital(s) of Cultures: A Nonholistic Approach to Status Situations, Class, Gender, and Ethnicity," pp. 257–285 in *Cultivating Differences*, edited by Michèle Lamont and Marcel Fournier. Chicago: University of Chicago Press.

Halle, David. 1984. *America's Working Man*. Chicago: University of Chicago Press.

Handler, Joel F. 1991. *The Moral Construction of Poverty: Welfare Reform in America*. Newbury Park: Sage.

Handler, Joel F. 1995. *The Poverty of Welfare Reform*. New Haven, CT: Yale University Press.

Handler, Joel F. and Yeheskel Hasenfeld. 1997. *We the Poor People: Work, Poverty, and Welfare*. New Haven, CT: Yale University Press.

Handler, Joel F. and Ellen Jane Hollingsworth. 1971. *The "Deserving Poor": A Study of Welfare Administration*. Chicago: Markham Publishing.

Harden, Blaine. 2002. "Finding Common Ground on Poor Deadbeat Dads." *New York Times*, February 3: A3.

Harrington, Michael. 1962 [1993]. *The Other America: Poverty in the United States*. New York: Touchstone.

Harris, Kathleen Mullan. 1993. "Work and Welfare Among Single Mothers in Poverty," *American Journal of Sociology* 99 (September): 317–52.

Harris, Kathleen Mullan. 1996. "Life after Welfare: Women, Work, and Repeat Dependency." *American Sociological Review* 61 (June): 407–426.

Harris, Kathleen Mullan. 1997. *Teen Mothers and the Revolving Welfare Door*. Philadelphia: Temple University Press.

Harvard School of Public Health. 2000. *Caregiving by Women: A Disproportionately Large Load.*" Project on Global Working Families. Cambridge, MA: President and Fellows of Harvard College.

Havemann, Judith and Barbara Vobejda. 1998. "The Welfare Alarm that Didn't Go Off." *Washington Post*, October 1: A1.

Hays, Sharon. 1996. *The Cultural Contradictions of Motherhood*. New Haven, CT: Yale University Press.

Hebdige, Dick. 1979. *Subculture: The Meaning of Style*. London: Methuen.

Held, Virginia, editor. 1995. *Justice and Care: Essential Readings in Feminist Ethics*. Boulder, CO: Westview Press.

Hernandez, Raymond. 1998. "Most Dropped from Welfare Don't Get Jobs." *New York Times*, March 23: A1.

Hernandez, Raymond. 1999. "Millions in State Child Care Funds Going Unspent in New York." *New York Times*, October 25: A29.

Hinton, Gigi. 2001. "Overall Child Poverty Rate Dropped in 2000 but Poverty Rose for Children in Full-Time Working Families." Children's Defense Fund Press Release (October 10). Washington, DC: Children's Defense Fund.

Hochschild, Arlie Russell with Anne Machung. 1989. *The Second Shift: Working Parents and the Revolution at Home*. New York: Viking.

Hochschild, Arlie Russell. 1997. *The Time Bind: When Work Becomes Home and Home Becomes Work*. New York: Metropolitan Books.

Hochschild, Jennifer L. 1995. *Facing Up to the American Dream: Race, Class, and the Soul of the Nation*. Princeton, NJ: Princeton University Press.

Holzer, Harry J. and Michael A. Stoll. 2001. *Meeting the Demand: Hiring Patterns of Welfare Recipients in Four Metropolitan Areas*. Washington, DC: Brookings Institution.

Horn, Wade and Isabel V. Sawhill. 2001. "Making Room for Daddy: Fathers, Marriage and Welfare Reform. In *The New World of Welfare*, edited by Rebecca M. Blank and Ron Haskins. Washington, DC: Brookings Institution.

Horowitz, Ruth. 1995. *Teen Mothers: Citizens or Dependents?* Chicago: University of Chicago Press.

Hunter, James Davison. 1991. *Culture Wars*. New York: Basic Books.

Jencks, Christopher. 1992. *Rethinking Social Policy: Race, Poverty, and the Underclass*. Cambridge, MA: Harvard University Press.

Jencks, Christopher. 1997. "The Hidden Paradox of Welfare Reform." *The American Prospect* 32 (May–June): 33–40.

Johnson, Amy and Alicia Meckstroth. 1998. *Ancillary Services to Support Welfare to Work. Prepared for the U.S. Department of Health and Human Services*. Princeton, NJ: Mathematica Policy Research, Inc.

Kalb, Claudia. 2001. "Playing with Pain Killers." *Newsweek* (April 9): 45–52.

Kantrowitz, Barbara and Pat Wingert. 2001. "Unmarried, with Children." *Newsweek* (May 28): 46–55.

Katz, Michael B. 1986 [1996]. *In the Shadow of the Poorhouse: A Social History of Welfare in America*. Revised edition. New York: Basic Books.

Katz, Michael B. 1993. "The Urban 'Underclass' as a Metaphor of Social Transformation," pp. 3–23 in *The "Underclass" Debate: Views from History*, edited by Michael B. Katz. Princeton, NJ: Princeton University Press.

Kessler-Harris, Alice. 1982. *Out to Work: A History of Wage-Earning Women in the United States*. Oxford: Oxford University Press.

Kittay, Eva Feder. 1999A. "Welfare, Dependency, and a Public Ethic of Care," pp. 189–213 in *Whose Welfare?* edited by Gwendolyn Mink. Ithaca, NY: Cornell University Press.

Kittay, Eva Feder. 1999B. *Love's Labor: Essays on Women, Equality, and Dependency*. New York: Routledge.

Knox, Virginia, Cynthia Miller, and Lisa A. Gennetian. 2000. *Reforming Welfare and Rewarding Work: The Minnesota Family Investment Program*. Study by Manpower Demonstration Research Corporation. Minneapolis: Minnesota Department of Human Resources.

Kollantai, Alexandra. 1909 [1980]. "The Social Basis of the Woman Question," pp. 58–73 in *Selected Writings of Alexandra Kollantai*, edited by A. Holt. New York: W. W. Norton.

Ku, Leighton and Bowen Garrett. 2000. *How Welfare Reform and Economic Factors Affected Medicaid Participation: 1984–96*. Washington, DC: Urban Institute.

Kurz, Demie. 1995. *For Richer, For Poorer: Mothers Confront Divorce*. New York: Routledge.

Kurz, Demie. 1999. "Women, Welfare, and Domestic Violence," pp. 132–151 in *Whose Welfare?* edited by Gwendolyn Mink. Ithaca, NY: Cornell University Press.

Lamison-White, Leatha. 1997. *Poverty in the United States: 1996*. U.S. Bureau of the Census, Current Population Reports, Series P60-198. Washington, DC: U.S. Government Printing Office.

Lamont, Michèle. 1992. *Money, Morals, and Manners*. Chicago: University of Chicago Press.

Lamont, Michèle. 2000. *The Dignity of Working Men: Morality and the Boundaries of Race, Class, and Immigration*. New York: Russell Sage Foundation.

Laracy, Michael. 1994. *The Jury Is Still Out: An Analysis of the Purported Impact of New Jersey's AFDC Child Exclusion Law*. Washington, DC: Center for Law and Social Policy.

Lareau, Annette. Forthcoming. *Creating a Childhood, Creating a Family: The Importance of Social Class*. Berkeley: University of California Press.

Lennon, Mary Clare, Julianna Blome, and Kevin English. 2001. *Depression and Low-Income Women: Challenges for TANF and Welfare-to-Work Policies and Programs*. Research Forum on Children, Families, and the New Federalism. New York: National Center for Children in Poverty.

Legler, Paul K. 1996. "The Coming Revolution in Child Support Policy: Implications of the 1996 Welfare Act." *Family Law Quarterly* 30 (Fall): 519–563.

Lerman, Robert I, Pamela Loprest, and Caroline Ratcliffe. 1999. *How Well Can Urban Labor Markets Absorb Welfare Recipients?* New Federalism: Issues and Options for States, Number A-33. Washington, DC: The Urban Institute.

Levy, Frank. 1998. *The New Dollars and Dreams: American Incomes and Economic Change.* New York: Russell Sage.

Lewis, Oscar. 1966. *La Vida: A Puerto Rican Family in the Culture of Poverty—San Juan and New York.* New York: Random House.

Lichter, Daniel T., Diane K. McLaughlin, George Kephart, and David J. Landry. 1992. "Race and the Retreat from Marriage: A Shortage of Marriageable Men?" *American Sociological Review* 57(6): 781–799.

Loprest, Pamela. 1999. *Families Who Left Welfare: Who Are They and How Are They Doing?* Washington, DC: Urban Institute.

Luker, Kristin. 1975. *Taking Chances: Abortion and the Decision Not to Contracept.* Berkeley: University of California Press.

Luker, Kristin. 1984. *Abortion and the Politics of Motherhood.* Berkeley: University of California Press.

Luker, Kristin. 1996. *Dubious Conceptions: The Politics of Teenage Pregnancy.* Cambridge, MA: Harvard University Press.

Lurie, Irene. 2001. *Changing Welfare Offices.* Washington, DC: Brookings Institution.

MacLeod, Jay. 1987 [1995]. *Ain't No Makin' It: Aspirations and Attainment in a Low-Income Neighborhood.* Revised edition. Boulder, CO: Westview.

Marmor, Theodore R., Jerry L. Mashaw, and Phillip L. Harvey. 1990. *America's Misunderstood Welfare State: Persistent Myths, Enduring Realities.* New York: Basic Books.

Marshall, T. H. 1950. *Class, Citizenship, and Social Development: Essays by T. H. Marshall.* Chicago: University of Chicago Press.

Marx, Karl. 1887 [1967]. *Capital, Volume I.* Edited by Frederick Engels. New York: International Publishers.

McLanahan, Sara, Irwin Garfinkel, and Ronald B. Mincy. 2001. *Fragile Families, Welfare Reform, and Marriage.* Welfare Reform and Beyond: Policy Brief No. 10. Washington, DC: Brookings Institution.

McLanahan, Sara and Gary Sandefur. 1994. *Growing Up with a Single Parent: What Hurts, What Helps.* Cambridge, MA: Harvard University Press.

Mead, Lawrence M. 1986. *Beyond Entitlement: The Social Obligations of Citizenship.* New York: Free Press.

Mead, Lawrence M. 1992. *The New Politics of Poverty: The Nonworking Poor in America.* New York: Basic Books.

Mead, Lawrence M. 1996A. "Raising Work Levels Among the Poor," pp. 251–282 in *Reducing Poverty in America: Views and Approaches,* edited by Michael Darby. Thousand Oaks, CA: Sage.

Mead, Lawrence M. 1996B. "Welfare Reform at Work." *Society* 33(5) July/August: 37–40.

Mink, Gwendolyn. 1995. *The Wages of Motherhood: Inequality in the Welfare State, 1917–1942.* Ithaca, NY: Cornell University Press.

Mink, Gwendolyn. 1998. *Welfare's End.* Ithaca, NY: Cornell University Press.

Mink, Gwendolyn, editor. 1999. *Whose Welfare?* Ithaca, NY: Cornell University Press.

Moffitt, Robert A. 1992. "Incentive Effects of the U.S. Welfare System: A Review." *Journal of Economic Literature* 30 (1) March: 1–61.

Moffitt, Robert A. 2002. *From Welfare to Work: What the Evidence Shows.* Welfare Reform and Beyond: Policy Brief #13. Washington, DC: Brookings Institution.

Morton, David A. 2001. *Nolo's Guide to Disability Benefits.* Berkeley, CA: Nolo Press

Moynihan, Daniel P. 1965. *The Negro Family: The Case for National Action.* Washington, DC: U.S. Department of Labor, Office of Planning and Research.

Murray, Charles. 1984. *Losing Ground: American Social Policy, 1950–1980.* New York: Basic Books.

Murray, Charles. 1996A. "Keeping Priorities Straight on Welfare Reform." *Society* 33 (5): 10–12.

Murray, Charles. 1996B. "Reducing Poverty and Reducing the Underclass," pp. 82–110 in *Reducing Poverty in America: Views and Approaches,* edited by Michael Darby. Thousand Oaks, CA: Sage.

Naples, Nancy. 1999. "From Maximum Feasible Participation to Disenfranchisement," pp. 56–82 in *Whose Welfare?* edited by Gwendolyn Mink. Ithaca, NY: Cornell University Press.

National Campaign for Jobs and Income Support. 2001A. *A Recession Like No Other: New Analysis Finds Safety Net in Tatters as Economic Slump Deepens.* Washington, DC: National Campaign for Jobs and Income Support.

National Campaign for Jobs and Income Support. 2001B. *Leaving Welfare, Left Behind: Employment Status, Income, and Well-Being of Former TANF Recipients.* Washington, DC: National Campaign for Jobs and Income Support.

National Governors' Association for Best Practices. 1999. *Round Two Summary of Selected Elements of State Programs for Temporary Assistance for Needy Families.* Washington, DC: National Governors' Association.

National Organization of Women. 1967 [1993]. "Bill of Rights," pp. 159–160 in *Feminist Frameworks: Alternative Theoretical Accounts of the Relations Between Women and Men,* edited by Alison M. Jaggar and Paula S. Rothenberg. New York: McGraw-Hill.

National Public Radio, Kaiser Family Foundation, and Kennedy School of Government. 2001. *Poverty in America.* Washington, DC: National Public Radio.

Negrey, Cynthia, Stacie Golin, Sunhwa Lee, Holly Mead, and Barbara Gault. 2001. *Working First but Working Poor: The Need for Education and Training Following Welfare Reform.* Washington, DC: Institute for Women's Policy Research.

Network Welfare Reform Project. 2001. "Welfare Reform: How Do We Define Success?" http://www.networklobby.org/wrwp.htm#welfare

Neuberger, Zoe and Ed Lazere. 2001. *Analysis of TANF Spending Through the Middle of Federal Fiscal Year 2001.* Washington, DC: Center on Budget and Policy Priorities.

Newman, Katherine S. 1988. *Falling from Grace.* New York: Free Press.

Newman, Katherine S. 1999. *No Shame in My Game: The Working Poor in the Inner City.* New York: Vintage Books.

Nock, Steven L. 1998. *Marriage in Men's Lives.* New York: Oxford University Press.

O'Connor, Alice. 2001. *Poverty Knowledge: Social Science, Social Policy, and the Poor in Twentieth-Century U.S. History.* Princeton, NJ: Princeton University Press.

Okin, Susan Moller. 1989. *Justice, Gender, and the Family*. New York: Basic Books.

Olson, Krista and LaDonna Pavetti. 1996. *Personal and Family Challenges to the Successful Transition from Welfare to Work*. Washington, DC: Urban Institute.

O'Neill, June E. and M. Anne Hill. 2001. *Gaining Ground? Measuring the Impact of Welfare Reform on Welfare and Work*. New York: Manhattan Institute.

Oppenheimer, Valerie Kincade. 2000. "The Continuing Importance of Men's Economic Position in Marriage Formation," pp. 283–301 in *The Ties that Bind: Perspectives on Marriage and Cohabitation*, edited by Linda J. Waite. New York: Aldine de Gruyter.

Parrot, Sharon. 1998. *Welfare Recipients Who Find Jobs: What Do We Know About Their Employment and Earnings?* Washington, DC: Center on Budget and Policy Priorities.

Parrot, Sharon. 2002. *The TANF-Related Provisions in the President's Budget*. Washington, DC: Center on Budget and Policy Priorities.

Parrot, Sharon, Wendell Primus, and Shawn Fremstad. 2002. *Administration's TANF Proposals Would Limit—Not Increase—State Flexibility*. Washington, DC: Center for Budget and Policy Priorities.

Parrot, Sharon and Zoe Neuberger. 2002. *States Need More Federal TANF Funds*. Washington, DC: Center on Budget and Policy Priorities.

Pear, Robert. 1998. "Number on Welfare Dips Below 10 Million. *New York Times*, January 21: A12.

Pear, Robert. 1999A. "White House Releases Glowing Data on Welfare." *New York Times*, August 1: A12.

Pear, Robert. 1999B. "10,000 Welfare Recipients Hired by Federal Agencies." *New York Times*, March 1: A12.

Pear, Robert. 2000. "A Million Parents Lost Medicaid, Study Says." *New York Times*, June 20: A12.

Pear, Robert. 2002. "Governors Want Congress to Ease Welfare's Work Rule." *New York Times*, February 24.

Pearce, Diana. 1978. "The Feminization of Poverty: Women, Work, and Welfare." *Urban and Social Change Review* (Winter–Spring): 28–36.

Piven, Frances Fox. 1999. "Welfare and Work," pp. 83–99 in *Whose Welfare?* edited by Gwendolyn Mink. Ithaca, NY: Cornell University Press.

Piven, Francis Fox, and Richard A. Cloward. 1993. *Regulating the Poor: The Functions of Public Welfare*. Updated edition. New York: Random House.

Polakow, Valerie. 1993. *Lives on the Edge: Single Mothers and Their Children in the Other America*. Chicago: University of Chicago Press.

Popenoe, David. 1988. *Disturbing the Nest: Family Change and Decline in Modern Societies*. New York: Aldine de Gruyter.

Preston, Jennifer. 1998. "Births Fall and Abortions Rise Under New Jersey Family Cap." *New York Times*, November 3: B8.

Primus, Wendell, Lynette Rawlings, Kathy Larin, and Kathryn Porter. 1999. *The Initial Impacts of Welfare Reform on the Incomes of Single-Mother Families*. Washington, DC: Center on Budget and Policy Priorities.

Public Agenda. 2001. "Welfare: Public Opinion." http://www.publicagenda.org/issues.

Putnam, Robert D. 1995. "Bowling Alone: America's Declining Social Capital." *Journal of Democracy* 6 (1): 65–78.

Putnam, Robert D. 2000. *Bowling Alone: The Collapse and Revival of American Community*. New York: Simon and Schuster.

Quadagno, Jill. 1994. *The Color of Welfare: How Racism Undermined the War on Poverty*. New York: Oxford University Press.

Rank, Mark R. and Thomas A. Hirschl. 2001. "The Occurrence of Poverty Across the Life Cycle: Evidence from the PSID." *Journal of Policy Analysis and Management* 20 (4): 737–755.

Raphael, Jody. 1996. "Domestic Violence and Welfare Receipt: Toward a New Feminist Theory of Welfare Dependency." *Harvard Women's Law Journal* 19 (Spring): 201–27.

Raphael, Jody. 1999. "Keeping Women Poor: How Domestic Violence Prevents Women from Leaving Welfare and Entering the World of Work," pp. 31–44 in *Battered Women, Children, and Welfare Reform*, edited by Ruth A. Brandwein. Thousand Oaks, CA: Sage.

Revkin, Andrew C. 1999. "Welfare Policies Alter the Face of Food Lines." *New York Times*, February 26: A1.

Risman, Barbara J. 1998. *Gender Vertigo: American Families in Transition*. New Haven, CT: Yale University Press.

Rivera, Carla. 1997. "Mothers Pressed into Battle for Child Support." *Los Angeles Times*, March 24: A1.

Rose, Stephen J. 2000 [1992]. *Social Stratification in the United States: The New American Profile Poster*. Revised and updated edition. New York: New Press.

Rubin, Lillian. 1976. *Worlds of Pain: Life in the Working Class Family*. New York: Basic Books.

Rubin, Lillian. 1983. *Intimate Strangers: Men and Women Together*. New York: Harper and Row.

Rubin, Lillian. 1994. *Families on the Fault Line: America's Working Class Speaks About the Family, the Economy, Race, and Ethnicity*. New York: HarperCollins.

Sainsbury, Diane. 1994. "Women's and Men's Social Rights: Gendering Dimensions of Welfare States," pp. 150–169 in *Gendering Welfare States*, edited by Diane Sainsbury. Thousand Oaks, CA: Sage.

Sapiro, Virginia. 1999. *Women in American Society: An Introduction to Women's Studies*. Fourth Edition. Mountain View, CA: Mayfield.

Schott, Liz. 2001. *Ways that States Can Serve Families that Reach Welfare Time Limits*. Washington, DC: Center on Budget and Policy Priorities.

Schudson, Michael. 1986. *Advertising, the Uneasy Persuasion: Its Dubious Impact on American Society*. New York: Basic Books.

Schwartz, Felice. 1989. "Management Women and the New Facts of Life." *Harvard Business Review* 67 (1): 65–77.

Seccombe, Karen. 1999. *"So You Think I Drive a Cadillac?" Welfare Recipients' Perspectives on the System and Its Reform*. Boston: Allyn and Bacon.

Seccombe, Karen, Kimberly Battle Walters, and Delores James. 1999. " 'Welfare Mothers' Welcome Reform, Urge Compassion." *Family Relations* 48: 197–206.

Seidman, Steven, editor. 1996. *Queer Theory/Sociology*. Cambridge, MA: Blackwell.

Shapiro, Isaac, Robert Greenstein, and Wendell Primus. 2001. *Pathbreaking CBO Study Shows Dramatic Increases in Income Disparities in 1980s and 1990s: An Analysis of the CBO Data*. Washington, DC: Center on Budget and Policy Priorities.

Sherman, Arloc, Cheryl Amey, Barbara Duffield, Nancy Ebb, and Deborah Weinstein. 1998. *Welfare to What? Early Findings on Family Hardship and Well-Being*. National Coalition for the Homeless. Washington, DC: Children's Defense Fund.

Sidel, Ruth. 1986. *Women and Children Last: The Plight of Poor Women in Affluent America*. New York: Viking.

Sidel, Ruth. 1996A [1998]. *Keeping Women and Children Last: America's War on the Poor*. Revised edition. New York: Penguin Books.

Sidel, Ruth. 1996B. "The Enemy Within: A Commentary on the Demonization of Difference." *American Journal of Orthopsychiatry* 66(4): 490–95.

Skocpol, Theda. 1991. "Targeting Within Universalism: Politically Viable Policies to Combat Poverty in the United States," pp. 411–436 in *The Urban Underclass*, edited by Christopher Jencks and Paul E. Peterson. Washington, DC: Brookings Institution.

Skocpol, Theda. 1992. *Protecting Mothers and Soldiers: The Political Origins of Social Policy in the United States*. Cambridge, MA: Harvard University Press.

Skocpol, Theda. 2000. *The Missing Middle: Working Families and the Future of American Social Policy*. New York: W.W. Norton.

Smeeding, Timothy M. 1992. "Why the U.S. Antipoverty System Doesn't Work Very Well." *Challenge* 35 (1): 30–35.

Smith, Adam. 1981. *An Inquiry into the Nature and Causes of the Wealth of Nations*, Volume I. Indianapolis: Liberty Classics.

Social Security Bulletin. 2000. *Annual Statistical Supplement: 2000*. http://www.ssa.gov/statistics/supplement/2000.

Solinger, Rickie. 1999. "Dependency and Choice: The Two Faces of Eve," pp. 7–35 in *Whose Welfare?* edited by Gwendolyn Mink. Ithaca, NY: Cornell University Press.

Sorenson, Elaine, Ronald Mincy, and Ariel Halpern. 2000. *Redirecting Welfare Policy Toward Building Strong Families*. Washington, DC: Urban Institute.

Sorensen, Elaine and Chava Zibman. 2000. *Child Support Offers Some Protection Against Poverty*. Assessing the New Federalism, Series B, No. B-10. Washington, DC: Urban Institute.

Spain, Daphne and Suzanne M. Bianchi. 1996. *Balancing Act: Motherhood, Marriage, and Employment Among American Women*. New York: Russell Sage.

Spalter-Roth, Roberta M. and Heidi I. Hartmann. 1994. "Dependence on Men, the Market, or the State: The Rhetoric and Reality of Welfare Reform." *Journal of Applied Social Sciences* 18 (1): 55–70.

Stacey, Judith. 1990. *Brave New Families: Stories of Domestic Upheaval in Late Twentieth Century America*. New York: Basic Books.

Stacey, Judith. 1996. *In the Name of the Family: Rethinking Family Values in the Postmodern Age*. Boston: Beacon Press.

Stack, Carol B. 1974. *All Our Kin: Strategies for Survival in a Black Community*. New York: Harper and Row.

Stanton, Elizabeth Cady. 1848 [1973]. "Seneca Falls Convention: Declaration of Sentiments," pp. 413–420 in *The Feminist Papers: From Adams to de Beauvoir*, edited by Alice Rossi. Boston: Northeastern University Press.

Stephan, James J. 1999. *State Prison Expenditures, 1996*. U.S. Department of Justice, NCJ 172211. Washington, DC: U.S. Government Printing Office.

Straus, Murray A. and Richard J. Gelles. 1986. "Societal Change and Change in Family Violence from 1975–1985 as Revealed by Two National Surveys." *Journal of Marriage and the Family* 48: 465–479.

Straus, Murray A., Richard J. Gelles, and Suzanne Steinmetz. 1980. *Behind Closed Doors*. New York: Doubleday.

Swarns, Rachel L. 1999. "New York City Admits Turning Away Poor." *New York Times*, January 22: B3.

Sweeney, Eileen P. 2000. *Recent Studies Indicate that Many Parents who Are Current or Former Welfare Recipients Have Disabilities or Other Medical Conditions*. Washington, DC: Center on Budget and Policy Priorities.

Sweeney, Eileen, Liz Schott, Ed Lazere, Shawn Fremstad, Heidi Goldberg, Jocelyn Guyer, David Super, and Clifford Johnson. 2000. *Windows of Opportunity: Strategies to Support Families Receiving Welfare and Other Low-income Families in the Next Stage of Welfare Reform*. Washington, DC: Center on Budget and Policy Priorities.

Swidler, Ann. 1986. "Culture in Action: Symbols and Strategies." *American Sociological Review* 51: 273–286.

Taylor, Charles. 1992. *Multiculturalism and "The Politics of Recognition."* Princeton, NJ: Princeton University Press.

Terry, Elizabeth and Jennifer Manlove. 1999. *Trends in Sexual Activity and Contraceptive Use Among Teens*. Washington, DC: Child Trends.

Toner, Robin. 2002. "Welfare Chief Is Hoping to Promote Marriage." *New York Times*, February 19: A1.

Toner, Robin and Robert Pear. 2002A. "Bush's Plan on Welfare Law Increases Work Requirement." *New York Times*, February 26: A23.

Toner, Robin and Robert Pear. 2002B. "Bush Urges Work and Marriage Programs in Welfare Plan." *New York Times*, February 27: A18.

Toy, Vivian S. 1998. "Tough Workfare Rules Used as Way to Cut Welfare Rolls." *New York Times*, April 15: A24.

Tronto, Joan C. 1993 [1994]. *Moral Boundaries: A Political Argument for an Ethic of Care*. New York: Routledge.

Tucker, M. Belinda. 2000. "Marital Values and Expectations in Context: Results from a 21-City Survey, pp. 166–187 in *The Ties that Bind: Perspectives on Marriage and Cohabitation*, edited by Linda J. Waite. New York: Aldine de Gruyter.

Tweedie, Jack, Diana Reichert, and Matt O'Connor. 1999. *Tracking Recipients After They Leave Welfare: Summaries of New State Follow-Up Studies*. Washington, DC: National Conference of State Legislatures.

U.S. Bureau of the Census. 1996. *Statistical Abstract of the United States: 1996*. Washington, DC: U.S. Government Printing Office.

U.S. Bureau of the Census. 2001A. *Families by Presence of Own Children Under 18: 1950 to Present.* (FM-1.) Washington, DC: U.S. Government Printing Office.

U.S. Bureau of the Census. 2001B. *Net Worth of Nation's Households Unchanged.* http://www.census.gov/hhes/www/wealth.html.

U.S. Conference of Mayors. 2001. *A Status Report on Hunger and Homelessness in America's Cities*: A 27-City Survey. Washington, DC: Conference of Mayors.

U.S. Congress. 1996. *Personal Responsibility and Work Opportunity Reconciliation Act of 1996.* Public Law 104–193, H.R. 3734.

U.S. Department of Health and Human Services. 1999A. *Characteristics and Financial Circumstances of TANF Recipients.* Washington, DC: U.S. Government Printing Office.

U.S. Department of Health and Human Services. 1999B. *Temporary Assistance for Needy Families Program: Second Annual Report to Congress.* Washington, DC: U.S. Government Printing Office.

U.S. Department of Health and Human Services. 2001. *Percentage of the U.S. Population on Welfare by Year Since 1960.* http://www.acf.dhhs.gov/news/stats/6097rf.htm

U.S. General Accounting Office. 2001. *Welfare Reform: More Coordinated Federal Effort Could Help States and Localities Move TANF Recipients with Impairments Toward Employment.* GAO-02-37. Washington, DC: U.S. Government Printing Office.

U.S. House of Representatives, Committee on Ways and Means. 1998. *Green Book: Overview of Entitlement Programs.* Washington, DC: U.S. Government Printing Office.

U.S. House of Representatives, Committee on Ways and Means. 2000. *Green Book: Overview of Entitlement Programs.* Washington DC: U.S. Government Printing Office.

U.S. Social Security Administration. 2001. *Title II—Federal Old-Age, Survivors, and Disability Insurance Benefits, Social Security Act.* Committee on Ways and Means, PL74-271. Baltimore, MD: Social Security Administration.

Uttal, Lynet. 1996. "Custodial Care, Surrogate Care, and Coordinated Care: Employed Mothers and the Meaning of Child Care." *Gender and Society* 10 (3): 291–311.

Venkatesh, Sudhir Alladi. 2000. *American Project: The Rise and Fall of a Modern Ghetto.* Cambridge, MA: Harvard University Press.

Ventura, Stephanie and Christine A. Bachrach. 2000. *Nonmarital Childbearing in the United States, 1940–99.* U.S. Department of Health and Human Services, National Vital Statistics Reports 48 (16). Washington, DC: U.S. Government Printing Office.

Waller, Maureen R. 1999. "Meanings and Motives in New Family Stories: The Separation of Reproduction and Marriage Among Low-Income Black and White Parents," pp. 182–218 in *The Cultural Territories of Race: Black and White Boundaries*, edited by Michèle Lamont. Chicago: University of Chicago Press.

Waller, Maureen R. 2001. "High Hopes: Unwed Parents' Expectations About Marriage." *Children and Youth Services Review* 23 (4/5): 441–460.

Weber, Max. 1978. *Economy and Society*, Volumes I and II. Berkeley: University of California Press.

Weiner, Lynn Y. 1985. *From Working Girl to Working Mother: The Female Labor Force in the United States, 1820–1980.* Chapel Hill: University of North Carolina Press.

Weinstein, Deborah. 2001. *The Act to Leave No Child Behind (S. 940/H.R. 1990): TANF and Food Stamp Reauthorization and Provisions to Ensure that Children and Families Receive Support to Promote Work and Reduce Poverty.* Washington, DC: Children's Defense Fund.

Weintraub, Jeff. 1997. "The Theory and Politics of the Public/Private Distinction," pp. 1–42 in *Public and Private in Thought and Practice,* edited by Jeff Weintraub and Krishan Kumar. Chicago: University of Chicago Press.

Weintraub, Jeff. Forthcoming. *Freedom and Community: The Republican Virtue Tradition and the Sociology of Liberty.* Chicago: University of Chicago Press.

Wertheimer, Richard, Melissa Long, and Sharon Vandivere. 2001. *Welfare Recipients' Attitudes Toward Welfare, Nonmarital Childbearing, and Work: Implications for Reform?* Series B, No. B-37. Washington, DC: Urban Institute.

Whitehead, Barbara Dafoe. 1993. "Dan Quayle Was Right." *The Atlantic* 217 (4): 47–84.

Whitehead, Barbara Dafoe. 1996. *The Divorce Culture: Rethinking Our Commitments to Marriage and Family.* New York: Vintage.

Williams, Patricia J. 1991. *The Alchemy of Race and Rights: Diary of a Law Professor.* Cambridge, MA: Harvard University Press.

Williams, Raymond. 1978 [1991]. "Base and Superstructure in Marxist Cultural Theory," pp. 407–423 in *Rethinking Popular Culture: Contemporary Perspectives in Cultural Studies,* edited by Chandra Mukerji and Michael Schudson. Berkeley: University of California Press.

Willis, Paul E. 1977. *Learning to Labor: How Working Class Kids Get Working Class Jobs.* New York: Columbia University Press.

Wilson, William Julius. 1987 [1990]. *The Truly Disadvantaged: The Inner City, the Underclass, and Public Policy.* Chicago: University of Chicago Press.

Wilson, William Julius. 1996 [1997]. *When Work Disappears: The World of the New Urban Poor.* New York: Vintage Books.

Wisconsin Joint Legislative Audit Committee. 2001. *An Evaluation: Wisconsin Works (W-2) Program, Department of Workforce Development.* Madison, WI: Legislative Audit Bureau.

Women's Committee of One Hundred. 2001. *An Immodest Proposal: Rewarding Women's Work to End Poverty.* http://www.welfare2002.org.

Young, Iris Marion. 1990. *Justice and the Politics of Difference.* Princeton, NJ: Princeton University Press.

Zaretsky, Eli. 1976. *Capitalism, the Family, and Personal Life.* New York: Harper and Row.

Zelizer, Viviana A. 1985. *Pricing the Priceless Child.* New York: Basic.

Zucchino, David. 1997. *Myth of the Welfare Queen.* New York: Touchstone.

Index

abortion, 89, 146, 160, 194. *See also* child-bearing, pregnancy

abstinence, sexual, 248n.4, 257n.15

abuse: in marriage, 171; physical, 82, 140–41, 147, 153, 157–58, 212; substance, 186, 195, 198–99; welfare, 149, 201, 205–6, 211, 217–18

adoption, 161. *See also* family

advocacy, 215, 251n.3

age of welfare mothers, 200

agreement of personal responsibility, 32–33, 39. *See also* Personal Responsibility Act

aid from family, 81. *See also* family

Aid to Dependent Children, 14

Aid to Families with Dependent Children (AFDC), 242n.18, 249n.29. *See also* bureaucracy; welfare

alcoholism, 186, 198–99. *See also* drugs

Americans: culture of, 97–98, 213; mainstream, 122; and the poor, 118; worries of, 22. *See also* nation; states; United States

Anderson, Elijah, 178, 184, 205

Arbordale (pseudonym) mothers' stories: Annette, 94; Celie, 165; Christine, 159–64, 166–67, 168, 176, 177, 255n.18; Clara, 51–52; Connie, 150; Darla, 179; Jillian, 150; Joanne, 68–69, 179–80; Julie, 165; Kendra, 52; Leslie, 150; Monique, 169–74, 228; Nadia, 183–92, 209–10, 213, 228; Sarah, 112; Sonya, 228.

See also mothers' stories; Sunbelt City mothers' stories

Arbordale (pseudonym) welfare office, 3–4, 63, 82, 89; author's visits to, 24–28; benefits of, 7, 169; caseworkers in, 4–7, 22, 38–41, 53–54, 75, 98, 100–102, 105, 238; childcare of, 102, 249n.16; discretion of, 89–90, 246n.8; exemptions of, 107, 112, 166, 251n.5; on foster care, 228; jobs of, 191; racial configuration of, 242n.14; recipients of, 99–100, 150, 227–28; reform in, 98; TANF agreement of, 32; time limits of, 16, 33–34, 105–6; training programs in, 40; workers of, 4–7, 62, 75, 98–108, 227, 238; workfare placements in, 246n.9. *See also* bureaucracy; Sunbelt City welfare office

assistance, financial, 206. *See also* welfare

autonomy, individual, 48–49. *See also* independence; individualism

beliefs, 10. *See also* culture; values

benefits, welfare, 7, 54, 71–72, 127–28, 169, 229, 241n.1, 249n.14, 255n.18. *See also* welfare

birth control, 67–68, 145, 160, 190–91

blacks, 11, 23, 128, 129–30. *See also* race

Blau, Joel, 54, 239

boundaries, symbolic. *See* symbolic boundaries

breadwinners, 132, 134, 135, 258n.28. *See also* wages